ONE THOUSAND YEARS OF PAINTING

AN ATLAS OF WESTERN PAINTING FROM 1000 TO 2000 A.D.

ONE THOUSAND YEARS OF PAINTING

AN ATLAS OF WESTERN PAINTING FROM 1000 TO 2000 A.D.

STEFANO ZUFFI

David & Charles

cover
Johannes Vermeer
Allegory of Painting, c. 1670
Kunsthistorisches Museum,
Vienna

back cover
Thomas Jones
A Wall in Naples, 1782
National Gallery, London

pp. 14-15
David Teniers the Younger
*Archduke Leopold William
in his Gallery*, c. 1650
Schlessheim Castle

pp. 366-367
Hieronymus Bosch
The Fourth Day of Creation,
outer panels of the triptych
*The Garden of Earthly
Delights*, 1500-1510
Prado, Madrid

Translated from the Italian
by Felicity Lutz, Lauren
Sunstein and Mark Eaton
for *Scriptum*, Rome

J. Albers, F. Bacon, Balthus,
J.-M. Basquiat, M. Beckmann,
G. Braque, C. Carrà,
M. Chagall, S. Dalí, P. Delvaux,
M. Duchamp, F. Depero,
O. Dix, L. Feininger,
N. Goncharova, G. Grosz,
E. Heckel, W. Kandinsky,
P. Klee, Y. Klein, M. Larionov,
F. Léger, R. Magritte,
P. Manzoni, C.M. Mariani,
J. Miró, P. Mondrian,
G. Morandi, E. Munch,
G. O'Keeffe, J. Pollock,
R. Rauschenberg, C. Schad,
P. Signac, D.A. Siqueiros,
A. Warhol, G. Wood
© by SIAE 2004

© Succession H. Matisse
by SIAE 2004

© Succession P. Picasso
by SIAE 2004

A DAVID & CHARLES BOOK

First published in Italy as
*Grande Atlante della Pittura,
dal Mille al Duemila*

Copyright © 2001 by Electa,
Milano Elemond Editori
Associati

New Revised Edition
Copyright © 2003 by
Mondadori Electa Spa,
Milano

First published in the UK
in 2004

David & Charles is a
subsidiary of F+W (UK) Ltd.,
an F+W Publications Inc.
company

A catalogue record for this
book is available from the
British Library.

ISBN 0 7153 2038 6

Printed in Spain by
Artes Gráficas, Toledo S.A.
for David & Charles
Brunel House Newton
Abbot Devon

Visit our website at
www.davidandcharles.co.uk

David & Charles books are
available from all good
bookshops; alternatively you
can contact our Orderline on
(0)1626 334555 or write to us
at FREEPOST EX2110, David
& Charles Direct, Newton
Abbot, TQ12 4ZZ (no stamp
required UK mainland).

How to Consult this Volume

The book is divided into two parts:
the *Atlas* itself and the reference sections
under the heading *Meridians and Parallels*.

Atlas
It comprises 140 themes, each developed
over a double page, in addition to detailed
critical commentaries on 35 timeless
masterpieces of painting.
Each double page has a heading that includes
place, date and title, and a colored band
indicating the geographic area:

Spain and the Iberian Peninsula

France

Italy

The Low Countries

Central Europe and Scandinavia

Great Britain and the United
States

Themes of general international
interest

When the theme concerns two different
geographic areas, their respective colors merge
in the band.
Some pages also include inserts in italics that
elaborate on particular themes or personalities.
The double pages devoted to the masterpieces
can be easily recognized since they have a black
ground. The heading adopts the same criteria
and color code as the other pages.
Due to the regulations governing the
reproduction of artworks, in the case of paintings
by some 20th century artists the thin white line
connecting the description to the detail in the
painting stops at the edge of the image.

Meridians and Parallels
The reference sections have been designed as an
aid to consulting the *Atlas* and therefore possess
some of the same graphic features, such as the
colored bands indicating the geographic area.
The *Historic Tables* are organized chronologically
and do not consider geographic areas.
While the *Geographic Tables* present the most
important works executed in the area under
consideration.
The *Timelines* map the lives of over one hundred
artists active between the 15th and 20th centuries.
Finally there is an *Index of Painters*
in alphabetical order.

Contents

Before the Journey

The creative effort of imagining and inventing codes, ways, and means of communication perhaps marks the pivotal difference between the human race and all other living species.

Few intellectual ventures are as fascinating as tracing and interpreting these signs through the millennia, allowing us to rediscover remote civilizations and eras where we find feelings and emotions similar to our own.

Many of these "messages" come from the visual arts that precede and then run parallel to the discovery and development of writing; and while the written word communicated with a very select audience consisting of those who had the privilege of knowing its "secret", the visual arts (as well as music, dance, and other forms of entertainment) were potentially accessible to everyone. Perhaps there is no way of knowing whether or not what we call "art" was born out of practical necessity. The images of animals on the walls of prehistoric caves may have had a religious significance, or maybe they served to teach young men to hunt.

However, during the same period, the urge to decorate a bowl with geometric motifs did not satisfy any immediate or direct need beyond the universal desire to surround oneself with the "beautiful" and the "personal" that exists in all cultures, eras, and latitudes.

The Artist, the Client, and the Public

Every means of communication has its own codes and instruments, but all messages imply the presence of at least two people: the "sender" and the "receiver", or in this case, the artist and the public.

The artist is trained and works within the same intellectual environment as the public he or she has to deal with. Hence a work of art is born of the relationship between creativity, individual talent, and collective taste. This coming together may be both harmonious and complementary or it may be filled with misunderstanding (this is the typical case of the *peintre maudit*, from Caravaggio to the twentieth century), but this has always been the condition of making art that is still indispensable.

However, to understand the visual arts better it is necessary to include a third element in the dialogue between the artist and society. This relationship is, in fact, nearly always filtered through the existence, before the execution of the work, of the demands of the client, or later (between the execution of the work and its acquisition) through its being placed on the art market.

Knowing the client's cultural identity, expectations and

historic context is often key to understanding many of the world's masterpieces, from the Middle Ages to the eighteenth century. Patrons (princes, ecclesiastics, dealers, and public institutions—today we would call them sponsors) frequently imposed specific conditions on the artist, from the use of certain materials to the inclusion of particular details and figures. In many cases when the works were destined for public display, the identity of the patron or the "hallmark" of the sponsor had to be made evident through symbolic references, according to a code of colors, positions, and emblems that must have been readily understood at the time, but that we can only partially reconstruct today,

Nonetheless the clients must not be seen as an obstacle to creativity or as being financially essential to the artists' career. On many occasions their intelligence and openmindedness turned out to be a powerful stimulus to the development of the arts.

The French Revolution marked a sharp break with the past that was also felt in the art world, thus completing a historic process that had begun long before. Until then, the patrons of the arts belonged mainly to two classes— the ecclesiastic and the aristocratic.

After the Revolution, their power was reduced with the emergence of the bourgeoisie. For the figurative arts this meant a transition from patronage to the free market. In other words, the artist no longer knew who would purchase his works, which were sold either directly to the public or, more often, through intermediaries (galleries, auction houses, and exhibits).

This apparently freer system was actually no less binding than the previous one, the art market imposes certain rules; first and foremost the work must satisfy public taste and must meet with the approval of the critics. But also in this case certain distinctions must be made. Exceptionally courageous gallery owners supported the development of the artistic avant-gardes in the twentieth century, while some leading art critics played a pivotal role in introducing the artists and their works to the public.

Sense, Subject, and Meaning

The relationship between the artist, the public, the market, and the critics brings us back to the concept of communication, in the broadest sense of the word. A work of art, like a work of poetry or prose, or like any complex message, can be read in many different ways. There is no single "correct" interpretation, but layer upon layer of

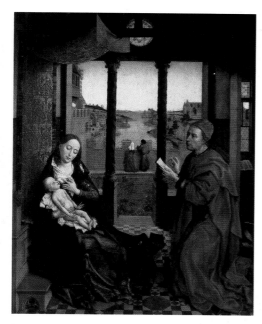

Rogier van der Weyden
*St. Luke Drawing
the Virgin*, c. 1435-38
Museum of Fine Arts,
Boston

tures, clothes and colors, through changing eras and styles. Other characters are given specific attributes by which they can be recognized (objects, animals, garments, signs, physical features), like the keys of St. Peter or the Lion of St. Mark. The communicative power of these attributes is such that at times they become autonomous, detached from the figure to whom they refer: in the two above-mentioned cases, they have become the symbols of entire states and republics, respectively the Vatican and Venice.

On the other hand, it must be added that these traditional devices are used for an audience that is primed to receive and understand Christian imagery.

Vice versa, they may be incomprehensible to people from another culture, just as the subjects of Buddhist or Hindu works of art are usually not understood by Western viewers.

Once the subject has been identified correctly, it may be important to ask oneself if there is a further meaning, a more subtle and profound level of communication.

Some paintings, like Picasso's emotionally charged *Guernica*, owe their exceptional significance not only to their illustration of a historic fact, but also to the artist's ability to render the meaning universal. On the other hand, although all the figures in Botticelli's *Primavera* are recognizable, experts do not agree on the painting's overall significance.

The Concept of the "Art Guide" and the Hierarchy of Forms of Expression

When we speak of the "history of art", very often—even though we are generally unaware of it—we are actually referring to the "history of painting".

This is a misunderstanding that arose during the second half of the nineteenth century as a consequence of two parallel phenomena: the development of the art market and pictorial production (the success of the Impressionists), and the spread of photography as a means of art reproduction more suited to producing two-dimensional images.

Moreover, the development of exhibits and museums favored objects that could easily be transported and moved (like paintings) over bulky and heavy sculptures. However, during the long course of the history of art, painting has not always been the "main" visual art; quite the contrary, in various historic periods, culture and taste were strongly reflected in other media. In addition, the classification of the arts has been an open debate for cen-

interwoven meanings that, when combined, enhance one another. The art historian's task is to reconstruct, analyze, and study the material and the historic, social, biographical, and cultural circumstances that led to the creation of the work.

As a visual means of communication, art appeals to the senses as well as the intellect. This is one of the main differences between visual art and poetry: in literary works the material aspect is irrelevant, and the value of a text remains the same in a deluxe edition or a paperback. On the contrary, in visual art, the "meaning" is communicated through what is visually perceived.

These two levels of communication, mental and visual, must be integrated by further details or "cues" in order to make the characters and episodes recognizable without resorting to explanatory captions. These "cues" can easily be found in cinema and television, where one has to learn to distinguish the "good guys" from the "bad guys".

To this end, art frequently resorts to the tradition of iconography, a word derived from the Greek *eikonographia* that means "sketch", or a way of communicating through images. Recurrent figures, for example Christ or the Virgin Mary are portrayed with the same physical fea-

turies. During the Renaissance, a sharp distinction was made between "high art" (drawing, painting, sculpture, and architecture) and the "minor arts", which included everything from cabinetmaking, to ceramics, textiles, and jewelry.

The painter, sculptor, and architect enjoyed a higher social status than the ceramist, cabinetmaker, goldsmith, tapestry weaver, and engraver, who remained at the level of specialized artisans, given that their specific field of activity demanded a complete mastery of materials, tools, and equipment.

Also within the "high arts" there were different levels according to media and subject. At the height of the Renaissance, Michelangelo was considered the universal artist, the ideal point of reference, and the leading authority on painting and sculpture.

Thus, fresco painters were considered bolder and more "virile" than those who painted on panel or canvas;

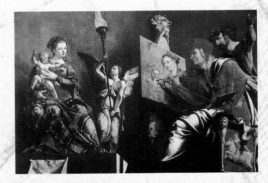

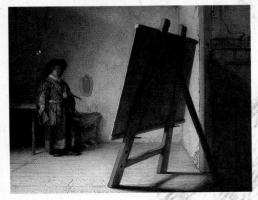

moreover, according to Michelangelo, the artist should aim for the most elevated subject: the human figure either in isolation or set within a "story".

Hence religious scenes and austere literary and mythological subjects were considered elevated; although the public and collectors increasingly preferred the illustration of episodes from everyday life, landscapes, and still lifes.

It was not until the second half of the nineteenth century—thanks to the increasing success of the Impressionists—that these barriers were broken and the subject of the work of art was no longer particularly important. In fact, there was almost a reversal of the situation, since religious and literary art virtually disappeared.

Abstract and Figurative

When we talk of a subject it means we are necessarily referring to the specific field of figurative art. It is important to make this distinction because, especially during the last century, there was a deep rift between art depicting scenes, figures and recognizable objects, and abstract art.

Abstraction, however, was not a discovery made in the twentieth century. Since its inception, art has been constantly characterized by the simultaneous presence of images inspired by reality and by a creativity that was not bound to nature.

Geometric designs, stylized signs, and ornamental patterns, have marked the course of art from prehistoric times onward, alternating with the developments of naturalism and of figurative art. Graeco-Roman art was mainly oriented toward the imitation of nature; by contrast, during the Barbarian invasions and for most of the Western Middle Ages, the image was simplified and reduced to its essential form until the figure completely disappeared. Islamic art and Jewish art were almost exclusively abstract, since it was forbidden to reproduce the image of God.

In Christian Europe too, theologians, intellectuals, revolutionaries, and politicians have, in recurrent phases over the centuries, railed against the power of art. This can be seen in the waves of iconoclasm during the Byzantine Empire, Martin Luther's elimination of paintings, Savonarola's "bonfires of vanities" in fifteenth-century Florence, the rampant destruction of (real or presumed) royal symbols during the French Revolution, the Napoleonic appropriations, and the thousands of works of "degenerate art" that were destroyed in Nazi Germany.

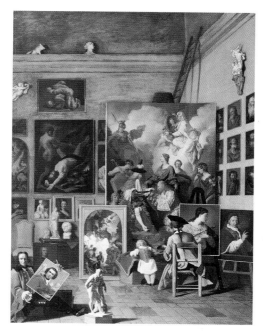

Pierre Subleyras
The Painter in his Studio,
after 1740
Gemäldegalerie der Akademie
der bildenden Künste, Vienna

However, from the fourteenth century on, the vast majority of Western artistic production was figurative. At the beginning of the twentieth century, especially as a result of World War I, traditional values were radically questioned.

The deliberate and programmed birth of abstract art in various European countries was perhaps the most radical innovation in the field of the visual arts during the last century.

Dot, Line, and Surface: the Artist's Gesture and Sign

Whether abstract or figurative, all visual art needs a surface on which to be created.

According to an ancient legend recounted in Greek philosophy, what first stimulated the birth of art were shadows projected onto the ground or a wall, the "double" of the human figure reduced to a surface, a shape without depth.

This characteristic distinguishes art from nature: every real object has three dimensions (height, width, and depth), while a painting has only two dimensions (depth is missing). In order to "imitate" nature the artist must use methods that create the illusion of reality, through visual devices that simulate a third dimension.

A historic dilemma of artists' is whether to opt for the imitation of nature (what the Greeks called *mimesis*) or independent creation ("an idea").

The first object a painter faces is a smooth surface—a sheet of paper, a plate, parchment, a wall, canvas, or a panel—that defines the field or physical limits within which the artist must operate.

This space is not neutral, destined to disappear under the painting: on the contrary, it is an integral part of the work, just as the setting or the size of a playing field are an integral part of a sport.

The artist has to explore the "terrain" not only with regard to the medium that will be used (painting a fresco requires timing, location, and tools that differ from those needed for the execution of a miniature), but most importantly, with regard to the subject matter, and the visual relationship between the work of art and the public.

In the last century some painters have chosen non-traditional materials, ranging from burlap to plastic, sponges and mirrors, often left visible in order to accentuate the basic surface.

In the art of the past the preliminary phase was very important, since it was necessary to prepare the surface carefully, especially in the case of panel paintings and frescoes.

Once everything was ready the first brushstroke marked the beginning of the creative act and the artist's energy was focused on that point. It was a psychologically delicate act, and it is not by chance that the art of the twentieth century paid particular attention to that moment, seeking affinities with music even in the terms it adopted. From the first brushstroke (the initial note or

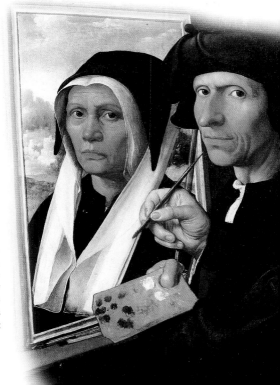

Dirck Jacobsz
*Artist with a Portrait
of his Wife,*
c. 1550
Museum of Art,
Toledo (Ohio)

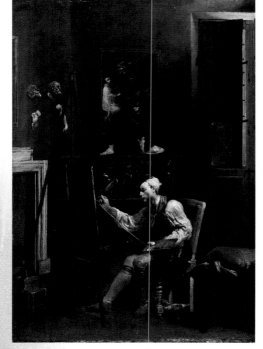

chord) the melodic "line" begins and the "composition" gradually takes shape.

The "sign" is the evidence of the artist's action at the creative moment. Van Gogh, for example, leaves his brushstrokes open and separate, almost allowing us to follow them one after the other. Every single brushstroke is charged with its own individual dramatic meaning: even though they all contribute to the final result, the signs Van Gogh leaves on the canvas are many expressive moments, like an actor's every word and gesture. Van Gogh's is not a technical choice, but an inner need.

We can compare it with the results achieved, during the same period and in the same geographic and cultural area, by Georges Seurat, who was experimenting with a kind of painting in which the artist's slightest touch is recognizable and separated from all the others. Seurat's painting, unlike Van Gogh's, produces an enveloping and diffused light. Basing his work on the laws of physics and the development of photography, Seurat applies numerous small dots of color close together, and from a certain distance they seem to fuse to form harmonious tints. In opposition to Van Gogh, Seurat seeks to eliminate the effect of the single, individual brushstroke and create an impression of the whole.

Drawing, Color, and Light

In sum, Van Gogh accentuates the expressive impact of individual sensations by completely excluding an "objective" closeness to reality; conversely Seurat studies the physical laws of the refraction and diffusion of light and

applies them in painting, seeking a visual effect of light and color.

Color, like drawing, has always been one of the most important elements in art. The human eye, unlike that of some animals, notes the variations in light, materials, and outlines through the various shades of color. Applying color to art means further seeking to adhere to nature, for example, to "imitate" flowers or fruit in a still life or—like the Impressionists—to render the effect of a sunny day *en plein air*, in the open air.

Taking Italian Renaissance art (especially Leonardo and Giorgione) as their starting point, the Impressionists sought to capture atmospheric effects by fusing light and color: for example, shadows are not painted only with black, but by carefully blending and intensifying different tints.

On the other hand, reproducing reality is only one of the possibilities offered by color. Colors possess a rich symbolic significance, partly based on simple feelings (for

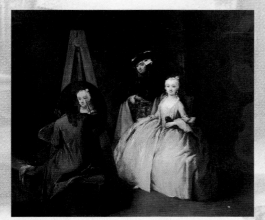

instance, red seems more festive than blue or black) and partly on traditions that have been handed down over the centuries. A particular meaning has come to be associated with many colors, from the Middle Ages to present-day advertising.

All colors are derived from different combinations of the three primary colors: blue, red, and yellow. When these pure colors are applied to a painting they have a power, an explosive energy. The Futurists and abstract painters like Boccioni, Kandinsky, and Mondrian, make abundant use of them, though with very different results. In Futurist paintings, red, yellow, and blue express the idea of a modern, positive dynamism, as conveyed in the frenetic activity of Boccioni's *The City Rises*.

In Kandinsky's compositions these same colors become conflicting patches, violent, disordered contrasts, while Mondrian employs a rigid network of straight lines to divide the field into austere, simple, square or rectangular spaces.

Thus we return to that old controversy: should drawing or color predominate? This debate has had considerable importance in the development of art, especially in sixteenth-century Italy. Artists and art critics were divided into two factions: the Tuscans gave priority to drawing, which they considered to be the starting point of all art, and the way in which the artist measures, controls, and reproduces the figures.

The Venetians on the other hand, championed color (epitomized in the works of Titian), which they used to give figures and nature life and credibility The opposition between drawing and color was taken so far it even involved the very meaning of art, which for the Tuscans was defined as the creation of an "artificial nature", while for the Venetians it was an "expression of life".

The results are obvious: in Tuscan painting an outline surrounds and defines everything clearly, while in Venetian art the transitions are more gradual and take the form of a sequence of tones of light and color. This effect is made possible by developments in the various media: the use of oil paints and the introduction of canvas permitted greater tonal effects.

Composition

One aspect that has not been sufficiently examined is the organization of the visual material to create a complex image. Composition literally means combining objects, figures, architecture, and so on, in a single context.

It is the equivalent of syntax and as such is a vital element in the language of the visual arts. The composition must take into account, above all, the objective condition of the work: the technique, materials, size, and relationship with the setting.

There are three main criteria that govern the arrangement of the figurative elements: the iconographic tradition, the need to emphasize certain figures, and the artist's imagination. The elaboration of original compositions is one of the features that distinguishes a master's style, and establishes his greatness in the same way as his use of color or drawing.

Generally speaking, the composition of a painting implies a prominent position for the main figure and makes the viewer's attention focus on those elements that the artist deems to be most important. In most cases the protagonist is placed at the center of the scene, where the lines of perspective converge.

The minor figures and elements are arranged symmetrically in a way that does not detract attention from the main figure. As all graphic designers know, the eye of the viewer follows set paths and the focus of attention is fixed

Georg Friedrich Kerstin
Caspar David Friedrich in his Studio, 1813
Nationalgalerie, Berlin

along the central axis, slightly above the average line of the horizon. For this reason artists have used various devices, like steps, pedestals, supports, and thrones, to raise the main figure above the level of the others. A triangular or pyramidal arrangement of figures is also common, as in scenes depicting the Madonna surrounded by two or more saints.

The concept of composition became vital from the fifteenth century onward, when a single square or rectangular panel, instead of the triptych, began to be used for altarpieces. In an undivided altarpiece the figures enter into a direct relationship with one another. Hence, it became important to create an architectural or natural setting that could effectively contain all the figures and determine their positions within the undivided space.

A case in point is the *Montefeltro Altarpiece* by Piero della Francesca in which a group of thirteen immobile figures are placed within a Renaissance church. The proportions of the building are in scale with the human body and the precision of the perspective allows the actual

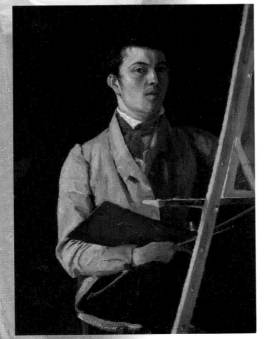

measurements of the church to be taken. The famous detail of the ostrich egg hanging in the background, apart from its symbolic significance, is an excellent demonstration of total control in this representation of space in depth. The eyes of nearly all the figures fix a single horizontal line. Their positions in the space follow the lines of the architecture, with one important exception: on the right of the composition, in front of the saints and protected by shining armor, kneels the Duke of Urbino, Federico da Montefeltro. Piero della Francesca has added the portrait of his client in such a way that it does not disturb the still atmosphere of mystic harmony, but also in a manner that sharply distinguishes it from the other figures by interrupting the scheme of symmetries.

This scheme is effective when the altarpiece is seen from the front, as is the case when placed above the high altar in a church; on the contrary, it may appear incongruous and lacking in balance if seen from the side.

Some artists have dealt in a highly original way with the problem of an image set at an angle. For example, when Caravaggio was faced with the task of painting the *Calling of St. Matthew* on the side wall of a relatively narrow chapel, he chose an elongated composition, with figures set around a table; Christ's gesture and the saint's reply are closely linked by the innovative diagonal light.

Focus on the rhythms of a composition increased during the twentieth century, when the reduction or even the disappearance of recognizable figurative elements placed even more emphasis on the composition itself. The word "composition" (also because of its affinity with musical terminology) is, in fact, used as a title for paintings by masters like Kandinsky and Mondrian.

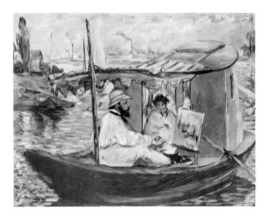

to be transmitted. Defining "form" simply as the wrapping in which "content" is enveloped means depriving art of its primary and most significant function as an "object" which is seen.

The word "technique" derives from the Greek *tékne*, meaning "art". Thus in the original meaning of the term, the "technical" aspect coexists with the creative idea, allowing us to experience, through the centuries, the moving, indispensable emotion of beauty.

Édouard Manet
Monet Working in his Boat-Studio, 1874
Neue Pinakothek, Munich

Paul Gauguin
Van Gogh Painting Sunflowers, 1888
Van Gogh Museum, Amsterdam

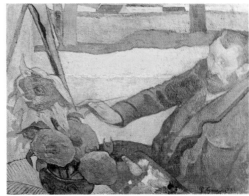

Form and Content, Technique and Creativity

Art criticism and more generally "aestheticism" have long been in the habit of separating "form" from "content". Traditionally critics have divided the history of art into periods where attention to formal aspects alternates with eras where the focus is directly on expressing feelings, passions, and ideas.

This distinction, which in the past was also made within an artist's oeuvre or even within a single work of art, is applied less today. Contemporary art historians generally maintain that the "form" is an integral and indispensable part of the "content". By evaluating his possible creative choices, the requirements of the time, and the receptiveness of the public, the artist is able to communicate with the observer and broaden his range of possible meanings

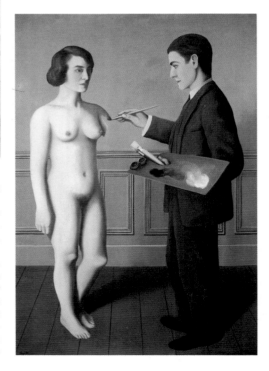

René Magritte
Attempting the Impossible, 1928
Courtesy Galerie Isy Brachot, Brussels-Paris

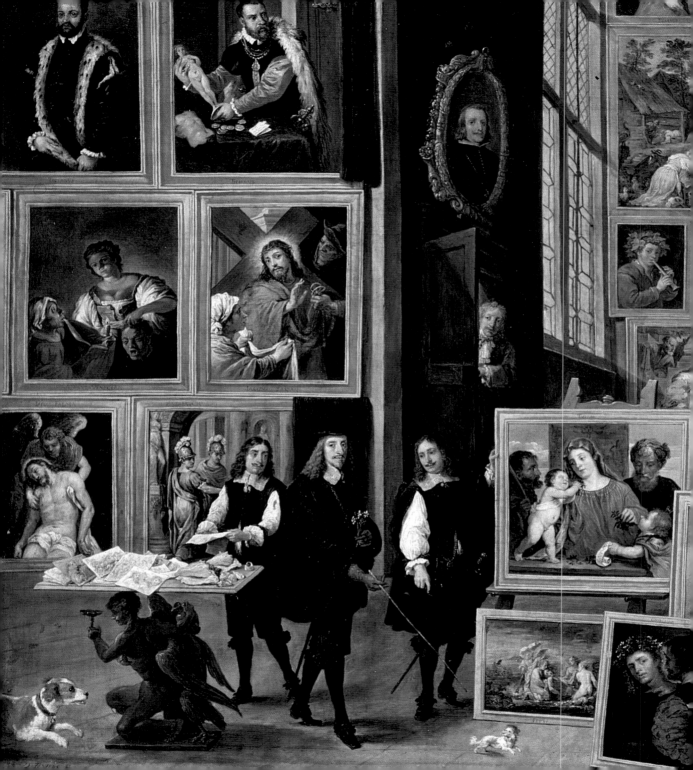

Spain

Eleventh Century

The Camino de Santiago

**Painting and Manuscript Illumination
in the New Europe**

A significant contribution to the "common language" of
the Romanesque came from the great pilgrimages. The
final destinations of itinerant Christian worship in the
Middle Ages were the tombs of two Apostles, St. James the
Greater in Spain and St. Peter in Rome, linked to Central
Europe by the Via Francigena. The great number of pil-
grims traveling through Europe allowed more widespread
cultural exchange. With a new sense of reality and action,
Western art started to move away from Byzantine culture
and artists began to develop a fascinating system of sym-
bols used to convey particular figures and episodes. Some
recurring figures, such as Christ, the Madonna, and the
Apostles, were always painted or sculpted in similar ways,
while certain animals, plants, monsters, dragons, and fan-
tastic figures represented human virtues and vices. The
diffusion of the same models, however, did not imply a
uniformity of style. On the contrary, there were notable
differences in expression from one region to another, dic-
tated by local materials, traditions, and needs, as well as by
the presence of influential patrons and artists.

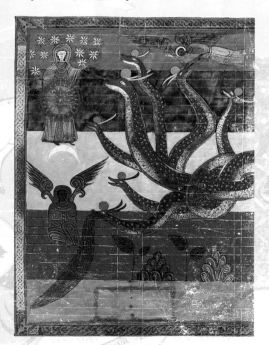

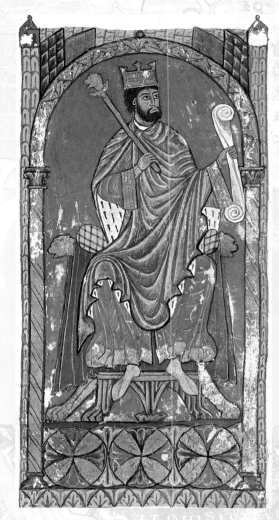

*Alfonso VII of Castile on the
Throne*, illumination from
the *Great Book of Privileges*,
12th century
Cathedral archive, Santiago
de Compostela

During the Romanesque
period in Spain, Christian art
reflected the influence of
the Islamic figurative
tradition, which, at this time,
was producing astonishing
masterpieces of architecture
and decoration in the
Andalusia region.

Illuminated page from the
Beatus of Ferdinand I, 1047
Biblioteca Nacional, Madrid
background image:
The Four Knights,
illumination from the
Apocalypse of Saint Sèver,
mid-11th century
Bibliothèque Nationale, Paris

Spanish Romanesque
manuscript illumination
centered on the Apocalypse
and its remarkable repertoire
of fantastic images painted
in bold colors.

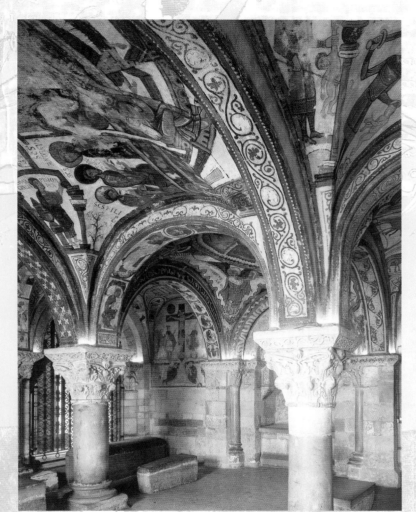

View of the Panteón
de los Reyes, c. 1063-1100
Church of San Isidoro, León

León is still one of the most
important cities on the road
to Santiago; the royal
pantheon, attached to
the Church of San Isidoro,
houses one of the best-
preserved and most
fascinating fresco cycles
of Romanesque Europe.
During this period,
monumental painting was
beginning to find its own
expressive form. Unlike
miniatures and manuscript
illumination, here the scenes
majestically and solemnly
unfold against a plain white
ground, while fine decorative
bands separate each section.

When the Pilgrims Reach Santiago, the Prophets Greet them with a Smile

*The Portico de la Gloria, the historic entrance to the cathedral of Santiago, is char-
acterized by its lively eleventh-century sculptures of the prophets. These smiling faces
served as a long-awaited greeting for the pilgrims who, after many weeks of gruel-
ing travel, had finally reached their destination: the* campus stellae, *miraculously
indicated to St. James by a shining star. The* camino *to the tomb of the apostle James
in Galicia, one of the western-most points of the European continent, normally
began from four different towns in France, where pilgrims from various countries
would gather to form parties and face the hardships and dangers of the long journey together. On the
Spanish side of the Pyrenees, the four paths joined to form a single road, which was lined with hostels,
refuges for the sick, monasteries and rustic inns, many of which are still visible today. The pilgrims could
easily be recognized by their dress, which included a walking stick, a loose-fitting cloak and the charac-
teristic wide-brimmed hat. The traditional emblem of the pilgrims was the scallop shell of
St. James, a sign of identity and worship that was carved into the stone façades along the route, becom-
ing a sort of road-sign and reassuring presence.*

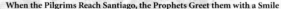

Central and Southern Italy
Eleventh and Twelfth Centuries
The Influence of Montecassino

The Pleasure of Making Images Speak

The patronage, interest, and tastes of many ecclesiastics contributed to the development of the arts during the eleventh century. Abbot Suger of Saint-Denis, for example, favored jewels and the polychrome splendor of stained glass windows, while Bishop Bernward of Hildesheim commissioned great bronze masterpieces, like the doors of the cathedral (known as "Bernward's doors") and its famous "Christ pillar". In Cluny, the abbots commissioned sculpted capitals for their cloister and complex architectonic forms, while St. Bernard of Clairvaux, hostile to any kind of decoration, developed an architecture for the Cistercian abbeys that paved the way for the Gothic style. Perhaps one of the most significant contributions was made by the Benedictine Abbot Desiderius (Pope Victor III in 1086) of Montecassino, who encouraged painting of all kinds, from monumental fresco cycles to the beautiful manuscript illumination of the monks of the *Scriptorium*. Under his guidance a special form of Byzantine painting developed in central and southern Italy. These images assumed a new narrative rhythm, and the concept of "illustration" extended from manuscript pages to walls, conveying a sense of history and real life. It is no coincidence that the earliest text in the Italian language (a legal document that begins with the words *sao ke kelle terre*, I know that those lands...) is conserved at Montecassino, and its powerful communicative force remains intact. During World War II, Montecassino abbey was tragically razed to the ground, however, the buildings have now been rebuilt as they were during the sixteenth and seventeenth centuries.

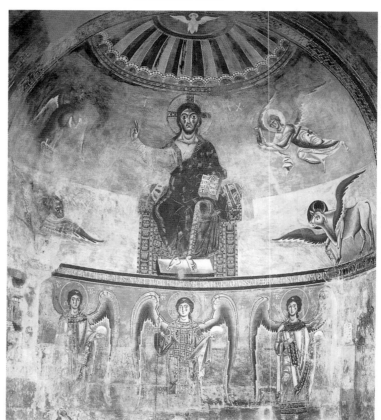

Christ Enthroned between the Symbols of the Evangelists and the Archangels with the Donor Abbot Desiderius, 1072-86, Basilica of Sant'Angelo in Formis (Caserta)

The disappearance of the frescoes and mosaics of Montecassino makes this pictorial cycle, commissioned by Abbot Desiderius, particularly important. The many scenes depicting the life of Christ express the desire to convey sacred concepts through art.

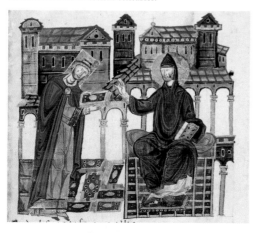

Abbot Desiderius Offers Books and Sacred Buildings to St. Benedict, illuminated page from the *Lezionario Cassinese*, c. 1080
Biblioteca Apostolica Vaticana, Vatican City

This is a poignant testimony of Desiderius's "project" to create new spaces and new languages for the faith. Following the schism with the Orthodox Church (1052) and in the face of a movement that was to lead to the Crusades, many felt a need to explore new forms of expression. During this time, painting began to timidly leave behind the traditional, cultured link to the "Greek" (intended in the Byzantine or Oriental sense) and embrace a language that was perhaps less refined, but more easily understood.

"Alberto Sozio"
Crucifix, detail, 1187
Cathedral, Spoleto

A century after Desiderius, this magnificent detail from the cross in the cathedral seems to evoke the energy and power of painting.

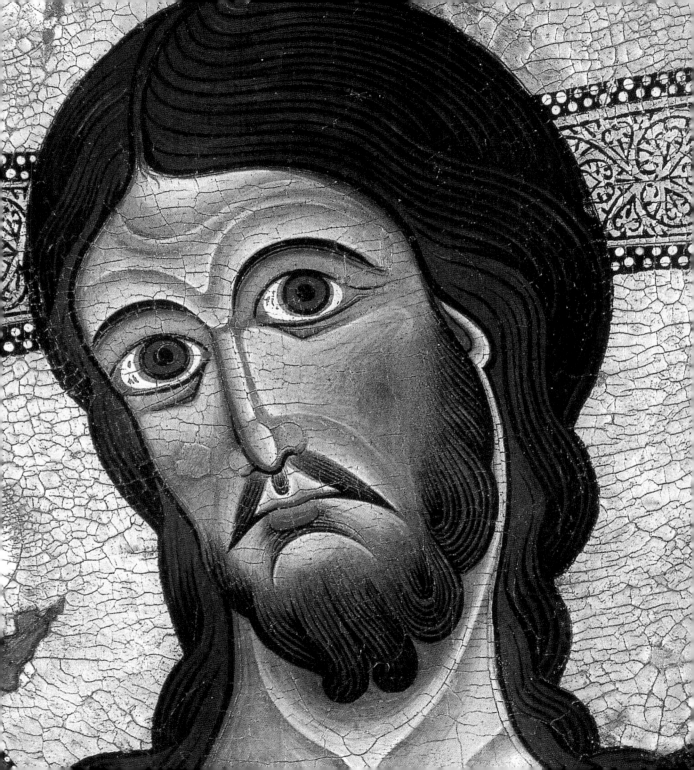

Rhaetia and the Alpine Passes
Eleventh and Twelfth Centuries
Romanesque Frescoes

The Language of Images for Christian Europe

Two peoples, once united by the administration, language, and laws of Rome, had difficulty recognizing each other when their paths finally crossed again. History, more than geography, had created a deep rift between the Germanic and Mediterranean worlds that were now linked only by the treacherous Alpine Passes and a common religion. Thus, illustrated religious scenes from this period, sought to unite all Christian peoples, including the illiterate masses, who were also divided by the increasing number of languages and dialects. The Grisons or Graubünden of Switzerland and Northern Italy, for example, developed figurative solutions for the *Biblia pauperum* "Bibles of the poor", while the murals of ancient Rhaetia and the neighboring valleys of Alto Adige, depicted naïve, but impassioned, figures and scenes that recounted stories of divine characters and the Mysteries of the Faith, giving concrete, visible meaning to the Holy Scriptures. Many centuries later these paintings may not seem remarkable, but in the isolated Alpine forests, through which the roads of medieval Europe passed, these unprecedented scenes, depicted in a universal figurative language accessible to all men, were one of the great cultural achievements of medieval Europe.

The Stoning of St. Stephen, 12th century Monastery Church of St. Johann, Müstair

Müstair, an important religious center located in the Swiss canton of Graubünden, contains a great cycle of Romanesque frescoes, characterized by their lively narrative spirit, but unfortunately damaged by clumsy early restorations.

Stories of Christ and Sea Monsters, ceiling panels, c. 1120 Church of St. Martin, Zillis (Graubünden)

153 excellently preserved painted panels form the remarkable ceiling of the Church of St. Martin in Zillis, in a village in Graubünden on the road that climbs from Ticino to Coira, near the Splügen Pass. The main subject of the ceiling is the life of Christ. The series of panels that runs around the edge does not contain narrative scenes, but a fabulous bestiary of sea monsters. Fantastic, bizarre animals, horrible beasts, and enchanting sirens swim among the waves of a boundless ocean, where the creatures of Evil are hidden, while in the four corners of the ceiling (which thus becomes a sort of symbolic map of the world) angels with open wings mark the cardinal points. References to medieval illumination, Byzantine art and the Ottonian figurative culture, embellish a powerful, synthetic and extremely effective style.

The Victory of the Archangels over the Dragon of the Apocalypse, end of 11th century Church of San Pietro al Monte, Civate (Lecco)

The Church of San Pietro al Monte, perched on a hill overlooking the road that descends from the Splügen Pass and Lake Como toward the Lombard plain, is a jewel of Romanesque art. Its perfectly preserved stuccoes and fine frescoes recount the victory of Good over Evil, culminating in the scene of the diabolical dragon pierced through by the javelins of the angel armies, who rescue the Child born of the Woman enveloped by the sun.

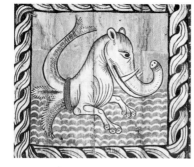

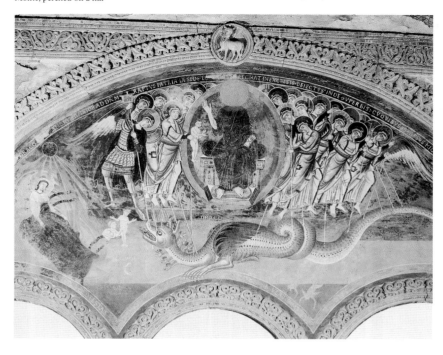

Stories of Christ and Sea Monsters, ceiling panels, c. 1120 Church of St. Martin, Zillis (Graubünden)

Venice
Twelfth and Thirteenth Centuries
The Mosaics of St. Mark's

Oriental Gold on the Shores of the Adriatic

Combining the Byzantine and Roman worlds to create a unique style, St. Mark's Basilica has been the heart and symbol of Venetian culture since the arrival of the relics of the city's new patron saint in the early ninth century. From this point on, the miracle of Venice spread like a wave on the calm waters of the lagoon to the islands of the archipelago, like Torcello and Murano, home to many other important medieval buildings and mosaic cycles. The basilica is filled with magnificent mosaics, executed between the twelfth and the sixteenth centuries and unified by a brilliant gold background. Upon careful observation, it is apparent that these mosaics are not all the same, but follow the stylistic evolution of Venetian painting: from its pure Byzantine origins to the curved Gothic forms, to the advent of perspective in the fifteenth-century humanism that spread from Tuscany, and to the glorious age of the Renaissance. Particularly significant are the mosaics executed during the thirteenth century, after the Sack of Constantinople in 1204. Venetians thought of their city as a "second Byzantium" and were proud of its political and religious independence from Rome and the Byzantine Empire.

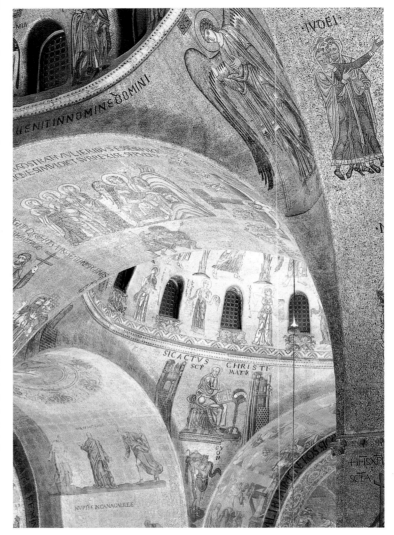

The Dance of Salome, mid-14th century Baptistery of St. Mark's Basilica, Venice

The extremely lively mosaics in the baptistery form an unusual Gothic interlude that interrupts the Byzantine tradition. The sinuous figures follow a lively narrative rhythm, and the agile Salome adds a note of exotic seduction.

Scenes from the Passion of Christ, first half of the 12th century St. Mark's Basilica (nave), Venice

The dazzling gold mosaics almost make one lose all sense of the architecture of the building. The mosaics in the nave, among the earliest in the basilica, follow a strict iconographic sequence based on the redemption of mankind. They must be read from east to west, following the path of the sun and, symbolically, human destiny, beginning in the apse, continuing along the series of cupolas and ending at the inner wall of the entrance arch. The first scene (in the apse) is that of Christ the Pantocrator. The next scene (spread over the three cupolas of the nave) depicts Emmanuel, consecrated to the advent of the Messiah; the Ascension, symbol of the Church living in Christ; and Pentecost, symbol of the Church that acts through the Apostles. The cycle concludes with the magnificent scene of the Last Judgment.

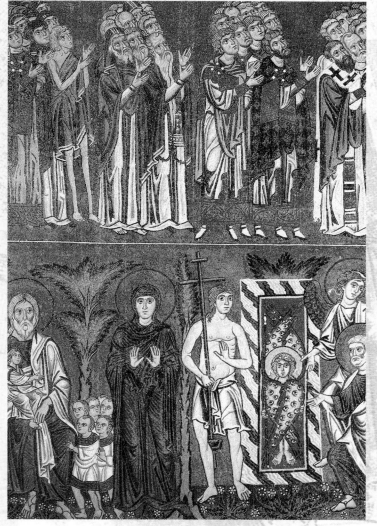

Virgin Praying,
first half of 13th century
semi-dome of the apse,
Basilica Santi Maria
e Donato, Murano

The tall, abstract figure
of the Virgin, the
work of Veneto-
Byzantine masters,
stands mystically
isolated against
a luminous
gold ground.

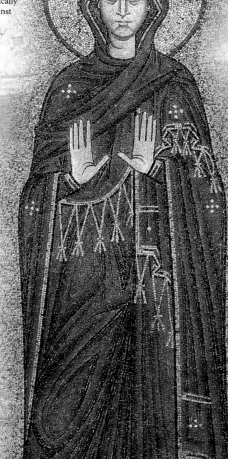

Last Judgment,
detail, 12th-13th centuries,
Cathedral of Santa Maria
Assunta, Torcello

The vast mosaic that covers
an interior wall of the splendid
cathedral of Torcello, organized
into superimposed bands,
and characterized by
a wonderful clarity of
composition, is one of the
masterpieces of Byzantine
art in the Venetian lagoon.
In the detail above, the upper
section shows the ranks of
the blessed, divided into
groups: virgins, martyrs,
monks, and bishops. Below,
the flowering grass beneath
the feet of the figures
represents Eden. To the far
left, the patriarch Abraham
greets the souls of the
righteous, followed by the
Virgin praying, the Good
Thief with the cross, the
gate of Paradise protected
by a seraph, and finally
St. Peter accompanied
by an angel.

Palermo, Monreale, and Cefalù
Twelfth Century
Arabian-Norman Sicily

"A work that has not been made by any king since ancient times, enough to create wonder in all those who come to know of it"

In 902, after the wars against the Byzantine Empire, the Arabs completed their conquest of Sicily, turning the largest island in the Mediterranean into a luxuriant garden studded with fine Islamic buildings. Arab rule lasted until 1061 when the island was conquered by the Norman King Roger. The Norman dynasty reached the height of its splendor during the reign of King Roger II, crowned in the cathedral of Palermo in 1130. For several decades, through a policy of tolerance, the Norman king managed to persuade the Muslim, Byzantine, and Western communities to coexist in peace; a difficult feat, even by today's standards. The most fascinating result of this remarkable period of history and culture are the mosaics in the royal buildings. The most astonishing cycle is undoubtedly the one found in Monreale Cathedral, described in the quotation by Roger II above. The interior of the vast church is decorated with over 8,000 square meters of mosaics on a gold ground, where the biblical stories become a magnificent treatise on the history of the world and the destiny of mankind.

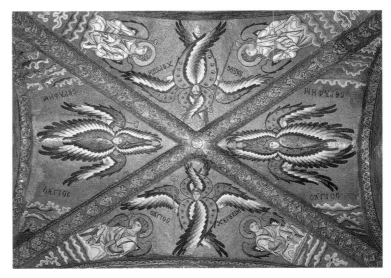

Seraphs and Angels, second half of 12th century Cathedral, Cefalù

The architecture and the mosaics that decorate the presbytery and the main apse, make Cefalù Cathedral a prestigious example of the style known as Arabian-Norman (in order to point out the dual cultural influence). In the figurative portions, however, the mosaics largely reflect the precepts and repertoire of Byzantine art. Even more than in Monreale, the time, space, action, and power of these images are concentrated in the immense figure of Christ the Pantocrator dominating the semi-dome of the apse.

Hunting Scenes, c. 1170 Sala di re Ruggero, Palazzo dei Normanni, Palermo

The influence of Persian art is clearly visible in this mixture of real elements and fantastic figures.

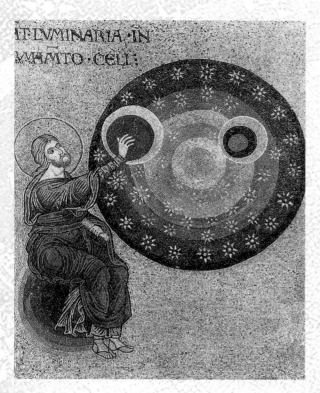

Creation of the Stars, 1172-76
Cathedral, Monreale

In Monreale Cathedral, the gold of the mosaics floods the apses, flows under the arches, outlines the moldings, and even creeps into the windows, producing an almost hypnotic effect that makes us lose all sense of space and breaks down the barriers of time. The stories of the Old and New Testaments unfold in a sort of eternal present and the ancient patriarchs of the Bible come alive, waiting for a final event to occur. The iconographic design (the image of God,

in the form of the Father or the Son, appears 53 times) is highly elaborate. Its author, very probably a Benedictine monk, was a true expert in the mysteries of religion, and also capable of bold interpretations. The actual artist of the mosaics was an early genius of communication through images. Never losing the narrative rhythm of the vast cycle, he manages to encapsulate the power of the message in each episode. Extremely moving moments of everyday life alternate with lofty symbolic scenes.

Nativity, c. 1150
Church of Santa Maria dell'Ammiraglio, Palermo

Begun in 1143 by King Roger, the church is also known as "la Martorana" after the surname of the founder of the nearby Benedictine convent. It houses a magnificent cycle of mosaics with scenes from

the life of the Virgin in elegant Byzantine style. The episode of the Nativity depicts the tender scene of Mary placing the tightly swathed Christ Child in the manger. Below, a woman tests the temperature of the water in the small bathtub.

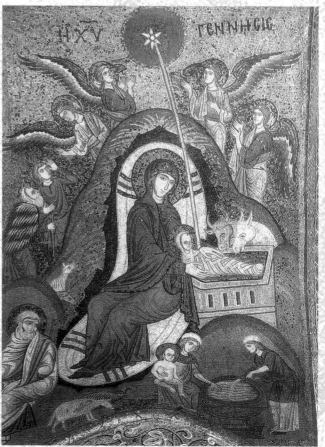

Catalonia
Twelfth and Thirteenth Centuries
Frescoes and Panels from the Pyrenees

A Firm, Resonant Voice in the Choir of European Romanesque

In the Romanesque period, figurative art was closely connected to the buildings that housed it: the sculpted portals, bas-reliefs, fresco cycles and other paintings were created in harmony with the architecture of the churches. In some cases, for conservation reasons, or in order to prevent the dispersion of what has remained of the art treasures of remote, unprotected areas, figurative elements have been removed from their original sites and taken to museums. One of the most outstanding examples of this practice is in Catalonia, where between 1919 and 1923, entire cycles of frescoes, as well as painted altar-frontals, were detached from small, isolated churches in the Pyrenees and placed on display in the Museu Nacional d'Art de Catalunya, Barcelona, in rooms recently redesigned by Gae Aulenti. A controversial operation, which separated the paintings from the architecture, but permitted the "rediscovery" of the astonishing, monumental achievements of a border region where the roads of Europe intersect. These works are essentially Lombard in style, modified by the influence of French sculpture and miniatures, though the presence of a strong, recognizable local accent is always visible.

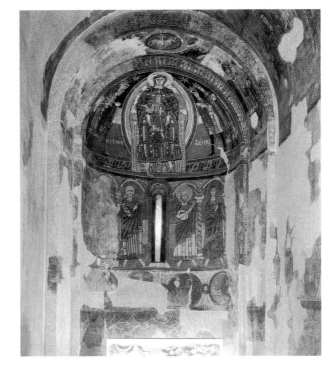

Virgin and Child Enthroned, (accompanied by the *Magi*), fresco detached from the apse of the Church of Santa María (Taüll); in the background on the opposite page: *Christ in Majesty,* fresco detached from the central apse of the Church of San Clemente (Taüll), c. 1120
Museu Nacional d'Art de Catalunya, Barcelona

The small town of Taüll can be considered the "capital" of Pyrenean Romanesque, home to two of the largest and best-preserved cycles that were perhaps the work of a Lombard master, and the craftsmen who built the churches.

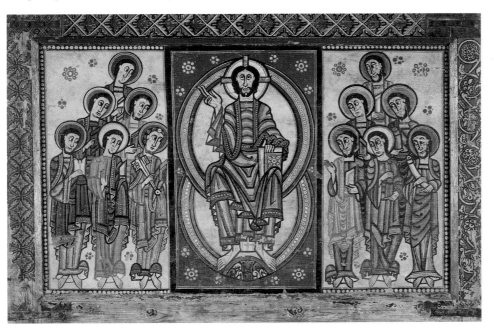

Altar-Frontal with Christ Enthroned among the Apostles, originally from the Cathedral of Santa Maria in Seo de Urgel, 12th century, Museu Nacional d'Art de Catalunya, Barcelona

In the altar-frontals, painted on panels, the influence of contemporary illumination is clearly visible.

Altar-Frontal of Gésera,
13th century
Museu Nacional d'Art de
Catalunya, Barcelona

Strange, primitive, and
"incorrect" from an anatomical
point of view (the feet are
inverted), this frontal
is nevertheless full of
communicative power, and
was even reworked by Picasso.
The painting depicts St. John
the Baptist in the desert, in front
of a thorny cactus. On each side
of him, are groups of the faithful
and wild or monstrous animals,
arranged in rows, symbolizing
the hostile nature of the desert.
The excellent state of
preservation allows us to
recognize the influence of
the goldsmith's art and enamel
work (in the gold lines on the
folds of the cloak).

Rome
Eleventh to Thirteenth Century
The Middle Ages in the Eternal City

Dark Ages, Golden Wonders

The fratricidal battles and in-fighting that tormented medieval Rome did not interrupt the continuous development of art. Pope Pascal II, elected in 1099, initiated a great restoration project of the ancient basilicas, while the art of mosaics reached heights of sublime elegance, in both the vast apsidal compositions and the polychrome inlay of floors and cloisters. A further boost to Rome's newly-discovered role as the center of art came in the second half of the thirteenth century when great Tuscan artists like Cimabue, Arnolfo di Cambio, and Giotto joined the independent-minded painters of the Roman School (Pietro Cavallini, Filippo Rusuti, and Jacopo Torriti) for the first Jubilee. The Roman artists greatly influenced Giotto and Italian painting in general, as the Byzantine style began to wane. Pietro Cavallini, who executed both frescoes and mosaics, was above all, the most influential figure, for his innovative choice of colors and use of light. His participation in the decoration of the Basilica of San Francesco in Assisi and the Chapel of the Sancta Sanctorum in Rome is still a matter of debate. The controversial papacy of Boniface VIII and the subsequent transfer of the papal seat to Avignon (1308) brought this creative period to an abrupt end.

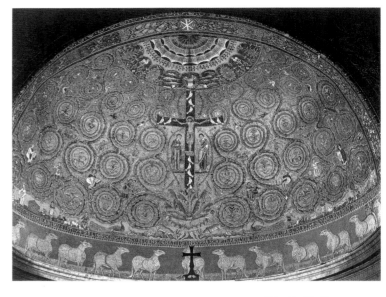

Triumph of the Cross,
mosaic decoration of the semi-dome of the apse, 1128
Basilica of San Clemente, Rome

This is one of the most "abstract" and intellectual Roman mosaics. Here, the cross rises from an acanthus plant, which develops into regular blue-green volutes against a gold ground. Among these floral arabesques are biblical scenes, mystic figures and symbolic animals that allude to the message of the Redemption.

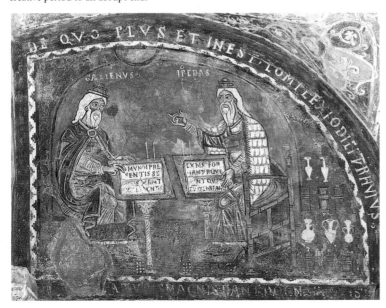

Magister Conxulus (?)
Hippocrates and Galen,
1231-55
Crypt of the Cathedral, Anagni

The small town of Anagni, often the summer residence of popes in the Middle Ages, boasts an imposing Romanesque cathedral. Its crypt houses one of the largest and most delightful fresco cycles of the Roman School before Pietro Cavallini. The artist, still influenced by Byzantine models, may have been Magister Conxulus, who subsequently painted frescoes on the life of St. Benedict in the Sacro Speco of Subiaco.

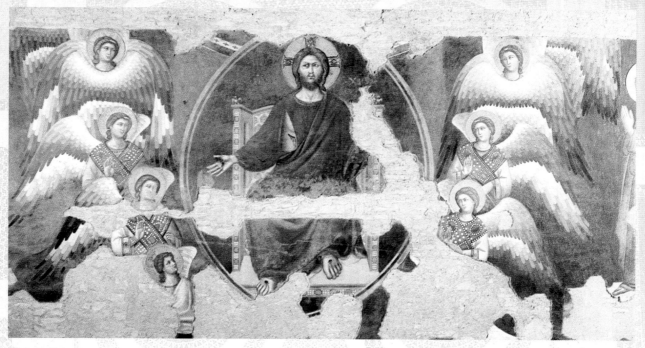

Pietro Cavallini
Last Judgment, c. 1293
Church of Santa Cecilia in
Trastevere, Rome

Although fragmentary,
the image of Christ the Judge
surrounded by angelic hosts
expresses the monumental
power of Pietro Cavallini.
The perfect frontality belongs
to the Byzantine tradition,
while the warm colors and
the play of shadows are
decidedly innovative.

Crucifixion of St. Peter,
last quarter of 12th century,
Chapel of the Sancta
Sanctorum, Rome

"There is no place more holy
in the city," reads an epigraph:
the Sancta Sanctorum,
a perfectly preserved treasure
of thirteenth-century Roman
art, is the ancient papal chapel
in the Lateran Palace, residence
of the popes in the Middle
Ages. The Gothic hall,
consecrated in 1279 by Pope
Nicholas III Orsini, has an
extraordinary cosmatesque
floor (background) and is
finely decorated with mosaics
and frescoes. These paintings
are the work of an anonymous
local artist influenced by
Cimabue (who was present in
Rome in 1272); some experts
believe they may be the first
works of the young Pietro
Cavallini. The traditional scene
of the crucifixion of St. Peter
with his head downward is set
against the backdrop of an
unusual urban view.

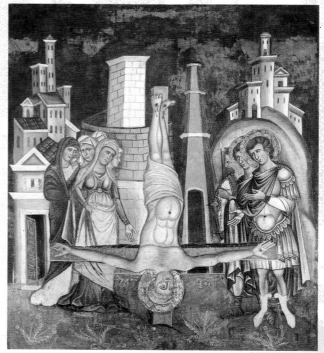

Florence and Assisi
Developments from 1272 to 1302
Cimabue

"Once Cimabue thought to hold the field / As painter; Giotto is now all the rage, / Dimming the luster of the other's fame"

A tradition begun at the beginning of the fourteenth century by Dante in the *Divine Comedy*, taken up by Giorgio Vasari in *Lives of the Artists* in 1550 and repeated for centuries by art historians, holds Cimabue to be the father of Italian painters. At the beginning of the fourteenth century he founded the Florentine School, imposing its language on the whole of Italy. This does not correspond entirely to the real historic development of Italian painting, for it places too much emphasis on the centrality of Tuscan art, and also leaves great artists of the thirteenth century in the shade. Nonetheless, it remains the main approach to interpreting the origins of great Italian painting. The turning point in figurative art involved the transition from Byzantine models to an art that always observes reality and rediscovers the still powerful lessons to be drawn from classicism. After a period in Rome in 1272, Cimabue began work on his series of frescoes in the Basilica of San Francesco in Assisi. Despite their poor state of preservation, works like the *Crucifixion* in the Upper Church display a dramatically expressive style that was already well-defined. The power of Cimabue's painting can be seen in his panels of the *Madonna Enthroned* (at the Louvre, the Uffizi, and in Bologna, each progressively more three-dimensional), in his disturbing Crucifixes on shaped panels (the one from the Church of Santa Croce in Florence that was ruined by the flood of 1966 is universally known), and in his cartoons for the mosaics in the Baptistery of Florence and Pisa Cathedral.

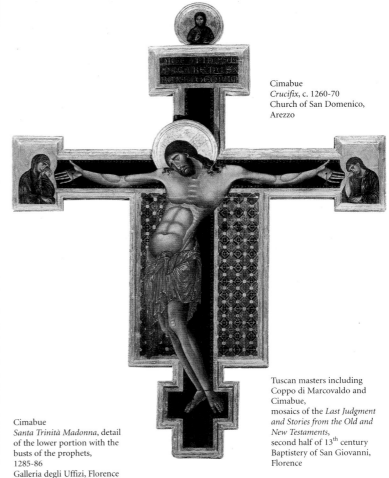

Cimabue
Crucifix, c. 1260-70
Church of San Domenico,
Arezzo

Cimabue
Santa Trinità Madonna, detail
of the lower portion with the
busts of the prophets,
1285-86
Galleria degli Uffizi, Florence

Tuscan masters including
Coppo di Marcovaldo and
Cimabue,
mosaics of the *Last Judgment
and Stories from the Old and
New Testaments*,
second half of 13th century
Baptistery of San Giovanni,
Florence

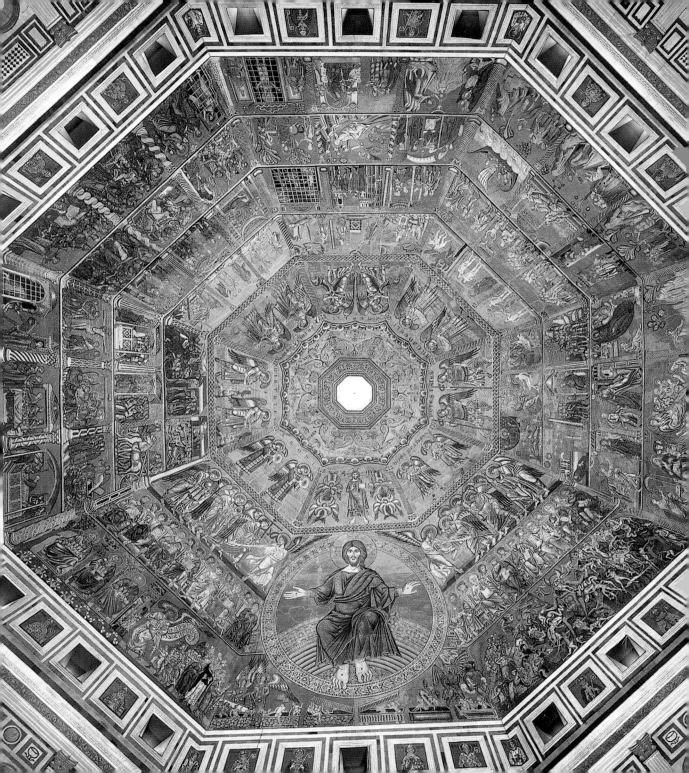

Florence, Assisi, and Padua
1267-1337
Giotto

Faith in Man and in History

The work of Giotto marked a decisive turning point in painting, breaking away from the rules and conventions of the centuries-old Byzantine tradition to obtain a naturalistic, narrative representation of episodes and characters. Giotto began work in Assisi, and in the frescoes devoted to the life of St. Francis he depicted the various episodes in extremely concrete natural or architectural settings, and with dynamic groups of figures, seeking to express not only facts but also emotions. To achieve this goal Giotto placed his figures on different planes, showing them not only frontally or in profile, but also with their backs turned. His great expressive power was gradually enriched by new opportunities offered during the various stages of his long and successful career. Particularly outstanding are his frescoes in the Scrovegni Chapel in Padua (c. 1304) and the cycles painted in the Church of Santa Croce in Florence. In the last years of his life he also turned his hand to architecture, designing the famous campanile of the Cathedral of Santa Maria del Fiore. A contemporary and fellow townsman of Dante, he brought profound human sentiments into art, giving the individual an identity and a historic role. Each figure has its own space and its own volume; for this reason Giotto is considered to be a precursor of Renaissance perspective.

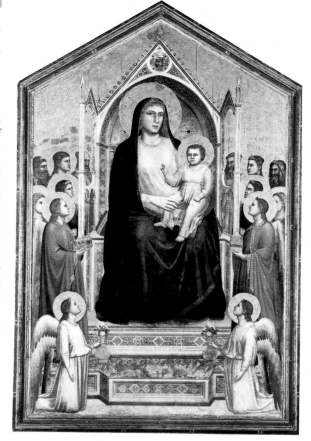

Giotto
Ognissanti Madonna,
1306-10
Galleria degli Uffizi, Florence

This recently restored altarpiece is part of the Tuscan tradition of depicting Madonnas against gold backgrounds on pentagonal panels. The solid volumes of the figures, deliberately based on the lines of regular geometric shapes, stand out against the delicate, elegant Gothic throne.

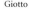

Giotto
St. Francis Giving his Mantle to a Poor Man, 1297-99
Basilica of San Francesco,
Upper Church, Assisi

The doubts expressed by some critics regarding the attribution to Giotto of the frescoes of the life of St. Francis do not reduce the charm of these masterpieces of European Gothic painting.

Giotto
Interior of the Scrovegni Chapel, 1304-06
Padua

The frescoes in Padua reveal again that spatial dimension within which each individual moves and acts.

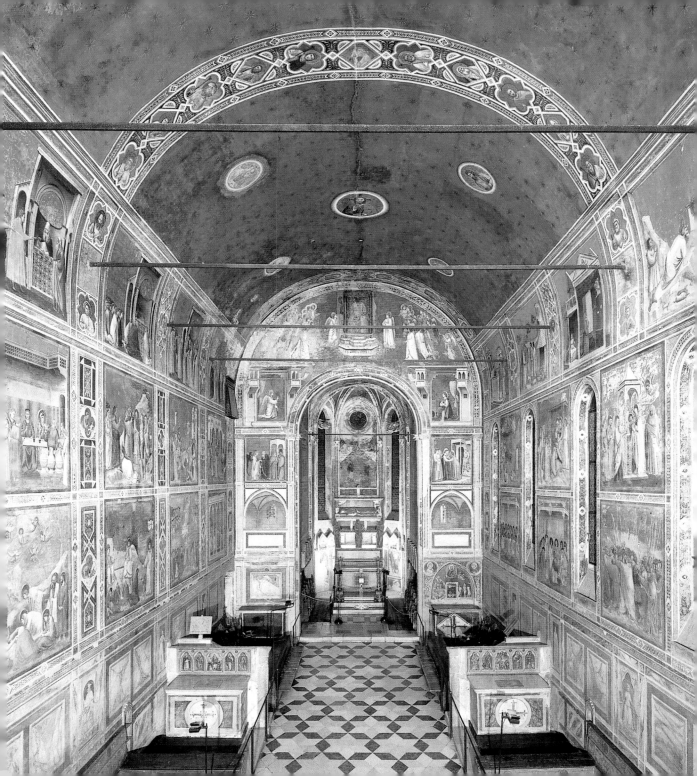

Giotto

1304

Lamentation

The *Lamentation*, the culminating episode and
expressive climax of the *Passion*, is on the lower portion
of the left-hand wall in the Scrovegni Chapel in Padua.
The chapel, built on the ruins of the ancient Roman
amphitheater of Padua, is one of the most important
treasures of medieval art, and the frescoes that decorate
its interior represent a decisive moment in the evolution
of painting. Breaking away from the Byzantine tradition,
Giotto's frescoes illustrate a more "modern" style,
characterized by a rich and complex symbolic structure
and a new spacial dimension, within which each
individual moves and acts. Just as each canto and
character in Dante's *Divine Comedy* has a place in the
larger, overall structure of the text, each scene painted by
Giotto is also united by a single, typically late-medieval
theme: man's journey to salvation. The story thus has an
"external" protagonist, the viewer, who, moves through
the chapel and observes the episodes. Scenes from of
the *Life of the Virgin* and the *Infancy of Christ* form the
background or the premise for the Redemption, while
the contrasting allegorical figures of *Virtues and Vices*
symbolize the continuous alternation between Good
and Evil. The *Last Judgment* represents the final
destiny of mankind.

In the *Passion* frescoes, Giotto's
tone becomes tragic and the sense
of crescendo is almost palpable,
recalling the example of Cimabue.
However, the contrast between
the two artists is significant:
while Cimabue depicted
the eternal, dramatic, and
superhuman conflict between
Good and Evil, Giotto remained
firmly attached to man.
Grief, anguish and despair belong
to the human sphere,
and they are dealt with as such.
The *Lamentation* is a fresco
characterized by its use of
different depths, obtained by
arranging the groups of figures
on different planes.

The composure and dignity
of these figures, conceived
as rounded geometric
volumes, is comparable
to the great masterpieces of
classical sculpture and (closer
to the time of Giotto) the marble
reliefs of Nicola and Giovanni
Pisano. Like concentric ripples,
the tragic center
of the scene is Mary's desperate
embrace of the dead Christ;
the emotions appear
more controlled as we move
outward. A similar effect
was created by Leonardo
in the *Last Supper*,

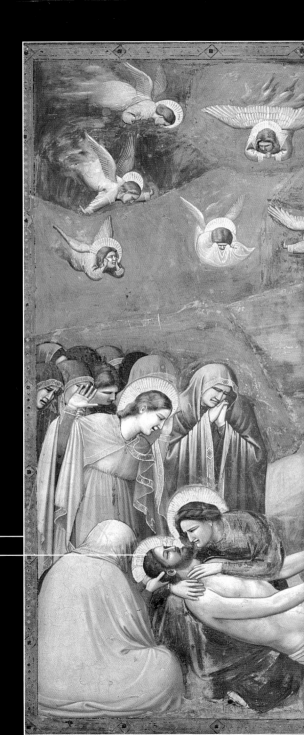

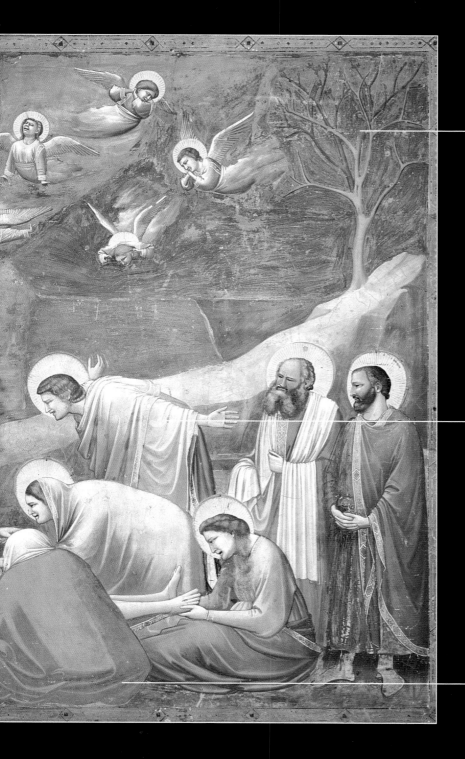

In the carefully designed frame
of natural or architectural settings,
sentiments that seemed to have been
forgotten, confined to the remote
fragments of classical art, reappear
in Western art. Nature (animals, trees,
rocks and clouds) helps to accentuate
mood and even the heart-rending
angels in the sky display an entirely
human despair. The descending line
of the slope to the right directs the eye
toward the center of the scene:
a visual device previously used
by Giotto in the frescoes in Assisi.

The figure of St. John, with his arms
stretched out, is the demonstration of
Giotto's desire to "break through"
and measure the space, creating
the illusion of a third dimension.

The Pious Women holding the body
of Christ in the foreground, have their
backs turned to the viewer, and look like
mere geometric forms. This was
an extremely bold choice, for Byzantine art
held that it was completely improper to
show the back of the human body.
Giotto, on the other hand, treated man
as a whole—the mind, the sentiments,
and the body—without any "hierarchy"
of parts. Mary Magdalen caresses the feet
of Christ, her long blonde hair almost
brushing against them, recalling
the episode of the dinner at the house
of the Pharisee, when she washed
Christ's feet with her tears and
dried them with her hair.

Siena

1308-1348

From Duccio to the Lorenzetti

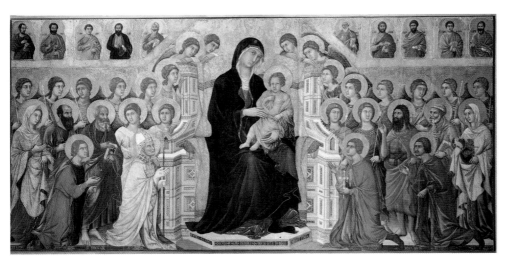

Duccio di Buoninsegna
Maestà, 1308-11
Museo dell'Opera del Duomo,
Siena

Acclaimed as a masterpiece and
as the symbol of the city, it was
carried in procession by the people
of Siena from Duccio's workshop
to the high altar in the cathedral.
The *Maestà* is a magnificent work,
painted on both sides. Although
the original frame and several
marginal portions have been lost,
the main sections are substantially
intact. Below: a detail from the
main scene.

A Bright, Colorful Art for a Resplendent City

In the fourteenth century Siena and Florence, beset by a
constant and often bloody rivalry, were the two cities in
which the debate on painting was most animated. Siena
responded to the sober, monumental art of Giotto with a
free expression of everyday life, human sentiments, and
pride in a city that was becoming more beautiful by the
day. All of the most talented painters in fourteenth-cen-
tury Siena worked for a time in Assisi. The first great
Sienese painter was Duccio di Buoninsegna, who was
commissioned by the city to paint the vast *Maestà* for the
high altar in Siena Cathedral. It was in his workshop that
the next generation of artists trained, including Simone
Martini, the brilliant painter who ended his career in
Avignon (the papal seat and home to Petrarch), and the
Lorenzetti brothers, Pietro and Ambrogio, who executed
numerous panels and frescoes. The social and cultural
development of Siena came to an abrupt end toward the
middle of the fourteenth century. Three years of famine
and a terrible outbreak of the Black Death in 1348
brought the whole of Europe to its knees, cruelly rav-
aging Siena: the death of the Lorenzetti brothers symbol-
ized the end of an era.

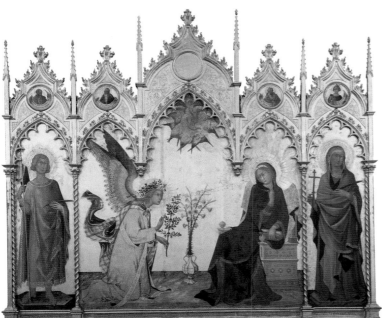

Simone Martini
Annunciation, 1333
Galleria degli Uffizi, Florence

Unlike his fellow townsmen
Pietro and Ambrogio
Lorenzetti, Simone Martini
did not develop the use of
architectural backdrops
and experimental perspectives.
Shining gold is the background
for the aristocratic, almost
unreal outlines of the two
main figures, while the vase
of lilies in the center adds a
touch of reality to the scene.
The dynamic relationship
of gestures and sentiments
between the insistent
Gabriel and the troubled
Mary is an almost abstract
expression of pure line and
two-dimensional pattern.

Pietro Lorenzetti
Birth of the Virgin, 1342
Museo dell'Opera del Duomo,
Siena

Pietro Lorenzetti was
concerned with rendering
the reality of everyday life.
The unity of the spaces
(accentuated by the ceilings
and by St. Anne's bed) unifies
the three parts of the triptych.
The gestures and the
expressions of the figures
are movingly realistic.

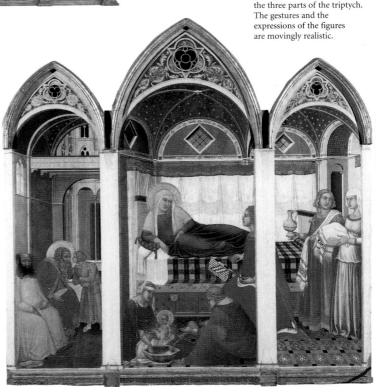

Art, Politics and History

For a city like Siena, the heart of a small and politically isolated area, painting was a means to celebrate its proud achievements. While the execution of works of art and architecture for the magnificent cathedral was in full swing, the social and political life of the city was reflected in artistic commissions that were unparalleled in the rest of Europe. A few years after the procession of joyful citizens that had accompanied Duccio's Maestà to the cathedral, the city council decided to compete with the Capitolo della cattedrale by commissioning a fresco of the same subject from the up-and-coming artist Simone Martini for the Palazzo Pubblico. On the opposite wall of the same room, Martini also painted the unforgettable commemorative Equestrian Portrait of Guidoriccio da Fogliano. Later, in the Sala dei Nove, Ambrogio Lorenzetti painted the fascinating frescoes of Good and Bad Government, a political manifesto that is also a novel, vibrant masterpiece. Finally, even the tax registers (called biccherne) were finely decorated with exquisite frontispieces painted by the most important Sienese artists.

Ambrogio Lorenzetti

1337-1339

The Effects of Good Government on Town and Country

To celebrate the virtues of the city administration, in the fourteenth century the proud government of Siena commissioned a series of works from the city's greatest artists. The main room of the Palazzo Pubblico houses the frescoes of Simone Martini, while in an adjacent room Ambrogio Lorenzetti painted an extremely political cycle, an early example of visual "propaganda". The cycle consists of the allegorical personifications of Good and Bad Government, surrounded by its Virtues or Vices respectively, and, on the longer walls, scenes illustrating the effects of the two types of government. On the wall depicting the Allegory of Bad Government, which is less well-preserved, there are scenes of violence, disorder, and disease, while the wall with the Effects of Good Government on Town and Country, almost entirely intact, offers animated pictures of everyday life in the fourteenth century. With astonishing mastery, Lorenzetti sets each episode in a single scenario, partly urban streets and partly panoramic landscape. A great exponent of the Sienese School, Lorenzetti studied under Duccio but also maintained contact with Giotto and artists in Florence, where he stayed several times. Although his early works were somewhat static in gesture, the characteristic lively expressions are already present. Lorenzetti acquired increasing confidence during the 1320s, eventually creating monumental groups, highly complex settings and dynamic scenes; the cycle of Good Government is the expression of a personal, mature style. Ambrogio's life, like that of his brother Pietro, came to a dramatic end during the Black Death of 1348.

The political message of the fresco is deliberately general and not related to Siena alone. For this reason the urban scene depicted by Ambrogio Lorenzetti should be seen as a sort of "ideal city" under the protection of Good Government. Nevertheless, the Gothic architecture is in the unmistakable style of fourteenth-century Siena, and the outlines of the campanile and the dome of Siena Cathedral are clearly visible in the top left-hand corner.

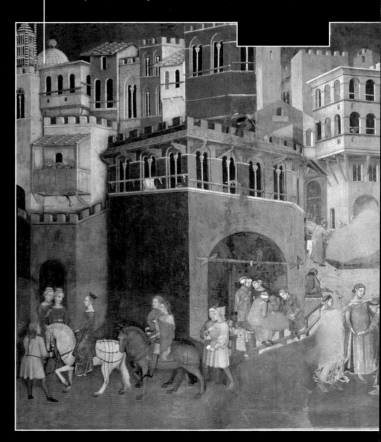

Under Good Government the city prospers and the masons build new and increasingly comfortable houses. In this fond portrayal of builders at work (as with all of the characters in this great scene) Lorenzetti displays emotional depth and human warmth.

Sturdy walls, reinforced by turreted gates, protect the citizens and create a clear division between the urban world and the countryside. It is impossible not to notice the complete lack of communication of any kind between the city-dwellers and the country people, who seem to belong to two entirely different worlds.

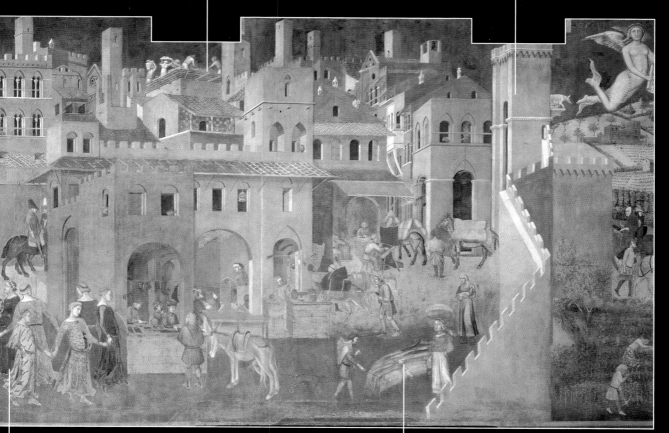

The group of dancing girls in the center of the bustling square stands out in its detachment from the concerns of everyday life. In a social context that closely reflects the reality of fourteenth-century Siena, the dance assumes a symbolic significance, underlined by the fact that the girls are larger in size than the other figures. It should also be added that the girls are nine in number, just like the ancient Muses. By means of this classical reference, Lorenzetti shows that harmony favors the flourishing of the arts.

The peaceful city is animated by a busy population. Everyone has his own place and his own role, and each trade seems to complement the others, without a marked social hierarchy. Merchants and masons, teachers and lawyers, simple passers-by and clergymen are unified in fruitable harmony.

Avignon and Paris

1309-1378

The Fourteenth Century in France

The Splendor of Painting under Popes and Kings

When Pope Clement V decided to move the papal seat from Rome in 1309, Avignon became the model for all of the European courts. Inside a building protected like a fortress, spacious rooms for meetings and ceremonies alternated with more private areas, and the atmosphere of each room was determined by the variety of pictorial decorations, from sacred subjects to themes of everyday life and purely naturalistic depictions. The example of Avignon changed the tastes of the European courts, now oriented toward a new variation of the Gothic style known as International Gothic, the link between the medieval world and the spread of classical humanism. The French court was naturally one of the first to take up the new style, which was expressed in miniatures and tapestries rather than in monumental painting.

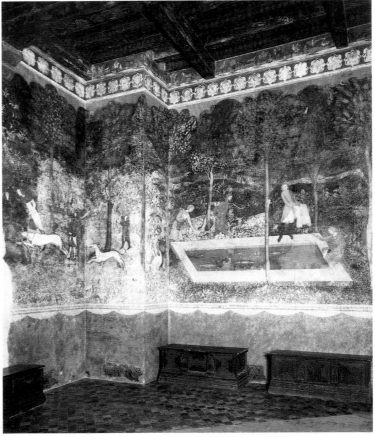

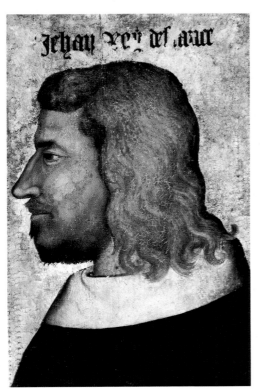

Anonymous French painter
Portrait of King John the Good,
c. 1349
Louvre, Paris

Gothic culture rediscovered the value of earthly life and faith in personal responsibility. This change was reflected in art that portrayed characters with a precise identity, acting in their own time and place. The portrait of the king of France is one of the first in the history of painting. During his stay in the region of Avignon, Petrarch dedicated a sonnet to the portrait of his beloved Laura by Simone Martini, introducing the concepts of true likeness and the use of the portrait as an aid to memory, ideas that have remained essential to portraiture over the centuries. Martini's painting is now lost, but the artist's style, marked by fluidity of outline, delicacy of features and the careful use of colors, was the model for the earliest panel portraits in French art.

Matteo Giovannetti and Assistants
Courtly Scenes of Hunting and Fishing, 1343
Chambre du Cerf, Palais des Papes, Avignon

The principal artist responsible for the decoration of the Palais des Papes, at least the surviving original portions, was the Italian painter Matteo Giovannetti, born in Viterbo and active in Avignon during the 1340s. His mural paintings show a lively, imaginative interpretation of decorative themes and a surprising ability to vary tone and rhythm.

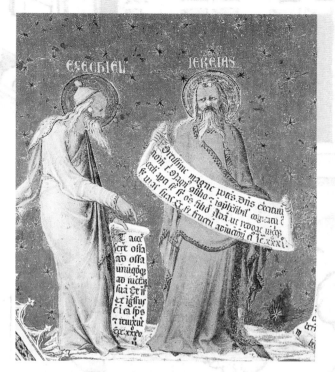

The Harvest of the Damned,
from the tapestry series
of the Apocalypse, 1374-81
Castle of Angers

The seventy tapestries of
the Apocalypse, commissioned
by Louis I, Duke of Anjou
and the younger son of King
John the Good of France, are
one of the masterpieces
of the Gothic period.
During the 1370s, painter
and miniaturist Hennequin
de Bruges executed the
preparatory drawings for
tapestries woven by the
Parisian tapestry-maker
Nicolas Bataille. Hennequin
reworked, adapted and
enlarged scenes of the
Apocalypse from fourteenth-
century manuscript
illuminations, inspired
by a Gothic repertoire that
combined monstrous creatures
with everyday life. The whole
tapestry series was completed
in seven years, thanks to
the concurrent use of dozens
of looms. The influence of
illumination also explains the
conception of the tapestry as
a two-dimensional surface
onto which the scene is
projected. Landscapes, figures
on land and in the air, and
architecture, are all presented
without depth, resulting in
a vertical "wall" from which
the episodes seem to loom
toward us with a powerful,
inevitable force. In the Angers
tapestries, medieval art finds
its highest expression,
becoming simultaneously
generous and chivalrous,
romantic and awesome,
imaginative and terrifying.

Matteo Giovannetti
*The Prophets Ezekiel
and Jeremiah*, 1352
Audience Chamber, Palais
des Papes, Avignon

As is clear in the better
preserved frescoes, Matteo
Giovannetti was influenced
by the Sienese painter
Simone Martini, precursor
of the courtly Gothic style,
whose frescoes in Avignon
Cathedral have unfortunately
all but disappeared.

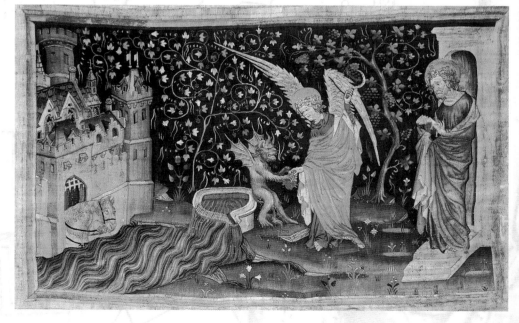

Bohemia

1346-1378

The Splendor of the Reign of Charles IV

The Prague Court at the Center of International Gothic

Charles IV, King of Bohemia from 1346 and Holy Roman Emperor from 1355, was one of the most remarkable figures in the history and culture of fourteenth-century Europe. Largely due to his efforts, Prague became an important center of trade between East and West: the famous Charles Bridge over the River Moldau was the symbol of this new role. Different international influences came together in Prague (also fostered by the opening of the university in 1348), giving a new impulse to art. Mathieu d'Arras and Peter Parler worked on the Cathedral of St. Vitus, one of the most ambitious projects of the late Gothic period, while Bohemian goldsmiths produced such dazzling wonders as the imperial insignia. The presence of the Italian master Tommaso da Modena in the Castle of Karlstein in 1350 ensured that Bohemian painters had been introduced to Giotto's robust forms, but they preferred to draw inspiration from the elegant, sinuous lines of French and German Gothic miniatures. Earlier than elsewhere, Bohemian painting in Prague combined reality, fantasy, compositional mastery and story-telling flair, which constituted the unmistakable, fantastic language of the Gothic court. After the death of Charles IV, Bohemian art suffered a decline due to the outbreak of civil strife caused by the religious schism triggered by John Huss.

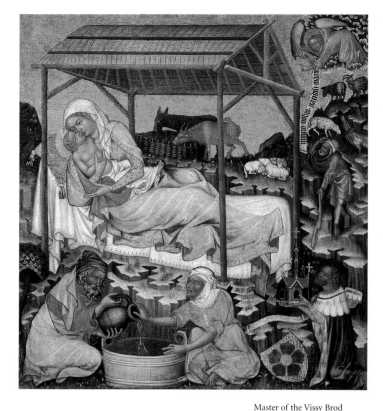

Master of the Vissy Brod
Altarpiece
Nativity, c. 1350
Národní Galerie, Prague

Master Theodoric
Saints Agnes, Wolfgang, Ambrose and a Cardinal Saint, 1357-67
Národní Galerie, Prague

Theodoric executed a vast painting cycle for the chapel in the Karlstejn Castle, which included the altarpiece, frescoes of scenes from the life of Mary and Christ, the Apocalypse, and 128 highly original panels of saints, some of which have been moved to the museum in Prague. The sequence had a mystic meaning, almost like a series of icons, but Theodoric depicted the gestures, faces and clothes of the saints with pungent wit, even using the surface of the frames.

Madonna of the Cathedral of St. Vitus, 1396
Národní Galerie, Prague

Master of the Trebon
Altarpiece
*Praying in the Garden
and Resurrection*, c. 1380
Národní Galerie, Prague

This anonymous painter
of great energy, active
at the end of the fourteenth
century, was also known
as the Master of Wittingau
(the German name of the
town for which the altar
was painted) and was
undoubtedly one of
the masters of late
fourteenth-century
European art. The tense,
marked rhythm of the
composition is combined
with a refined sensibility
in the use of glancing
light and unusual colors.

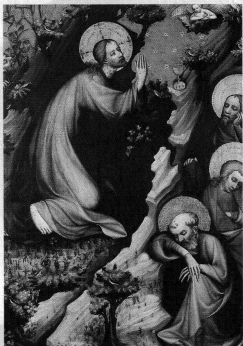

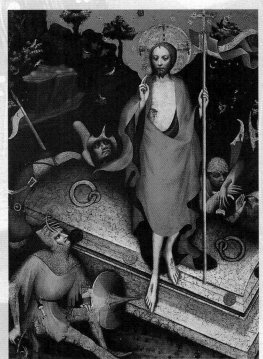

Dijon, Burgundy, and Flanders
1363-1476
The Duchy of Burgundy

**Gold and Lapis Lazuli for the Autumn
of the Middle Ages**

Over the course of the fourteenth century, France became a lively and prolific center of art. While, during the second half of the century, the Hundred Years' War caused a certain decline in the commission of important works in Paris, this was largely offset by the pope's move to Avignon and the rapid rise of the Duchy of Burgundy. From Philip the Brave to Charles the Fearless, a shrewd policy of arranged marriages led to the development of a flourishing independent state that stretched from the rich commercial cities of Flanders to north-eastern France. The dukes, their relatives, and members of the court, were generous patrons, and from the end of the fourteenth century to about 1475, they commissioned some of the finest examples of miniatures, sculptures, paintings, and tapestries in Europe. Burgundian art is characterized by a controlled elegance of gesture, impeccable technique, the use of refined materials, and the rarefied atmosphere of courtly romance, suspended between reality and fantasy. The example of the Duchy of Burgundy was admired in all the courts of Europe, for its development of a new version of International Gothic, acting as a delightful link between the medieval world and the spread of classical humanism.

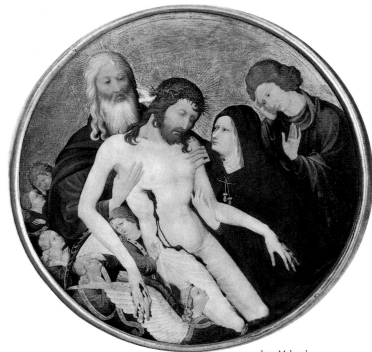

Jean Malouel
Pietà, 1400-10
Louvre, Paris

The softness of the folds
and the fluid gestures
are perfectly suited to
the tondo format.

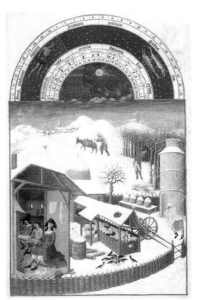
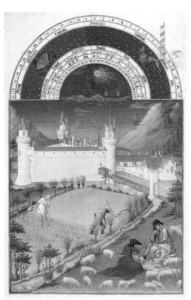

Limbourg Brothers
The months of February
and July from the *Très Riches
Heures du Duc de Berry*,
1410-16
Musée Condé, Chantilly

Against a background of fields,
lawns and castles, the splendid
miniatures of the Limbourg
brothers depict a series
of agricultural and pastoral
activities as well as the
amusements of the nobility.
The evocation of nature
and the seasons is particularly
memorable. The celebrated
astrological image in
the background on the
opposite page is also
from this manuscript.

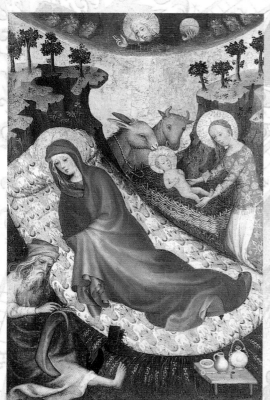

Anonymous Meusan painter
Nativity, c. 1400
inside panel of a polyptych
for Philip the Bold
Museum Mayer van
den Bergh, Antwerp

The commissions of the
Burgundy court were
the prelude to the birth
of Flemish "realism". In these
sacred scenes the human
element prevailed: St. Joseph
mending a boot, the Virgin
resting after giving birth,
and a woman wearing an
apron placing the Christ
Child in the manger.
The faint smiles that light up
the faces accentuate the
magic atmosphere of
the composition.

Melchior Broederlam
*The Presentation in the Temple
and Flight into Egypt;
The Annunciation and
Visitation*, 1392-99
side panels of the Champmol
Altarpiece,
Musée des Beaux-Arts, Dijon

The focus of many of
the dukes' commissions,
the Champmol Charterhouse,
was home to many
masterpieces of Burgundian
late Gothic art, including
the magnificent sculptures
of Claus Sluter, as well as
the panels by Broederlam.

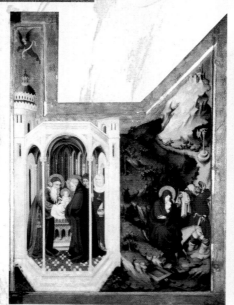

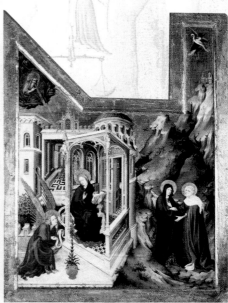

Germany and the Hanseatic Towns
1390-1440
The Masters of German Gothic

A Rich Period of Magic and Miracles

The emergence of autonomous territories created a particularly lively climate in early fifteenth-century German culture. The free imperial cities, the commercial towns of the Hanseatic League, and the powerful routes of trade and art along the great rivers gave rise to a rich vein of painting, largely by anonymous artists. Of particular importance are the large polyptychs planned in Hamburg by Master Bertram (d. 1415), who took up the legacy of the Bohemian School and designed vast sequences of scenes. It was his example that inspired artists active in northern Germany and in the Baltic region during the early fifteenth century. The extremely delicate Cologne School, with its dreamy contemplation of nature and its contacts with the Flemish masters, is best represented by the work of Stephan Lochner. Further south, near the wealthy city of Basel, Konrad Witz furthered the development of a new, realistic, robust style.

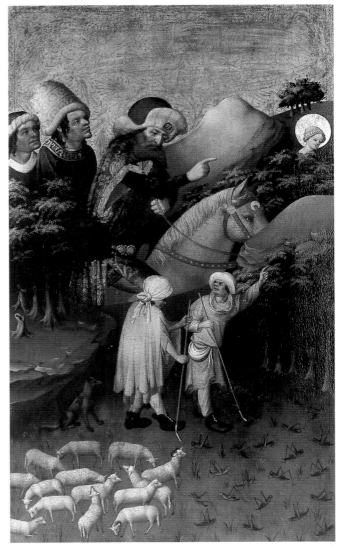

Master Francke
Persecution of St. Barbara,
panel of the St. Barbara Altar
from the Cathedral of Turku,
1410-15
National Museum, Helsinki

Unconcerned about the difference in proportion, Francke combines the narrative skill and the delicate details of Flemish and Burgundian miniatures with the monumental power of Bertram.

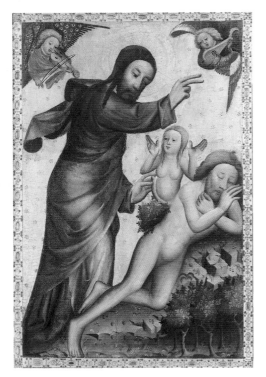

Master Bertram
Creation of Eve, part
of the Grabow Altar,
1379-83
Kunsthalle, Hamburg

Konrad Witz
The Miraculous Draught of Fishes, panel of the St. Peter Altar for Geneva Cathedral, 1444
Musée d'Art et d'Histoire, Geneva

The four large panels of the Geneva altar mark the peak of the career of Konrad Witz, a unique figure in the art of southern Germany (c. 1400-46). Of Swabian origin, but active mainly in Basel, Witz gave his figures a solid, vigorous form, accentuated by a powerful and lively sense of reality. The episode of the miraculous draught of fishes is set in the real landscape of Lake Geneva. The natural environment, from the pebbles on the shore to the distant glaciers on Mont Blanc, is depicted with meticulous precision.

Master of the Garden of Paradise
The Garden of Paradise, c. 1410
Städelsches Kunstinstitut, Frankfurt

The anonymous painter of this dreamy masterpiece, a fine example of the mature Gothic style, is typical of the lyrical spirit of the Cologne School. Cologne was the main city in the Rhineland, where the active aristocracy and the ambitious patronage of the Church laid the foundations for the birth of a flourishing period of art. The Cologne artists developed the so-called soft style, one of the most poignant and poetic chapters of the entire history of German painting.

The Marches, Venice, and Florence
1370/80-1427
Gentile da Fabriano

**An Extraordinary Career Spanning the Splendors
of Late Gothic and the Dawn of Humanism**

Gentile da Fabriano, the master from the Marches, was the
most sought-after Italian artist in the first quarter of the fif-
teenth century. He worked in most of the major cities of art
and culture, and trained many of the leading artists of the
next generation, including Pisanello, Jacopo Bellini, and
Domenico Veneziano. His major early work is the polyptych
of the *Coronation of the Virgin*, from the Convent of Valle
Romita, now in the Brera, Milan. In 1408 Gentile painted
several frescoes (now lost) in the Doge's Palace in Venice.
After a spell in Brescia in 1419, he settled in Florence, where
artists like Donatello, Ghiberti, and Brunelleschi were also
active. His style is notable for its elegance, attention to detail,
and refined technique, and displays an interest in classical
sculpture. In 1423 he completed the *Adoration of the Magi*,
now in the Uffizi; this was followed by the *Quaratesi
Altarpiece* (1425), now divided between different museums.
After working in Siena and Orvieto, in
January 1427 Gentile arrived in Rome,
where he died in
August of the
same year.

Gentile da Fabriano
Nativity, c. 1420
J. Paul Getty Museum,
Los Angeles

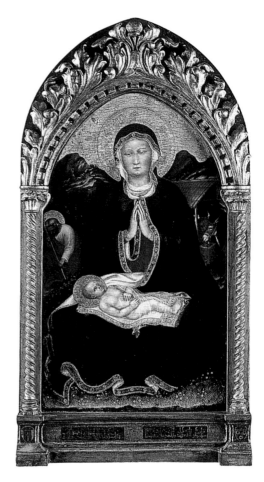

Gentile da Fabriano
Adoration of the Magi, 1423
Galleria degli Uffizi, Florence

Commissioned by Palla
Strozzi, the wealthiest man
in Florence at the time,
this resplendent altarpiece is
Gentile's greatest masterpiece.
Here, the chivalrous
atmosphere of courtly
romance is translated into
a rich painting that is almost
overflowing with handsome,
fair-haired heroes; horses
with golden harnesses;
keen greyhounds; exotic
costumes, and sumptuous
gifts. In a magic, rarefied
atmosphere, the procession

of the Magi winds its way
along the path amidst a
fantastic landscape, finally
reaching the chubby, smiling
Christ Child, cared for by his
mother and two women who,
although they belong to
the lower classes, resemble
princesses. Gentile da Fabriano
brings to the painting the
elegant fantasy of the
International Gothic style.
Even the materials themselves
are precious: the pure gold
glitters brightly, the
ultramarine blue has
the texture of a jewel, and
the red shines like a ruby.

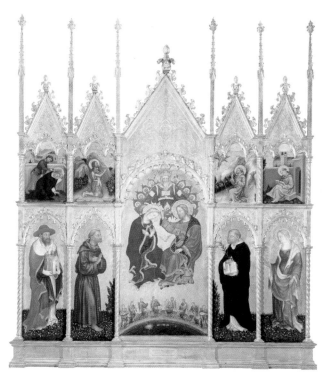

Gentile da Fabriano
Polyptych of Valle Romita,
1400-10
Pinacoteca di Brera, Milan

This early masterpiece came
to Brera from the hermitage
of Valle Romita, near Fabriano.
The panels of the polyptych
form a complete, refined
anthology of the motifs of
International Gothic.
The large central scene of
the *Coronation of the Virgin*
seems to float in the rich,
shining gold of the celestial
background, while the
characters are enveloped
in splendid, finely drawn
draperies. Below, the small
angel musicians are set
in the celestial vault,
while the painter's
signature can be
seen beneath them
in the starry sky.

Pisanello, the Appointed Heir

*Unable to finish the magnificent decoration of the Basilica of San
Giovanni in Laterano in Rome, Gentile handed the tools of his trade
to Pisanello, shortly before his death, a symbolic gesture and also a
sign of his perceptive sensibility. For of all his pupils, Pisanello was
undoubtedly the most suited to follow the path indicated by Gentile,
despite the fact that he gradually began to execute prevalently secular
subjects, working as a salaried painter in the service of the aristocrat-
ic courts. Born in Verona around 1395, Pisanello died in Mantua at
about sixty. After training in his native city, he went to Venice, where he worked beside
Gentile from 1418 to 1420. After completing the decoration left unfinished by Gentile in
Rome, he worked for various Italian courts, great and small, including the Visconti in
Milan, the Malatesta in Rimini, the Este in Ferrara, and above all the Gonzaga in Mantua,
and the Aragona in Naples. The last splendors of the Gothic style in Italy were thus entrust-
ed to his , at times romantic, at times ironic art. Many of his works have been lost, which
means that we have only a partial knowledge of his output, but fortunately his fine draw-
ings and celebrated medals have survived. The art of Pisanello, with its attention to detail,
nature and human sentiment, should be considered not as alternative but as complemen-
tary to Tuscan humanism. This is evident from his widespread fame, and from the many
poems devoted to him by men of letters, which contain profuse praise as well as illuminat-
ing comments on his style. Halfway through the century the spread of humanist and clas-
sical culture to the courts of northern Italy led to a rapid decline in his popularity, and after
his death he was almost forgotten.*

Gentile da Fabriano
St. Catherine, detail of the
Polyptych of Valle Romita

The four saints on the side
panels stand on the
grass and flowers
of a wonderful
garden. The
whole painting is
characterized by
delicate outlines,
sweet expressions,
and the suspended
atmosphere of
an enchanted dream.

Cologne
c. 1410-1451
Stephan Lochner

The Soft Style of the Cologne School

Lochner, perhaps the greatest German painter before Dürer, was the main exponent of the Cologne School, a fascinating branch of International Gothic. The episodes and characters of the Holy Scriptures are seen as the heroes of a charming, poetic legend that aspires to the Garden of Paradise, the song of the angels, and the sweetness of unending smiles. After training on the shores of Lake Constance, in the elegant climate of the courtly art of the Upper Rhine, Lochner went northward, following the course of the river, and came into contact with the Alsatian, Burgundian, and Flemish Schools. He was acquainted with the latest developments in perspective to the extent that some scholars have claimed that he must have had some knowledge of Italian painting of the time, especially that of Fra Angelico. The *Annunciation* painted on the side panels of the polyptych for Cologne Cathedral, for example, shows monumental figures placed in a correctly drawn domestic space, with the furnishings at an angle to enhance the three-dimensional aspect. In general, however, he preferred to set his fairy-tale figures against compact golden backgrounds or in gardens full of flowers. In the 1430s, Lochner settled in Cologne, where he died, still young, during the plague epidemic of 1451.

Master of Saint Veronica
St. Veronica with the Sudarium,
c. 1420
Alte Pinakothek, Munich

This devotional panel, admired by Goethe, began the nineteenth-century rediscovery of the German "primitives". The artist's name is not known, though scholars have managed to trace with some precision the path of his life and art from Dortmund to Cologne between 1395 and 1425. In the moving sensibility of the holy scenes, the subtle use of color, and the soft lines of features and drapery, the anonymous master can be considered the direct precursor of Lochner.

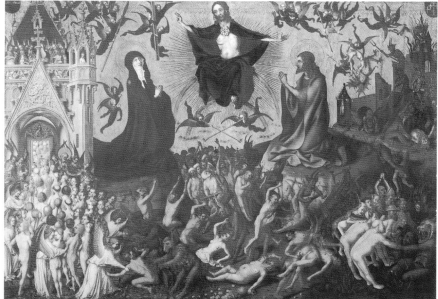

Stephan Lochner
Last Judgment, c. 1435
Wallraf-Richartz Museum,
Cologne

The *Last Judgment* is the surviving central panel of a polyptych destined for the Church of St. Lawrence in Cologne. Following the traditional pattern, Lochner uses a different scale for the divine figures and the teeming multitude of souls, contended for by angels and devils. The terrifying, chaotic image of the infernal creatures contrasts sharply with the calm, orderly procession of the blessed toward the Gate of Paradise, where St. Peter, assisted by angels, guards the entrance. The idea of the great turreted Gothic gate and the angelic choir was to be used by Memling in his Danzig polyptych.

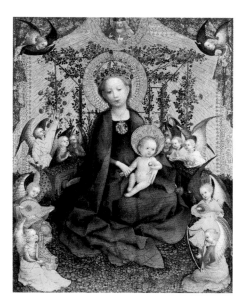

Stephan Lochner
Madonna of the Rose Bush,
c. 1450
Wallraf-Richartz Museum,
Cologne

With his customary grace,
Lochner depicts the theme
of the "Humble Madonna",
with the Virgin seated on
the ground in a garden.
This image, derived from
the worship of Mary begun
by the Dominican Friars,
was a favorite in late Gothic
art throughout Europe.

Lochner's Rich Blue

The ubiquitous presence of blond angels with deep blue wings and garments, visible in these two details of the Adoration of the Christ Child (1440-45, Alte Pinakothek, Munich), serves almost as a kind of signature for the artist. To obtain this rich color Lochner used powdered lapis lazuli, which was even more expensive than the pure gold he used for the back-grounds. For the artist from Cologne this must have been the color of paradise; he often used it for the veil of the Madonna and the banners of the saints. Also, whenever possible he placed groups of little angels scat-tered in the sky, almost all of them "bodiless". While their faces, arms and wings are relatively substantial in volume, their bodies are little more than slight flourishes, blue curlicues on the gold ground. Lochner's angels are fantastic creatures that belong to an enchanted world.

Stephan Lochner
Adoration of the Magi, central
panel of the Altarpiece of the
Patron Saints of Cologne,
1435-40
Cathedral, Cologne

Commissioned by the city of
Cologne, this altarpiece is the
greatest example of Lochner's
art and one of the highest
achievements of European
painting in the 1430s. The main
scene recalls the presence of
the Magi's relics in the cathedral,
which were brought by Frederick
Barbarossa from Milan and
placed in the splendid reliquary
by Nicolas de Verdun. In the
evident pleasure he takes in
depicting the rich mantles
of the saints, the glittering armor
of the knights, and the finely
wrought caskets that contain the
gifts of the Magi, Lochner almost
seems to compete with the great
medieval goldsmiths.

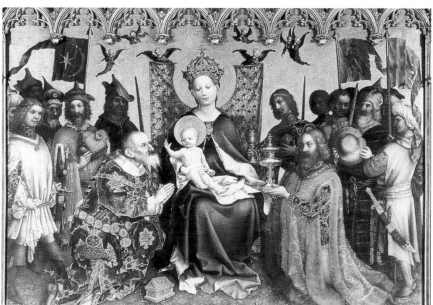

Florence
1401-1428
Masaccio

A Country Boy on the Threshold of the Renaissance

In 1424, while Florence was still enthralled by Gentile da Fabriano's stunning *Adoration of the Magi*, Masolino da Panicale began to execute the frescoes in the Brancacci Chapel in the Church of Santa Maria del Carmine in Florence. With him was a young man from the Valdarno. His name was Tommaso, but everyone called him Masaccio. After beginning his career close to home, he became the assistant of the refined Masolino. Restless and brilliant, Masaccio spent long hours in the Basilica of Santa Croce copying the frescoes of Giotto. When Brunelleschi and Donatello walked together through the streets of Florence, he followed them, eager to learn all the secrets of the new art of perspective. The rickety scaffolding in the Brancacci Chapel became the stage from which the young man, at the age of twenty-three, proclaimed the discovery of a new form of painting. Only a year after the glittering procession of Gentile's *Magi*, Masaccio's dramatic *Expulsion* is down to earth: Adam and Eve, cast out from the Garden of Eden, weep and wail in anguish and despair. On the left-hand wall of the chapel, Masaccio painted *Tribute Money*, a silent group of men whose intimidating gaze typifies the artist's austere and powerful style. Once again in the company of Masolino, Masaccio set off for Rome, where he died a sudden, terrible death in the first few days of 1428. Masaccio died at the age of twenty-seven, but he had already achieved a great deal: his major works include the Pisa Polyptych, now dismantled and in various museums around the world, and the fresco of the *Trinity* in the Church of Santa Maria Novella in Florence.

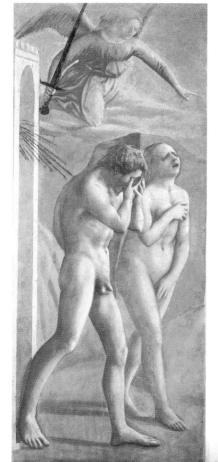

Masaccio
Expulsion from the Garden of Eden, 1424-25
Brancacci Chapel, Church of Santa Maria del Carmine, Florence

Desperate, weighed down by guilt, Adam and Eve take their first steps toward the inhospitable desert. Their condemnation, however, is the great opportunity for the human race, for once they have left Eden Adam and Eve must imitate the Creator by turning the inert matter of a hostile world into a garden, moving from lament to action, and redeeming mankind with the resources of the mind, hand, and heart.

Masolino and Masaccio
Madonna and Child with St. Anne, detail
1424-25
Galleria degli Uffizi, Florence

The *Madonna and Child* is the first and most celebrated example of the collaboration between Masolino and Masaccio. The Madonna, solidly geometric, is the work of Masaccio, who always painted very blonde, almost albino Madonnas.

Masaccio
Tribute Money, c. 1425
Brancacci Chapel, Church of Santa Maria del Carmine, Florence

A key scene in the cycle commissioned by tax collector, Felice Brancacci. In the austere solemnity of its gestures and poses, it forms a link between Giotto and Michelangelo.

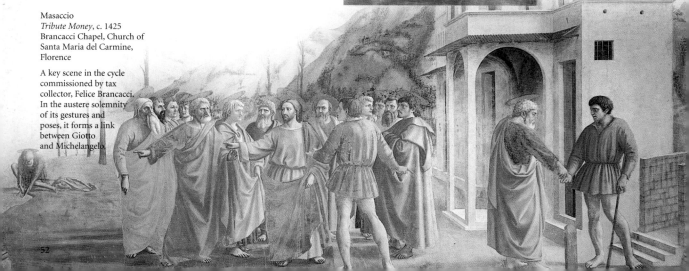

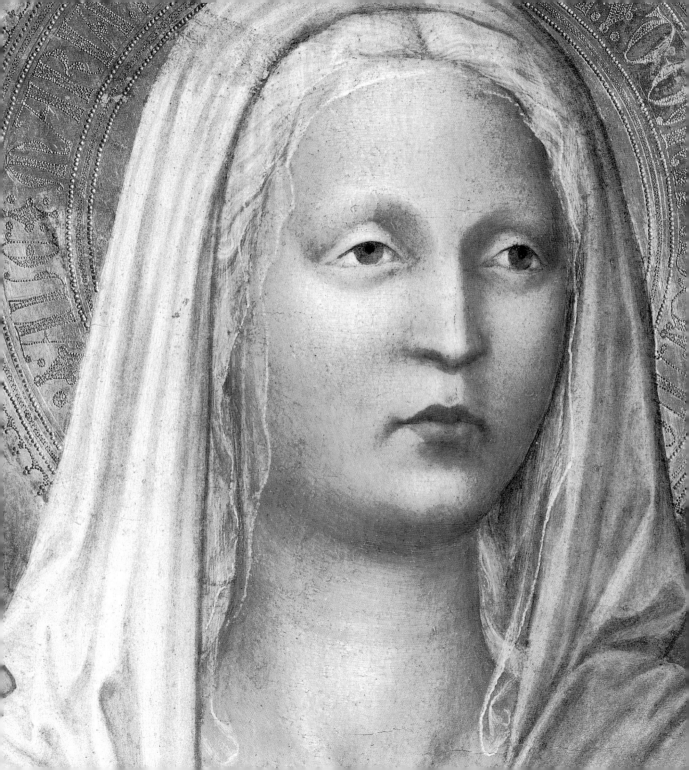

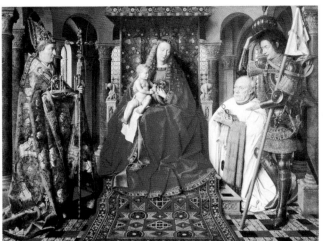

Jan van Eyck
*Madonna with Canon
van der Paele*, 1436
Groeninge Museum, Bruges

This *Madonna* is perhaps
the work in which Van Eyck's
highly detailed reproduction
of reality is taken to the
extreme, in a meticulous
depiction of the light effects
on the different materials,
the metals, stones, and even
the folds of flesh on the face
of the striking portrait
of the donor.

Jan van Eyck
Portrait of a Man, 1433
National Gallery, London

From Van Eyck onward,
Flemish portrait painters
depicted their subjects in
three-quarter profile, with
lively expressions and hand
gestures. The figures stand out
from the backdrop and speak
directly to the viewer.

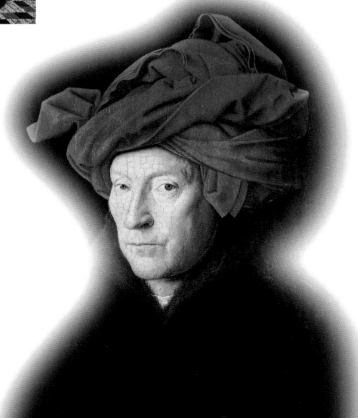

The Incomparable Magic of Light

Jan van Eyck, a key figure in the history of Western art, came
from a family of painters; his brothers Hubert (who died
during the execution of the *Adoration of the Lamb* polyp-
tych) and Barthélemy (who lived in Provence), were also
artists. Jan van Eyck, founder of the Flemish School, was a
celebrated figure in artistic and intellectual circles, and his
fame even stretched into the political sphere. The Dukes of
Burgundy entrusted him with secret diplomatic missions in
several countries, and these journeys gave his art a European
breadth. However, his fame remains largely linked to the
commercial cities of Bruges and Ghent in Flanders (where
he was in contact with Robert Campin and Rogier van der
Weyden), which were experiencing the most prosperous
period in their history. Even his earliest works are charac-
terized by a meticulous attention to detail and a mastery of
the subtle effects of light. In Van Eyck's art, the wonderful
universe of Flemish and Burgundian illumination, previ-
ously known only to a fortunate few, assumed monumental
proportions, moving into the public sphere of great altar-
piece-painting. During the 1430s, after completing the
Adoration of the Lamb polyptych left unfinished by his
brother Hubert, he produced a remarkable series of master-
pieces of religious painting. However, his contribution to
portraiture was no less significant. He also mastered a tech-
nique using oils and varnish, which has preserved the bril-
liant colors of his works through the centuries.

Jan van Eyck
*Portrait of Giovanni (?)
Arnolfini and his Wife
(The Arnolfini Portrait)*, 1434
National Gallery, London

In this highly evocative
painting celebrating
the marriage of the Tuscan
merchant Giovanni Arnolfini,
Van Eyck cleverly combines
the real and the symbolic.
The metal chandelier
(the true center of the
composition, simulating
the reflections of the gilded
bronze with astounding
realism) emphasizes the
volumes in the room and
the source and direction
of the rays of light.
The orderly arrangement
of the objects, the elegance
of the clothes, and the
refined features of the bride
and groom convey their
high social rank, while
the small dog and clogs
add a more domestic
touch, as well as alluding
to the virtue of faithfulness,
essential in a marriage.
Using a much-celebrated
visual device, Van Eyck
also depicts the two
witnesses to the wedding
reflected in the convex
mirror behind the couple.

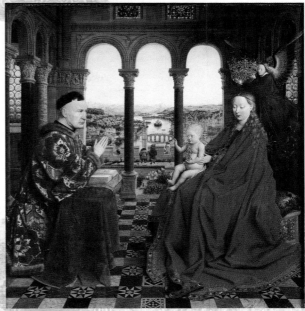

Jan van Eyck
Madonna of Chancellor Rolin,
c. 1435
Louvre, Paris

The extraordinary light effects
in the painting are created
by using a single, vast
perspective that has been
meticulously analyzed down
to the last detail. The device
of the river, in line with
the three-light window in
the background, extends
the view as far as the distant
horizon. The detail of the two
figures looking out from
the balustrade would long
be imitated in Flemish and
Netherlandish painting.

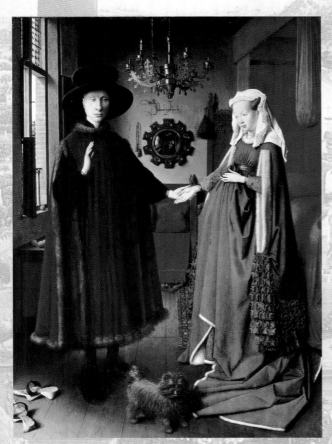

Hubert and Jan van Eyck

1425-1432

Polyptych of
the Adoration of the Lamb

This polyptych, a monument of Flemish painting and a cornerstone of fifteenth-century European art, is housed in the Cathedral of St. Bavon in Ghent. The altarpiece comprises a total of twelve panels mounted on hinges, eight of which are painted on both sides. Destined for the ancient Church of St. John in Ghent, the polyptych was begun in 1425 by Hubert van Eyck, Jan's elder brother. However, the following year, shortly after beginning the design of the central panels, Hubert died. The commission then passed to his brother Jan, who can be considered the true artist of the work as a whole, which he completed in 1432. Influenced by the developments of fifteenth-century theology, Jan believed that the beauty of that which is created, is the imprint of the Creator. By depicting the surfaces, light and variations in material with infinite patience and astonishing mastery, he exalted the miracle of the world, teaching us to love every detail of nature.

On the outer face of the side panels (sometimes mistakenly described as the "back" of the polyptych) Jodocus Vijd and his wife, who commissioned the work, can be seen kneeling in an arched Gothic portico in front of their respective patron saints.
The subtly ambiguous contrast between the living characters and the statues is underlined by the rays of light that seem to warm and animate the very marble.
The saints are John the Baptist and John the Evangelist. The former holds the traditional symbol of the lamb, while the latter is the author of the Apocalypse,

Two Prophets and two Sybils, the announcers of the birth of the Messiah, are depicted in the rounded cusps of the panels. Van Eyck makes the narrow spaces more harmonious by adding long, wavy scrolls.

Through brilliant use of light and perspective, Van Eyck creates a tight unity of setting for the four panels depicting the Annunciation. The mysticism of the scene is reflected in the everyday reality.

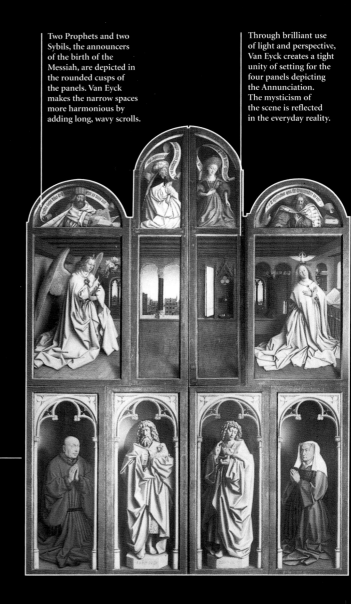

At the two ends of the polyptych, on long, narrow panels, Van Eyck presents Adam and Eve surmounted by illusionistic bas-reliefs with the sacrifice of Cain and Abel and the slaying of Abel. These nude figures are often considered the greatest demonstration of Van Eyck's realism and a testimony of the evocative magic of light. Adam emerges forcefully from the shady niche, his remorse for his sin clearly visible. The angle of the foot is turned toward the viewer.

The animated angel musicians offset the austere gravity of the motionless central group. The masterly use of oils creates subtle vibrations of light within the dense, saturated colors that are full of symbolic significance. The magnificence of the fabrics and the beauty of the musical instruments allude to the artistic capacities of man, in his turn the creator of beauty.

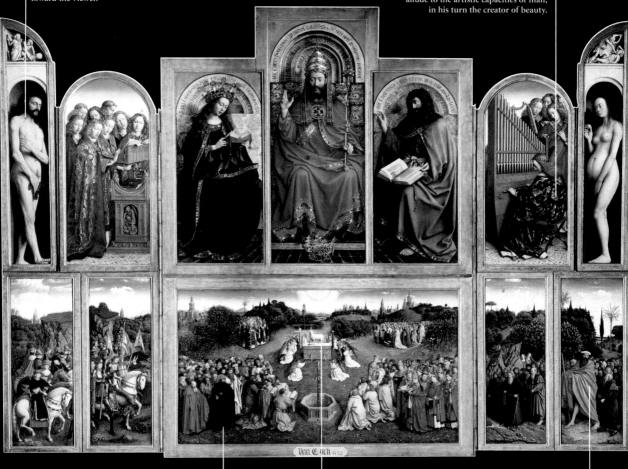

The unforgettable appeal of the polyptych lies above all in the magic, luxuriant blossoming of nature. Unlike Masaccio and the Florentine humanist painters, Van Eyck does not concentrate only on the human figure. His eye ranges over a varied universe, revealing every detail, from the foreground to the spires and bell towers that stand out on the horizon. The painting thus becomes the image of a microcosm, a rich, full, self-contained miniature world where the human and the divine come together.

The subject that gives the work its title is depicted in the whole lower portion of the polyptych. It is the Eucharistic sacrifice of the Mystic Lamb (the symbol of Christ), placed on the altar along the central axis, between the fountain of Grace and the dove of the Holy Spirit in flight. The magnificent procession of the blessed makes its way toward the Lamb.

The side panels of the lower section depict various groups of saints (the Judges and Soldiers of Christ on the left, hermits and pilgrims on the right), conceived in a single landscape with verdant hills, but a stony path. On the far right towers the gigantic figure of St. Christopher.

Flanders, Brussels, and Burgundy
1400-1464
Rogier van der Weyden

A Flemish Master at the Heart of European Art

Brussels, after becoming the capital of the Duchy of Philip the Good in 1430, blossomed into a new center of culture, with important architectural projects (like the palaces surrounding the spectacular Grande Place) and a painting school of its own. The leading figure of this school was the Walloon "Rogelet de la Pasture", a pupil of Robert Campin and slightly younger than Jan van Eyck. He translated his name into Flemish and thus became Rogier van der Weyden. Employed by the cities and members of the Burgundian court (one of his largest and most important works is the polyptych of the *Last Judgment* in Beaune), Van der Weyden was a painter of international renown. On the one hand he introduced religious scenes with large figures in scaled perspective (typical of Italian art) into Flemish painting, while on the other he exported a taste for fine detail and the new technique of oil painting—with several different layers superimposed to obtain effects of transparency and atmosphere—to southern Europe. In 1449-50 Van der Weyden traveled to Rome for the Jubilee. During his journey he was able to observe the works of Masaccio and Fra Angelico in Florence. He also stopped in Ferrara where he was the guest of the magnificent Este court; there he met Piero della Francesca and Leon Battista Alberti and began to make his compositions even more grandiose.

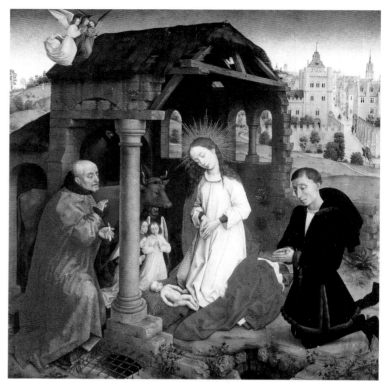

Rogier van der Weyden
Nativity, 1450-55
central panel of
the Bladelin triptych,
Staatliche Museen
Gemäldegalerie, Berlin

This triptych was
commissioned by Pierre
Bladelin, a high official of
the Burgundian court, who
is portrayed in the holy scene.

Rogier van der Weyden
Deposition, 1430-35
Prado, Madrid

A masterpiece of fifteenth-century European painting, the *Deposition* illustrates the difference between Van der Weyden and Van Eyck. While Van Eyck extends his spaces toward the horizon, Van der Weyden encloses the image within a box-like perspective, adapting the large figures to the constriction by arranging them on different planes. His more emotional style is evident in the fainting Virgin, whose pose reflects that of Christ's descending body.

Rogier van der Weyden
Portrait of a Young Woman,
detail, 1432-35
Staatliche Museen
Gemäldegalerie, Berlin

A sensitive observer of character and an accurate painter of physical appearance, Van der Weyden was one of the most refined and influential portraitists of the early fifteenth century.

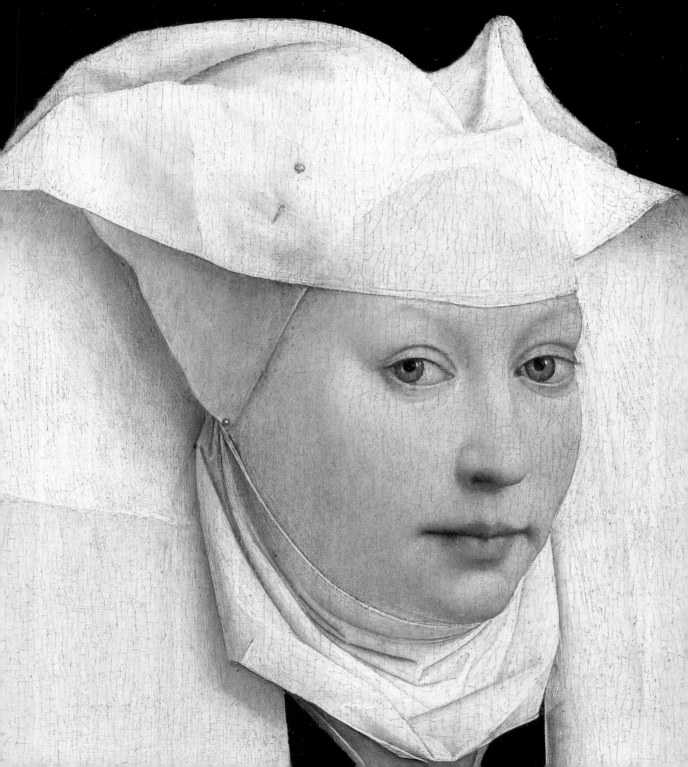

Florence

c. 1395-1455 1397-1475

Fra Angelico and Paolo Uccello

The Open Horizons of the Sky and the Measured Perspective of the Earth

Deprived of artistic guidance by the premature death of Masaccio, Florentine painters of the 1430s joined forces in the shared goal of a novel figurative culture, combining new discoveries with the search for rules based on the laws of geometry. The Dominican friar Giovanni da Fiesole, known in the art world as Beato Angelico (The Blessed Angelico), developed the "altar panel", a new model of sacred painting that led to the gradual disappearance of the outdated triptych format. In his frescoes in the Convent of San Marco and in his dazzling panels we find an atmosphere of monumental solemnity, a measured sense of space, an intellectual presence, and a personal involvement that was to characterize the great masterpieces of the Italian Renaissance. Of all the Florentine artists, Paolo Uccello was probably one of the most interesting. Engrossed in the applied geometry of "sweet perspective", he preferred to focus on single aspects of the composition rather than on the overall effect. The frescoes for the Chiostro Verde in the Church of Santa Maria Novella and the three *Battles* he painted for the Medici family appear to be works suspended between the ancient and the modern.

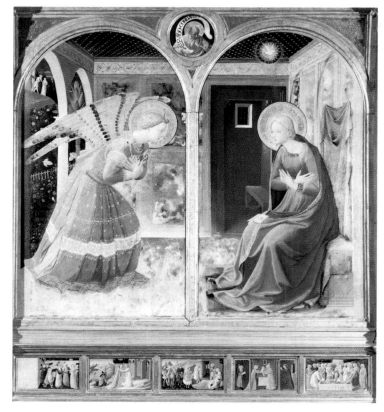

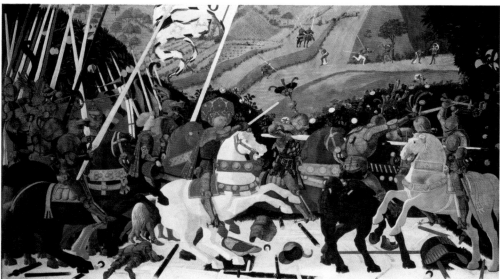

Fra Angelico
Annunciation, c. 1430
Sanctuary of Santa Maria delle Grazie,
San Giovanni Valdarno

Fra Angelico
Madonna of the Shadows,
detail, c. 1450
Convent of San Marco,
Florence

Paolo Uccello
Battle of San Romano,
c. 1465
National Gallery, London

The battle seems to be a courtly tournament. Every detail (the broken lances, fallen horses, and warriors on the ground) is executed in meticulously correct perspective, but the scene is rather artificial, as unreal as an episode from a Gothic romance.

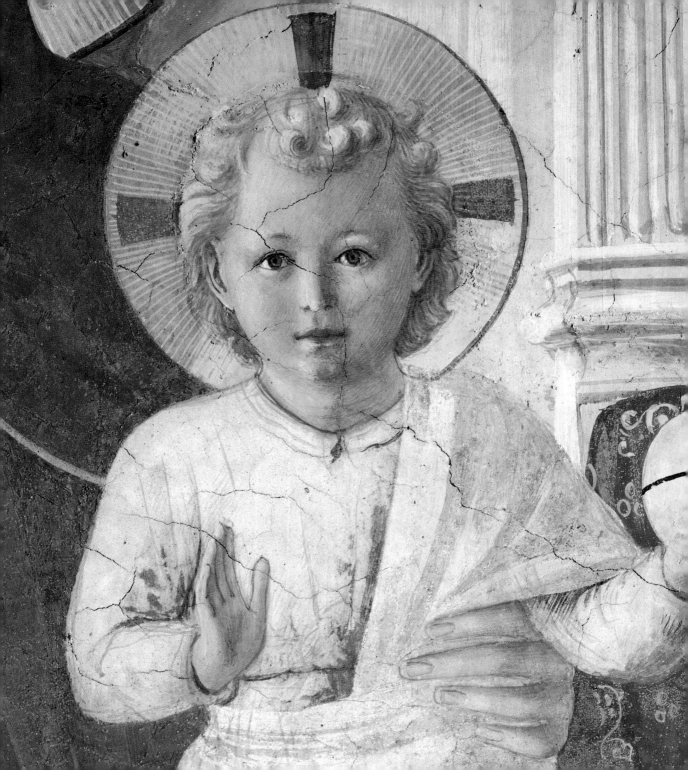

Catalonia, Castile, and Aragon
1440-1492
The Age of Retables

A Glorious New Power is Born

The presence of vast pictorial and sculptural works in Spanish cathedrals often comes as a surprise to visitors. Elaborate and grandiose polyptychs with superimposed orders, occupy the altars and almost become part of the architectural setting. The prolific production of retables reflected the lively artistic climate in Spain as the country moved toward territorial and religious reunification, a goal that was reached at the end of the century by the "Catholic sovereigns" Ferdinand of Aragon and Isabella of Castile. The Spanish altarpieces were a local interpretation of various artistic influences and were often delightfully original. The presence of Jan van Eyck in Spain in 1428 was a sign of the Spanish interest in Flemish painting, and the trade routes to Naples allowed Spanish artists to appreciate Italian developments in the use of space. The most significant Spanish painters were also keen travelers: the Catalan Jaume Baço Jacomart spent time in Naples and Rome; the Andalusian Bartolomé Bermejo studied in Flanders and traveled widely in Aragon and Catalonia; and in 1474 Pedro Berruguete moved to Urbino to work for the cosmopolitan court of Federico da Montefeltro. In general, however, the underlying style remained closely linked to the Gothic tradition, which entered a new phase marked by rich splendor in fifteenth-century Spain.

Dello Delli (Niccolò Fiorentino)
Altarpiece of the High Altar and frescoes of the *Last Judgment*, c. 1445
Old Cathedral, Salamanca

The polyptych, comprising 53 panels, is one of the first and most magnificent Spanish altarpieces.

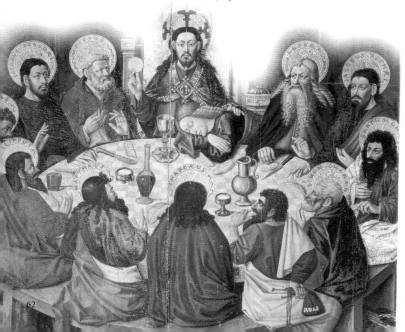

Jaume Baço Jacomart and assistant (Joan Rexach?)
Last Supper
central panel of the *Altarpiece of the Last Supper*, 1446
Cathedral Museum, Segobre (Castellón)

This work was left unfinished by Jacomart, who was summoned to Italy by King Alfonso of Aragon.

Bartolomé Bermejo
St. Dominic of Silos
central panel of the altarpiece of the saint, detail, 1477
Prado, Madrid

Impressive and solemn in his rigorous frontality, the saint is wearing an embroidered cope so rich in gold that it seems the work of a goldsmith rather than a tailor. The jewel-encrusted miter, the rich pastoral staff, and the dazzling carved and gilded throne create a magnificent image in powerful contrast with the vivid realism of the saint's solemn features.

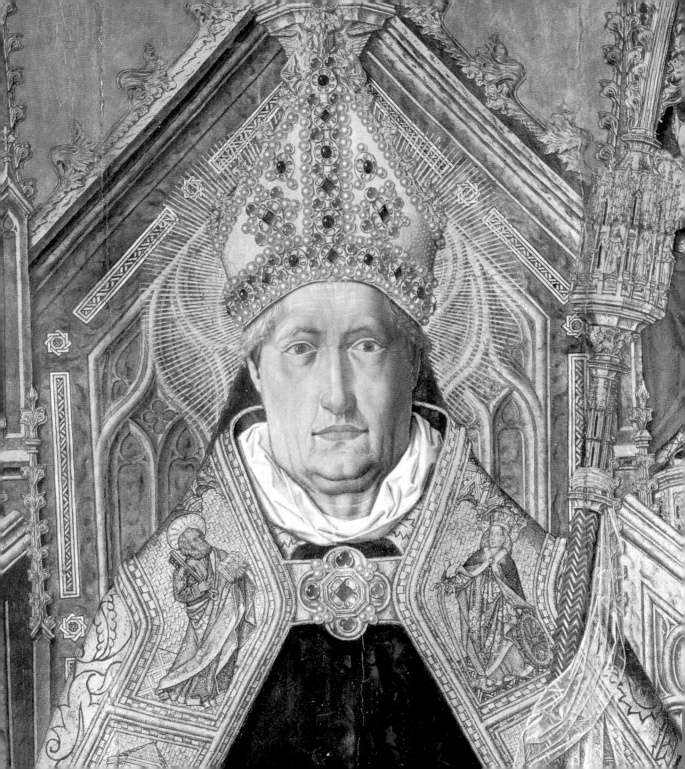

Avignon and Provence

1444-1476

The Masters of the Midi

Mediterranean Light in the Autumn of the Middle Ages
The popes had left long ago and in the Avignon palace frescoes, memories, controversies, regrets, and foolish ambitions were all that remained. The kings of France, involved in a never-ending war with the English, continued to move their court in search of peace and quiet, and Provence was thus restored to its former role as an influential center of art patronage. The old pilgrim routes, now easy trade routes, as well as the economic and cultural exchange across the waters of the Mediterranean, placed Avignon and the other cities of Provence at the hub of a dense network: from the Côte d'Azur to the Rhone valley, the French Midi experienced a golden age of artistic production. The geographic and cultural closeness of Burgundy explains the prevalently Flemish influence, which increased with the arrival in the region of the third Van Eyck brother. The technical refinement of the Flemings combined with the monumental power of Italian painting, and above all with a solar luminosity very different from the cold, analytical light of northern Europe. Compositions became larger and took on a unique character, combining courtly magnificence with sentiments typical of the common people.

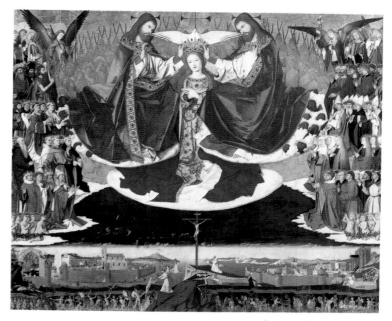

Enguerrand Quarton
Coronation of the Virgin,
1453-54
Musée de l'Hospice,
Villeneuve-les-Avignons

The greatest and most original of the Provençal masters of the fifteenth century combined Flemish precision, Mediterranean light and the compositional rigor of Piero della Francesca. This painting is a monumental synthesis of theological concepts, expressed harmoniously in a single image. Quarton was also the author of the Avignon *Pietà*, reproduced in the background on the opposite page.

Nicolas Froment
Mary Appearing to Moses,
detail of the central panel
of the *Triptych of the Burning Bush*, 1475-76
Cathedral of Saint-Sauveur,
Aix-en-Provence

Commissioned by King René of Anjou, Froment's masterpiece shows the influence of the use of space in Italian painting.

Hard Times for Provence

By ancient tradition Provence offers an enchanted refuge from the troubles of the world, a role that was reconfirmed during World War I and World War II. During the fifteenth century the kingdom of France was ravaged by the Hundred Years' War with England, and the southern regions were not spared. Josse Lie-ferinxe, a Provençal painter in contact with the Piedmont School, left this moving picture of beggars, cripples, pilgrims, and the sick praying to the relics of the saints for a better life.

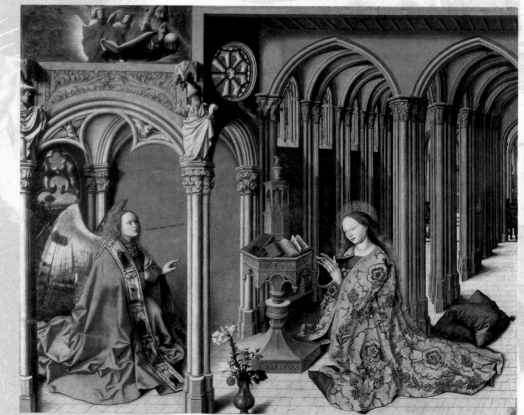

Barthélemy d'Eyck
Annunciation, 1443-45
Church of Sainte-Marie-
Madeleine,
Aix-en-Provence

One of the most fascinating mysteries in the history of art was the identity of the refined "Master of the Aix Annunciation", a key figure for understanding the stylistic links between Flanders, Provence, Burgundy, and the Italian courts. It is likely that the painter was Barthélemy, the brother of Jan and Hubert van Eyck, who had moved to the south of France in search of independent international fame.

Paris

c. 1425-c. 1480

Jean Fouquet

The Chronicler of a Nation and the Founder of French Humanism

A painter of royal portraits from as early as the 1440s, Fouquet went to Italy some time between 1444 and 1447; he spent time in Rome, Naples and Florence, encountered perspective artists (like Fra Angelico, Domenico Veneziano and Piero della Francesca), and studied ancient art. On his return to the French court, he combined the naturalistic detail of the Flemings with the monumental spatiality and luminosity of Italian painting. Fouquet, a versatile painter (though his works are rare) and the unrivaled author of a magnificent series of miniatures, evolved from the Gothic tradition to develop a new figurative language, the highest pictorial expression of humanism in France.

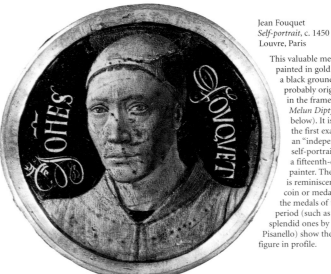

Jean Fouquet
Self-portrait, c. 1450
Louvre, Paris

This valuable medallion, painted in gold on a black ground, was probably originally set in the frame of the *Melun Diptych* (see below). It is one of the first examples of an "independent" self-portrait by a fifteenth-century painter. The format is reminiscent of a coin or medal, but the medals of the same period (such as the splendid ones by Pisanello) show the figure in profile.

Jean Fouquet
Étienne Chevalier with St. Stephen,
panel of the *Melun Diptych*, c. 1450
Staatliche Museen Gemäldegalerie,
Berlin

Jean Fouquet
Madonna and Child, panel of
the *Melun Diptych*, c. 1450
Musée Royaux des Beaux-Arts,
Antwerp

This Madonna is a portrait of Agnès Sorel, the favorite of King Charles VII. Étienne Chevalier was the executor of the king's will.

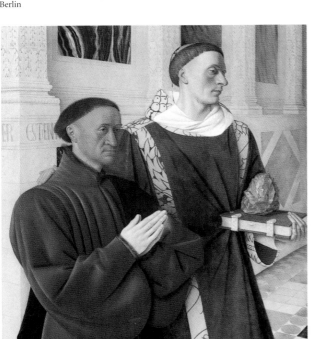

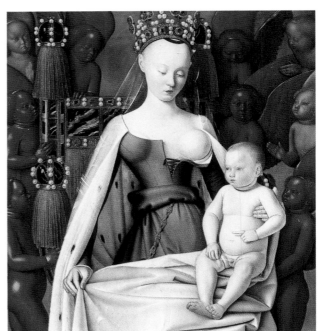

Jean Fouquet
The Virgin and Child Enthroned and *Simon de Varie Kneeling in Prayer*, illuminated page from the *Hours of Simon de Varie*, J. Paul Getty Museum, Los Angeles

Fouquet is one of the greatest miniaturists in the entire history of art. His work is characterized by an original combination of images, a great ability to describe settings, natural details and costumes, and the refined technique of using gold dust that gives the garments of the Madonna and Child a special luminosity.

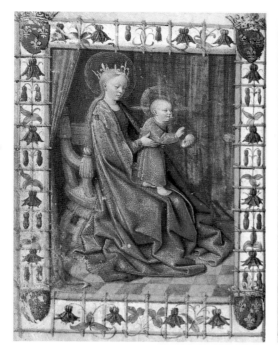

Jean Fouquet
Pietà, c. 1444
Parish Church, Nouans-les-Fontaines

This solemn and dramatic painting resembles the pictorial transposition of a sculptural group. It is charged with pathos and lifelike intensity, especially in the finely characterized main figures, worthy of the Burgundian sculptor Claus Sluter. This is one of the few extant works from the period before Fouquet's journey to Italy.

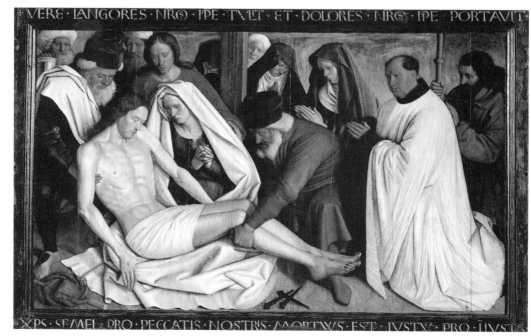

Tuscany and the Marches
1416/17-1492
Piero della Francesca

Human Rationality and "Divine Proportion"

Piero della Francesca occupies a central position in Italian and European art of the fifteenth century. A member of the second generation of humanist painters, he brilliantly fuses art and geometry, spirituality and the rigorous application of the rules of perspective. He trained in Florence, but spent his whole career working in the "provinces" (Sansepolcro, Arezzo, Rimini, Ferrara, Urbino, and Perugia), thus making an important contribution to the spread of humanist art in Italy. He spent as much time as possible in his hometown Sansepolcro, located on the road that runs from eastern Tuscany to Umbria and Urbino. During the 1440s he alternated periods of work in his hometown with stays in other cities, including Rome. In Ferrara he came into contact with Leon Battista Alberti, and perhaps with Rogier van der Weyden. In 1452 he began work on the most important undertaking of his career, the *Story of the True Cross* in Arezzo. In the variety of narrative situations, the monumentality of the figures, the careful calculation of the spaces, and the intensity of the expressions, it is one of the fundamental works of the European Renaissance. During the 1460s Piero was active mainly at the court of Federico da Montefeltro in Urbino. His time there was marked by frequent contact with foreign artists, by the treatises he wrote on geometry, perspective and algebra, and by several memorable masterpieces. In the mid-1470s his sight began to fail and he was forced to give up painting. Back in Sansepolcro, he devoted himself to completing his treatises. By a curious coincidence, the artist who symbolizes the intellectual world of the fifteenth century died on the same day as the discovery of the New World, 12 October 1492.

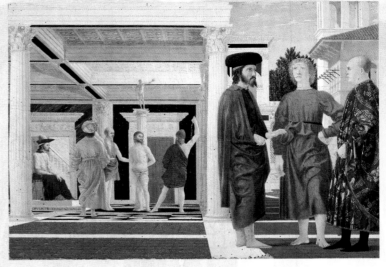

Piero della Francesca
Flagellation of Christ, 1450-60
Galleria Nazionale delle
Marche, Urbino

In this perfect synthesis of the characteristics of Italian art in the mid-fifteenth century, the spaces are calculated on the basis of a strict geometric grid, while the natural light accentuates the perspective and the relationship between interior and exterior.

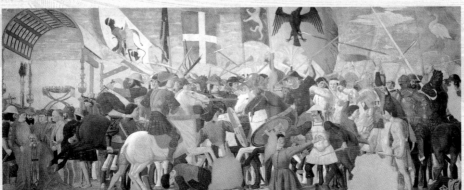

Piero della Francesca
Battle between Heraclius and Chosroes, from the *Story of the True Cross*, 1452-60
Church of San Francesco,
Arezzo

Friends and enemies form a compact group of knights and soldiers in the foreground, engaged in a fight to the death marked by measured, studied gestures, as in the martial arts.

Piero della Francesca
*Montefeltro Altarpiece
(Brera Madonna)*, 1472-74
Pinacoteca di Brera, Milan

Painted for Duke Federico
da Montefeltro, this altarpiece
was made for the Church of
San Bernardino in Urbino.
Here the two aspects of this
great painter are evident.
On the one hand the theorist
of geometry, and the author
of important treatises on
perspective, and on the other
the creative artist devoted to
the search for an ideal image.
The scene is set inside a
Renaissance building and its
proportions are carefully
scaled to the figures. The light
models the silent group with
remarkable clarity, giving them
the lofty tone of a celestial
court, arranged according
to a precise hierarchy. The
Madonna, in the center
of the composition, is seated
on a chair; she is flanked
by six saints; behind her are
four angels, recognizable
by the curve of the wings
that can be seen just above
their shoulders; the duke
is kneeling in an act of
devotion and homage.
A low platform makes the
arrangement of the characters
more effective. An ostrich
egg hangs on a chain from
the semi-dome of the apse,
a celebrated detail (an allusion
to the birth of Christ and to
the coat-of-arms of the
Montefeltro family) that
combines a symbolic value
with an impressive
demonstration of the
rendering of depth.

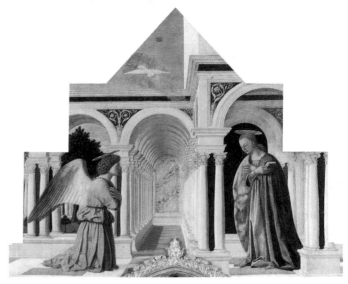

Piero della Francesca
Annunciation, upper section
of the *Polyptych of St. Anthony*,
1460-65
Galleria Nazionale
dell'Umbria, Perugia

The step-shaped frame
was cut in the eighteenth
century, but the scene
retains its moving clarity.

A fundamental element
of the composition is the
wonderful portico that links
the figures, indicates the
direction of the light (through
the shadows) and also creates
a harmonious relationship
between the natural space,
on the left, and the calculated
construction of the cloister.

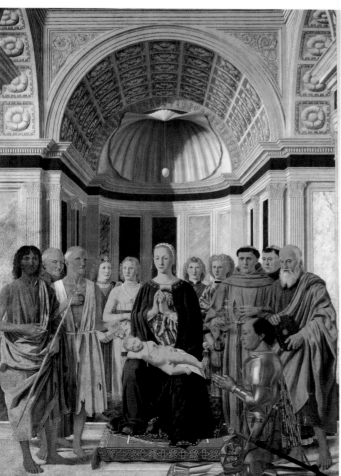

The Dukes of Urbino

*Until the middle of the fif-
teenth century Urbino was a
small city of stone and brick,
nestling among green hills in
an area of the Marches
between Romagna, Tuscany
and Umbria. The Monte-
feltro family turned it into a
"city in the form of a palace". Federico da Montefeltro and his wife
Battista Sforza, portrayed by Piero in the famous diptych now in the
Uffizi, reigned over a court that was small in size but of great cultur-
al importance. Federico, who was always shown in profile to conceal
the loss of an eye during a tournament, was a true prince, cultured,
enlightened and poised. In 1465 he decided to rebuild the family res-
idence. Designed by the Dalmatian Luciano Laurana and the Sienese
Francesco di Giorgio Martini, the Palazzo Ducale became the most
important and harmonious civil building in fifteenth-century
Europe. It was frequented by artists from all over Italy and also from
Spain and Flanders, including Pedro Berruguete, refined sculptors
and carvers, Piero della Francesca and Joos van Gent, Paolo Uccello
and many others. In his palace Federico (who died in 1482, to be suc-
ceeded by his son Guidobaldo) created a wonderful "ideal city" of the
Renaissance, where "divine proportion" regulated all things in har-
mony with nature. It was in this climate that two of the great artists
of the High Renaissance, Bramante and Raphael, were born and
completed their training.*

Piero della Francesca

c. 1455

King Solomon and the Queen of Sheba

The fresco cycle in the choir of the Church of San Francesco in Arezzo is one of the great masterpieces of Italian Renaissance painting, and a flawless triumph of proportional balance, measure, order, and composure. It was begun by Piero della Francesca in 1452. The events represented were inspired by the thirteenth-century *Golden Legend*, a collection of lives of saints and mystic episodes compiled by the Dominican monk Jacopo da Varagine. The fresco cycle tells the complicated story of the wood of the True Cross, from the death of Adam to Emperor Constantine. Piero, however, chose not to adhere scrupulously to the sequence of the scenes, preferring instead a rhythmic structure that is clearly symmetrical. Thus, moments of full ritual solemnity alternate with confused battle scenes, lyrical, contemplative landscapes, and vivid, narrative episodes. The controlled, superior mind of the master dominates, giving a measured cadence to the gestures and pauses according to a consistent, mathematical logic. Piero della Francesca's true grandeur lies in his ability to make the thrill of emotion, tenderness, and even terror, vibrate from within his intellectual rigor. The world of emotions does not disturb the geometric purity of his creation; on the contrary, it enriches it with warmth and a hauntingly, intense spirit.

Piero repeats simple volumes throughout the composition, but also conveys the smaller details—as in the group of smiling handmaidens in the Queen of Sheba's entourage—with infinite patience and delicacy. Throughout the vast, masterly painting, the more animated portions are contrasted with quiet interludes found in the interiors and exteriors between the groups of people and the empty spaces. This extraordinary model was taken up again at the end of the nineteenth century by Seurat and still later, by the Metaphysical painters.

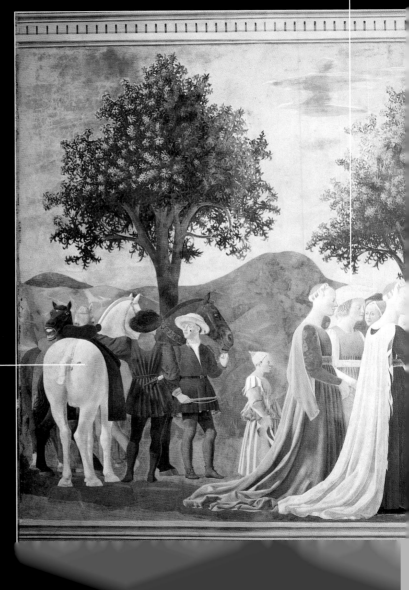

The bright colors and landscapes full of light can now be admired once again, thanks to a delicate restoration of the entire cycle, made necessary by damage to the walls over the centuries. Thus, one can better appreciate the geometric logic of the shadows and colors (note the alternation of the black horse seen from the front beside the white horse seen from behind). Some details, like the pleats in the doublet of the squire holding a dagger at his waist.

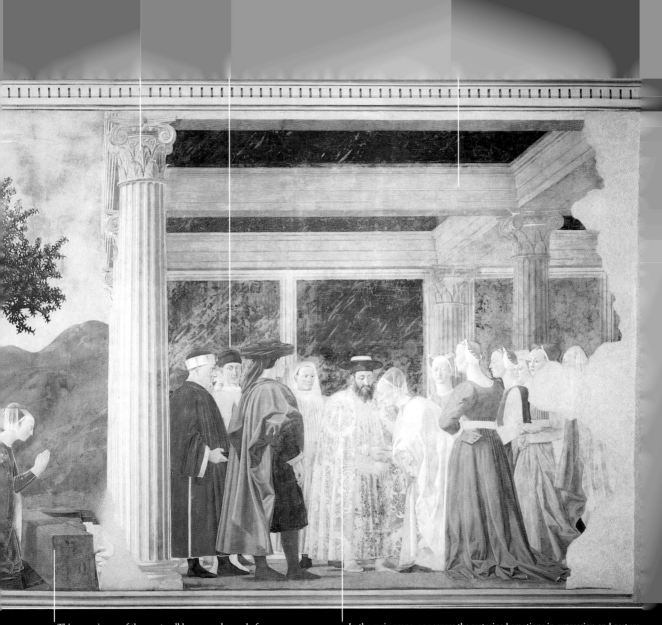

This scene is one of the most well known and sacred of the entire cycle. According to the *Golden Legend*, before the Queen of Sheba encountered Solomon, she knelt down to pray in front of the rough wooden parapet of a simple, little bridge, foreshadowing the later use of wood for Christ's cross.

In the main scene, one senses the restrained emotions in expression and gesture, an aspect that Piero shared with his predecessors, Giotto and Masaccio. In this case, however, he surpasses them and succeeds in going beyond the pioneering phase of humanism to achieve conscious mastery of complex representation, that combines figure and architecture, nature and intellect, light and movement.

Bruges
1435/40-1494
Hans Memling

A Poet of Tenderness Among the Cloth Merchants

The work of Hans Memling, a painter of the second generation of Flemish masters, represents the full maturity of the Bruges School. Memling was born in Germany, and studied in Cologne, where he admired the fine works of Stephan Lochner. As a young man he moved to Brussels and became Van der Weyden's most trusted assistant. When the master died in 1464, Memling settled in Bruges, where he spent thirty, highly productive years and became well established in the town's busy merchant life. Although he was gifted with technical perfection and a constant sense of delicacy and restraint, he was never a great experimenter. His work stayed essentially unchanged from youth to maturity, constituting, in fact, the consummate model of Flemish painting in the mid-fifteenth century. He does not seem to have traveled, although he kept in close contact with clients from Florence (agents for the Medici Bank in Bruges). He painted his first major masterpiece, the *Last Judgment* for the Tani family (though it went to Gdansk), and a triptych and several portraits for the Portinari family. In this genre, Memling perfected the format of the bust seen in three-quarter profile and set in a landscape, which would later often be found in both Flemish and Italian art. Among Memling's moving religious works are a number of tasteful, original panels depicting many episodes within a single architectural framework or landscape.

Hans Memling
Marian Flowerpiece,
1485-90
Thyssen-Bornemisza
Collection, Madrid

Memling painted this surprising composition on the back of a portrait more than a century before the official "birth" of the still life genre.

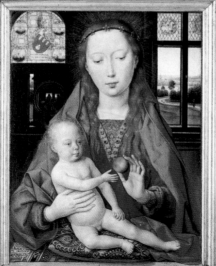

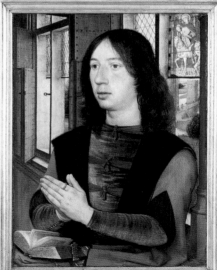

Hans Memling
*Diptych of Martin
van Nieuwenhove*, 1487
Memlingmuseum, Bruges

Memling's great talent as a portraitist, as well as his sense of mystic wonder, shine through in this diptych.

Hans Memling
Bathsheba, 1485-90
Staatsgalerie, Stuttgart

Memling sets this biblical
episode in the wealthy,
merchant-class Bruges
of his day. Every detail
alludes to the comforts
of the home. Here an
attentive servant helps
the young lady into her
ample robe, as she steps
distractedly into her slippers.
Memling has produced
a realistic middle-class idyll,
laced with a sensual
touch of intimacy.

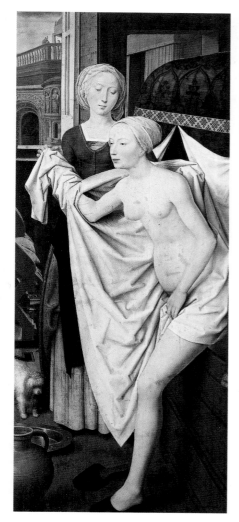

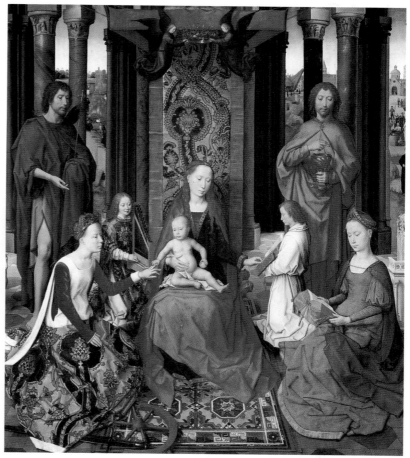

Hans Memling
*The Mystic Marriage
of St. Catherine of Alexandria*,
central panel of
the *San Giovanni Polyptych*,
1474-79
Memlingmuseum, Bruges

This spectacular polyptych
is the painter's most complex
masterpiece. The central panel,
with its spacious composition,
gives a stunning sample
of the sumptuous fabrics
traded in Bruges.

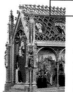

St. Ursula Shrine

*The St. Ursula Shrine is a unique piece
among the many marvels found in the
Memlingmuseum located in the former hos-
pital of St. John in Bruges. This reliquary is
in the form of a small Gothic chapel, with a
characteristic sloping roof and spires. Along
the sides, in a series of arches, Memling
painted miniature episodes from the fantas-
tic, tragic legend of St. Ursula, the blonde princess who faced voy-
ages and adventures in the name of love and faith. The shrine was
completed around 1489, only a few years before Carpaccio's cycle
of paintings in Venice devoted to the same saint.*

Hans Memling

1466-1473

Last Judgment

This dazzling triptych, Memling's first large-scale masterpiece, was painted for the banker Jacopo Tani, director of the Bruges branch of the Medici Bank. The triptych was sent to Florence by cargo ship, since the commercial route between Bruges and the Tyrrhenian ports was considered faster and safer than the long journey by road. Off the English coast, however, the ship was boarded and looted by the Baltic pirate Paul Benecke, who took the painting to Gdansk as part of his booty. So began the incredible vicissitudes of this triptych, contended for by the most powerful figures in Europe. Over the centuries, the masterpiece was coveted by the Medici of Florence, Pope Pius II, and the King of Prussia. Following the wars that raged through Poland, it was taken first to the Louvre by Napoleon, later to Thuringia by Goering, and then to the Hermitage by the Red Army. However, thanks to Polish tenacity, more than five centuries later the triptych is back again in Gdansk, in the elegant Muzeum Narodowe, located in the former Gothic Convent of the Trinity. This work, product of an artist and a city that were reaching the height of their magnificence, is an expression of the qualities and characteristics of fifteenth-century Flemish painting: the painstaking, inexhaustible attention to detail, the splendid light made possible by the use of oil paints (the gleam of St. Michael's armor and the globe at Christ's feet are truly memorable), the chaste but realistic nudes, and the high quality of the portraits and studied expressions. The triptych follows a logic based on perfect symmetry that converges on a central vertical axis marked by Christ the Judge and the Archangel Michael. On one side of the triptych, the fires of Hell blaze, while on the other, the drama has vanished, the contorted limbs relax little by little, tears are dried, and faces brighten. Although the attention of the painter and the viewer is usually drawn to the strange, and macabre creatures of Hell, Memling gives us here one of the most beautiful images of Paradise ever painted.

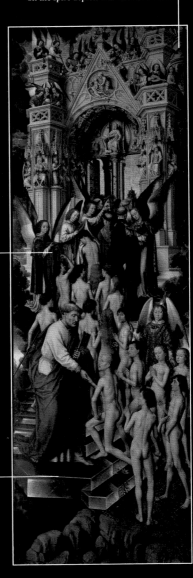

A choir of angels, on the turrets of the monumental entrance to the Heavenly Jerusalem, celebrates the arrival of the blessed. The Gothic architecture recalls the buildings of Bruges, while the circular bas-relief on the spire depicts the creation of Eve.

At the top of the stairs, the naked blessed souls are dressed in magnificent nuptial robes by the angels, a reference to a particular passage in the Gospel. The door is slightly open, allowing us to glimpse the radiance of the everlasting light on the other side.

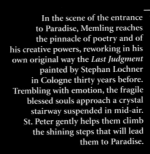

In the scene of the entrance to Paradise, Memling reaches the pinnacle of poetry and of his creative powers, reworking in his own original way the *Last Judgment* painted by Stephan Lochner in Cologne thirty years before. Trembling with emotion, the fragile blessed souls approach a crystal stairway suspended in mid-air. St. Peter gently helps them climb the shining steps that will lead them to Paradise.

In a world that has become bare and inhospitable, the struggle between angels and demons erupts, as they grasp and wrench the feeble, terrified, and defenseless risen souls.

Memling combines the iconographic tradition
of the Last Judgment in Flemish and German art
with a reinterpretation of the Apocalypse and
biblical texts describing Judgment Day.
The heart of and key to the entire composition
is the bright rainbow, the Old Testament symbol
of God's everlasting covenant with man.

Memling always counterbalances a scene
of horror and punishment with a vision
of salvation. Even in the midst of Hell,
he includes the sweet presence
of an angel. The clouds rimmed
with light connect the sky of the central
panel with the one on the right.

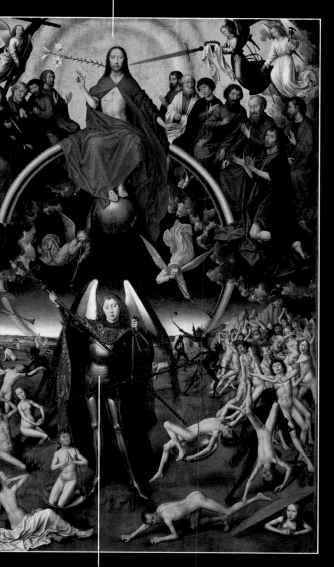

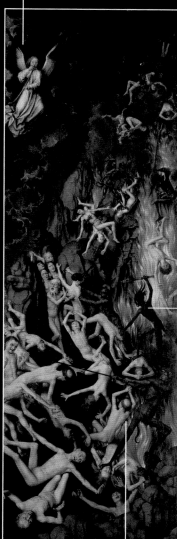

The triptych is conceived
as one great, unified scene,
with no break between
the three parts. Beginning
in the central panel,
the damned, forced on
by demons, seek to escape.
Once on the edge of the
abyss of Hell, they fall
chaotically into the eternal
flames. Unlike other
painters, Memling does not
over emphasize the
representation of brutal
torments and devilish
beings. He prefers to use
his great talent for
portraiture to depict,
with extraordinary
intensity, the contracted
faces, clenched jaws,
and bulging eyes of
the condemned souls.

The Last Judgment is dominated by the figure of
the Archangel Michael, intently weighing and separating
the souls. Despite the dramatic situation, Memling
depicts the female figures with a touch of sensuality.

As in many medieval
Last Judgments, here
priests thrown into hell are
recognizable by their tonsure.

Sicily, Naples, and Venice
c. 1430-1479
Antonello da Messina

The Link between Flanders and Italy

Antonello is a key artist in understanding the Mediterranean links to international painting in the mid-fifteenth century. He led an enviable artistic and personal life, which began with his relationship with the great Flemish and Provençal masters and brought him into contact with Piero della Francesca. Later his influence played a pivotal role in the evolution of the Venetian School. He began painting around 1450 in the cosmopolitan atmosphere of Naples, at the school of the master Colantonio, where he had access to the royal collections of Flemish art. From his earliest works, he demonstrated his innovative ability to combine attention to the smallest natural details with a feeling of spaciousness. Dividing his time between frequent trips abroad and longer stays and commissions in Sicily, Antonello developed his style quickly and independently—as can be seen from his novel versions of the Crucifixion and a fascinating series of mysteriously anonymous male portraits. Traveling through Italy, he came into contact with Piero della Francesca in Rome and Urbino; however, he reached the peak of his career during a stay in Venice from 1474 to 1476. His presence was also largely responsible for a significant stylistic shift in local painting, which was quickly assimilated by Giovanni Bellini.

Antonello da Messina
Crucifixion, 1475-76
Musée des Beaux-Arts, Antwerp

This painting is the most complex and dramatic of Antonello's numerous variations on the theme of the Crucifixion. The minute description of the landscape, in which every detail is recorded, is effectively offset by the large "void" of the sky, against which the three crosses are silhouetted.

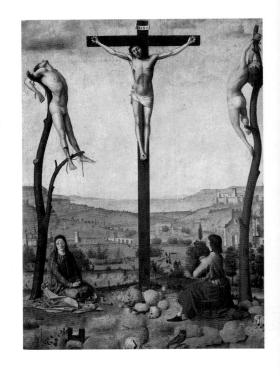

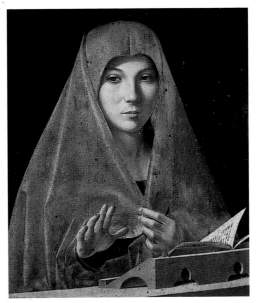

Antonello da Messina
Annunciation, c. 1477
Galleria Nazionale, Palermo

This may well be the best-known image in the whole of Sicilian painting. Antonello succeeds in expressing purity, modesty, and emotional involvement very movingly, even though gesture and expression are restrained. Here he gives his extremely personal interpretation of Piero della Francesca's geometric rigor, simplifying the colors and volumes to the utmost.

Antonello da Messina
St. Jerome in his Study, c. 1474-75
National Gallery, London

This work, a superb demonstration of Antonello's mastery of perspective and his keen research, is quite unique in the history of Italian painting, in fact, for years it was attributed to the great Flemish masters. The diffusion of the light, the glimpse of nature through the windows in the background, the world of erudition reflected in the pages of the book, and a sense of the very private pleasure of learning all contribute to this masterpiece's fascination.

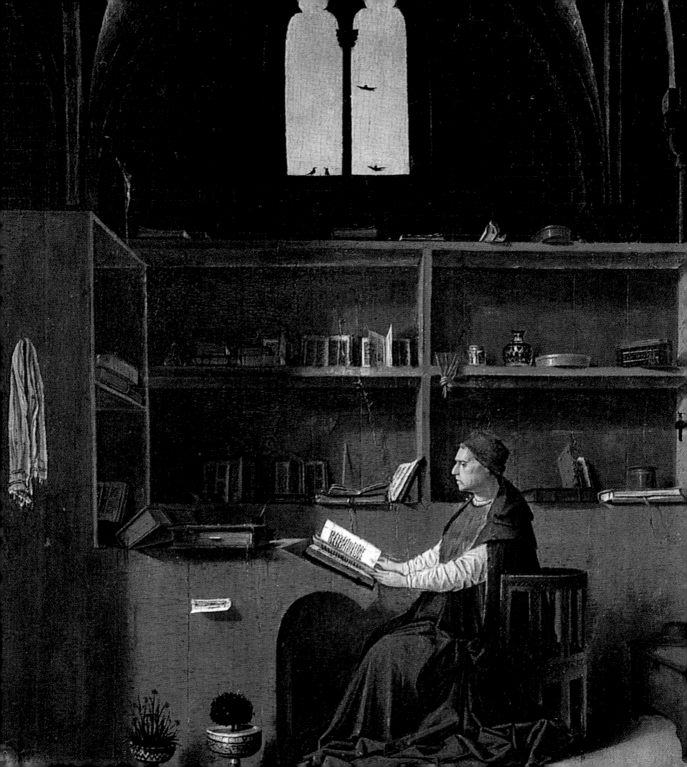

1453-1491 1430/35-1498

Martin Schongauer and Michael Pacher

German Painting Moves toward a Great Turning Point
Two great masters dominated German painting during the second half of the fifteenth century. Both lived in border regions and harmoniously combined diverse artistic traditions, following distinct but parallel paths that led German art toward a regeneration of the Renaissance style. Their ability to bring together different influences perhaps stems from the fact that neither was completely "German". Schongauer was from Colmar in Alsace, an environment permeated with the influence of Flanders and Burgundy. Pacher was from Brunico in Alto Adige and had spent time in Padua with Donatello and Mantegna, familiarizing himself with the latest developments in humanism and perspective. A painter of exquisite Madonnas and harmonious religious scenes, he was a pioneer in the field of engraving. His prints spread throughout Europe and, as we know, the young Michelangelo copied one of his most famous engravings. Pacher's solemn compositions have the regular, majestic breadth of Florentine art of that same period, but are enlivened by the limpid light and gleaming colors of the late Gothic style. Dürer was influenced by these great masters and continued their legacy.

Martin Schongauer
Virgin in the Rose Garden,
1473
Church of St. Martin,
Colmar

In the lively artistic center of Alsace, Schongauer was in contact with many religious institutions, including the monastery of the Order of St. Anthony in Isenheim, which would later house the work of Matthias Grünewald.

Martin Schongauer
*Adoration of the
Shepherds*, c. 1472
Gemäldegalerie, Berlin

Schongauer meticulously portrays the physiognomy and fabrics with a softness, typical of the late-Gothic style.

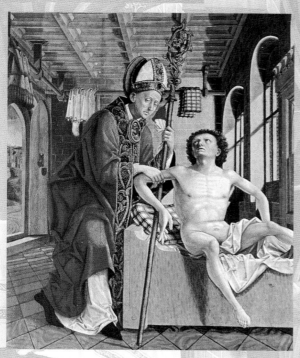

Michael Pacher
*St. Augustine Freeing
a Prisoner*, outer panel of
the *Altar of the Four Latin
Fathers*, c. 1482
Alte Pinakothek, Munich

Pacher's paintings are full
of deep, and harmonious
perspectives, but
the architecture and
furnishings are still
markedly Gothic, and
typical of the Alpine region.
The perfectly proportioned
figures have the striking
features and intense
expressions of the art
of northern Europe.

Michael Pacher
Altar of the Four Latin Fathers,
inner panels, c. 1482
Alte Pinakothek, Munich

This splendid altarpiece
was created for the
Augustinian Abbey of
Novacella, near Bressanone.
The painted sections are
perfectly preserved, though
the sculpted frame, also
made by Pacher, has been lost.
He was, in fact, an excellent
sculptor and specialized in
linden wood altarpieces.

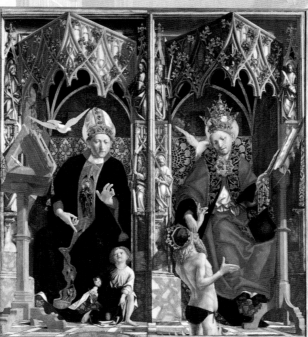

Urbino, Mantua, and Ferrara

1453-1499

The Renaissance Courts

The Dialogue between "Center" and "Periphery", the Key to Italian Art

The large number of artistic centers in Italy during the fifteenth-century was unmatched by any other country. During this period, Italy boasted five major states (Milan, Venice, Florence, Rome, and Naples), as well as other smaller ones. The lords of the smaller towns and the dynasties that established themselves in the larger cities all vied for prestige through wide-ranging artistic and cultural initiatives. The phenomenon peaked during the second half of the century, when many courts developed their own artistic schools, thanks to a constant exchange with artists from other cities. The most complete and fascinating example was the court of Urbino, under Duke Federico da Montefeltro. The leading artist was Piero della Francesca, whose work in Urbino achieved a consummate balance between the laws of geometry and a serene, monumental tone. In Ferrara, the Este family sponsored an autonomous group of painters, led by Cosmè Tura. Here a similar international atmosphere could be found, thanks to masters of the caliber of Pisanello, Piero della Francesca, Leon Battista Alberti, and the Fleming Rogier van der Weyden who spent time there. Mantua, however, was a different case. There, the Gonzaga family appointed the Venetian Andrea Mantegna as court painter in 1460. He single-handedly transformed the small Lombard court into a groundbreaking workshop of Renaissance painting over a period of almost fifty years.

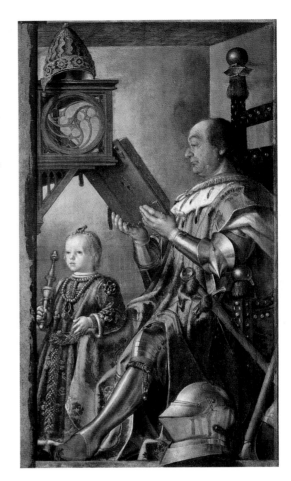

Pedro Berruguete
Federico da Montefeltro with his Son Guidobaldo,
1474-77
Palazzo Ducale, Urbino

In the magnificent palace in Urbino, artists and courtiers debated the form of the "ideal city", the rules of perspective, and the moral and historic legacy of "illustrious men". Besides Piero della Francesca, the painters at the court included the Florentine Paolo Uccello, the Fleming Justus of Ghent, and the Spaniard Pedro Berruguete (c.1450-c.1504), who painted this pleasant official portrait of the duke.

Andrea Mantegna
The Court of Ludovico Gonzaga,
1465-74
Palazzo Ducale, Mantua

The fresco cycle in the so-called *Camera degli Sposi* (Bridal Chamber) is the most celebrated example of profane painting in the Renaissance courts of Italy. The exquisite minutiae of late Gothic art are replaced by spacious scenes with a strong sense of perspective, and a precise depiction of nature.

Anonymous (Luciano Laurana
or Francesco di Giorgio?)
The Ideal City, c. 1480
Galleria Nazionale delle
Marche, Urbino

This quintessential image
of humanism expresses
the intellectual moderation
that inspired Italian art
in the fifteenth century.

Piero della Francesca
*Sigismondo Pandolfo Malatesta
before St. Sigismund*, 1451
Tempio Malatestiano, Rimini

Malatesta, bellicose lord
of a small, turbulent state,
succeeded in bringing two
of the absolute geniuses of
humanism to Rimini, Leon
Battista Alberti and Piero della
Francesca, in addition to many
other important artists.

Cosmè Tura
Spring (The Muse, Erato),
c. 1460
National Gallery, London

The traditional title does not
correspond to the identity
of the fascinating figure seated
on a throne decorated with
copper dolphins. This is
actually one of the muses
painted for the small
Este study in Belfiore.
The decoration of this elegant
room, which has unfortunately
been dismantled, was the work
of several artists working for
the dukes of Ferrara. Among
them was Tura (c. 1430-1495),
whose extravagant, bizarre,
and restless genius
distinguishes him as one
of the most original painters
in fifteenth-century Europe.

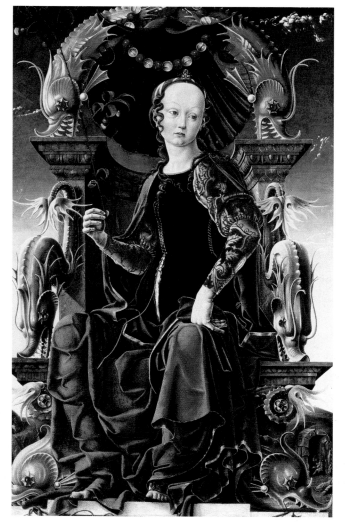

Padua and Mantua
1431-1506
Andrea Mantegna

A Court Painter who Signed his Name in Greek

Son of a humble carpenter, Mantegna had the good fortune to study art in Padua at a time when Tuscan masters like Donatello and Paolo Uccello were in the city. Mantegna displayed a precocious and "modern" talent, and was interested in the new developments in perspective. His career progressed rapidly: his first important work was the frescoes for the Ovetari Chapel in Padua; his marriage to Giovanni Bellini's sister Nicolosia soon linked him to the most important family of artists in Venice; and the majestic altarpiece in the Church of San Zeno in Verona (1457-59) was his last youthful work. In 1460, he moved to Mantua to occupy the position of court painter. He lived and worked in the city of the Gonzaga family from then until his death, with just one interval studying in Rome (1489-90). Mantegna succeeded in radically changing the artistic style of the court, from the ornate fantasy of late Gothic, to humanism, which emphasized archaeology and perspective. The *Camera degli Sposi* is the most effective and complete confirmation of Mantegna's style and of his ability to analyze and experiment with draftsmanship. Despite his relationship with Giovanni Bellini and later with Leonardo, Mantegna never adopted the techniques of tonal color or sfumato, but preferred his own lucid, infallible visual precision. Virtually none of Mantegna's works remain in Mantua; like all of the princely collections of Renaissance Italy, they are now scattered throughout Europe.

Andrea Mantegna
St. Sebastian, c. 1459
Kunsthistorisches Museum,
Vienna

Andrea Mantegna
St. George, 1467
Gallerie dell'Accademia,
Venice

Andrea Mantegna
Parnassus, 1497
Louvre, Paris

This image marks the beginning of the fresco cycle for Isabella d'Este's extraordinary "small room" in Mantua.

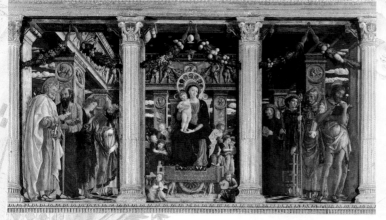

Andrea Mantegna
*Madonna Enthroned with
Saints* (polyptych), 1456-59
Basilica of San Zeno, Verona

Despite the painting's three-
part format, Mantegna
succeeded in transforming
the work into a monumental,
unified altarpiece by depicting
the three parts within a single
setting. An architectural
construction of columns,
forming a portico, decorated
with large garlands of fruit
and leaves, opens onto the sky,
which serves as the backdrop
for a solemn group of finely
rendered figures.

Andrea Mantegna
The Dead Christ, c. 1500
Pinacoteca di Brera, Milan

Mantegna probably painted
this striking, yet harsh
masterpiece toward the end
of his life for his own funerary
chapel. It is an extremely
experimental work, both in
terms of its technique (it is
one of the few works on
canvas from the period)
and its composition with
its dramatically extreme
foreshortening. The body
of Christ, lying on the cold
marble mortuary table,
is depicted in the stillness
of death in mercilessly
detailed close-up, while
the faces of the mourners
are crammed into the corner.
A funereal ashen color
dominates throughout.
Mantegna takes to the extreme
his penetrating search for
a subtle, implacably severe
style, conceding nothing
to the softness of tone that
was becoming so popular
in Venetian painting of
the early sixteenth century.

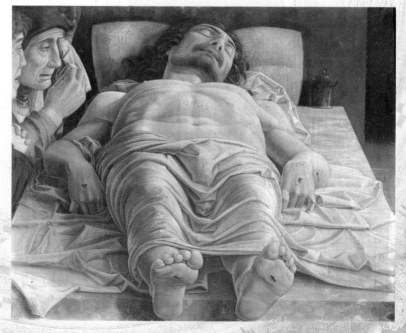

Florence
1445-1510
Sandro Botticelli

A Master of Style among the Triumphs of Lorenzo the Magnificent

Botticelli's *Primavera*, symbol of Lorenzo the Magnificent's Florence, confirms the artist as the leading figure in a truly remarkable period of history. His long artistic career began at the height of humanism and extended to the dawn of Mannerism. Beginning as a pupil of Filippo Lippi in 1464, and then an assistant of Verrocchio, the young Botticelli painted variations on the theme of the *Madonna and Child*. In 1472 he joined the guild of Florentine painters and entered Medici circles. He painted portraits of various members of the family and produced increasingly important works, such as the *Adoration of the Magi* (1475, Uffizi). The *Primavera* marks the beginning of a cycle of allegories (Uffizi), which also includes the *Birth of Venus* and *Pallas Subduing a Centaur*. In 1482, at the height of his fame, he was called to Rome to paint three frescoes in the Sistine Chapel. Upon his return to Florence, he was recognized as the indisputable leading painter of the local school. The death of Lorenzo the Magnificent marked the end of an era, which along with the teachings of Savonarola, drove Botticelli to radically re-examine his art. In his final, intense creative period, he produced works of great spirituality, like his two versions of the *Descent from the Cross*, and the *Mystic Nativity* (1501, National Gallery, London).

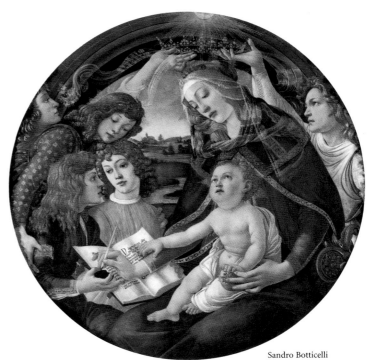

Sandro Botticelli
Madonna of the Magnificat,
1483-85
Galleria degli Uffizi, Florence

The tondo was a typical format in Florentine Renaissance painting, and Botticelli was an expert in dealing with the problems in composition and perspective posed by the circular wooden panel. This radiant Madonna takes her name from a Marian prayer that appears in the book held by the angel. The optical distortion, clearly visible toward the top of the painting, creates the effect of a concave mirror.

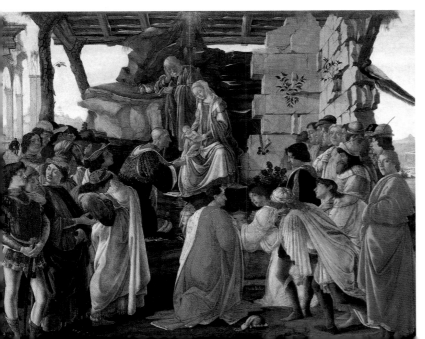

Sandro Botticelli
Adoration of the Magi, 1475
Galleria degli Uffizi, Florence

The Magi's visit to the manger in Bethlehem was a favorite theme of the Medici family, who commissioned the work and whose members are portrayed among the figures in this painting. The young man with the yellow robe on the far right is a self-portrait of the artist.

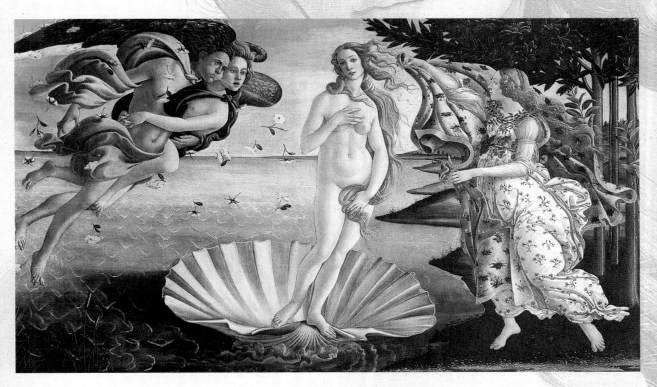

Sandro Botticelli
Birth of Venus
1484-86
Galleria degli Uffizi, Florence

The great profane allegories
painted for the Medicis
mark the culmination of the
deliberate revival of ancient
myths, values, and symbolic
figures within the context
of a humanistic culture,
where poetry, art, ideas,
and an enjoyment of life
merged wonderfully.

The Sermons and Bonfires of Fra Girolamo Savonarola

As a result of Lorenzo the Magnificent's untimely death in 1492 Florence entered a deep moral and political crisis. The thundering sermons of the Dominican monk Girolamo Savonarola (shown here in a portrait painted by fellow monk Fra Bartolomeo), prior of the Church of San Marco, roused the city as if from a dream. For six years, Florence was pervaded by a wave of penitence and meditation. Savonarola took on the role of spiritual guide, criticizing the recent past as a depraved and intolerably frivolous era. There followed endless processions of atonement and raids by the piagnoni, *groups of devoted followers who imposed strict laws on everyday life. They burned books, objects, and works of art considered "improper" (including some of Botticelli's profane paintings) in large bonfires until 1498, when Savonarola himself was burned at the stake. The period of Savonarola was a terrible trauma for the history of art and for Botticelli, in particular. It caused him to have a nervous breakdown, which is painfully reflected in his last, desperate, but still beautiful paintings.*

Sandro Botticelli

c. 1482

Primavera

At the height of his artistic career, Botticelli painted great secular allegories, of which the *Primavera* is the first and most complex. Created for the young Lorenzo di Pierfrancesco de' Medici, cousin of Lorenzo the Magnificent, the paintings had the didactic aim of encouraging virtue and an appreciation of beauty. Thanks to the Florentine painter and his patrons, a thousand years after the fall of the Roman Empire, the European West rediscovered large-format mythological painting. In addition to the *Birth of Venus*, and the *Primavera* (actually the retinue of Venus, which includes Flora and the Graces), both in the Uffizi, Botticelli also painted two smaller allegorical paintings: *Pallas Subduing a Centaur* (also housed in the Uffizi), and the panel with *Mars and Venus* (in the National Gallery, London). The exact dates of the paintings (c. 1480) and a thorough iconological interpretation have continued to fascinate scholars, who have put forward many theories over the centuries. They have been interpreted as a painted version of the literary passages of Poliziano; a visual rendering of the Neoplatonic philosophy of Marsilio Ficino; and a humanist revision of passages from classical literature. Aside from these hypotheses, the overall meaning of Botticelli's allegories is clear: a harmonious relationship between human beings and the world can only be achieved through the triumph of reason, intelligence, and beauty over brute force and arms. It could be said that this was, in essence, the premise of the entire humanist movement in Italy, even if it was often contradicted and obstructed by the rivalry between the small states forced to share the country.

The diaphanous garments of the Graces are seductively transparent. Here Botticelli successfully adopts the techniques learned from Flemish painting. He no longer uses tempera paints, which are thick and strong. Instead, using linseed oil as a binder, he superimposes thin layers of paint that leave the underlying hue still visible. It is easy to understand the "scandal" aroused by Botticelli's profane, mythological paintings in the years of Savonarola's ascendancy.

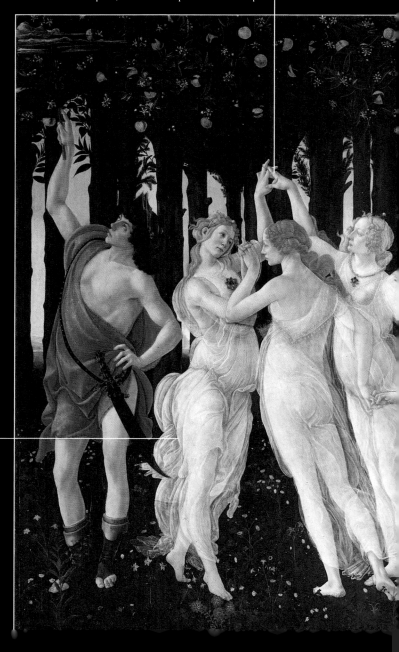

The group of the three Graces, delightfully intertwined in a dance, is the very image of harmony and serenity. To the left, the god Mercury clears the sky of clouds with his caduceus. All the figures are aligned on a single plane, with little attempt made to create depth.

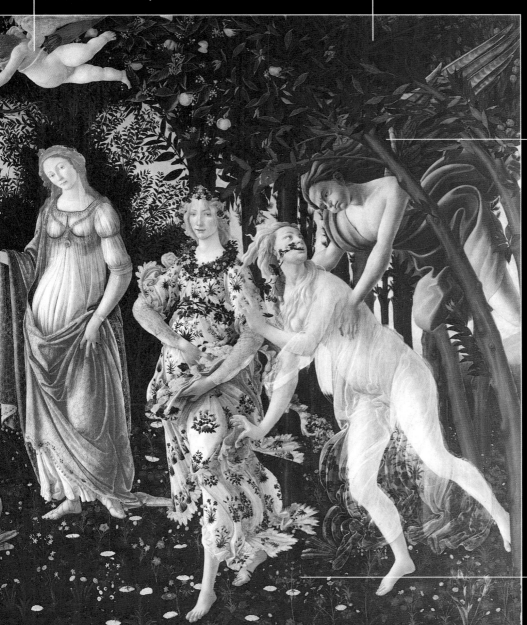

The little Cupid hovers over the figure of Venus, ready to shoot an arrow of passion. The glowing Venus, raising her hand reassuringly, stands out against the dark green of a thick bush, which rises into the cloudless sky. This sequence of light-dark-light recalls Leonardo's first works painted in Florence.

The dense screen of trees divides the space rhythmically and pushes the characters into the foreground, almost as in a tapestry.

The impetuous Zephyr chases his lover Clori through the forest. Embraced by the spring wind, Clori is transformed into Flora, who brings flowers to the world. The *Primavera* displays a passion for literary and classical references in addition to establishing a style that would dominate the last quarter of the fifteenth century in Florence. Here an exquisite linear graphic style replaces the mathematical explorations of the pioneers of perspective. Botticelli became recognized as the leading painter of the Florentine School, as confirmed by his major role in the prestigious enterprise of frescoing the walls of the Sistine Chapel in Rome.

In the wonderful flowering meadow the painter accurately depicts approximately 150 different botanical species. In fact, Botticelli's close observation of natural detail rivals that of the Flemish artists, whose work was well-known in Florence, thanks to masterpieces commissioned by merchants and emissaries of the Medici bank, like the Arnolfinis, Tanis, and Portinaris.

Venice

c. 1430-1516

Giovanni Bellini

The Spring of Venetian Painting

Giovanni Bellini studied and worked under his father, Jacopo, and did not embark on an independent career until he was in his thirties. However, this did not stop him from becoming the great reformer of Venetian painting by introducing a new tonality, and approaching the Renaissance model. Some of Giovanni Bellini's early works were inspired by similar compositions painted by his brother-in-law Andrea Mantegna, but he soon displayed a distinct way of rendering light and atmospheric effects. *The Polyptych of San Vincenzo Ferreri* (Church of San Zanipolo, Venice) marks the start of his public career. Soon his work was on a par with the greatest art of central Italy. Antonello da Messina's presence in Venice prompted an exploration of a more subtle use of light, though in solemn, large-format compositions. Giovanni became the official painter of the Venetian Republic in 1483, and the leader of the local school in charge of a successful workshop, where two generations of artists were trained, including Lorenzo Lotto and Titian. Giovanni Bellini's oeuvre is extremely varied, including many versions of his favorite subject, the *Madonna and Child*, as well as portraits and altarpieces. In the early sixteenth century, his work showed an even more delicate, intense research into light effects. Influenced by Giorgione's unconventional painting, the aging Bellini extended his repertoire to include profane subjects.

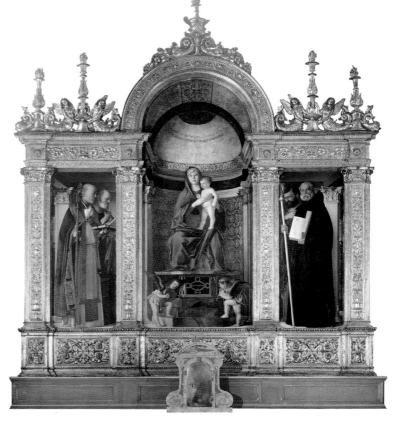

Giovanni Bellini
Frari Triptych (Madonna and Child with Saints), 1488
Sacristy, Church of Santa Maria Gloriosa dei Frari, Venice

Wonderfully well conserved, this triptych is still in its original frame, also designed by Giovanni Bellini. The real architectural elements of the wooden structure perfectly match those painted in the background.

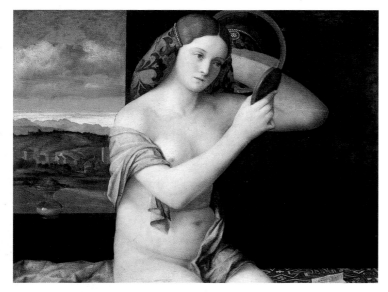

Giovanni Bellini
Nude Woman in front of the Mirror, 1515
Kunsthistorisches Museum, Vienna

This painting, executed the year before his death, is the definitive proof of Bellini's untiring inventiveness. It is his first and only large female nude which, softly caressed by the light, possesses an air of sweet, innocent purity.

On the clock tower in Piazza San Marco, built by Mauro Codussi, one of the countless winged Venetian lions stands guard over passing time. From its vantage point, it witnessed Titian's replacement of Giovanni Bellini as the Venetian Republic's official painter—a highly prestigious position with very few duties (virtually the only one being to paint the Doge's portrait) and a huge salary drawn from the salt tax. There were numerous other benefits as well, such as being exempt from taxes. Giovanni Bellini was appointed in 1483 and held the post until he died in December 1516. The following week, his place was taken by the eager youthful Titian, who in turn, remained court painter for a full sixty years. The only interruption was during a very brief period when the senate imposed a "punishment" for yet another delay in the delivery of a particular painting for the Doge's Palace. Thus, the Venetian School, so blessed with painters of the highest quality, was led by only two, unrivaled masters almost throughout the entire Renaissance, from 1483 to 1576.

Giovanni Bellini
*Virgin and Child between
St. Catherine and St. Mary
Magdalen,* c. 1500
Gallerie dell'Accademia, Venice

Giovanni Bellini's sensitive approach to light is not only evident in his exteriors and limpid, sun-drenched landscapes. He also reveals his mastery in paintings with dark or neutral backgrounds, as in this case. Mary Magdalen, on the right, emerges from the darkness as an image of pure beauty.

Venice

1480-1520

The Early Renaissance

A Vision of Light, Color, and Nature

At the end of the fifteenth century, the Venetian Republic came into possession of Cyprus, which marked the height of its territorial expansion. During this period, its was one of the great powers of the Mediterranean and a leader in political and commercial organization. Until the middle of the century, the art of Venice drew inspiration from Byzantine models (such as the mosaics in the St. Mark's Basilica) and the fanciful forms of the ornate Gothic style, but an original renewal of painting, led by Giovanni Bellini, soon transformed the Venetian School. This new style is characterized by a use of atmospheric effects, where light, color, and the details of the landscape blend perfectly, and outlines are only vaguely defined. Thanks to the unparalleled generation of Giorgione, Lotto, Titian, and Sebastiano del Piombo, Venetian painting perfected the pictorial technique known as tonalism. With this technique, paint was applied in thin, superimposed layers to create the soft diffused effect of colors blending with the natural atmosphere. The Schools (corporations with thousands of members) played a major role in the development of Venetian painting, by commissioning entire cycles of large narrative canvases depicting scenes from the lives of their patron saints.

Vittore Carpaccio
Stories from the Life of St. Ursula: St. Ursula's Dream, 1495
Gallerie dell'Accademia, Venice

The cycle for the School of Saint Ursula is the most famous series of paintings by Carpaccio (c. 1460-1526). Here, in the early morning light, an angel holding the martyr's palm leaf steps into the bedroom where Ursula sleeps, bringing into her dream the announcement of her imminent death. The objects and furnishings in the sleeping saint's room are depicted with poignant, tender care. This is one of the only existing faithful reproductions of the interior of a wealthy Venetian home at the end of the fifteenth century.

Vittore Carpaccio
Stories from the Life of St. Ursula: Meeting of the Betrothed Couple and the Departure of the Pilgrims, 1495
Gallerie dell'Accademia, Venice

The skillful combination of real and fantastic elements gives credibility to the enchanting setting—a fairy-tale Venice, where the bittersweet adventures of Princess Ursula take place.

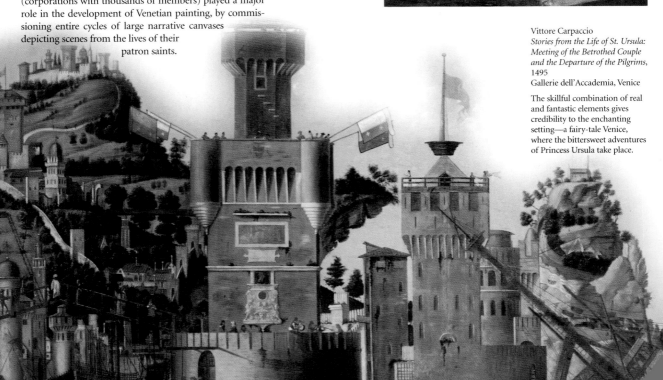

Cima da Conegliano
Madonna of the Orange Tree,
1495-97
Gallerie dell'Accademia, Venice

Although Cima (c. 1459-1517)
came from the hinterland,
he became a major figure
in the Venetian School.
His large, serene altarpieces
are characterized by their
luminously rendered
landscapes, decorous gestures,
and sharp outlines. This style,
which shared elements with
the painting of northern
Europe, was soon to be
challenged by the emergence of
tonalism. The nature of this
shift can be appreciated by
a comparison between
this work and the altarpiece
painted one generation later by
Palma il Vecchio, who was
from the province of Bergamo,
but was influenced by Titian's
fascinating and brilliant
use of color.

Jacopo Palma il Vecchio
*Madonna with St. George
and St. Lucy,* 1521
Church of Santo Stefano, Vicenza

Portugal

1495-1521

The Manueline Style

Art and Sea in the Age of Geographic Discoveries

The most distinctive period in Portuguese art coincides with the reign of Manuel I and the conquest of new continents and trade routes by Portuguese navigators. The enterprising king gave his name to the Manueline style, a final, imaginative burst of Gothic art in the western-most country in Europe. Thanks also to the patronage of Queen Eleanor (John II's widow and Manuel's sister), convents and monasteries distinguished by bold, unique architecture and richly decorated with elaborate sculpture and ornamentation also began to appear. A new school of painting developed in connection with the decoration of these buildings. Unlike the Spanish School of the time that tended to follow Italian models, this school was linked to Antwerp, in part because of seafaring associations. After the death of Eleanor and the king, the magnificent Manueline period ended abruptly and the chapels of the Batalha monastery were not completed.

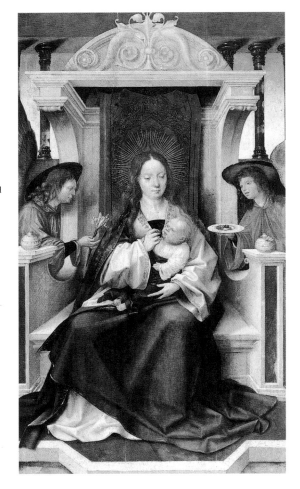

Anonymous
Portuguese-Flemish
*Madonna and Child
with Angels*, 1515-18
Museu Nacional
de Arte Antiga, Lisbon

Contacts between
Portuguese painters
and the Antwerp School
were very frequent
during the reign
of Manuel I.

Nuño Gonçalves
Polyptych of St. Vincent,
c. 1460
Museu Nacional
de Arte Antiga, Lisbon

A distinguished precursor of the Portuguese School, Nuño Gonçalves (dates unknown, though there is evidence of his life from 1450 to 1492) is one of the most mysterious painters in fifteenth-century Europe. He probably died in 1492, the year that also marked

the beginning of the age of geographic discoveries. Though Gonçalves was celebrated by writers of the past, little evidence remains of his life or work. In fact, his name is connected only with this extraordinary painting, influenced by Flemish art. This polyptych includes nearly sixty figures, depicted so insightfully that he has created a "group portrait" of Portuguese society.

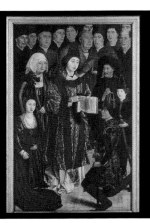
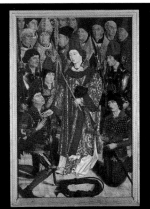

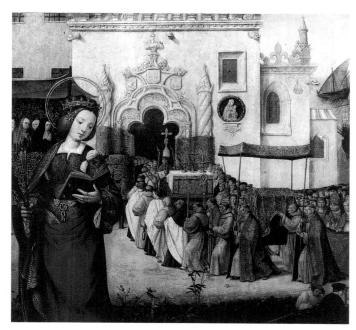

Attributed to Eduardo
o Português
*The Arrival of the Relics of
St. Auta at the Church of
Madre de Deus in Lisbon*
c. 1522
Museu Nacional
de Arte Antiga, Lisbon

The architectural
background, depicted
with great precision,
shows a typical building
in the Manueline style.

Attributed to Eduardo
o Português,
*The Angel Appearing to
St. Clare, St. Agnes and
St. Colette*, 16th century
Museu Nacional
de Arte Antiga, Lisbon

This painting is an elegant
variation on a panel by
Quentin Metsys painted
around the year 1500 for the
Poor Clare Convent in Setubal.
The image subsequently
became very popular in the
convents of Franciscan nuns.
Here, Eduardo o Português
(who had studied under
Metsys) follows the Flemish
master closely in his depiction
of the figures, but makes
significant changes
in the background.

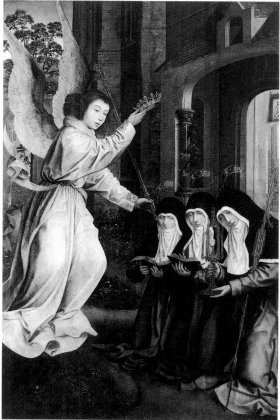

Where the Earth Ends and the Sea Begins

*This is the motto of Cabo da Roca, the
extreme western tip of Europe and a natural
observation point overlooking the ocean.
Confined within their small, marginal coun-
try, the Portuguese gaze toward distant hori-
zons.
At the time of Manuel I, they ventured well
beyond the limits of the known world, in
their search for a sea route to the Indies. Here we can only men-
tion some of the most famous exploits.
In 1498, Vasco da Gama circumnavigated Africa sailing around
the Cape of Good Hope. In 1500, Cabral participated in the dis-
covery of Brazil, which at the time, many believed to be the orig-
inal Garden of Eden. Between 1519 and 1522, Ferdinand
Magellan sailed around the world, after struggling for 38 days to
round Cape Horn.
These great ocean voyages made a very deep impression on the
soul, culture, and art of the Portuguese.
In fact, if we merely consider the outward signs, marine motifs are
found everywhere. Nets, tow-ropes, masts, oars, globes, measuring
instruments, steering wheels, small models of boats, sails, astro-
labes, and sextants all belong to the standard repertoire of deco-
rative sculpture and the traditional ornamental tiles used for
exteriors in Portugal and abroad.*

Florence, Milan, Amboise
1452-1519
Leonardo da Vinci

"If a painter wishes to see beauties that enchant him, he himself can produce them"

Leonardo is certainly the symbol of the Italian Renaissance, but he is also the prototype of modern man. His painting reflects his wide-ranging activities and talents. He was an inventor, architect, engineer, city planner, an expert in anatomy, botany, astronomy, and a writer of treatises and poems. According to Leonardo, painting is the sum of all the sciences, leading to a knowledge of the world and to a kind of creation of it. Born in a small village in Tuscany, Leonardo did his apprenticeship in Verrocchio's workshop in Florence with Perugino and Botticelli. His training was eclectic, comprising the diverse techniques of painting, sculpture, and the decorative arts. Even as a boy, he sketched impressions, observations, and ideas for compositions. By the end of the 1470s, Leonardo was one of the most promising young artists in Florence. However, his dislike of workshop rules led him to distance himself from the Tuscan art scene. In 1482, he went to the court of Ludovico the Moor in Milan. Lombardy became his second home and he spent twenty-four years there, in two long periods (1482-99 and 1506-13). During the first period, he painted his *Virgin of the Rocks* and the *Last Supper*, among other works. When the Duchy of Milan fell in 1499, Leonardo returned to Florence, vying with Michelangelo in the frescoes (since lost) in Palazzo Vecchio, and began painting the *Mona Lisa*. Upon his return to Milan in 1506, he executed the *Virgin and Child with St. Anne*. Finally, invited by King Francis I, he moved to France, where he painted his last works. He died in Cloux Castle, near Amboise.

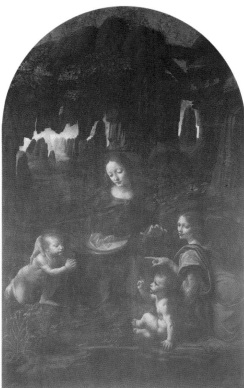

Leonardo da Vinci
Virgin of the Rocks,
1483-86
Louvre, Paris

We can thank the humility of two painters for Leonardo's first masterpiece in Milan. The de Predis brothers had been commissioned to paint an altarpiece, but they humbly left the central panel to their illustrious Florentine guest. Since they were unable to reach an agreement about payment when it was finished, Leonardo delivered a copy a few years later and kept the original all his life. The backdrop of glistening rocks is extremely innovative, with its fascinating natural light, reflections, and distant haze.

Leonardo da Vinci
Annunciation, c. 1474
Galleria degli Uffizi, Florence

Despite a certain awkwardness typical of an inexperienced painter, Leonardo demonstrates from the very beginning the distance separating him from the polished, slightly vacuous manner of the Florentine School. A humid, misty atmosphere pervades the background of the scene.

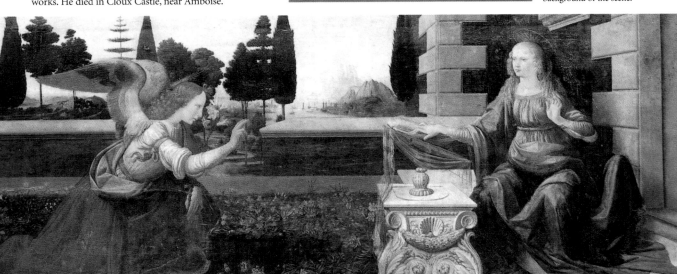

Leonardo da Vinci
Mona Lisa (La Gioconda),
1503/06-1513
Louvre, Paris

This painting, the most
famous portrait in the history
of art, is the fruit of a lengthy
and tormented process.
Leonardo was in the habit of
executing his works patiently
and meticulously and insisted
on the right to retouch them
repeatedly over the years.
Mona Lisa's elusive smile,
in fact, results from the
application of an infinite
series of thin layers of color.

Leonardo da Vinci
Virgin and Child with St. Anne,
c. 1510-13
Louvre, Paris

Leonardo began this painting
during his second stay in Milan
and completed it in France,
but it was based on a fine
cartoon the artist had made
previously in Florence.
It possesses the characteristics
of his late work, and epitomizes
his search for a mysterious
affinity between man and
nature, in an uninterrupted
interplay of sky, water,
rocks, fields, animals,
figures, and emotions.

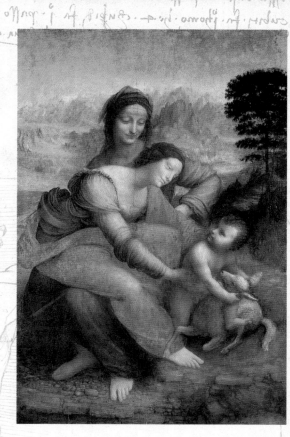

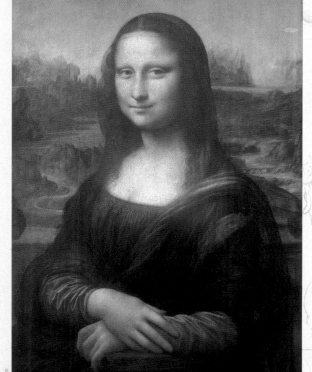

A Court Painter?

*Leonardo spent almost
his entire career "in the
service" of powerful
lords—not only the
Duke of Milan and the
King of France, but also
the Marchioness of
Mantua and Cesare
Borgia, the pope's illegitimate son. For all these, he executed the
kind of works typically commissioned from court painters, which
included portraits and other paintings, coats of arms, stage sets for
grand parties and theatrical events, decorations, and cartographic
surveys. In 1482, when he went to the Milan of Ludovico the Moor
(shown left), the thirty-year-old Leonardo presented himself to the
duke with a letter listing his talents as inventor, civil and military
engineer, and "in times of peace", great artist. Ludovico the Moor
was Leonardo's contemporary, and was the ambitious lord of a
"modern" state, but his lifestyle was still linked to the taste and
splendor of a Gothic court, which revolved around the glorification
of the duke himself. When Leonardo was invited to France, he was
already over sixty. His arrival in Amboise marked a turning point
in French culture, which King Francis I (shown right) urged to fol-
low the models of the Italian Renaissance. At the French court the
aging Leonardo was venerated as a patriarch and prophet. The
king's final embrace of the dying genius has become legendary.*

Leonardo da Vinci

1494-1497

The Last Supper

This painting, commissioned by Ludovico the Moor, is located in the refectory of the Convent of Santa Maria delle Grazie, in Milan. Leonardo, who by this time had been in Milan for twelve years, chose not to use the usual fresco technique. Instead, he attempted to make the paint adhere to the wall by applying a double layer of the preparation, in order to achieve a subtlety of execution that was not otherwise possible. In addition, he radically modified the scene's traditional composition. In all the previous Last Suppers, the table with Christ and the Disciples has a wall behind it and Judas is generally seated on the opposite side from the others. Here Leonardo places all of the figures on a single plane, in groups of three, with a deeply receding background in perspective behind them. The physiognomies and gestures of the larger-than-life figures are also novel. Leonardo singled out the most dramatic moment of the Gospel story, when Christ announces that one of his Disciples will betray him. These words pronounced by Christ (who is the dynamic center of the composition) trigger a whole range of emotions, including anger, resignation, pain, shock, dismay, and fear. Each Disciple has his own distinct reaction, displaying (as Leonardo said) the "emotions of the soul", which stresses their individual psychology.

The recent restoration of the *Last Supper* has made the regular rectangles leading back in perspective along the walls more clearly visible. Now one can make out the "thousand flower style" Flemish tapestries nailed to the walls.

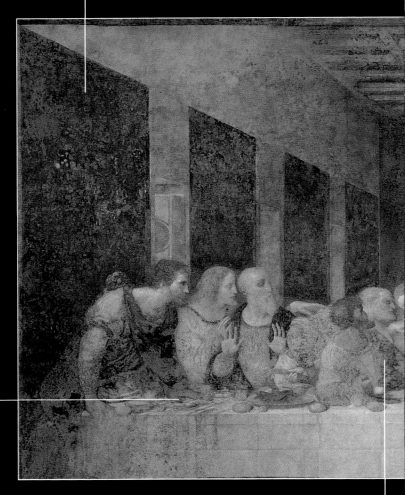

On the set table, one can clearly distinguish the lacework of the tablecloth, pewter dishes, glasses, pitchers of water, wine and the tray with the main dish of the Last Supper, duck in orange sauce. These descriptive details, painted with such meticulous realism, can be seen as anticipating the birth of the still life genre.

Judas, the traitor, is the only person resting his elbow on the table and leaning forward. In this position he is looking back and his face is in shadow. He is also grasping the bag containing the thirty pieces of silver, the price of betrayal, and seems to be pushed by the impetuous Peter who, brandishing a knife, leans toward Christ as if to defend him.

The coffered ceiling indicates the orientation of the light and accentuates the receding motion of the perspective, creating a harmonious whole. It is very reminiscent of the architectural design adopted by Bramante in the Church of Santa Maria delle Grazie.

Thomas's index finger points upward in a questioning gesture. This makes the figure easily recognizable (doubting Thomas wanted to put his finger in the wounds of the risen Christ). However, Leonardo also used this gesture in other works and in completely different contexts. With a touch of sympathetic caricature, Raphael painted Leonardo in the center of the *School of Athens* with his index finger in just this position.

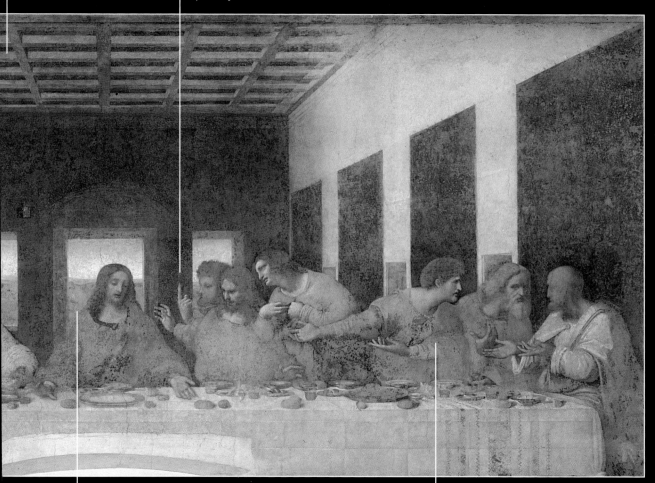

In the background of the composition, the warm, poetic, clear light of late afternoon enters through three large openings. A distant yet easily visible stretch of the Lombard countryside thus combines the luminosity in the background with the real light in the refectory itself, which enters

Leonardo used novel means to achieve a new level of communication, one that was not based on artistic conventions but on highly emotional human situations. Aware of the limits of painting (which he himself described as "silent poetry"), he did not hesitate to adopt new, unusual, and even slightly irreverent methods. For instance, he used to stop

The Low Countries

c. 1450-1516

Hieronymus Bosch

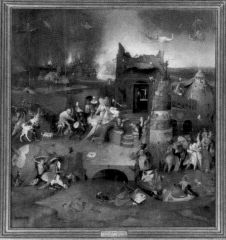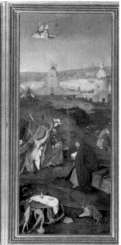

Hieronymus Bosch
Temptation of St. Anthony,
1505-06
Museu de Arte Antiga, Lisbon

This triptych is the
masterpiece of Bosch's
maturity. The central panel
shows the saint forced to
witness the celebration of
a diabolical black mass.
On the left-hand panel,
St. Anthony is carried away
and then dropped by a demon
in the guise of a toad. On the
right-hand panel, the hermit
attempts to be engrossed
in holy texts, while satanic
apparitions and elements
from alchemy and witchcraft
crowd around him.

Adrift Aboard the "Ship of Fools"

Jeroen Anthoniszoon van Aken was the real name of the
most enigmatic painter in the whole history of Western art,
though he chose to sign his works with the name of his
home town, 's-Hertogenbosch. Bosch led a peaceful exis-
tence, undisturbed by shocking or unusual events. Only
one long trip to northern Italy broke the serene monotony
of a life otherwise spent entirely in 's-Hertogenbosch. Folk
and humanistic elements, alchemy, science, religious
beliefs, and contact with other painters all contributed to
Bosch's cultural background. He drew freely from literary
sources, such as the *Malleus Maleficarum*, the sermons of
the monk Ruysbroeck, the *Vision of Tondalo*, the *Ars
Moriendi*, the *Ship of Fools* by Sebastian Brant, and the
Golden Legend by Jacopo da Varagine. His wide-ranging
allusions indicate a heterogeneous culture that was still,
however, essentially medieval. Bosch puts this background
to use in such an unconventional way that it is impossible
to determine his position. Works with traditional iconogra-
phy alternate with sacrilegious and diabolical versions of
religious themes, which leads to the suspicion that he might
have sympathized with heretical sects. Bosch's unique art
emerges from this mix of influences, and though it is close-
ly linked to its historical period, it also expresses eternal
moral values. His typic format is the triptych, a sequence of
panels that allowed him to develop a narrative over time
and space, and also to use the outside of the shutter panels
to depict background events and moral commentary.

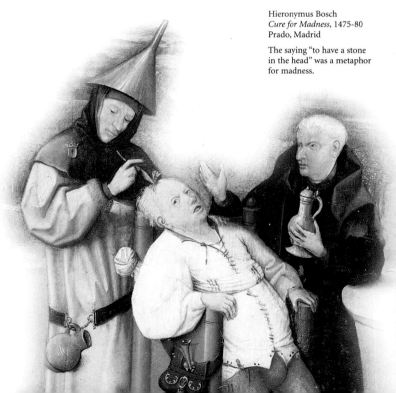

Hieronymus Bosch
Cure for Madness, 1475-80
Prado, Madrid

The saying "to have a stone
in the head" was a metaphor
for madness.

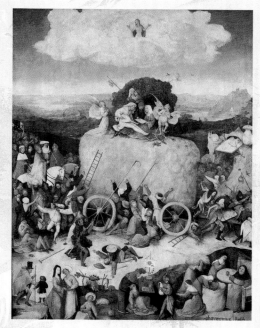

Hieronymus Bosch
Christ Carrying the Cross,
1503-04
Musée des Beaux-Arts, Ghent

Disturbing characters, mercilessly portrayed, crowd around Christ. Evil is no longer represented by symbols, but has become incarnate in human beings. Deformed faces, aquiline noses, sunken eyes, and toothless mouths emerge from the darkness of the background, which is offset by the brilliant colors of their headgear. There is no free space. The scene has a centrifugal motion, which eddies through the arrangement of the nineteen figures, following the diagonal line of the cross, and finally comes to rest on the serene face of Christ. Parallels with Leonardo's sketches of heads have been recognized in Bosch's rendering of the expressions.

Hieronymus Bosch
Hay Wain, central panel
of the triptych, 1500-02
Prado, Madrid

A Flemish proverb says, "The world is a mountain of hay: everyone takes as much as they can grab". This painting features humanity corrupted by earthly pleasures, truly mad, and inexorably heading toward eternal damnation. The hay, the symbol of man's greed, is slowly being dragged to Hell by a group of monstrous hybrid creatures half-man, half-animal. Even the Pope, the Emperor, and other potentates appear in the procession. On top of the cart, separated from all the tumult below, sit those who have committed the sin of lust. A peasant couple kisses in the bushes, while others take part in lascivious songs, accompanied by a diabolical figure with a trumpet for a nose and a peacock's tail, an allusion to the sin of vanity.

Hieronymus Bosch

1503-1504

The Garden of Earthly Delights

This is Bosch's most enigmatic and evocative painting, and one of the most studied and variously interpreted works in the whole of Western art. It is housed in the Prado Museum, Madrid, which possesses the world's largest collection of the Dutch master's panels.
Given the absence of reliable data or documentation concerning the subject or patron of this singular work, numerous theories have been put forward, including its connection with esotericism, alchemy, literary passages, and the painter's supposed association with heretical millenary sects. The central panel (from which the title of the triptych is taken) has the greatest number of unusual iconographic features, but the two side panels also depict fascinating and absolutely original scenes. In effect, the three panels, nearly 4 m long and 2.2 m high, should be read in sequence. The starting point is the garden of earthly paradise, where Eve has just been created. However, at the same time and in the same place, monstrous creatures are also being born to share with mankind the illusory bliss of the central panel and they are found again in the gruesome scene of Hell, on the right. Deaf to Divine Law and fallen irredeemably into sin, they are being punished in horrendous ways, in accordance with the law of retaliation. Rather curiously, Bosch includes some musical instruments (lute, harp, and hurdy-gurdy) in this scene, which the devils are using as instruments of torture.

The iconography of the left-hand panel is quite distinct from the other pictures Bosch painted of Eden. Here, the artist only represents the Creation of Eve, rather than the usual scenes of the Creation, Original Sin, and Expulsion. This choice is the key to understanding the moral theme of lust that dominates the triptych.

The biblical image of Paradise, understood as an enchanted garden, acquires entirely new features in Bosch's representation. The traditional Eden, with its lush fruit trees, here has strange, pastel-colored rocky outcrops.

The similarity between the "natural" architecture in this panel and in the one on the left serves to unify the setting of the two episodes. Lust thus appears to be the logical consequence of the creation of woman.

The small pond of dark water surrounded by disquieting creatures marks the thematic transition from this panel to the *Garden of Delights*. The dead fish alludes to sin, while the long-nosed figure reading a book is a personification of Evil.

The sin of lust is being committed by lovers in a lascivious position enclosed in a huge transparent bubble, the natural outgrowth of an exotic water flower. This motif of the glass sphere recalls the alchemist's instruments and also an old Flemish proverb, "Happiness is like glass, it is quickly shattered".

The perfectly round pond in the center of the enchanted garden is the fountain of youth and it is surrounded by nude figures riding imaginary animals.

The panels of this triptych swarm with animals, some of which appear in both Paradise and Hell. Beasts that evoke exotic worlds, such as elephants and giraffes (familiar from zoological collections) accompany other more common species, chosen for their symbolic value. Creatures found in other figurative sources of the period mix with unusual, fantastic animals, monstrous hybrids spawned by the artist's imagination that create a deliberate contrast to the old moralizing bestiaries. In Bosch's universe, Evil inevitably lurks in every aspect of existence.

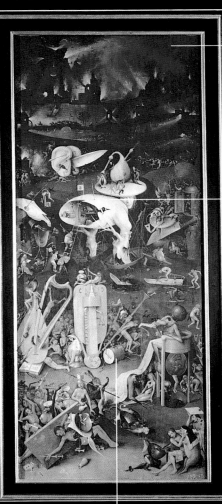

The background of Hell is dark, in obvious contrast with the clear skies of the other two panels. It is dimly lit, however, by the macabre glow of an inextinguishable fire.

In the center of Hell, Bosch painted a mocking self-portrait, in the guise of a tree/man whose roots/arms are set in two boats. The hollow body contains a kind of hellish tavern, frequented by devils "taking a break". He has a rotating platform on his head with a bagpipe, a symbol of Evil and lust. On the left are two enormous ears, pierced by an arrow and sliced by the blade of a long knife. According to one convincing interpretation of this infernal contraption it symbolizes man's deafness to the words of the New Testament, "If any man have ears to hear, let him hear".

Black men and women occasionally appear among Bosch's characters. In alchemy, the color black represents the original state of matter. Some consider the hairy woman on the right to be a satirical image of a nun.

The strawberries, and various other kinds of berries that appear throughout the composition, symbolize a greed for earthly things and are yet another symbol of lust.

Satan is the diabolical being with the head of a bird wearing a large cooking pot as a hat (symbolizing insatiable appetite). He swallows the damned and then excretes them into a pit. A greedy man is condemned to expel gold coins into this same hole, while another sinner vomits up his meal, an obvious punishment for gluttony. A naked woman lies motionless at the feet of Satan's throne, with a toad on her chest, condemned to look at her reflection in a mirror on a devil's rear, this being the punishment for vanity.

The Veneto

c. 1478-1510

Giorgione

The Wonderful Discovery of Natural Light

Giorgione was not a legendary, adventurous figure, quite the contrary, he was an intellectual artist working in a milieu inclined toward codified language, esoteric symbols, and the glorification of nature. He was a pupil of Giovanni Bellini and later rapidly absorbed the novel ideas of the "outsiders" who passed through Venice, including Leonardo and Dürer. A constant feature in all of his work is the presence of a warm, all-enveloping natural atmosphere. To this end, the outlines of his figures and landscapes are sfumato and not strongly defined, creating the predominant effect of gradations of color and light. Giorgione executed his whole oeuvre during the first decade of the sixteenth century, since the plague brought his brief career to an untimely end. His personal turning point was the altarpiece at Castelfranco Veneto (1504), with its spacious view of a countryside bathed in natural light. Giorgione led a very successful workshop, and in 1508, with his apprentice Titian, he frescoed the exterior of the Fondaco dei Tedeschi along the Grand Canal in Venice, although only a few fragments have survived. His works for collectors have fared better, and include portraits and religious subjects set in vast landscapes, but also secular subjects, moralizing compositions, allegories of the "three ages of man", scenes of concerts, busts of female figures, and erudite mythological and literary themes. Many iconographic innovations made their first appearance in Giorgione's lyrical paintings. Upon his death, several of his works were completed by his two most outstanding pupils, Titian and Sebastiano del Piombo.

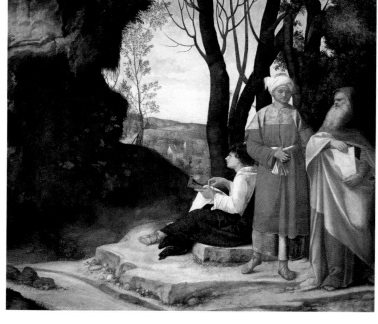

Giorgione
Sleeping Venus, 1510
Gemäldegalerie, Dresden

Titian completed this painting, which was probably left unfinished when Giorgione died.

Giorgione
The Three Philosophers, c. 1505
Kunsthistorisches Museum, Vienna

Three figures, who differ in age, appearance and dress, have stopped on the edge of the woods. According to the most reliable interpretation, they represent the three Magi seeking the road to Bethlehem.

The youngest fixes his eyes on the countryside, as if expecting a revelation. The other two are having a discussion. The Magi are thus transformed into a metaphor for three distinct states of being, or three distinct moments on the inner "journey" undertaken by mankind at various stages of their lives.

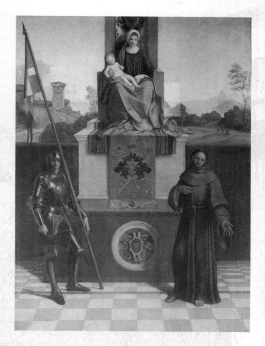

Giorgione
*Madonna and Child with
St. Liberale and St. Francis,*
1504
Cathedral, Castelfranco Veneto

This small altarpiece, which
is still in the cathedral of
Castelfranco Veneto, Giorgione's
birthplace, marks an important
step in the development
of the theme of the
Sacra Conversazione (Holy
Conversation). The beautiful
Madonna, silent and lost in
thought, seems to be suspended
between the damask on the
throne and the wonderful

shades of autumn. In an
uninterrupted flow of tones,
the colors range from gold to
red and from green to the faded
blue of a drowsy season.
The soft country light travels
through the painting, moving
slowly down the yellowed stone
of the tower in the background,
soaking into the velvet of the
balustrade's lining and the thick
folds of St. Francis's coarse
habit, and gleaming subtly from
St. Liberale's burnished armor,
which is part-silver and part-
black, like the night that will
follow this dreamy afternoon.

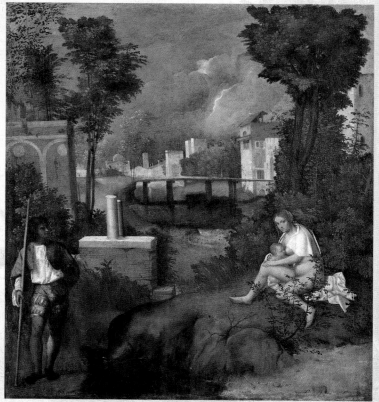

Giorgione
Tempest, c. 1506
Gallerie dell'Accademia, Venice

This impassioned tribute
to the magic of nature has
inspired an unusual number
of interpretations, readings, and
hypotheses. The most widely
accepted theory (confirmed by
a comparison with other works
of the period) holds that the two
characters represent Adam and
Eve after being expelled from
Paradise. The bolt of lightning
that rends the sky would thus
symbolize the flaming sword
of the Archangel. Whatever
the interpretation of this work,
Giorgione was perhaps the first
painter to assign such an explicit
leading role to the glory
and wonder of nature.

Nuremberg
1471-1528
Albrecht Dürer

"But I don't know what beauty is"

Dürer was an endlessly fascinating character, and unquestionably one of the leading figures of his time. He consorted with sovereigns, artists and thinkers, and was always at the center of contemporary debate. At the age of nineteen, he finished his apprenticeship in Nuremberg and made a series of trips to Basel, Strasbourg, Vienna, and Venice to further his studies, which gave him a European perspective on figurative art. Blessed with charisma and penetrating self-knowledge, Dürer was a committed intellectual when many other artists were still regarded as no more than specialized craftsmen. He spent the years 1505 to 1507 in Italy at the height of his artistic maturity, and was exposed to the Italian Renaissance at the pinnacle of its splendor. One of the most exciting episodes in the whole of European painting emerged from this exchange, and Dürer's work, inevitably characterized by superb draftsmanship, achieved true monumentality during this period. He felt a growing desire to create beauty that was both ideal and natural. Further travels took him to Antwerp and the Low Countries in 1521, where he came in contact with Quentin Metsys and Lucas van Leyden. In his final years, during the conflicts that beset Germany, he sought a difficult equilibrium through art and moderation. Dürer possessed prodigious powers of invention and was indeed a "universal" artist, open to very diverse themes, formats, and techniques.

Albrecht Dürer
Madonna of the Siskin, 1506
Gemäldegalerie, Berlin

The Madonna was Dürer's favorite subject and she appears again and again in his paintings, drawings, and engravings. This charming version, showing the influence of Bellini and Lotto, can easily be identified as belonging to the period of the artist's second trip to Venice.

Left and on the opposite page
Albrecht Dürer
St. George and St. Eustace,
side panels of the Paumgärtner
Altarpiece, 1502-04
Alte Pinakothek, Munich

One of Dürer's first large-scale works was a triptych, whose central panel depicts the Nativity. The superb saints in their armor on the side panels can be identified by their specific symbolic attributes. The defeated dragon indicates St. George and the banner with the head of a deer identifies St. Eustace. These are certainly portraits of the two Paumgärtner brothers who commissioned the work.

Albrecht Dürer
Four Apostles, 1526
Alte Pinakothek, Munich

Dürer donated these two panels
to the city of Nuremberg.
Toward the end of his life,
he sought to interpret the
major historic events, and
psychological, social, and
religious transformations he had
witnessed. He had a growing
conviction that had remained
virtually hidden for many years,
a kind of dark presentiment of
what was about to occur.
He began to be aware of
the limits of art and of the
contrast between the utopias
of humanism and reality.
In Dürer's last masterpieces one
senses his anxious desire to make
a lasting impression, but also his
certainty of the failure of the
ideals to which he had devoted
his life. After being close to
Giovanni Bellini and Leonardo,
Dürer now found himself sharing
the views of Michelangelo,
who was almost the same age.
They were the two most caustic,
embittered, and disillusioned
artists in the Europe of the
Reformation.

Albrecht Dürer

1511

Adoration of the Trinity

This altarpiece, now in the Kunsthistorisches Museum in Vienna, was commissioned by Matthäus Landauer (a wealthy and devout merchant from Nuremberg) for the chapel of the "House of the Twelve Brothers", an institution that offered assistance to elderly artisans. The commission also included a richly decorated, gilded wooden frame, designed by Dürer and carved by a Nuremberg sculptor. However, when the Hapsburg Emperor Rudolf II acquired the painting for the imperial collection in 1585, the original frame was left in Nuremberg. The Last Judgment, carved in the upper portion of the frame, and the gathering of the saints, painted on the panel, are part of a single unified iconographic scheme based on *De Civitate Dei* by St. Augustine. In the extraordinary semicircular arrangement of saints suspended in mid-air around the image of the Trinity, Dürer reaches unprecedented heights in the German figurative tradition (especially in his use of brilliant colors) while also rivaling the most sublime Italian models. In addition to the breadth of this spacious vision and the majestic classical composition, Dürer painted the garments in meticulous detail that was typically "northern", thus boldly combining the northern European style and that of Italy.

The double semicircle of saints arranged around the central axis of the Trinity floating in the sky can be compared to a similar composition used by Raphael in his fresco, *Disputa* (1508), in the Raphael Rooms in the Vatican . Almost all the female saints hold palm leaves, which are both a symbol of martyrdom and a visual reminder of the palms carried to celebrate Christ's entry into Jerusalem.

To the far left is a portrait of the donor, Matthäus Landauer, humbly kneeling in devout prayer. His simple dark coat contrasts sharply with the dazzling cloaks of the saints to his right: St. Jerome, in the deep red robes of a cardinal and Gregory the Great, in his golden papal vestments.

The landscape with the wide expanse of calm water may be an allusion to Lake Garda, which Dürer had admired on his trips to Venice.

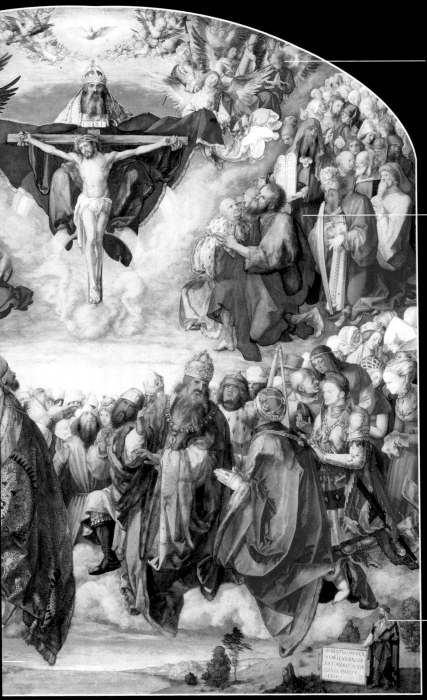

The angels with the instruments of the Passion are an explosion of vivid colors. This almost violent, brightness recalls the works of Dürer's contemporary, Matthias Grünewald.

Dürer depicts a vast number of saints (some dressed in the clothes of the period), as well as figures from the Old Testament, including Moses with the Ten Commandments, David with his harp, and Solomon with his ermine-lined gown, a symbol of royalty. This extraordinary gallery of portraits has been described as "Shakespearean" because the distinctly individual characters are portrayed within a powerfully orchestrated narrative structure.

A self-portrait of Dürer appears in the lower right-hand corner, beside a large memorial tablet with his signature and the date in Latin. Dürer was a particularly handsome man and took pride in his appearance.

Florence and Rome
1475-1564
Michelangelo Buonarroti

"Non sendo in loco buon, né io pittore"

Michelangelo wrote these words in a sonnet he composed when he was painting the frescoes on the ceiling of the Sistine Chapel. While creating one of the greatest masterpieces in the world, the thirty-five-year-old Michelangelo felt ill at ease and denied being a painter: "I am not in a good place, nor am I a painter". In fact, in this same sonnet, he describes his work as "dead painting". It was in this spirit that he served as the critical conscience of the Renaissance and the intense witness of its demise. Michelangelo dominates and characterizes the entire sixteenth century in Europe, not only in his consummate mastery as a sculptor, but also as a superb architect and painter. His apprenticeship took place in the Florence of the Medicis, in the workshop of Ghirlandaio, where he studied painting (not sculpture). He was drawn into the humanist circles of Lorenzo the Magnificent at an early age and was soon tackling monumental marble statuary. Before 1500, he had already sculpted masterpieces like the *Pietà* for the Basilica of Saint Peter's in Rome, and a little later, the *David* in Florence. In the first decade of the sixteenth century, Michelangelo frequently devoted himself to painting, beginning in Florence, where he vied with Leonardo in the frescoes of Palazzo Vecchio (now lost). During this time, he also executed his only completed painting on wood, the exemplary yet controversial *Holy Family (Doni Tondo)*. He was then commissioned by Pope Julius II and went to Rome to begin the daunting task of decorating the Sistine Chapel ceiling, a dramatic history of man and also a triumphant celebration of the beauty of Creation. After this exhausting work, executed with hardly a break from 1508 to 1512, Michelangelo virtually abandoned painting for twenty years, devoting himself to sculpture and architecture (the new sacristy of the Church of San Lorenzo in Florence). He took up the paintbrush again in the 1530s, for the long and tormented creation of the Sistine Chapel's *Last Judgment*. This extraordinary masterpiece was followed by two other frescoes for the Pauline Chapel in the Vatican (the *Crucifixion of St. Peter* and the *Conversion of St. Paul*). In his last years, he produced a final pair of *Pietà*, two marble meditations on death, which are now in the Museo dell'Opera in Florence and the Castello Sforzesco in Milan.

Michelangelo
Holy Family (Doni Tondo),
c. 1504
Galleria degli Uffizi, Florence

Unlike Leonardo's chiaroscuro and sfumato, Michelangelo's paintings have almost exaggeratedly bright, gleaming colors. Each form looks as if it has been coated with a shining layer of metal.

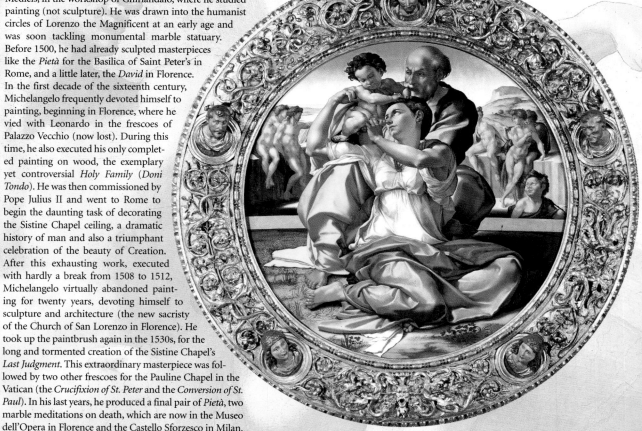

Michelangelo
Last Judgment, 1537-41
Sistine Chapel (rear wall),
Vatican City

With total creative freedom
and impassioned, personal
involvement, Michelangelo
produced one of the most
stirring and controversial works
in the history of art. In many
ways, the *Last Judgment* is
the antithesis of Michelangelo's
Creation frescoes on the ceiling
of the chapel. The gesture
of Christ the Judge dividing
the elect from the damned is
very similar to that of God the
Father as he separates the waters
from the land. Set against a
clear, uniform sky with neither
spatial nor temporal depth, the
dynamic vision of Christ is the
fulcrum of a devastating scene,
populated by over four hundred
figures. An impressive mass
of bodies (nearly all of them
naked) is suspended between
Heaven and Hell in a terrifying
chaos informed, however,
by a superior intelligence and
prevailing foresight. The nudes
are no longer heroic; they are
simply the shadows of terrified
men who are shaken, stunned,
and deafened by the sound
of the trumpets. The *Last
Judgment* overwhelms both the
spirit and the flesh. Man, whom
Michelangelo had exalted in his
nude figures on the ceiling,
is now crushed. The time of
illusions has come to an end.

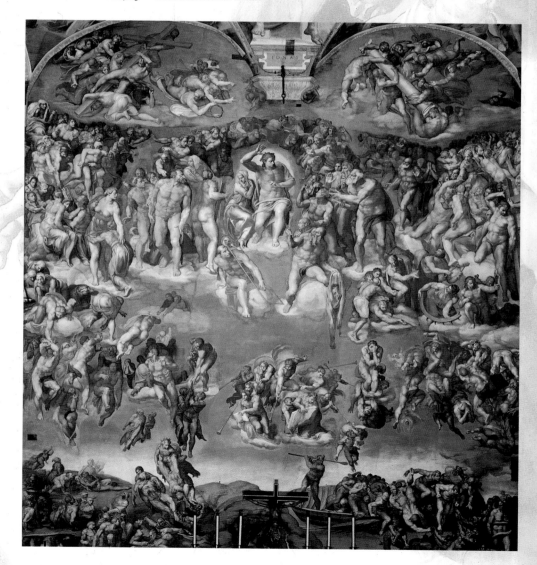

Michelangelo Buonarroti

1508-1512

Ceiling of the Sistine Chapel

The Sistine Chapel, built around 1480 by Pope Sixtus IV, is a rectangular room within the Vatican complex that hosts the most sacred ceremonies of the Catholic Church, including the election of new popes. The side walls were frescoed when the construction was first completed by various artists, including Botticelli, Perugino, and Ghirlandaio. The ceiling at that time was painted as a starry night sky. In 1508, Julius II obdurately forced Michelangelo to undertake the decoration of the over 1,000 square meters of ceiling with a novel cycle of frescoes. Despite the fact that Michelangelo considered himself a sculptor at heart and not a painter, he began painting the work that would undermine his health and bring him world renown. He worked on scaffolding for four and a half years, often lying on his back, which gave him scoliosis, arthritis, cramps, and eye infections from the paint that dripped onto his face. He completed the work on 11 October 1512. Beginning with the Ancestors of Christ (on the lunettes near the windows), followed by the four great events from the Old Testament (in the corners of the ceiling), Michelangelo created a monumental composition within an illusionistic architectural framework. This complex yet unified work culminates in the figures of the Prophets and Sibyls, and the scenes from Genesis. Michelangelo, however, never lost sight of the overall compositional effect, which is, in fact, the most overwhelming aspect of the Sistine Chapel ceiling. The major binding elements are the strong, bright, radiant colors, which have been returned to their original splendor by recent restoration.

There is a series of alternate Prophets and Sibyls around the ceiling's edge, namely, those who foretold the coming of the Messiah. They are figures of gigantic proportions, but Michelangelo brilliantly varies their poses, appearance, and gestures. They hold books or writings, and are placed in regular spaces, not unlike a row of scholars at their desks.

The nine scenes in the center of the vault narrate episodes from Genesis, from the Creation to the Deluge. They are set within alternate large and small rectangular fields. Vigorous, athletic nudes pose at the corners of these smaller rectangles.

These *ignudi* may appear to be a "profane" intrusion into the vault's iconographic program. Actually, on the contrary, they convey a profound sense of the celebration of creation through the beauty of the human body: "the image and likeness" of God.

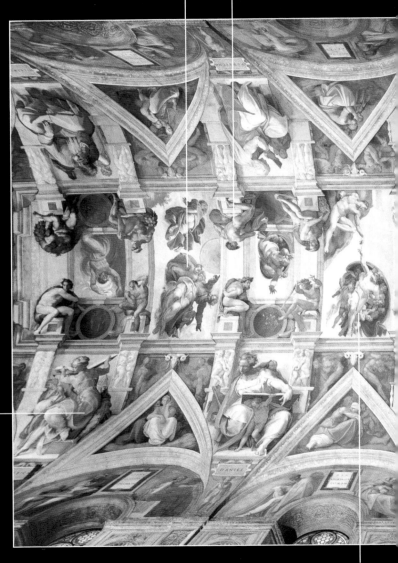

The irresistible will and power of God the Father dominates the vault. The Creator moves through the sections of the ceiling, His every gesture is an order, and every moment is an explosion of power. The climax of the work is reached in the scene of the Creation of Adam, in the cosmic spark that passes through the small almost immeasurable space between God's index finger and that of the first man.

The execution of a fresco cycle was usually a group enterprise. However, after testing two Florentine painters (Giuliano Bugiardini and Francesco Granacci) with the scene of the *Deluge*, Michelangelo chose to work on the scaffolding completely alone, subjecting himself to an exhausting trial of physical endurance.

Four biblical scenes are depicted in the corner compartments of the vault: David and Goliath, Judith and Holofernes, the punishment of Aman, and the bronze serpent. The unifying theme is God's Divine intervention in favor of the chosen people and His punishment of aggressors. The choice of subjects is also linked to events of Michelangelo's day, in particular the failure of Julius II's military campaigns. In addition to their negative political and military outcome, these exploits drained the Church's coffers. In fact, the scandalous sale of indulgences, so harshly condemned by Luther, was introduced in order to pay for the papal army. It is not an exaggeration to state that this probably sparked the Protestant schism.

If we could mentally "erase" the biblical scenes, Prophets, Sibyls, and nude figures, Michelangelo's innovative architectural design would appear in its full glory. The space is regularly divided by five pairs of ribs, each of which is supported by little *putti* standing on platforms with small, elegant gilded columns on either side.

Urbino, Florence, and Rome
1483-1520
Raphael

The Divine gift of Eternal Youth

Raphael was born in Urbino, in the shadow of the Palazzo Ducale of the Montefeltro family. He was the son of Giovanni Santi, a fine artist and intellectual. Raphael received a cosmopolitan, figurative training starting in his early youth, which focused on problems of the representation of space as well as the exploration of emotion, light, and physiognomy. He was endowed with an extraordinarily precocious talent, and completed his apprenticeship in Umbria and the Marches, during which time he also assisted Pietro Perugino. In 1504, at the age of twenty-one, he moved to Florence to be near Leonardo and Michelangelo. There he executed a number of works, including portraits and several small, but extraordinary versions of the *Madonna and Child*. In these paintings he combines a rich figurative culture with a simple, spontaneous, natural style. In 1508, he was summoned to Rome by Pope Julius II and began working on the memorable fresco cycle, in what have come to be known as the Raphael Rooms in the Vatican. Year after year, he modified his painting style with impressive speed. From the limpid scheme of the Stanza della Segnatura (1508-11), he moved on to the dramatic, insistent rhythm of the Stanza di Eliodoro (1511-14). Finally, in the design of the Stanza dell'Incendio di Borgo (1514) and the Loggias, he laid the foundations for Mannerism. From that point on, he continually produced altarpieces, portraits, and works inspired by classical antiquity. Raphael died at the premature age of 37, while working on the *Transfiguration*, however, during his brief lifetime he achieved a subtle balance between serene perfection, and delightful, spontaneous beauty. The most divine of all painters was entombed in the Pantheon in Rome.

Raphael
School of Athens, 1510
Stanza della Segnatura,
Vatican Museums, Rome

Plato and Aristotle lead the group of ancient philosophers. Plato (an idealized portrait of Leonardo) points to the sky,

while Aristotle stretches his hand toward the earth. Around them, the variety of gestures, poses, and expressions makes this one of the liveliest and most complex groups of figures in the history of art.

Raphael
Galatea, 1511
Villa Farnesina, Rome

Commissioned by the banker Agostino Chigi, this is a scene of crystalline purity, displaying Raphael's love for the art and literature of antiquity.

Between Julius and Leo

Raphael spent his years in Rome under the sway of two great popes (and he painted both of their portraits). Julius II was impatient, ambitious and hot-tempered and it was he who commissioned the frescoes that Raphael began while Michelangelo was working on the ceiling of the Sistine Chapel, and Bramante was laying the foundations of Saint Peter's Basilica. Leo X, who succeeded Julius II in 1513, however, was a completely different kind of pope. He was the son of Lorenzo the Magnificent and a lover of moderation and the arts. Raphael continued the work on his Stanze under him, and also coordinated the decoration of the Vatican Loggias and produced cartoons for the tapestries depicting the Acts of the Apostles.

Raphael
Marriage of the Virgin, 1504
Pinacoteca di Brera, Milan

This masterpiece, painted for a church in Città di Castello, marks the end of Raphael's early career. The scene, set in a square in front of a splendid temple, fades into a distant landscape of hills, fields and woods, culminating in the luminous opening of the doorway in the center of the temple. Within this harmonious blend of architecture and nature, the figures are arranged with great simplicity in a series of semicircles following the shape of the dome and the panel itself. A suspended grace, slightly veiled with poetic melancholy pervades the work. No expression is overdone and no single emotion prevails, not even in the group of disappointed suitors shown breaking their staffs. Raphael wrote the date and his signature, with "Urbinate" (of Urbino), in fine classical Roman letters.

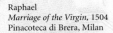

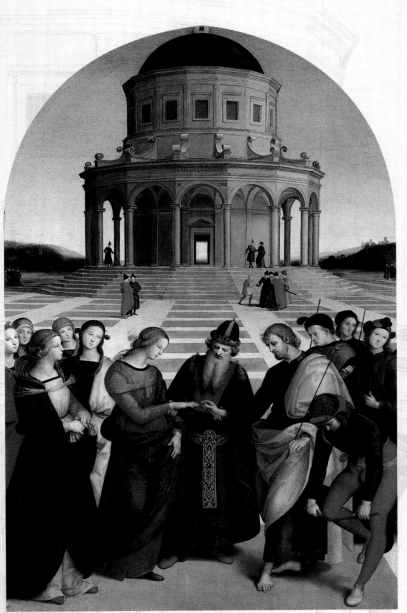

113

Raphael

1513

Madonna of the Chair

One of Raphael's first works was a fresco painted on the wall of a private house, showing the soft profile of a very young Mary clasping the Christ Child. This delicate fresco in Urbino marked the beginning of Raphael's poetic experimentation with the theme of the Madonna and Child. This subject renewed the tender, heart-rending memory of the lost embrace of his mother, who died in 1491 when he was only eight-and-a-half years old. From this moment on Raphael devoted himself to a series of variations on one of the most celebrated and common themes in painting, depicting natural, reassuring smiles of truly moving beauty. Raphael's Madonnas constitute a "gallery" of charms, minimal gestures, subtle smiles, and tenderness. These paintings are also evidence of the artist's capacity to vary positions, groups, landscapes, situations, and light with increasing complexity.

The *Madonna of the Chair*, now in the Galleria Palatina in Florence, represents the culmination of this process. Using the traditional parameters of art criticism, we might describe it as an extraordinary blend of Leonardo's *Mona Lisa* and Michelangelo's *Holy Family*. This painting, however, has a completely novel impact. For once, it is not "we" who look at the Madonna, it is "she" who looks at us, gently inviting us into a circle of emotions and smiles, caresses and gazes that is unparalleled in the entire history of art.

The Madonna looks directly at us. This unforgettable gaze, accentuated by the centripetal force suggested by the tondo, establishes an almost hypnotic rapport with the viewer.

The Madonna's clothes and hairstyle provide an unexpected touch of exoticism. The color combinations, though highly successful, are actually quite unconventional and totally foreign to the iconographic tradition, which calls for the Madonna to be dressed in blue and red.

This painting takes its name from the elegant armchair in which the Madonna is seated. Upon closer observation, it can be identified as a valuable piece of furniture made of gilded wood with a brocade backrest and elaborate crimson and gold tassels. In fact, it is no modest chair as the title suggests—a title that led to the erroneous interpretation of the group as "common people". This confusion also stems from the fact that Raphael was working in two different registers: the composition is elegant, with rich details, but it is rendered with a touching simplicity that suggests a domestic atmosphere. The gold knob on the arm of the chair repeats and accentuates the painting's circular composition.

The central part of the painting is occupied by the Christ Child, whose nose, elbow and left leg determine the vertical axis of the composition. However, as was his habit, Raphael has modified the geometric arrangement by creating an impression of immediacy and truth. The chubby Infant is moving his feet restlessly, perhaps because the Madonna is holding Him too tightly in her affectionate embrace.

The tondo format poses considerable compositional problems. This is partly the reason why it was used so often during the Tuscan Renaissance, because it demonstrated the painter's perfect control of perspective. The old anecdote that Raphael painted this masterpiece on the bottom of a cask in payment for a night spent at an inn is very far-fetched.

The young St. John the Baptist, identifiable by his little reed cross and his coarse hair shirt, is depicted with the same kind of beauty as the Madonna and Child and thus balances the painting.

The Christ Child's elbow occupies the exact geometric center of the tondo. Raphael's impressive intellectual control of the composition that appears so natural is confirmed by the bent elbow, which extends slightly beyond the circles of light, creating the illusion of a convex surface. This explains the circular movement given to the group of figures and also the way St. John the Baptist appears to be receding and slightly out of proportion.

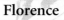

Florence

1510-1529

The First Stirrings of Mannerism

Doubts, Proposals, and Tensions at the Heart of the Renaissance

Faced with a rapidly changing world, artists of the time felt a pressing need to re-examine the forms and accepted rules of their art. In this climate, Mannerism emerged, gradually becoming the predominant trend over the course of the century. The link between the style of the great masters of the first decade of the sixteenth century and the emergence of the "modern manner" is Andrea del Sarto (1486-1530), described by Vasari as "the flawless painter" and whose school produced the most daring innovators. Andrea del Sarto is the intermediary between humanism's vanished certainties and the tensions of Mannerism. His figures effortlessly assume eloquent poses, while group compositions freely reinterpret the traditional triangular scheme of fifteenth-century *Sacre Conversazioni* (Holy Conversations). Jacopo Carucci, known as Pontormo (1494-1557), was one of Andrea del Sarto's pupils working on the frescoes in the Church of Santa Annunziata, and soon distinguished himself as a painter. Even in his earliest works his figures possess a particular expressive power distinct from the

"psychologically undefined" tradition of Botticelli and Perugino. Pontormo adopted novel figurative influences, including, for example, Dürer's prints. Stimulated by the Protestant Reformation, he proposed daring innovations in religious painting, adding greater tension, drama and restlessness than ever before. This phase was brought to a sudden halt in 1529, when the siege of Florence by Imperial troops cast Pontormo into deep depression. Andrea del Sarto's other great pupil was Rosso Fiorentino (Giovan Battista di Jacopo, 1495-1540), whose influence had extended internationally by the end of his career. This painter's style evolved rapidly and progressed from the Florentine influence of Pontormo and Andrea del Sarto to the Roman influence of Michelangelo, and finally, to that of Parmigianino. In 1523 Rosso settled in Rome where his painting acquired polished clarity. After the Sack of Rome (1527), Rosso plummeted into despair. In 1530, he moved to Paris, where he worked on Francis I's castle at Fontainebleau (1532-37), which played a pivotal role in the spread of Mannerism in Europe.

Andrea del Sarto
Last Supper, 1519
Convent of San Salvi, Florence

This is the last great *Last Supper* of the Florentine Renaissance. Though Leonardo's influence is evident, this is an extremely elegant composition that is expressive without being overly emotional.

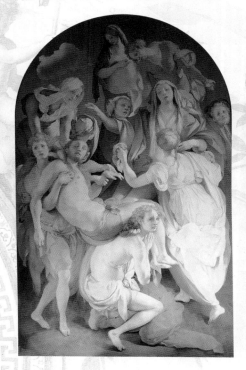

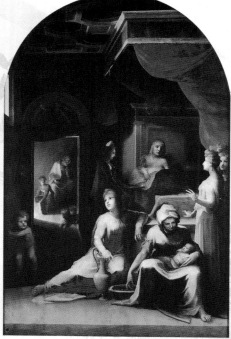

Domenico Beccafumi,
Birth of the Virgin, 1530
Pinacoteca Nazionale, Siena

The work of Beccafumi
(1486-1551), who was active
almost exclusively in Siena,
displays a series of different
influences over the course
of his artistic career. Consistent
throughout, however, is his
search for magic, visionary
effects, glancing light and
shifting color in sensational
compositions. In his later years,
his monumental altarpieces
were replaced by more
intimate works. However, his
chromatism remains unchanged
and unmistakable in its range
of transitions from areas
bathed in warm light to
those in shadow. This
particular painting
demonstrates the difference
between Beccafumi and his
Florentine contemporaries.
However, despite his overt
experimentation, Beccafumi did
not reject the models of the late
fifteenth century and, in fact,
was influenced by Perugino.

Jacopo Pontormo
Deposition, c. 1525
Church of Santa Felicita,
Florence

This work, the most innovative
and astonishing altarpiece
produced in Florence in the
early sixteenth century, is
a full-fledged "manifesto"
of the newly emerging
Mannerism. The regular
structure of humanist painting
becomes fragmented in an
ambiguous composition,
completely devoid of the stable
points of reference generally
provided through architecture
and perspective. The figures,
with their powerful poses
and features, seem to be
wandering aimlessly in an
undefined space, while a cold,
sharp light gives the colors
a livid, unreal quality.

Rosso Fiorentino
Deposition, 1521
Pinacoteca, Volterra

Rosso Fiorentino gave his
figures grotesque, and even
diabolical physiognomies
("cruel and desperate airs",
according to Vasari), which
left his patrons perplexed.
The Volterra altarpiece is
typical in this respect, and its
violently distorted figures,
the metallic gleam of its
brilliant colors, and its
disturbingly aggressive style
are characteristic of the genre.
A rather forced, unreal
structure of smooth ladders
and planks frames a group of
absolutely motionless figures
in melodramatic poses.
The livid sky is dense
and oppressive, like
an impenetrable layer
of varnished lead.

Rhineland and Alsace

c. 1480-1528

Mathis Grünewald

New Horizons in Painting and Consciousness

The name "Grünewald", coined in a seventeenth-century biography, is actually the result of a mistake. In documents from the period, the painter is called "meister Mathis". Grünewald began working in Mainz and Frankfurt in 1510. In 1512, he initiated the artistic undertaking that would define his entire career, the *Isenheim Altarpiece*. In 1516, he entered into the service of the archbishop of Mainz, Cardinal Albert of Brandenburg, who was also the patron of Dürer, Cranach, and Holbein. As a result, he had increasingly frequent contact with the other great German masters. In 1520, Grünewald was present with Dürer at the coronation of Charles V in Aachen. Though still in the employ of the archbishop of Mainz, Grünewald was increasingly drawn to the Reformation. He was forced to leave Mainz after being implicated in the repressive actions following the defeat of the peasants under Thomas Müntzer. He moved to Frankfurt, where he traded in paints and produced a soap with pharmaceutical properties. In 1527 he began working in Halle as a hydraulic engineer and died the following year. Grünewald's works remain a superior testimony of a dramatic historic period, tellingly interpreted by someone who was deeply involved in the traumatic transformation of religion and society.

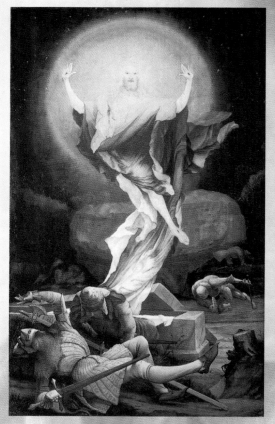

Mathis Grünewald
Resurrection, side panel of the
Isenheim Altarpiece, 1512-16
Musée Unterlinden, Colmar

With spectacular chromatic
inventiveness, Grünewald
creates a vortex rising from
the empty sepulcher, like
a column of ice that appears
to possess an inner fire as
it ascends, filling with color
and finally exploding in an
iridescent sphere surrounding
the face of Christ, who
is transfigured by its light.

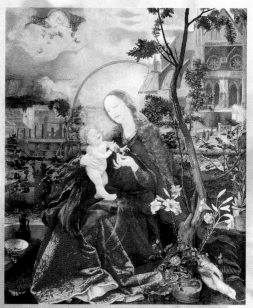

Mathis Grünewald
*Madonna and Child
in a Landscape*, c. 1520
Catholic parish church,
Stuppach

Mathis Grünewald
Isenheim Altarpiece,
central panel: *Crucifixion,
St. Sebastian and St. Anthony
Abate*; predella: *Deposition*,
1512-16
Musée Unterlinden, Colmar

The disproportionately large
Christ is riddled with wounds,
bruised and in agony. His body
is an almost repulsive ashen
color, his head tortured by
a thick crown of thorns, and
his hands and feet are lacerated
by nails. This is surely one of
the most terrifying images
in the entire history of art.
One can easily imagine the
powerful effect that it had
on Good Friday, the candles
of the Sepulcher burning
dimly before the bare altar
dominated by the agonizing
image of the desperate Christ,
full of blood and horror under
the dark sky. Then, on Easter
Sunday, as the creaking of
the hinges blended with
the triumphant ringing
of the bells, the aura of joy
and hope in the *Resurrection*
was displayed, recalling
the covenant between
God and Noah.

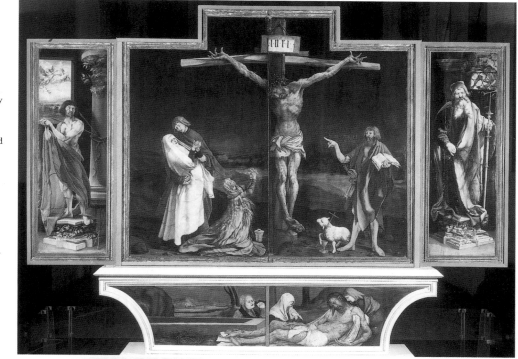

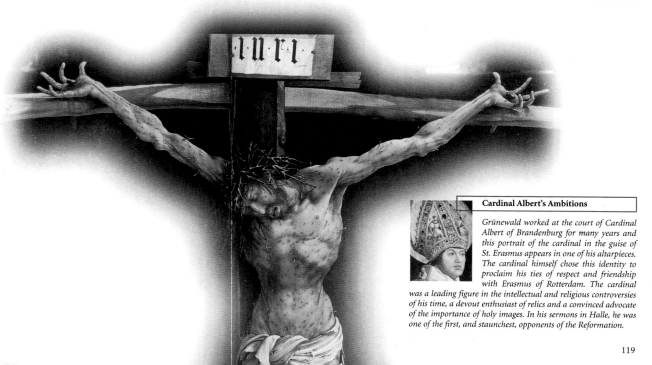

Cardinal Albert's Ambitions

*Grünewald worked at the court of Cardinal
Albert of Brandenburg for many years and
this portrait of the cardinal in the guise of
St. Erasmus appears in one of his altarpieces.
The cardinal himself chose this identity to
proclaim his ties of respect and friendship
with Erasmus of Rotterdam. The cardinal*
was a leading figure in the intellectual and religious controversies
of his time, a devout enthusiast of relics and a convinced advocate
of the importance of holy images. In his sermons in Halle, he was
one of the first, and staunchest, opponents of the Reformation.

Mathis Grünewald

1512-1516

Isenheim Altarpiece

Now in the Musée Unterlinden in Colmar, this group of panels was originally made for the high altar of the Monastery of the Order of St. Anthony in Isenheim and is recognized as one of the most dramatic masterpieces of the European Renaissance. At the same time, it proved to be one of the most scandalous works in German art, serving as a model for twentieth-century Expressionism, and during the Third Reich, it was condemned as "degenerate art".

Grünewald's panels were hinged to a winged structure, connected to a large central chest with a group of wooden statues, sculpted by Nicolas d'Hagenau. These wings were opened and closed at different times during the liturgical year, and especially during Advent, Lent and Easter. The iconographic program must have been dictated by Guido Guersi, a man with a profound mystic culture, who produced this successful choice of subjects. This side of the polyptych shows an unusual mystic allegory of the Immaculate Conception and the Nativity, accompanied by a radiant orchestra of colorful angels.

The Holy Spirit descends from the cloud, radiating down toward Mary. Throughout this polyptych, Grünewald produces an endless series of wonderful effects of light and color, including transparency, superimposition, iridescence, and striking contrasts of light with deeply shadowed areas, all of which create an astonishingly original work.

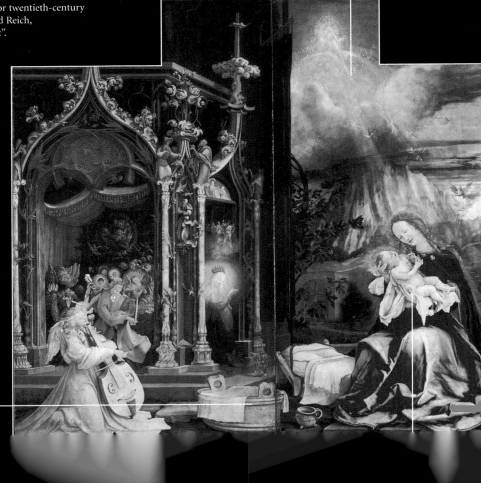

In his brilliant use of different figurative registers, Grünewald loved to include

The monastery of Isenheim in Alsace was the mother house of the Order of St. Anthony, a community that followed the Augustine rules but was largely aristocratic and involved in charitable works. The monks were considered the finest doctors of their time, especially in curing infectious diseases, like herpes, shingles (St. Anthony's Fire), syphilis, epilepsy and the plague. The polyptych is dedicated to St. Anthony Abate, portrayed encountering St. Paul the Hermit, in an imaginary Alpine landscape.

In stark contrast to the dignified calm of the meeting of the two hermits, a complementary panel shows the diabolical tumult of the Temptation of St. Anthony, who is being savagely tortured by a horde of horrendous devils. Far off, among the clouds, God watches without intervening. The torture of St. Anthony Abate is one of the most common themes in northern European art in the early sixteenth century. Masters of the caliber of Bosch, Schongauer and Lucas van Leyden all produced memorable representations.

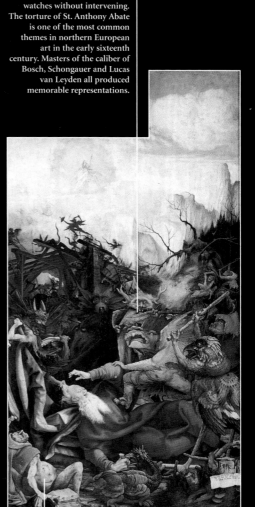

The coat of arms of the patron, Sicilian nobleman Guido Guersi, prior of the Order of St. Anthony of Isenheim can be seen in the bottom left corner. His death on 20 February 1516 coincided with the conclusion of the polyptych.

Grünewald displays a real passion for medicine in this polyptych. One of the devils, shown in a semi-reclining position and whose body is swollen and covered with open sores, resembles a patient in the ward for infectious diseases at the Isenheim hospital. He is not torturing the hermit, because he is overcome by fever and the pain of his pustular sores.

Bavaria and Saxony

1510-1531

On the Threshold of the Reformation

The Brief yet Splendid German Renaissance
The first thirty years of the sixteenth century were one of the most brilliant and exciting periods in the history of German art. Germany was blessed with a unique generation of great artists, who were in constant contact and often anxious to travel and exchange experiences in other cities and countries. Although Dürer dominated the country's cultural scene, a productive, intense, polycentric artistic debate developed around him. This was the brief yet splendid period of the Renaissance. During this time, power was distributed among commercial cities, like Nuremberg (home of Dürer), Regensburg (Altdorfer), and Augsburg (the Holbeins and Burgkmair), and the noble residences of the Prince Electors (like the Elector of Saxony, patron of Cranach), dukes (such as William of Bavaria, patron of Altdorfer), and powerful cardinals (like the archbishop of Mainz, Albert of Brandenburg, who invited Dürer and Grünewald to his court). Then the onset of the Reformation (that began in earnest with Martin Luther's "95 Theses" in 1517), however, soon came crashing down onto this situation in ferment. Luther was subsequently excommunicated on 2 July 1520 by Pope Leo X, son of Lorenzo the Magnificent. Luther repudiated all devotional images, which brought an end to religious painting and hence a drastic stasis in German art.

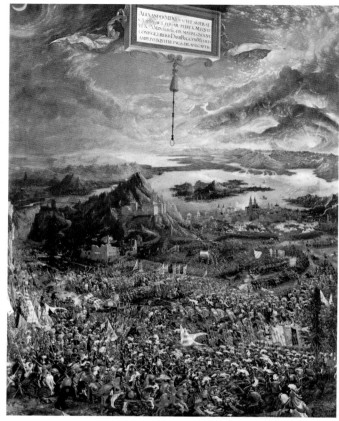

Albrecht Altdorfer
*The Battle of Alexander
(The Battle of Issus)*, 1529
Alte Pinakothek, Munich

This panel, commissioned by Duke William of Bavaria, depicts a bird's eye view of a very intriguing landscape (perhaps inspired by the Salzburg region). The sun is setting behind a range of mountains, with the crescent moon already visible in the sky, creating a fascinating atmosphere. Thanks to Altdorfer's fine rendering, the two formations, the troop movements, and their encampments can all be distinguished. In the foreground, Alexander in his golden armor gallops after the chariot driven by Darius.

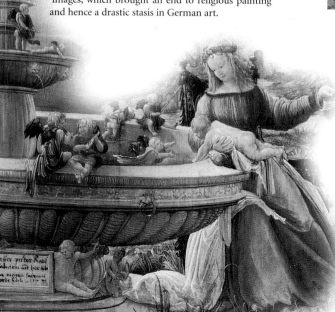

Albrecht Altdorfer
Rest on the Flight into Egypt,
1510
Gemäldegalerie, Berlin

Altdorfer (c. 1480-1538), who worked mainly in Regensburg, is the leading exponent of the so-called Danube School. This was a group of painters in southern Germany who were characterized by their impassioned depiction of nature and their smiling vision of reality. In this extremely original image, Altdorfer portrays the Virgin washing the Christ Child in a fountain full of little angels.

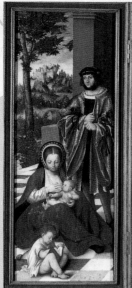
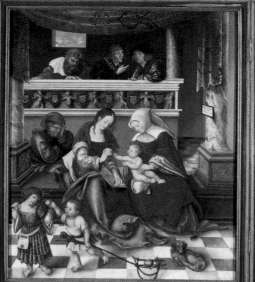
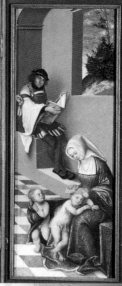

Lucas Cranach the Elder,
*Altar of the Holy Family
(Torgau Altar)*, 1509
Städelsches Kunstinstitut,
Frankfurt

In 1505, after beginning his
career in the Danube School,
Cranach (1472-1553) was
invited to Wittenberg by
the Prince Elector of Saxony,
Frederick the Wise. In fact,
he continued working for
the Saxon court until he died
almost fifty years later, which
made him one of the most
long-lived and active artists
of the German Renaissance.
His style evolved from the
legendary expressionism
of his early production to the
intellectual, decorative, and
almost abstract graphic quality
of his late works. He produced
everything from altarpieces
to classical nudes, portraits,
allegories, hunting scenes,
and Lutheran propaganda.
Being one of the first artists to
convert to the Reformation,
Cranach went to great lengths
to circulate his portraits
of Luther (like the one seen
here in the background),
his wife Catherine von Bora,
and Melanchthon.

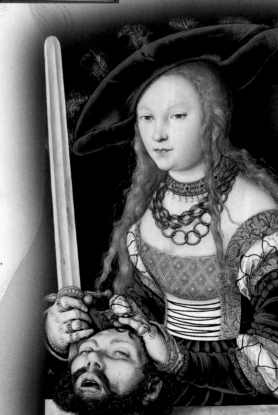

Lucas Cranach the Elder,
*Judith with the Head
of Holofernes*, c. 1530
Kunsthistorisches Museum,
Vienna

This unforgettable figure
is a masterly example of
Cranach's exceptional skill
in the rendering of texture
and the sumptuous
treatment of the color red.
The magnificently elegant
Judith can be considered
a German response to
early Italian Mannerism.

Basel and London

1497/98-1543

Hans Holbein the Younger

The Sure Eye and Firm Hand of the Witness

Holbein, born in Augsburg, was the son of Hans Holbein the Elder. He trained under his father in his hometown, but began his career in Basel and Lucerne in 1516. After a trip to Lombardy, Holbein's female figures and early portraits acquired a Leonardesque quality, and were already remarkable in their psychological penetration and meticulous rendering of the model's physical appearance. During the 1520s, Holbein painted mostly religious works, including the impressive *Dead Christ* in the Kunsthalle, Basel, though he also produced engravings and cartoons for stained glass windows. He went to England for the first time in 1526, where he was favored by the patronage of the scholar Sir Thomas More, and stayed there for two years. He then made another trip to Italy, during which he studied the portraits of Lorenzo Lotto. In 1531, the Reformation caused him to move to London, where he remained until he died of a plague in 1543. Holbein became the portrait painter for the court of Henry VIII and the intellectual aristocracy. His paintings display the symbols of his models' social status with admirable precision, but they also penetrate beneath the surface. Holbein's psychological acumen, his statuesque forms, and his realistic accuracy make him one of the most well-balanced and outstanding portraitists in the history of European art. He also established a relationship with King Henry VIII marked by a deep intellectual understanding.

Hans Holbein the Younger
Georg Gisze, a German Merchant in London, 1532
Gemäldegalerie, Berlin

Rare objects, scientific instruments, books, and vases of flowers appear frequently in Holbein's portraits. In fact, in some cases, they assume a dignity and compositional "weight" that almost competes with the model. In this respect, Holbein can be seen to anticipate the still life genre.

Hans Holbein the Younger
Portrait of Henry VIII, 1539-40
Galleria Nazionale d'Arte Antica, Rome

The king is wearing the sumptuous attire created for his fourth marriage to Anne of Cleves, celebrated on 6 January 1540.

Hans Holbein the Younger
The French Ambassadors, 1533
National Gallery, London

This masterpiece depicts
a somewhat ordinary event,
the visit of Georges de Selve
(the man in the sober but
stylish ecclesiastical dress
on the right) to his friend
Jean de Dinteville, French
ambassador in London,
on Easter Day 1533. The two
young men (respectively 25
and 29 years old) had rapidly
carved out successful
diplomatic careers. De Selve,
who had been appointed
bishop as a boy, was promoted
to the Holy See, and served as
ambassador to Venice, where
he was involved in attempts
to reconcile Protestants and
Catholics. De Dinteville,
Prince of Polisy, was one
of the most respected advisers
on international affairs to
the King of France. In this
splendid painting, however,
Holbein does not simply
depict the two men. In a subtle
play of symbolic references,
he portrays them leaning with
elegant nonchalance on a piece
of furniture bearing valuable
musical and scientific
instruments. The main theme,
however, is the ephemeral
nature of beauty, art, and
harmony. The apparently
incomprehensible object
in the foreground also refers
to this symbolic motif. It is,
in fact, a human skull,
optically distorted through
anamorphosis, a technique
also used by Leonardo.

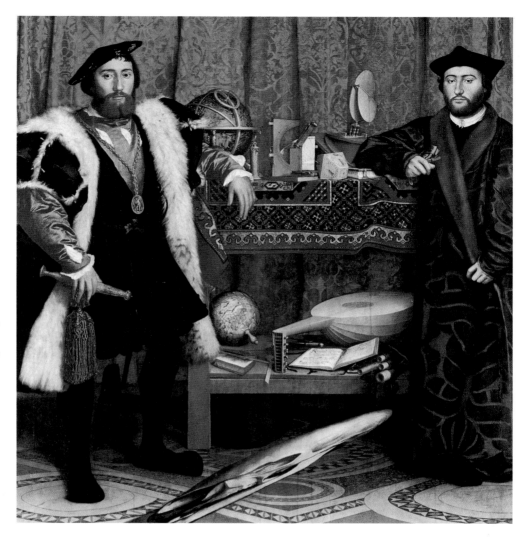

The Portrait of Erasmus of Rotterdam: Celebrated Painters in Crisis

Published in the year 1500, the Adagia *are a collection of proverbs, which combine folk culture, scholarly quotations, common sense, and their author Erasmus of Rotterdam's humanist detachment from the throes of passion. He was the most revered intellectual figure in northern Europe and in 1509, the* Elogium Insaniae (The Praise of Folly) *won him immense acclaim. A critical reference point of Christianity, Erasmus never adhered to the Reformation, though he spent years trying to encourage a peaceful and constructive dialogue. Many northern artists competed for the honor of painting Erasmus's portrait, but they found themselves faced with an unexpected difficulty: the illustrious humanist had a rather anonymous face, totally lacking in charisma, which Erasmus himself was ironically aware of. In Quentin Metsys's portrait, he resembles an accountant, where as Dürer said in the Greek inscription that accompanies his 1526 engraving, that he was unable to render his model's spirit. Only Holbein seems to have found the right key, and he painted three panel portraits of Erasmus. The most famous, in the Louvre, was executed in 1523, with Erasmus seen in profile, absorbed in writing a letter.*

Venice, Bergamo, and The Marches

c. 1480-1556

Lorenzo Lotto

**A Life and Artistic Career like a Thorn
in the Flesh of the Renaissance**

One spring day in 1549, on an unassuming street in Venice, the elderly Lorenzo Lotto auctioned off his few possessions and set out on the last stage of his endless odyssey. "I am a Venetian painter" Lotto told himself every time he was rejected from the artistic circles of the Serenissima. Though he was a pupil of Giovanni Bellini, the young Lotto preferred sharper draftsmanship, reminiscent of northern European painting, and principally worked in the provinces. The intelligent, vigorous face of Bernardo de' Rossi, bishop of Treviso, was the first of a gallery of portraits that display Lotto's penetrating psychological insight. He lived for a time in Treviso and then in the Marches until 1509, when he was summoned to Rome. Unfortunately, as happened repeatedly throughout his life, Lotto managed to arrive in the right place at the wrong time. Obliged to meet the high standards of the Vatican by Pope Julius II, before he was even thirty years old, Lotto found himself not up to the task and fled the Roman scene in despair. In 1513, he was invited to Bergamo, which became the center of a network of artists, including Leonardo, Correggio, Gaudenzio Ferrari, and Hans Holbein. In 1526, Lotto felt ready to face the challenge of Venice, but the public received him coldly and Titian's circle was very hostile. In over twenty years, Lotto only painted three works for Venetian churches, and even they were criticized as "a rather notable example of bad painting". In 1549, his "mind very troubled by many strange perturbations" (as he himself said), the painter left Venice for the Marches, which again filled the void left by his native city. He asked to be admitted to the Monastery of the Santa Casa at Loreto, where he painted his last, moving works with trembling hands. He died there in solitude, between 1556 and 1557. Ten years later, Vasari wrote, "He lived decently as a good Christian and so also did he die, giving up his soul to the Lord. The last years of his life were happy ones, with his soul at peace, and even more, according to what people say, he earned his place in Heaven."

Lorenzo Lotto
Annunciation, 1527
Pinacoteca, Recanati

Lorenzo Lotto
Stories of St. Barbara, 1524
Suardi Chapel, Trescore
Balneario (Bergamo)

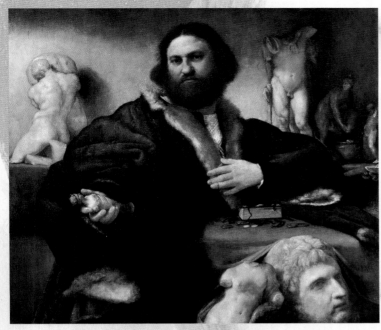

Lorenzo Lotto
Portrait of Andrea Odoni,
c. 1527
Royal Collection,
Hampton Court

Lorenzo Lotto's career in
Venice was rather ill-fated.
The only exception was the
support he received from
the art dealer Andrea Odoni,
a man of very refined tastes,
whose collection ranged from
archaeological pieces to the
most modern paintings of
his time. This memorable
portrait reveals the image
and psychology of a man
surrounded by fragments of
ancient beauty, lit by a warm,
soft light that seems to breathe
life into the classical marbles.
These broken statues and
crumbling bas-reliefs possess
a touch of wistfulness, as if
Lotto could not help but be
aware of beauty's transitory
nature.

Lorenzo Lotto
Portrait of a Young Man, 1505
Kunsthistorisches Museum,
Vienna

This portrait was painted in
Treviso at the beginning of
Lotto's career. Here, he already
displays his talent as one of
the most fascinating, original
portrait painters in sixteenth-
century Europe. Lotto's
treatment of surfaces and light
as well as his handling of poses
and expressions are never banal.
Each individual reveals a full,
intriguing, and sometimes even
tormented, inner life. Lotto
faithfully portrayed the features
of his models, but his main
concern was what Leonardo
called "the emotions of the
soul". In this painting, the sharp
contrast between the young
man's austere, black apparel and
the delicate silvery brocade in
the background is accompanied
by fine details, such as
the small lantern burning
in the top right-hand corner.

Venice

c. 1490-1576

Titian

"He who wishes to be a painter must know three colors: white, red, and black, and be the master of them"

Throughout his long life, Titian (Tiziano Vecellio) dominated painting thanks to his inventiveness and brilliant use of color. A pupil of Giovanni Bellini, he also worked with Giorgione, but by around 1515 he was the undisputed master of the Venetian School, praised by intellectuals, admired by collectors, and increasingly sought after by the noble courts. During the 1520s his fame began to spread, and in addition to major commissions in Venice, he painted many works for the Gonzaga and Este courts, establishing himself as one of the most acclaimed portrait painters in Europe, to the extent that Pietro Aretino became, to all intents and purposes, his "agent". In 1533 Emperor Charles V appointed Titian *pintor primero*, marking the beginning of a relationship with the Spanish court that was to last over thirty years. It was not until the 1540s that, with the advent of Mannerism, Titian visited Rome, where he met Michelangelo. On his return to Venice, apart from two visits to the Imperial Court at Augsburg with Charles V, he began to become increasingly isolated from the mainstream. The masterpieces of his late period are characterized by extremely free handling and the use of patches of color to render form. Titian went beyond the social and cultural limits of Renaissance art, and in many ways, can be seen as the founder of modern painting. His interpretations of mythological and classical scenes are not only the proof of an unrivaled talent as a painter but also a profound and poetic exploration of human destiny.

Titian
Urbino Venus, 1538
Galleria degli Uffizi, Florence

Approximately twenty years after the Dresden *Venus*, Titian abandoned the contemplative style of Giorgione for a more direct immediacy.

Titian
Charles V at the Battle of Mühlberg, 1548
Prado, Madrid

An illustrious prototype of the equestrian portrait, it was often imitated throughout the Baroque period. The fiery sunset that filters through the trees in the background is particularly impressive.

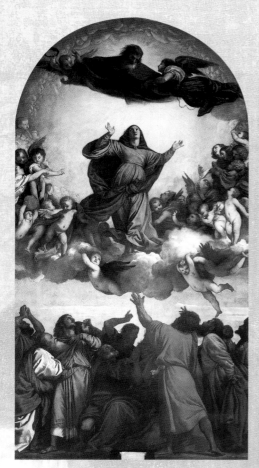

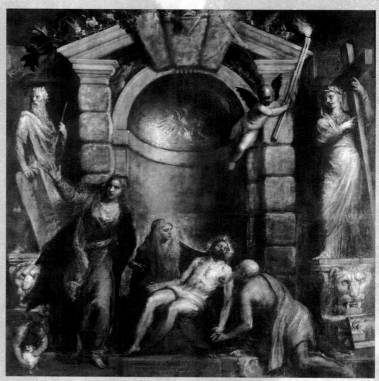

Titian
Pietà, 1576
Gallerie dell'Accademia,
Venice

Titian's final, harrowing work, left unfinished, was intended for his tomb (the figure of Nicodemus on the right is a self-portrait) in the Frari Church, for which he had painted the Assumption fifty years earlier. Now almost ninety years old, Titian took his sublime late style to the extreme, rendering form as dense patches of color.

Titian
Assumption, 1516-18
Church of Santa Maria
Gloriosa dei Frari, Venice

This work was presented on 18 May 1518, a memorable date for Venetian painting. Those who first saw it were astonished and disconcerted. Father Germano Casale, who had commissioned it, wondered whether the rough fishermen had sufficient "decorum" to represent the Disciples. The Austrian ambassador offered to buy it, while, as the author Ludovico Dolce wrote in 1557,

"the clumsy painters and the foolish populace, who till then had seen nothing but the dead, cold things of the Bellinis and the Vivarinis, without relief or movement, spoke ill of the said panel. But when their envy cooled, the people began to be astonished by the new manner that Titian had found in Venice: in this panel there is the greatness and awesomeness of Michelangelo, the pleasantness and grace of Raphael, and the true colors of nature."

Titian

1514

Sacred and Profane Love

Held by the Galleria Borghese in Rome, and still known
by its conventional eighteenth-century title, this
painting is now rightly interpreted as a magnificent
and auspicious wedding gift from the Venetian
nobleman Nicolò Aurelio to his bride, Laura Bagarotto.
The large-scale canvas was painted at a dramatic time,
since a serious fire had recently devastated the Rialto
market, the hub of Venetian trade. This tragic event,
at a moment when relations with the Spanish court
were tense and Venice was at war with the Turks in
Dalmatia and Friuli, symbolized the end of the
mercantile age and the need for profound changes
in commercial life, public building, and even everyday
habits. That same year Giovanni Bellini's *Feast of
the Gods*, representing a large group of figures in a
pastoral setting, for the Duke of Ferrara Alfonso d'Este,
sparked a new interest in mythological subjects in
Venetian art. Titian's response, who aspired to succeed
the aging Bellini as Painter to the Republic, was the
so-called *Sacred and Profane Love*. The work contains
a number of bold innovations, including the presence
of a female nude and its size, which was very unusual
for an allegorical theme. Unlike Giorgione's delicate
tones, the colors are more densely applied and full of
expressive power. The Senate of the Venetian Republic,
generally in favor of more cautious reforms in the field
of art, must have been struck by the innovative force
of the work, for in 1514 Titian received his first
commission for the Doge's Palace, and success
was now not far away.

The rabbits are an explicit
appeal to fertility, and also
a delightful touch of realism
in a backdrop consisting of
a busy, animated landscape.

The fully-clothed young woman
is a clear reference to marriage,
symbolized by the white dress,
gloves, belt, myrtle garland,
loose hair, and roses. However,
the figure is not so much
a portrait of Laura Bagarotto
in her bridal gown
as an allegory of matrimony,
of the union that promises
fertility and love.

Cupid stirs the water between the two kinds of love. Although the subject is allegorical, Titian goes far beyond the straightforward transcription of a complex literary theme or the illustration of Neoplatonic philosophy. This painting is ultimately an exaltation of beauty and love. As one sixteenth-century writer put it, "Titian's brushes always generated expressions of life."

Unlike the bucolic serenity of Giorgione's landscapes, Titian creates a backdrop full of bustling action: clouds, breezes, figures, trees, and lakes, all participate in the ceaseless rhythm of the universe.

The young women are leaning on a classical sarcophagus used as a bath. Rather unexpectedly, in the middle of a painting exalting love there is an allusion to death, the marble relief of a violent scene, probably a reference to the unjust hanging of Laura's father, Bertuccio Bagarotto, in 1509. The fact that the sarcophagus contains clear water suggests that life can be reborn even from death. The Aurelio coat-of-arms appears on the sarcophagus, while the basin alludes to that of the Bagarotto family.

The two beautiful women, so alike that they could be twins, are dressed in contrasting ways: one is wearing sumptuous clothes, while the other is virtually nude. Critical interpretations vary, but they all have one point in common. According to traditional classical and medieval iconography, the simultaneous presence of two women, one nude and the other clothed, does not signify an opposition (as the erroneous title would suggest), but a complementary balance. The clothed woman alludes to marital love, while the nude woman raises love to an eternal, celestial plane symbolized by the lamp.

Parma

1489-1534 1503-1540

Correggio and Parmigianino

A Confrontation of Beauty and Elegance

In the 1520s and 1530s the peaceful city of Parma in the Po valley became an important center of art. Two local artists, Antonio Allegri who took the name of his native town Correggio, and Francesco Mazzola, nicknamed Parmigianino, established a dialogue between the generous, radiant image of beauty and intellectual elegance. Free from the need to compete with other masters, Correggio developed a fluid, luminous, immediate and highly personal style. In the softness of the expressions and the astonishing boldness of his use of perspective, he was a fundamental precursor of the Baroque. Tense, polished and intellectual, Parmigianino developed a stylistic counterpoint to his master Correggio. Blessed with precocious talent, his work was a sophisticated version of the emerging Mannerist style.

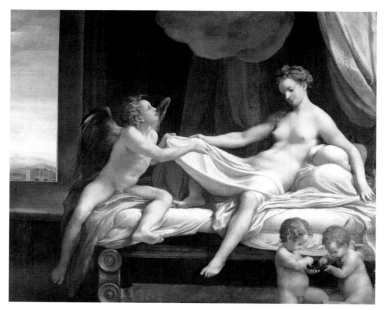

Correggio
Danaë, c. 1531
Galleria Borghese, Rome
right:
Jupiter and Io, c. 1531
Kunsthistorisches Museum, Vienna

These two paintings are part of the "Loves of Jupiter" series, which also includes the Vienna *Ganymede* and the Berlin *Leda*. Particularly impressive is the scene in which Jupiter, transformed into a cloud, embraces and kisses the nymph Io, causing her to swoon. The soft divine cloud seems to envelop the nymph's gleaming body, clasping her in a gentle, irresistible embrace.

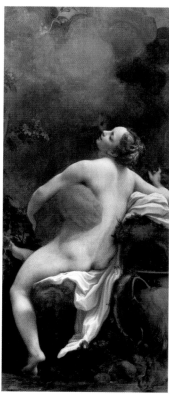

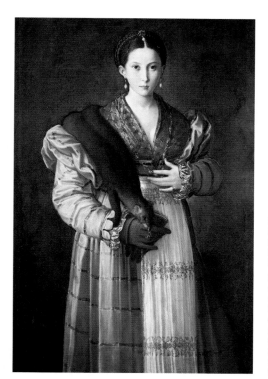

Parmigianino
Portrait of a Young Woman known as "Anthea", 1524-27
Museo di Capodimonte, Naples

Parmigianino's extremely refined handling creates an effect of almost magic hyper-realism, making him an excellent and fascinating portrait painter. The faces of his models often express a sense of doubt and tension concealed behind their gelid stillness.

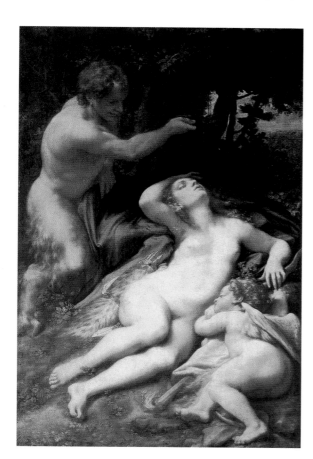

Correggio
Antiope, c. 1528
Louvre, Paris

The grace, smile, and voluptuous sense of beauty in Correggio's handling always assure that scenes of this kind remain far removed from any kind of coarse eroticism.

Correggio
Madonna of St. Jerome, 1523
Galleria Nazionale, Parma

Correggio gave a novel touch to the composition and feeling of the altarpiece without adopting the norms of Mannerism. Inspired by the soft style of Leonardo (in the Madonna's features and the light that blurs the outlines), he creates a sense of tender abandonment and confident faith. For the execution of this work he received a payment that was very typical in the Emilia region: 44 imperial liras, two cartloads of firewood, a few measures of wheat, and a pig.

Self-Portrait in a Convex Mirror

When he was just twenty years old, Parmigianino painted this remarkable self-portrait (now in Vienna), a virtuoso tour-de-force that recreates the distortion of the face, hands, and room as reflected in a convex mirror.

He took the painting to Rome as a proof of his talent. In the artistic climate of the court of Pope Clement VII, he painted fine, confident portraits and religious subjects that began to manifest the influence of Mannerist experimentation.

After the Sack of Rome in 1527, he spent a few years in Bologna before returning to Parma in 1531 where he resumed his former rivalry with Correggio. In his home city he painted the frescoes in the Church of the Madonna della Steccata that were marked by a highly refined and stylized classicism. During this period his figures became unnaturally elongated, assuming sinuous poses. In the final years of his short life he withdrew into himself, and became obsessed with his experiments in alchemy.

Northern Italy

1510-1540

The Great Fresco Cycles

The Triumph of the Fresco in Renaissance and Mannerist Art

In the sixteenth century Italian painting confirmed its traditional preference for the fresco. Writers and critics of the period, like Giorgio Vasari, claimed that the ultimate test of a painter's talent was his ability to tackle large-scale mural paintings using the fresco technique, which demanded both grandiose imaginative schemes and sureness of hand. Venice was naturally an exception to this rule: due to the damp climate, frescoes are very rare and generally replaced by cycles of narrative canvases. Even outside the main city centers, early sixteenth-century frescoes reveal the various trends. Before the Sack of Rome in 1527, masters like Giulio Romano and Parmigianino took the elegant, intellectual elements of the classically-inspired, inventive Mannerist style to the north. Other artists in small and medium-sized towns, like Correggio, Gaudenzio Ferrari, Lorenzo Lotto, and Pordenone, developed a style of great popular appeal.

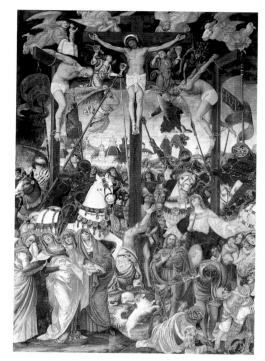

Gaudenzio Ferrari
Crucifixion, 1513
Church of Santa Maria delle Grazie, Varallo Sesia (Vercelli)

The central scene on the dividing wall in the church, located at the beginning of the path to the sanctuary of the Sacro Monte in Varallo is almost a prelude to the powerful, immediate and lofty scenes in the Sacro Monte chapels. The *Crucifixion* is an excellent example of the combination of almost popular elements (the helmets, the armor, and the harnesses are in relief) and refined figurative allusions to painters like Perugino and Leonardo. Gaudenzio's (c. 1475-1546) narrative and dramatic power unifies the painting and involves the figures in a single, overwhelming wave of emotion. He sets the Gospel episode in his own time. At the foot of the Cross, on the right, are two figures from Varallo, accompanied by a playful little dog and women carrying babies. These are tender scenes from everyday life, forming an effective contrast with the caricatured features of the soldiers playing dice for Christ's clothes.

Parmigianino
Wise Virgins, Allegorical Figures and Plants, decoration on the underside of the arch of the presbytery,
1535-39
Church of the Madonna della Steccata, Parma

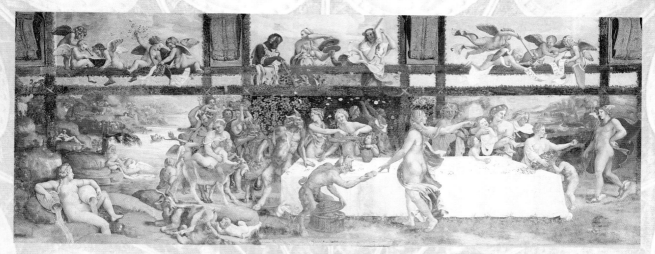

Giulio Romano
The Country Banquet,
1526-28
Sala di Amore e Psiche,
Palazzo Te, Mantua

In the construction and
decoration of the suburban
residence of the Gonzaga
family, the supreme example
of Mannerism in northern
Italy, the architect and
painter Giulio Romano
(c. 1499-1546), a pupil of
Raphael, gave free rein to his
inexhaustible imagination,
making each room an
astonishing work of art.

Correggio
View of the Room of the Abbess
(background)
and detail of the ceiling with
Putto with Hunting Trophy,
1519
Monastero di San Paolo, Parma

This extraordinary room,
a perfect example of
Renaissance taste, remained
secret for centuries. It was not
thought proper, in fact, for
an abbess to hold literary
conversations in an intensely
profane salon, dominated by
the figure of Diana (over the
fireplace) and transformed
into a bower by the illusionist
frescoes on the ceiling.
The monochromes on the
upper portions of the walls
are magnificent yet subtly
disturbing.

Antwerp, Utrecht and Leyden
1510-1560
Italian Art and the Low Countries

Antwerp, a New Capital of European Art

The first few decades of the sixteenth century witnessed a major turning point in Flemish and Dutch art. The decline of the last generation of great masters in the fifteenth-century tradition made way for a new current, based on a reworking of the novel trends in Italian art, experienced first-hand in journeys to the south and combined with the decorative exuberance and descriptive detail typical of Flemish art. The star of Antwerp shone ever more brightly, as the port at the mouth of the Scheldt became the main commercial and artistic center along the North Sea coast.

Painters like Bosch, Metsys, Mabuse, and Scorel traveled to Venice and Rome to study Italian art, acquiring the monumental sense of Italian perspective and also meeting other leading European artists. The northern European artists did not go to Italy simply to learn, however, but also to make their own decisive contribution to the evolution of the painting of the High Renaissance and to the birth of the "modern manner". The Antwerp "Italianate painters" formed a clearly recognizable movement, in close contact with the art centers of the northern provinces, where Dürer's influence was strongest.

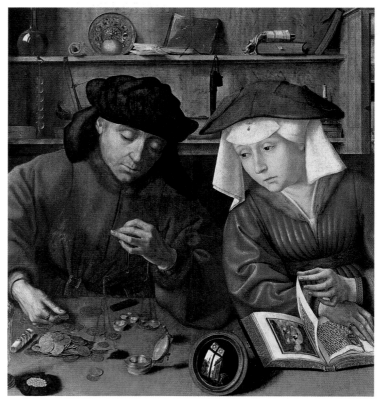

Quentin Metsys
Banker and his Wife, 1514
Louvre, Paris

Unlike fifteenth-century models, Metsys (1466-1530) no longer uses a religious theme as a filter, producing a remarkably lively and realistic picture.

Maarten van Heemskerck
*Self-portrait in Rome
with the Colosseum*, 1553
Fitzwilliam Museum,
Cambridge

This painting is actually a double portrait: the artist portrays himself middle-aged, dressed soberly in black, and recalling his stay in Rome twenty years earlier, also shows himself as a young artist intent on drawing the immense ruin of the Colosseum.

Jan van Scorel
Mary Magdalen, c. 1528
Rijksmuseum, Amsterdam

The periods Scorel spent in
Nuremberg (where he met
Dürer), Venice, and above all
Rome were fundamental to his
career. In the Eternal City,
during the pontificate of his
fellow countryman Hadrian VI
of Utrecht, Scorel was strongly
influenced by Raphael and
Michelangelo, and was
appointed keeper of the
Vatican antiquities. On his
return to Holland he made
fruitful use of his many
cultural experiences and
developed a new kind of
painting that bore little trace
of the Flemish tradition,
now replaced by the dominant
influence of the emerging
Mannerist style.

Lucas van Leyden
Triptych of the Last Judgment,
central panel, 1526
Stedelijk Museum, Leyden

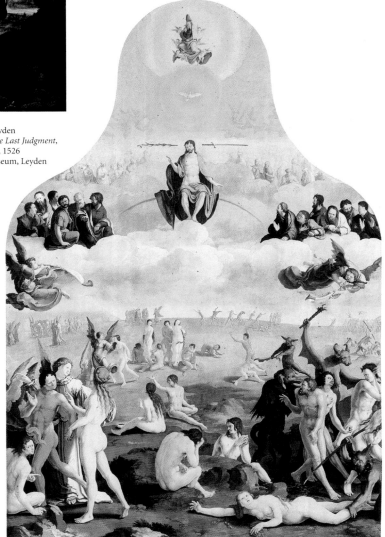

Mabuse's Innovations

*Jan Gossaert, one of the most original and
influential "Italianate painters" of the
Flemish Renaissance, took the name Mabuse
from the ancient name of his native town.
First documented in the Antwerp Painters'
Guild in 1503, he traveled to Rome with
Duke Philip of Burgundy in 1508.*

*On his return, his works began to display an
original style that retained some of the meticulous attention to
detail typical of fifteenth-century Flemish painting, but also bor-
rowed from the Italian "modern manner", particularly in their
use of light, perspective, architectural settings, monumental fig-
ures, and the relationship between figures and their surroundings.
His early work shows an over-abundance of decorative elements,
an ornamental richness in which extreme Gothic seems to com-
bine with aspects of Mannerism.*

*His paintings of classical or mythological subjects, such as
Neptune and Amphitrite (now in Berlin) and the later Danaë
(1527, now in Munich), are more "modern", but still character-
ized by descriptive detail.*

*In 1527 he made a memorable journey with Lucas van Leyden to
the main cities of Flanders, Brabant and Zeeland, traveling by
boat along the canals and navigable rivers.*

Antwerp and Brussels
1525/30-1569
Pieter Bruegel the Elder

The Eternal Merry-Go-Round of Human Life

Pieter Bruegel the Elder lived and worked in important cultural centers during an extremely eventful period of history. Despite this, relatively little is known about his life, certainly not enough to reconstruct a complete biography. His habit of signing and dating his works, however, has permitted a reliable chronology of his paintings, drawings, and prints. A member of the Antwerp Painters' Guild, his work shows few signs of the local classically inspired school or the influence of the Italian Renaissance. His earliest known works are landscape drawings that can be dated to 1552. Shortly after this, between 1552 and 1556, he traveled to Italy and brought back vivid memories of crossing the Alps. After devoting himself for a time to engraving, he chose to work mainly as a painter and moved to Brussels in 1563. Here his two sons, both painters, were born, Pieter the Younger and Jan, born in 1568, who specialized in finely executed still lifes. In 1565 he produced the great cycle of *The Seasons*, his most complex masterpiece. In Brussels his work took on a new monumental compactness, abandoning the abundant detail typical of his early career, but his premature death on 5 September 1569 interrupted this promising development.

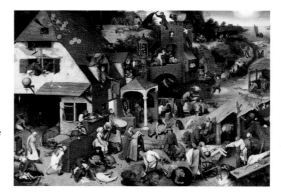

Pieter Bruegel the Elder
Flemish Proverbs, 1559
Gemäldegalerie, Berlin

Bruegel's culture, like that of his "spiritual master" Bosch, was largely based on folklore, proverbs, and sayings. In this remarkable painting he manages to illustrate over one hundred different proverbs, which are primarily devoted to the theme of human gullibility and inspired by rural life, within a single landscape.

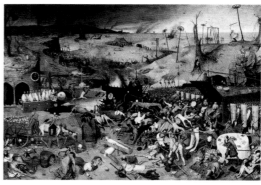

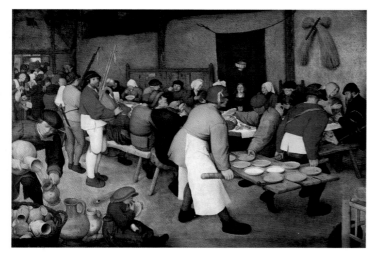

Pieter Bruegel the Elder
Peasant Wedding, c. 1568
Kunsthistorisches Museum, Vienna

The smiling bride, plump-cheeked and awkward, sits at the center of the table in front of a green drape and the groom may be the young man gobbling his food. This banquet is a rustic version of the "Land of Plenty"; the guests are eager to lay their hands on the platefuls of food brought in by the two men in aprons.

Above and opposite:
Pieter Bruegel the Elder
Triumph of Death, c. 1562
Prado, Madrid

Although rooted in folk culture, this subject seems somewhat outdated in the second half of the sixteenth century, but Bruegel returns to it to demonstrate its continuing relevance. The scene is dominated by the macabre cart drawn by Death that carries everyone away, young and old, kings and cardinals, clowns and maidens. The landscape is filled with details of torture and devastation.

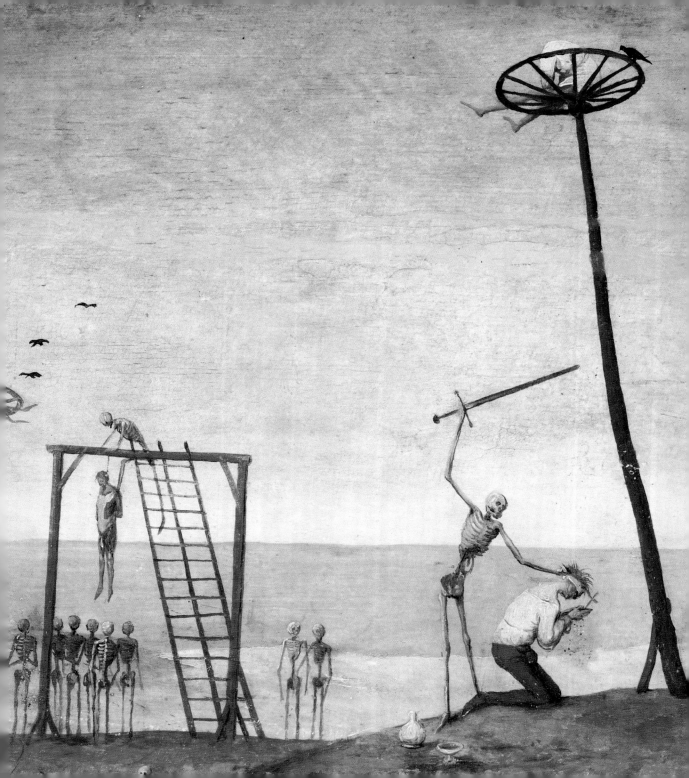

Pieter Bruegel the Elder

1565

The Seasons

The variety of weather conditions and light effects, rendered with surprising sensitivity and naturalness, is perhaps the most spectacular feature of this cycle of paintings. The contrast between the gleaming snow in the scene reproduced below and the *Gloomy Day* is evidence of Bruegel's great versatility. He is an extremely original artist who is sometimes erroneously considered almost a sixteenth-century naïf painter.

The cycle of *The Seasons* constitutes the major organic nucleus of Bruegel's mature work. It became part of Emperor Rudolf II's Prague collections and reflected the Hapsburgs' rather anti-conformist tastes. Dispersed after the Sack of Prague during the Thirty Years' War, it can now be only partially reconstructed, and critical conjecture and theories regarding the overall composition abound. It probably consisted of six panels, perhaps each devoted to two months of the same season, however, only five of the panels still survive: the *Harvesters* (Metropolitan Museum of Art, New York), *Hay Harvest* (recently returned to a private collection in the Czech Republic, but previously on exhibit in the National Gallery in Prague), and *Gloomy Day, Hunters in the Snow*, and the *Return of the Herd* (all in the Kunsthistorisches Museum in Vienna). The panels are all more or less the same size, approximately 160 × 120 cm, with slight variations due to their individual history and conservation.

The *Hunters in the Snow* panel, representing the coldest months of the year, is the most celebrated in the cycle. Beginning from a vantage point that is higher than the foreground, Bruegel arranges this composition around the contrast between the white of the snow and the black outlines of the figures, trees and buildings. This simple scheme accentuates his mastery of the use of light, especially in the landscape in the background. Few other works of art manage to convey so skillfully the atmosphere of icy air and impending snow that surrounds the mountain peaks. The bare skeletal trees form a black screen against the dense backdrop of the sky. Below, deep in the valley, a tiny village nestles at the foot of the towering mountains. The children's games on the frozen pond add a delightful touch of jollity

In the *Return of the Herd* Bruegel creates an unusual circular rhythm that links the foreground to the background. This same scheme is also used in other paintings. In the world of peasants and nature, the movement of the figures and the clouds passing in the partly overcast sky become a metaphor for the cyclical rhythm of time and the seasons.

Hay Harvest possesses the rhythm and gaiety of a country festival. As in *Hunters in the Snow*, the downward-looking viewpoint displays Bruegel's mastery of landscape painting. Born and bred in the flat countryside of Flanders, the Alps made a strong impact on him when he saw them for the first time on his journey to Italy. The memory of the jagged mountain tops and rugged peaks emerges in images that combine reality and fantasy in a highly evocative manner.

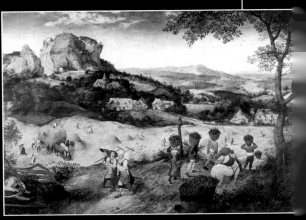

The *Harvesters* is bathed in the haze of midsummer. The sultry air and weariness of the peasants, contrasts with the golden wheat, while our gaze is drawn further and further into sweeping panoramic view. Compared to the other scenes in the cycle, this panel appears to be more inspired by a human and social condition, which is also reflected in the weather and the landscape.

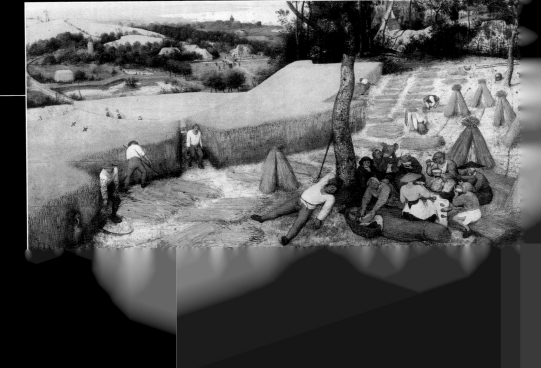

Venice

1519-1594

Jacopo Tintoretto

"Titian's color, Michelangelo's drawing"

Son of a *tintore* (clothes-dyer), Jacopo Robusti, nicknamed Tintoretto, was the most exuberant and prolific Venetian painter of the second half of the sixteenth century. From the very beginning of his long career, his work is characterized by its muscular figures, dramatic gestures, and bold use of perspective in the Mannerist style, while maintaining the color and light typical of the Venetian School. He never shied away from large-scale undertakings and summed up his "plan of attack" on a sign pinned to the wall of his studio: "Titian's color, Michelangelo's drawing". This eclectic and ambitious aim met with the approval of the Venetian public, as is proven by his dozens of works in Venetian churches, the imposing commissions in the Scuola Grande di San Marco and the Scuola Grande di San Rocco, and especially by his decoration of the Doge's Palace after the devastating fire in 1577. The role played by Tintoretto in the late Venetian Renaissance was decisive and controversial. His unique style and innovative solutions, when imitated by less talented artists, became monotonous and restrictive. Although it was not Tintoretto's fault that the Venetian School suddenly lost impetus after his death, he himself seemed to foresee its decline. His late works, after the death of Titian and Veronese, are shrouded in the mystery and magic of supernatural worlds.

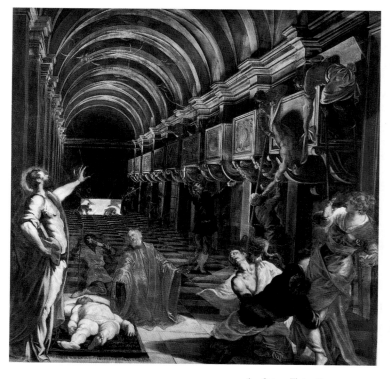

Jacopo Tintoretto
Finding of the Body of St. Mark, 1562-66
Pinacoteca di Brera, Milan

The "secret" of Tintoretto's unusual perspectives and clever arrangement of groups of figures was his use of miniature wooden models that he constructed (with puppets made of wax and cloth, illuminated in bizarre ways) to simulate the painting. To the left of the body of St. Mark looms his ghost.

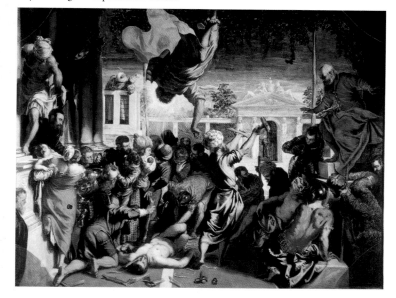

Jacopo Tintoretto
St. Mark Rescuing the Slave, 1548
Gallerie dell'Accademia, Venice

This painting, destined for the Scuola Grande di San Marco, made his reputation as a leading exponent of the Venetian school.

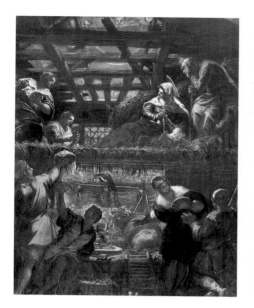

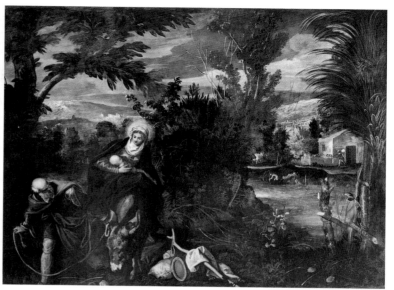

Jacopo Tintoretto
Adoration of the Shepherds,
1577-78
Sala Superiore, Scuola di
San Rocco, Venice

Jacopo Tintoretto
Flight into Egypt, 1583-88
Sala Terrena, Scuola di
San Rocco, Venice

Jacopo Tintoretto
Sala Superiore, Scuola di
San Rocco, Venice

In 1564 Tintoretto won the
competition for the decoration
of the Scuola Grande di San
Rocco. He thus began an
undertaking that was to absorb

most of his creative energy for
over twenty years. The dozens
of canvases in the three halls
of the Scuola display the artist's
transition from the descriptive
realism of his early paintings
to the visionary power
of his later works.

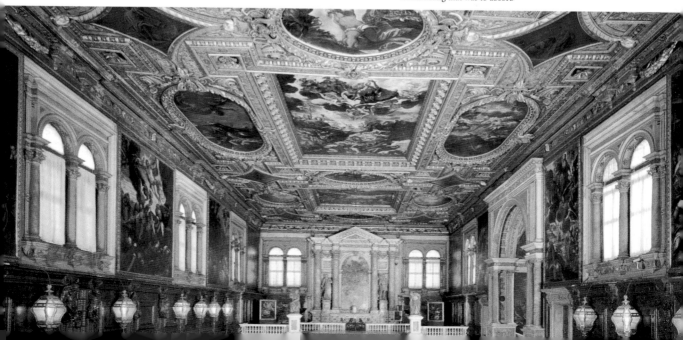

The Veneto

1528-1588

Paolo Veronese

"We painters take the same license that poets and madmen take"

This expression of creative freedom appears in the records of the tribunal of the Inquisition, when Veronese was summoned to account for the presence of over fifty figures in his *Last Supper*. He was able to turn any subject into a festive allegory, and literary themes, abstruse allegories, altarpieces, and, his favorite, Last Suppers, all seem to be a pretext for the pure expression of the joy of life and art. Having completed his training in Verona, his native city, he began collaborating on group projects. By 1553 he was working in the Sala del Consiglio dei Dieci in the Doge's Palace in Venice, and well on his way to becoming one of the main "public" painters in the city. His clear, magnificent style, with its classical symmetry and bright colors, won him many major commissions: three tondi for the ceiling of the Libreria Marciana (1556), the decoration of the Church of San Sebastiano (carried out in stages between 1556 and 1567), and the crowded *Supper at Emmaus* now in the Louvre (1562). Veronese also worked with the great architect Andrea Palladio in Villa Barbaro at Maser, decorating the main rooms with frescoes extolling beauty, youth, and abundant harvests. During the whole of the 1560s he produced a large series of brilliant paintings for the churches in Venice. The doubts raised by the Inquisitor on the decorum of the *Feast in the House of Levi* (1573, Gallerie dell'Accademia) forced Veronese to tone down his exuberance. His religious painting gradually became more contemplative and even developed *intimiste* characteristics in his final years.

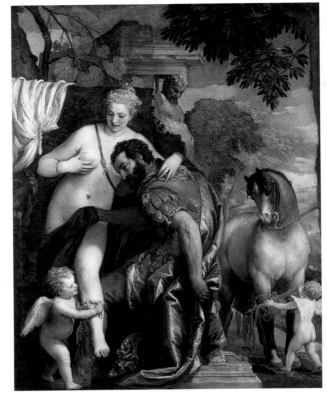

Veronese
Mars and Venus United by Love,
c. 1580
Metropolitan Museum of Art,
New York

This work was probably painted for Emperor Rudolf II of Hapsburg's celebrated collection of works of art and natural curiosities in Prague.

Veronese
Feast in the House of Levi,
1573
Gallerie dell'Accademia,
Venice

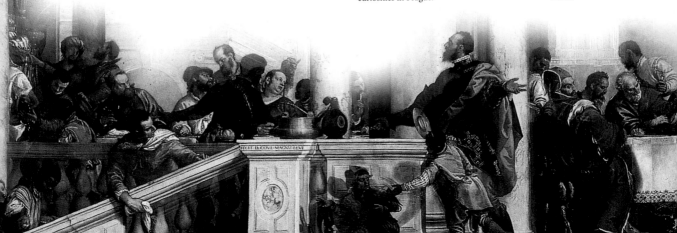

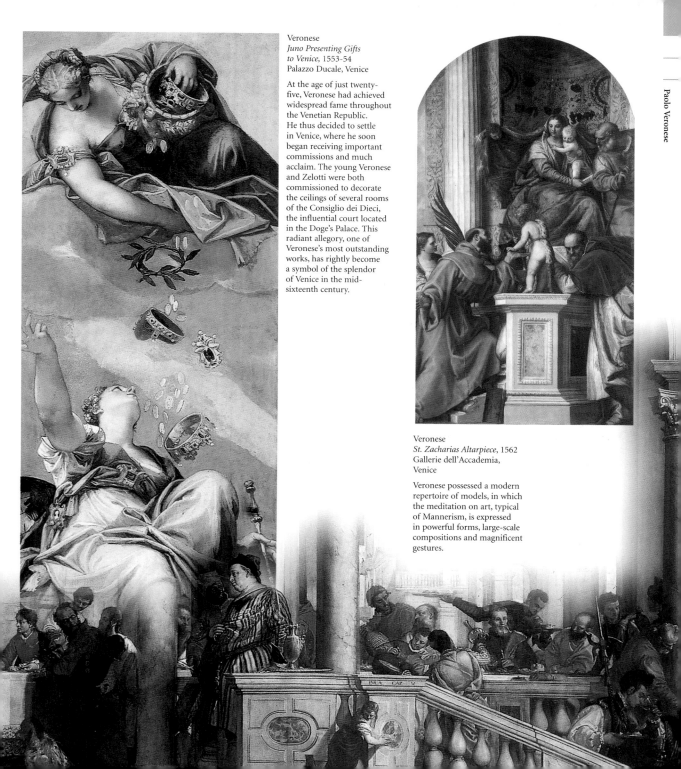

Veronese
*Juno Presenting Gifts
to Venice*, 1553-54
Palazzo Ducale, Venice

At the age of just twenty-
five, Veronese had achieved
widespread fame throughout
the Venetian Republic.
He thus decided to settle
in Venice, where he soon
began receiving important
commissions and much
acclaim. The young Veronese
and Zelotti were both
commissioned to decorate
the ceilings of several rooms
of the Consiglio dei Dieci,
the influential court located
in the Doge's Palace. This
radiant allegory, one of
Veronese's most outstanding
works, has rightly become
a symbol of the splendor
of Venice in the mid-
sixteenth century.

Veronese
St. Zacharias Altarpiece, 1562
Gallerie dell'Accademia,
Venice

Veronese possessed a modern
repertoire of models, in which
the meditation on art, typical
of Mannerism, is expressed
in powerful forms, large-scale
compositions and magnificent
gestures.

Crete, Venice, and Toledo
1541-1614
El Greco

A Visionary Ulysses in Counter-Reformation Spain

Domenikos Theotokopulus trained under the Cretan icon-painter Michail Damaskinos, and by 1560 was already considered a "master painter" in his homeland. Shortly afterward he traveled to Venice (Crete was then a part of the Venetian Republic), where he came into contact with Titian, Tintoretto and Jacopo Bassano, acquiring a rich, Flemish sense of color and a taste for elaborate perspective. Around 1572 he moved to Rome, where he studied the works of Michelangelo, and in 1577 he relocated to Toledo, which became his second home. It was here that he was given the nickname El Greco, a reminder of his distant, but never-forgotten birthplace. He sought the favor of the Spanish court, but Philip II did not appreciate his work and the intricate *Martyrdom of St. Maurice and His Legions* (1583, Escorial) was a failure. However, he succeeded in becoming a leading exponent of the religious art of the Counter-Reformation and his altarpieces, medium-sized devotional paintings, and intense portraits mark a turning point in Spanish art between the Renaissance and the Baroque. His painting acquired a fantastic, visionary tone, with unnaturally elongated figures, phosphorescent colors, and dizzying compositions. For the churches of Toledo he painted such masterpieces as the *Burial of the Count Orgaz* and the *Espolio*. In his later works he developed an intensely evocative and mystic style. In addition to the great paintings in the Prado, the remarkable *Laocoön*, now in Washington, D.C., should also be mentioned. It is the only mythological work in his whole vast output, and it marked the dawn of the *siglo de oro* in Spain.

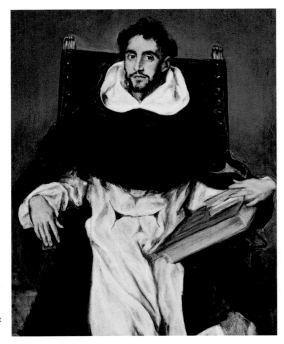

El Greco
Fray Hortensio Felix de Paravicino, 1609
Museum of Fine Arts, Boston

Despite the fact that his output was so varied, the "hand" of El Greco is truly unmistakable. Even in his extraordinary portraits, there is a sense of feverish tension in his models that makes their eyes bright, their complexion bloodless, and their aristocratic hands thin and nervous. Above all, the psychology of the subject is revealed through the rapid brushstrokes and brilliant use of light that create a vivid impression of movement.

El Greco
Christ Driving the Traders from the Temple, c. 1600
National Gallery, London

This is one of the artist's favorite subjects and he repeated it a number of times during his career. A comparison of the different versions allows us to trace his stylistic development.

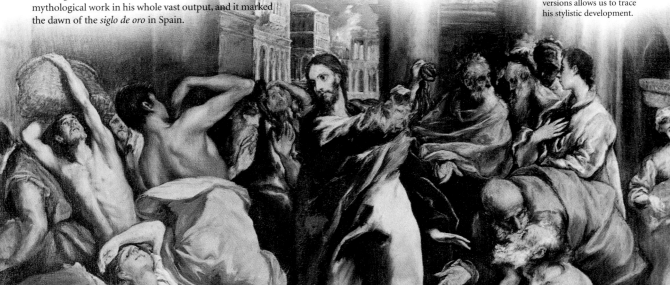

El Greco
Resurrection, c. 1590
Prado, Madrid

As the century drew to a close,
El Greco's compositions acquired
a vertical movement and an almost
unnatural distortion, accentuated
by phosphorescent highlights
and pervaded by mystic tension.

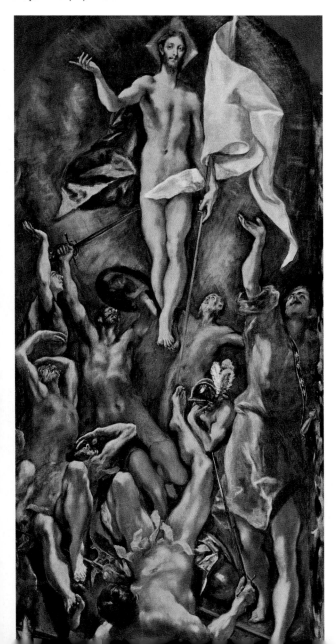

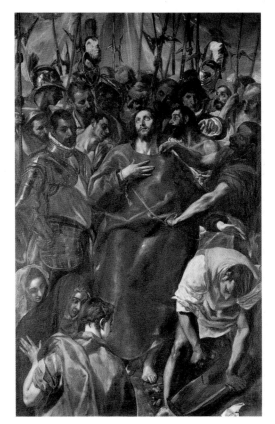

El Greco
El Espolio (Disrobing of Christ),
1577-79
Sacristy, Toledo Cathedral

This crowded composition,
with figures crammed into
the foreground, was later
admired and imitated
by Goya and Picasso.

Under the Eyes of the Inquisition

The Portrait of Don Fernando Niño de Guevara *(1596, Metropolitan Museum of Art, New York) is a vivid reminder of the historic period and the particular religious context in which El Greco lived and worked. After the Council of Trent (1563), painters were asked to produce works that would arouse popular devotion by depicting figures who would serve as examples of virtue for the faithful. Any digression or license was examined by the Inquisition, who demanded strict doctrinal orthodoxy and* faithfulness to the Holy Scriptures. El Greco may well have witnessed the famous trial of Paolo Veronese in Venice, in 1573. Moreover, in Spain, the second half of the sixteenth century was also the age of great mystic saints, like Teresa of Avila and John of the Cross, who experienced visions and ecstasy.

El Greco

1586-1588

Burial of the Count Orgaz

This great canvas, still in the modest Church of San Tomé in Toledo for which it was painted, depicts a miracle that took place at the beginning of the fourteenth century. Upon the death of the devout knight and count of Orgaz, Don Gonzalo Ruiz, St. Stephen and St. Augustine are said to have attended personally to the knight's burial. All those present at the funeral ceremony saw the skies open and Christ appear in all his resplendent glory, surrounded by saints and angels. Detailed historic and archival sources permit us to follow the various stages of the commission and execution of this magnificent altarpiece, and also the subsequent financial dispute between the painter and the parish priest over its payment. El Greco was scrupulously faithful to his subject and the final result is astonishing. Now in the fullness of his maturity, he drew on his long and complex experience as a man and as an artist to produce a highly original masterpiece. In various parts of the work we can recognize the influence of the colors of Titian, the Roman compositions of Raphael and Michelangelo, mystic Byzantine icons, the magic light of Tintoretto and Jacopo Bassano, the distorted gestures of Mannerism, and perhaps even the compositions of Dürer. Despite this, the *Burial* is an original work, and by no means merely a patchwork of allusions. The scene is pervaded by a palpable sense of disquiet, evident in the feverish expressions, trembling hands, and moist eyes. Within a magnificent and superbly controlled composition, El Greco creates unprecedented effects; the contrast between the realistic rendering of the count's gleaming burnished armor and the impalpable transparency of the celestial figures is particularly impressive. When the work was completed, the parish priest of San Tomé, who had commissioned the painting, quite rightly noted in his register: "La pintura es una de las màs excelentes que hay en España (...) y viénenla a ver con particolar admiración los foresteros..." (The painting is one of the most excellent in Spain, and foreigners come to see it with particular admiration).

The scene of Christ the Judge surrounded by the Virgin and saints recalls Michelangelo's *Last Judgment*, which El Greco studied intently during his stay in Rome.

The composition is divided into two distinct parts, earth and sky, and El Greco adopted every means possible to emphasize this difference, including the use of light and color, the proportions of the figures, and the density of the brushstrokes. While the characters in the lower part are portrayed with a sculptural fullness, the saints crowded among the clouds tend to gradually vanish, becoming mystically evanescent.

The portraits of dignified gentlemen in dark clothes form an unforgettable gallery of the leading figures of the Counter-Reformation, a prelude to the great period of seventeenth-century Spanish literature.

The kneeling boy is Jorge Manuel, El Greco's son and future assistant (although mediocre compared to his father). A letter protruding from the folds of his austere black suit shows the year of his birth, 1578, and the painter's signature in Greek, a little pun intended to point out that El Greco had "made" both the painting and his son. The boy is one of the few figures that look at the viewer, thus establishing a direct relationship. His finger, on the other hand, points to the body of the count, focusing attention on the subject of the work.

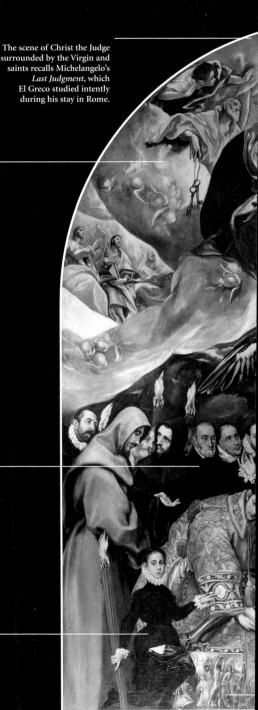

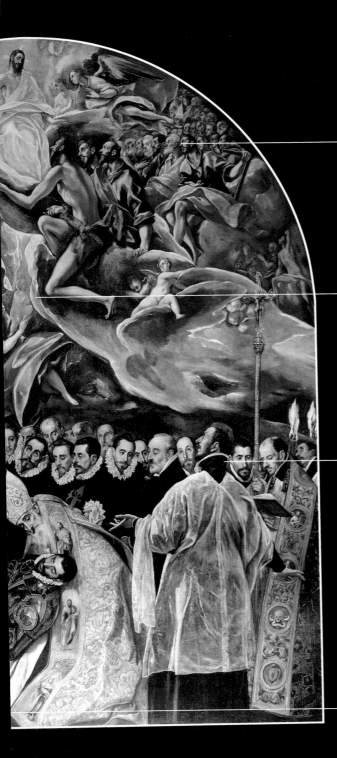

The profile of Emperor Philip II has been identified among the saints and angels surrounding the figure of Christ. El Greco repeatedly sought to win the monarch's favor, but in vain. The paintings he produced for the Escorial did not please the demanding, somber Philip. This detail, which might appear mere flattery, actually has an illustrious precedent with which the king was familiar: in *The Glory*, now in the Prado, Titian had added the figure of Charles V.

In the center of the scene, halfway between the earthly plane and the vision of Paradise, an angel is bearing to heaven the count's *animula* (little soul), which resembles a cocoon or a baby wrapped in swaddling clothes. This is a detail typical of Byzantine iconography that El Greco remembered from his youth.

The white surplice of the priest with his back turned, through which his black cassock is visible, is a memorable touch of virtuosity. Here El Greco draws on a work by Jacopo Bassano, the master from the Veneto, whom he had encountered during his time in Venice. The elongated flames of the torches in the funeral procession are also reminiscent of Venetian painting of the second half of the sixteenth century (Titian, Tintoretto, and Jacopo Bassano).

The figures of St. Stephen and St. Augustine are the focal point of the work. Both are wearing fine vestments (those of a bishop for St. Augustine, those of a deacon for St. Stephen), woven with gold thread and richly embroidered. The scene of St. Stephen's stoning is depicted on his dalmatic.

Fontainebleau

1527-1594

Mannerism in France

The Icy Thrill of Cerebral Eroticism

After the Sack of Rome in 1527, King Francis I managed to persuade the most celebrated Italian painters, stucco-workers, sculptors, and architects to move to France, where they worked on prestigious commissions. The arrival of Rosso Fiorentino, who frescoed the gallery of the castle at Fontainebleau, was a particularly important event. He was followed by the architect Sebastiano Serlio, the painter Niccolò dell'Abate, and the sculptor Benvenuto Cellini. Together they founded the Fontainebleau School, an international workshop in the "modern manner" that, by 1540, was to become the "art of the regime", a kind of formal code shared by all the rulers of Europe that boosted the fixed, unassailable image of absolute power. The aristocratic ideal, court etiquette, and the self-assurance of power are conveyed through still, almost crystallized forms. The allusions to classical models, like ancient statues or prints made from the works of Raphael, could only be recognized by the highly cultured few; thus becoming a kind of code, accessible only to those who belonged to an elite, able to appreciate the cold charm of "timeless" images, in which the production of a true likeness is less important than the need to present an idealized courtly model.

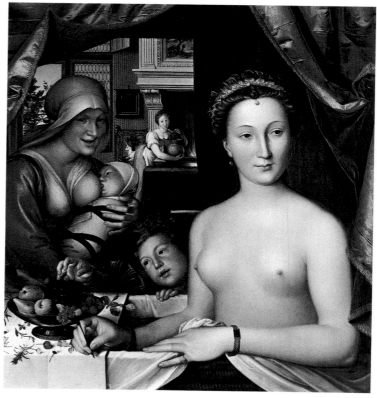

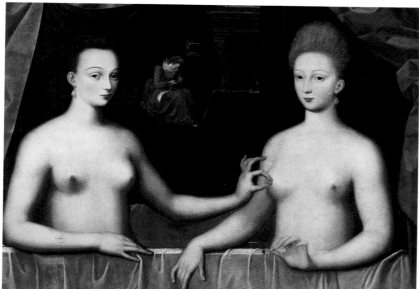

François Clouet
Lady in her Bath, c. 1570
National Gallery of Art,
Washington, D.C.

Portraitist of Francis I and court painter to his successors Henry II and Charles IX, Clouet (1515-1572) was the most important French artist of the sixteenth century. The supreme elegance of his paintings conceals a series of sophisticated symbols.

Anonymous French artist
Two Ladies in Their Bath, c. 1594
Louvre, Paris

The Fontainebleau School was a unique combination of elements: on the one hand a rather complacent revival of classical models, and on the other an obsessive attempt at visual seduction through female nudes, meticulously drawn flowers and other objects, and an abundance of descriptive detail.

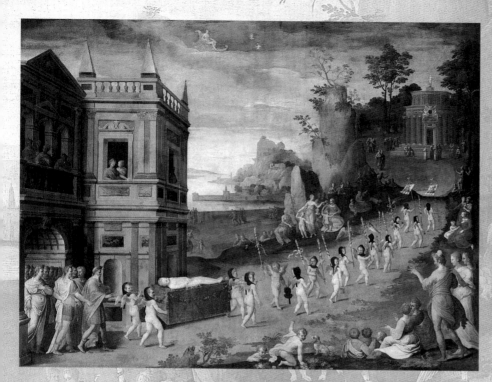

Attributed to Henri Lambert
The Funeral of Cupid
Louvre, Paris

The favorite themes of the Fontainebleau painters are literary allusions to the myth of Cupid, which was often interpreted symbolically, as happened during the same period in the work of the Pléiade painters, who were inspired by Petrarch.

Antoine Caron
Augustus and the Sibyl,
c. 1571
Louvre, Paris

The themes, style and characteristics of the painters of the Fontainebleau School are all closely linked, so that it is often difficult to distinguish the hand of the individual artists. For this reason, many works have remained anonymous. Among the more recognizable painters is the eccentric Antoine Caron (1527-1599), who was noted for his imaginative mythological and literary scenes, full of wildly gesticulating figures and fantastic architecture.

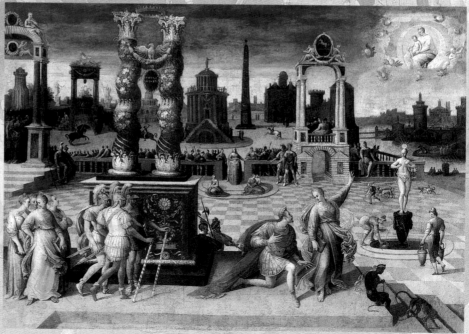

Prague

1583-1618

Rudolf II and Late Mannerism

The Sensual and Cerebral Thrill of Artifice

In 1583 Emperor Rudolf II of Hapsburg unexpectedly decided to transfer the capital of the empire from Vienna to Prague. Thus, toward the end of the century, the city became the most brilliant cultural center of northern and Central Europe. In the cabalist Prague of Rabbi Löwe and the Golem, Rudolf was an obsessive collector, accumulating wonderful treasures, astonishing objects, fine works of art, unusual natural finds, and masterpieces in gold, ceramic, and carved wood. A large school of painters formed around Rudolf's court, which developed its own recognizable style despite diverse cultural backgrounds. It included Joseph Heintz (1564-1609) from Basel, Hans van Aachen (1552-1615) from Germany, Giuseppe Arcimboldi (1527-1593) from Italy, and Bartholomeus Spranger (1546-1611) from Antwerp. However, these artists were linked by the fact that they had all spent time in Italy and by their penchant for overtly erotic subjects depicted in a fascinating sensual manner. The school continued to flourish even after the death of the emperor, and was only interrupted in 1618 by the outbreak of the Thirty Years' War, which began with the "defenestration of Prague" and ultimately led to the sack of the city by the Swedes and the dispersion of its collections.

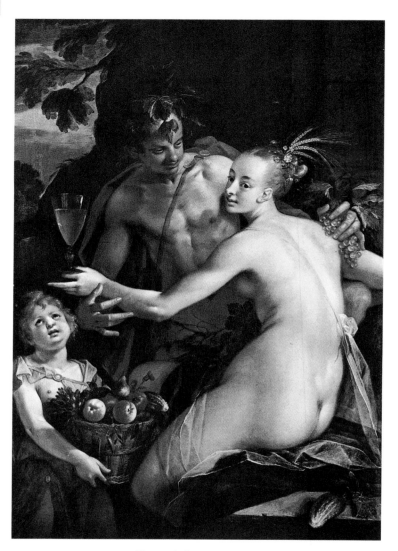

Bartholomeus Spranger
Salmacis and Hermaphroditus
detail, c. 1582
Kunsthistorisches Museum,
Vienna

After spending many years in Fontainebleau and Italy, Spranger settled at Rudolf's court in Prague, where his work displayed all the salient features of international Mannerism.

Hans van Aachen
Bacchus, Ceres and Cupid
Kunsthistorisches Museum,
Vienna

This work, one of Aachen's masterpieces, illustrates the conversion of Mannerism from an "avant-garde" movement to an "official" court style. The overt sensuality, a reflection of Rudolf's rather voluptuous tastes, combines with a sense of controlled formal perfection and a sophisticated use of cultural and figurative allusions. The basket of fruit borne by Cupid is a wonderful miniature still life.

The Many Faces of the Emperor

The portrait of Rudolf II on the left, painted by Hans van Aachen, displays the typical, rather unattractive features of the Hapsburgs. The face on the right, however, is another portrait of the eccentric Hapsburg emperor, this time painted by Giuseppe Arcimboldi in 1591. The Lombard artist, commonly known as Arcimboldo, portrays the emperor, a passionate lover of alchemy and scientific experiments, as the mythological deity Vortumnus, who was able to transform himself into the various elements of nature. The extraordinary head is a virtuoso creation of flowers and fruit. The painting was originally at the center of a complex composition that included another eight works by Arcimboldo depicting the four seasons of the year and the four elements. Here Rudolf II becomes the focal point of a wonderful allegory of an artificial world.

Bartholomeus Spranger
Glaucus and Scylla, c. 1582
Kunsthistorisches
Museum, Vienna

Spranger's sophisticated style adopted artistic and cultural allusions and a kind of cold sensuality (all the more provocative in its apparent detachment) to appeal to a more intellectual audience. The emperor particularly appreciated the works where Spranger used classical mythology as a pretext for depicting voluptuous female nudes like the two figures that frame these pages.

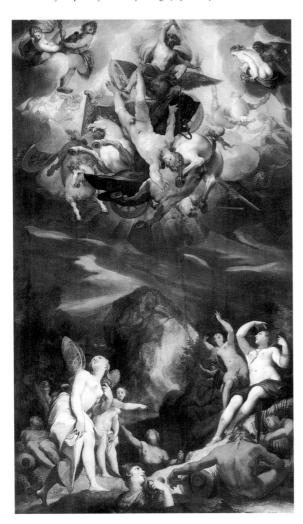

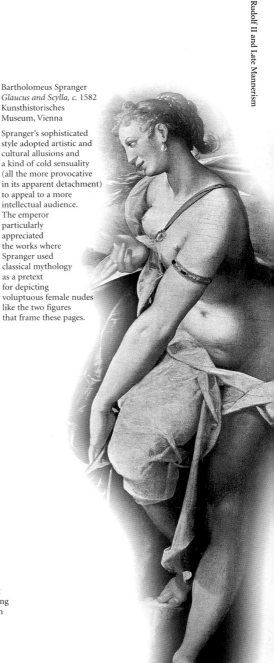

Joseph Heintz the Elder
Fall of Phaëthon, 1596
Museum der Bildenden
Künste, Leipzig

Heintz combines and refines the most sophisticated trends of the late Renaissance. The subject here is almost a mere excuse for displaying the artist's culture through recognizable allusions to classical statuary.

From the End of the Sixteenth Century
The Birth of Still Life

A New Genre Destined to Change the Art Market

At the end of the Renaissance the art market was no longer limited to the aristocracy and high-ranking prelates, but expanded to include the wealthy bourgeoisie and the rising merchant classes. This change encouraged the introduction of new subjects. The depiction of inanimate objects became a separate theme that excluded the presence of human figures. This genre acquired a dignity of its own thanks to the work of talented specialists and was soon much sought after by the new clients. Significantly, Caravaggio claimed that a good flower-piece is as difficult to paint as a composition with figures, providing a sublime and perhaps insuperable example of the genre in the *Basket of Fruit* now in Milan. During this period, the still life genre developed throughout Europe, particularly in the northern countries. However, the rare though remarkable Spanish still lifes, depicted in a style that was both simple and austere, but imbued with powerful mysticism, by Zurbarán and the specialist Sanchez Cotán, deserve special mention.

Jan Bruegel
Bouquet in a Clay Vase, c. 1607
Kunsthistorisches Museum, Vienna

The fame of Jan Bruegel (1568-1625), the son of Pieter Bruegel the Elder, is based above all on his ability to "arrange" and depict lavish bouquets, sometimes accompanied by unusual small objects such as coins, insects or jewels. In his letters from Antwerp and Brussels to the Milanese Cardinal Federico Borromeo, his great admirer and patron, Bruegel

stressed the fact that composing these bouquets, consisting of dozens of different flowers, was an exhausting task. In fact, all of his compositions were painted from real life, and he therefore had to wait for the various varieties to bloom, sometimes months apart. Thanks to his good relations with the ruling Archduchess of the Netherlands, he had access to the royal conservatories, where unusual plants and flowers were cultivated, including some of the first European tulips.

Luis Eugenio Meléndez
Still Life with Box of Sweets, Bread Ring, and Other Objects, 1770
Prado, Madrid

Meléndez (1716-1780) was undoubtedly the greatest eighteenth-century Spanish painter before Goya. The astonishing clarity and the perfectly precise rendering of his still lifes make them fascinating, but also somewhat disturbing.

Georg Flegel
Dessert Still Life
Alte Pinakothek, Munich

In the work of the German painter Georg Flegel (1566-1638), there is a clear sense of order, harmony and pleasure taken in accurate depiction. Born in Bohemia, Flegel probably studied in the Low Countries. He is one of the earliest and most important exponents of the "archaic" still life, characterized by religious and symbolic overtones.

Louise Moillon
Basket with Peaches and Grapes, 1631
Staatliche Kunsthalle, Karlsruhe

This sensitive French painter (the still life genre was much favored by the first women artists) seeks to recreate the surface textures. The velvety skin of the peaches is a fine example of virtuosity.

Evaristo Baschenis
Still Life with Musical Instruments
Private Collection

Baschenis (1617-1677), a reserved priest from Bergamo, specialized in still lifes with musical instruments, which he rendered with great mastery and a touch of nostalgia for a lost style of music. Baschenis belonged to the long and successful Lombard tradition of still life painting. Vincenzo Campi was a leading early exponent of the genre and the background image on this page is a detail of his *Fruit-Seller* (c. 1590), now in the Pinacoteca di Brera in Milan.

Rome, Naples, and Sicily
1571-1610
Caravaggio

From Poverty to Fame: the Odyssey of a Genius

Born in Milan, Michelangelo Merisi, known as Caravaggio after the town his family originated from, lived most of his short life in Rome, where he radically changed the course of art. The most innovative quality of his work was its passionate, raw, poetic realism, drawn directly from everyday life. His early paintings depict urchins, charlatans, gypsies, and all kinds of dubious characters, introducing a novelty that was subsequently imitated throughout Europe. Initially, Caravaggio's indecorum caused a scandal and magnificent works were rejected because they were considered too close to real life. Gradually, however, the churches of Rome began to accept his works which marked a new era in painting. Diagonal lateral rays of light illuminate scenes full of dramatic action, in which a deep religious spirit is immersed in a wealth of everyday detail. In 1606, at the peak of his career, Caravaggio killed an opponent in a dispute over a game of tennis and was sentenced to death. Rather than face his sentence, he fled Rome, traveling to Naples, Malta, Sicily, and back to Naples, before reaching Porto Ercole where he died in 1610. On every stage of his journey, he left masterpieces in his wake, which however, increasingly reveal his growing anguish. Nonetheless, Caravaggio had caused a revolution in painting that not only involved the artists, but also the viewers, who were called upon to play a more intense role, not merely as detached observers but as eyewitnesses to the dramatic events unfolding before their eyes.

Caravaggio
Bacchus, 1594-96
Galleria degli Uffizi, Florence

From the outset of his career Caravaggio's work was marked by a realistic approach. Thanks to his incomparable mastery, he is considered to be the true founder of the still life genre and his works were immediately sought after by collectors. Caravaggio himself stated that it takes as much skill to make a good painting of flowers as one of figures.

However, his only work that can be considered a "pure" still life is this *Basket of Fruit*, which has been in Cardinal Federico Borromeo's collection in Milan since it was painted in 1596. The collection opened to the public under the name of Pinacoteca Ambrosiana, in 1618.

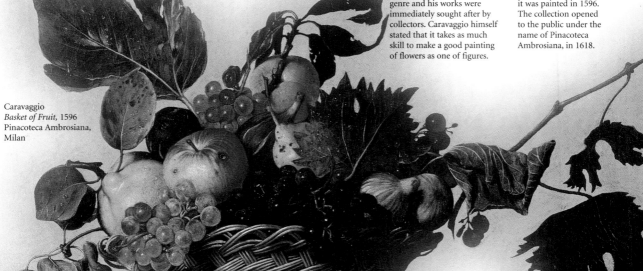

Caravaggio
Basket of Fruit, 1596
Pinacoteca Ambrosiana,
Milan

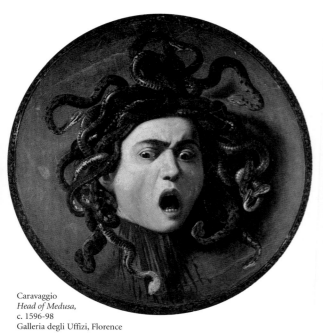

Caravaggio
Head of Medusa,
c. 1596-98
Galleria degli Uffizi, Florence

Caravaggio
Madonna of Loreto
1603-05
Church of Sant'Agostino,
Rome

This scene takes place in
a humble, but intensely
moving setting. Here Mary
is depicted as a simple
woman, very different from
traditional iconography.
The two poor, ragged,
filthy pilgrims kneeling
before her, however, are the
real protagonists of the scene,
and show the viewer a close-
up of their sore, dirty feet,
a realistic detail that
brought bitter criticism
from Caravaggio's
contemporaries.

Caravaggio
Judith and Holofernes,
1595-96
Galleria Nazionale d'Arte
Antica, Rome

This spectacular, dramatic
scene is part of a distinct group
of paintings, executed at the
beginning of Caravaggio's
relationship with Cardinal
Del Monte, in which the
figures are drawn with
unusual, almost harsh clarity
(note, for example, the face
of the old handmaid who
accompanies Judith). A clear,
still light reveals even the most
macabre details: the severed
head and the flowing blood
are almost the leitmotif of the
painter's career. He repeatedly
chose subjects involving
decapitation (Medusa, Judith,
David and Goliath, John
the Baptist), at first
subconsciously and then,
after he was condemned
to death by decapitation in
1606, as a terrible reference
to his own life.

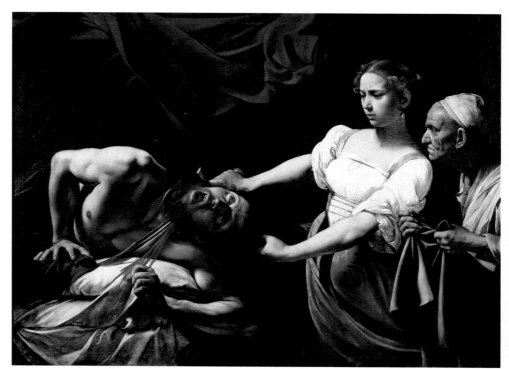

157

Caravaggio

1599-1602

The Paintings in
San Luigi dei Francesi

San Luigi, founded by Giulio de' Medici in 1518 and completed in 1589, is the church of the French community in Rome. The funeral chapel of the French gentleman Mathieu Coyntrel (whose surname was Italianized as Contarelli) contains a series of paintings devoted to Contarelli's patron saint, St. Matthew, that are the most important works in Caravaggio's career. The long story of the chapel's decoration lasted several decades and involved numerous artists, but eventually ended with Contarelli's courageous decision to commission three paintings from Caravaggio: an altarpiece with St. Matthew writing the Gospel, and the side walls with the most important episodes from the saint's life. Caravaggio began his task with his first version of *St. Matthew and the Angel,* but the painting was rejected on the grounds of indecorum. Before returning to the altarpiece (the final version, executed in 1602, is more pleasant but perhaps less intense than the first), Caravaggio began the paintings for the two side walls. Completed around 1600, they constitute a major turning point in the history of art. The viewer is almost literally drawn into the scene as it reaches its dramatic climax.

Placed over the altar in the chapel, this painting is the second version of this subject executed by Caravaggio. In the first (destroyed by fire in Berlin in 1945) the poses of the saints and the angel had been considered indecorous. In the approved work, St. Matthew is balanced precariously in an unconventional pose as he writes down the words dictated by the beautiful angel in flight, a heavenly messenger who stands out brightly against the black ground.

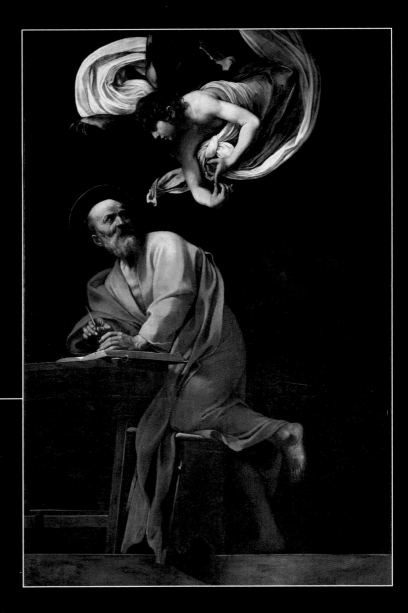

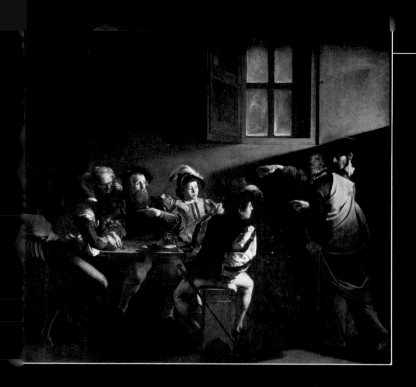

Christ invites the tax collector Matthew, depicted with his companions in a large bare guardhouse, to follow Him. Between the two main figures there is a silent, though extremely clear dialogue of gestures, reminiscent of Michelangelo's *Creation of Adam* on the ceiling of the Sistine Chapel. On the right Christ (partly hidden by St. Peter) raises his right hand to point to Matthew, who in turn, points to himself in astonishment. The young men in plumed hats turn casually, as the soldiers greedily count money. The light that floods in from the right, toward the flaking wall and the dusty window, is a key to the interpretation of the work, since it directs the observer's gaze to the focal point. In this shabby, realistic setting, light is a symbolic allusion to the divine grace that enters everyday life.

The *Martyrdom of St. Matthew* is the most dramatic episode in the series, a brutal execution, carried out by a killer who bursts into the church to strike down the saint during the celebration of mass. Caravaggio seems to recall Leonardo's *Last Supper*, and portrays the diverse "emotions of the soul" of a group of people involved in a dramatic event: the assassin shouts, St. Matthew groans, an altar boy flees screaming, and the people scatter. The martyr is left alone, and the church is filled with the darkness of horror. Above, a solitary angel reaches down to give the saint a palm branch, the symbol of martyrdom and his ascent to heaven. However, it is difficult to tell whether the saint is raising his hand to grasp the palm or in a weak attempt to defend himself. In the background, to the left, is a pale, frowning man of about thirty with a black beard; Caravaggio has depicted himself in the painting as an eyewitness of the scene.

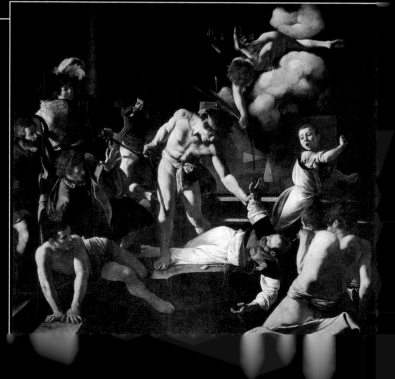

The Seventeenth Century
Baroque Europe

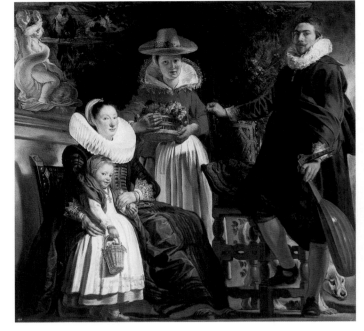

Cosmos and Microcosm

During the seventeenth century, Europe underwent profound political, social and cultural changes, causing a crises for the traditional powers (including the Spanish empire and the small Italian city-states) and the appearance of new nations in a scenario that extended across the oceans to far-off continents. However, the seventeenth century was also full of surprising contrasts. During this time, the arts developed a highly imaginative style while the sciences began to elaborate the rules of the modern method of inquiry. Economics saw the birth of bourgeois capitalism, and the sovereigns of Europe built magnificent palaces. Italian culture and taste spread throughout Europe at a time when Italy was relegated to the sidelines of international trade. Despite these contradictions, the Baroque age was a fascinating period of artistic development and exchange, and increased circulation of ideas. New national schools also became consolidated during this time (for example, in Rembrandt's Holland and Velázquez's Spain) and homogeneous stylistic features spread throughout the continent. A number of great masters, like Caravaggio, Bernini, Poussin, and Rubens, became the models for the figurative arts in all of Europe. Various influences alternated: the chiaroscuro and the vivid realism of Caravaggio, the colorful fantasy of Baroque decoration, and the domestic *intimisme* of the Dutch School.

Jacob Jordaens
Jordaens' Family in a Garden,
1621-22
Prado, Madrid

The Antwerp School was one of the most triumphant currents of European Baroque art, and Jacob Jordaens (1593-1678) was perhaps its most spectacular exponent. The artist does not depict himself at the easel or in his painter's smock, but in extremely elegant attire, holding a lute instead of a palette. His family is enjoying the relaxing atmosphere and the shade of a garden in full bloom at the end of summer, with a gushing fountain and a young maid carrying a basket of ripe grapes. The delightful little blonde girl is portrayed smiling and timid, with a gentle blush suffusing her cheeks and an expression that is both coy and curious: a figure worthy of Renoir.

Johannes Vermeer
The Astronomer, c. 1670
Louvre, Paris

Vermeer's close friendship with scientists, like the inventor of the microscope Adrian van Leeuwenhoek, explains his sensitive portraits of thinkers and scholars, in which their intelligence, application, intuition, and concentration clearly emerge, almost spreading the light of genius and knowledge.

The Stargazers

While Galileo pointed his telescope at the star-filled sky, advancing doubts and theories about the "great systems" that govern the universe, Italian artists did not present "cosmic" images such as that of Elsheimer, nor did they have relationships with men of science, such as the friendship between Vermeer and Van Leeuwenhoek (or that between Rembrandt and Dr. Tulp), perhaps marking the incipient decline of Italian culture. The relationship with the stars was thus mediated by antiquity, mythology, and classical texts. One example of this is a painting by Guercino (now in the Galleria Doria Pamphilij in Rome). The sleeping shepherd depicted with a telescope on his lap is the mythical Endymion, enamored of the Moon, who has been granted eternal youth by the gods but is doomed to spend his time sleeping. In short, Italian artists and men of letters continued to view the cosmos through the lens of classical literature, while Galileo was forced to renounce his theories. The skies continued to be shrouded in mystery, and as late as the beginning of the nineteenth century the most famous Italian Romantic poet asked himself "What dost thou do, O Moon, in the sky? Tell me, what dost thou do, O silent Moon?".

Sébastien Stoskopff
Still Life with Glasses in a Basket, 1644
Musée des Beaux-Arts, Strasbourg

The glasses in the wicker basket, each one different, are reproduced with astounding accuracy to form a wonderful composition. One of the delicate glasses is broken. No longer serving any purpose, it introduces the theme of the transitoriness of beauty.

Adam Elsheimer
Flight into Egypt, 1609
Alte Pinakothek, Munich

This enchanting nocturnal elegy is undoubtedly the German painter's best-known work. The perfect depiction of the expanse of sky, with the Milky Way and sparkling constellations , illuminated by a full moon, is a notable example of Elsheimer's great interest in science, particularly the discoveries of Galileo Galilei.

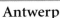

Antwerp

1577-1640

Peter Paul Rubens

The Sensual Pleasure of Life and Painting

Peter Paul Rubens burst onto the European scene at the beginning of the seventeenth century with astonishing force. After several years in Italy studying the great masters and perfecting his art, he returned to Antwerp in 1608 and very soon achieved resounding success. His style was rich and exuberant; he reveled in painting and in seeing the pigment on canvas, tackling the widest possible range of subjects and formats. With over a hundred assistants, his workshop produced a vast output and exported all over Europe. Between 1620 and 1640, in fact, he was the most sought-after European painter and commissions poured in. He worked in Rome, Paris and London, though Antwerp remained the center of his activity. In his fruitful relations with reigning monarchs, Rubens resembles the great masters of the Italian Renaissance, and his expansive, sensual paintings filled the royal collections. No collection could be considered complete if it did not contain his works.

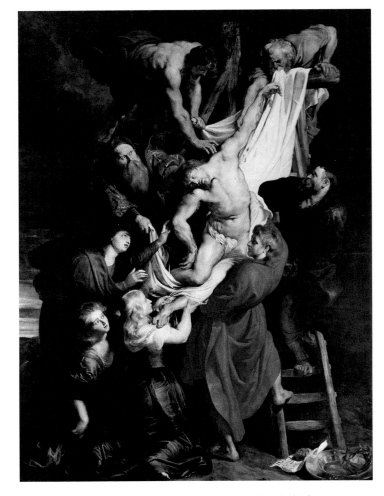

Peter Paul Rubens
Descent from the Cross, 1612
Cathedral, Antwerp

This monumental, dramatic composition reworks Italian precedents (Titian and Caravaggio) with a remarkable energy and sense of involvement.

Peter Paul Rubens
The Artist and His First Wife, Isabella Brant, in the Honeysuckle Bower, 1609-10
Alte Pinakothek, Munich

This extremely accurate rendition highlights the many symbolic details of the natural setting and the couple's dress, which are allusions to love, faithfulness, and their high social status. Rubens was fluent in five languages, and was blessed with fine manners and a natural elegance, further refined by the long periods spent at European courts. His image as a painter was the opposite extreme to that of the unfortunate *peintres maudits* like Caravaggio or, in his later life, Rembrandt.

Peter Paul Rubens
The Hermit and the Sleeping Angelica, 1630
Kunsthistorisches Museum, Vienna

This small but beautiful late work depicts an episode from *Orlando Furioso,* the celebrated epic poem by Ludovico Ariosto, during which the sleeping Angelica is carried to an island by a demon, conjured up by a hermit's magic. The handling of this subject is remarkably fine, and reminiscent of the early Rembrandt, while in general stylistic terms the painting can be considered a blend of Titian and Delacroix.

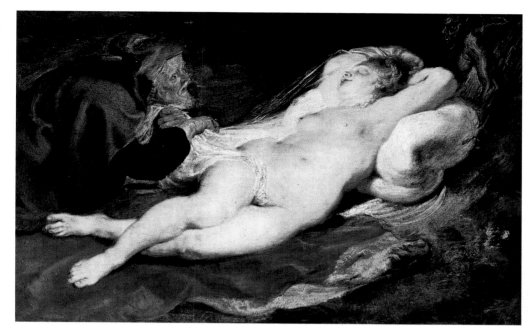

Peter Paul Rubens
The Four Continents,
c. 1612
Kunsthistorisches Museum, Vienna

This painting is a Baroque allegory on the theme of geography, notable for its realistic representation of exotic animals like the crocodile and the tigress and her suckling cubs, which Rubens must have admired on the quayside in Antwerp. In addition to the animals, plants, and archaeological references indicating the various parts of the world, there are also four female figures who represent the continents, embraced by their respective rivers: on the left is Europe with the bearded Danube; in the center black Africa with the fertile Nile crowned with ears of wheat; on the right Asia with the sturdy Ganges, and behind her America with the Amazon.

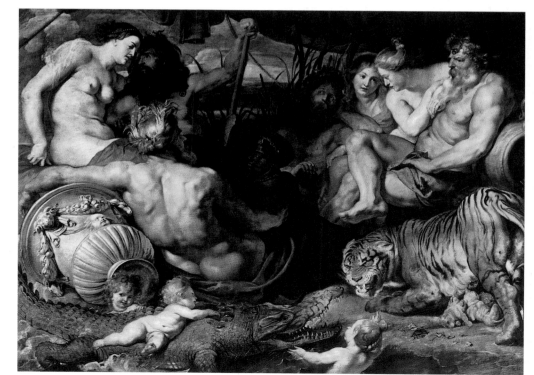

Peter Paul Rubens

c. 1618

The Rape of the Daughters of Leucippus

Rubens's mythological works express to the full his grandiose conception of painting, especially when he chooses, with evident pleasure, to portray voluptuous monumental female nudes. This work, in the Alte Pinakothek, Munich, is traditionally interpreted as depicting the myth of the twins Castor and Pollux, the sons of Leda and Zeus (who had turned himself into a swan). This literary episode, drawn from the texts of Theocritus and Ovid, represents the rape of Phoebe and Hilaeira, the daughters of King Leucippus of Argos, by the divine twins. The abduction led to a fight with the girls' betrothed, which ended in the death of Castor and the subsequent metamorphosis of the twins into the constellation Gemini. If the identification of the subject is correct, this is the only important painting depicting this part of the myth. Based on the fact that the two men do not seem to be twins and the horses are also different in color, it has recently been suggested that the title should be changed from *The Rape of the Daughters of Leucippus* to the more common *Rape of the Sabine Women*. It is an image of love and violence, and in fact the Cupid on the left does have a rather evil expression. However, the theme itself is overshadowed by the imposing composition and lavish brushwork. This is a true masterpiece of the mythological genre, executed not with cerebral elegance, but as a sensual wave of forms and colors.

The horses add a thrilling animal force to the scene, while the Dioscuri, especially the one seen in profile, are reminiscent of classical models. Rubens's "classicism" is influenced by Hellenistic sculpture, in which the vehemence of the passions is conveyed through dynamic forms.

Rubens depicts this immense group, consisting of the two girls, the divine twins, the horses and the cupids, as a single quivering block. Everything revolves, in perfect balance, like a colossal mechanism under the masterly control of the painter.

The rearing horse, with its gleaming eyes and whitish nostrils, stands out magnificent against the sky. Later Velázquez copied it almost exactly in his equestrian portraits for the Spanish court.

The voluptuous female nudes fill the space in the diffused light of the sun. The brilliant play of reflections on the silk and on the blonde hair of the girl still lying on the ground is reminiscent of sixteenth-century Venetian painting. The bracelets around her upper arm and the man's hand under her armpit accentuate the full softness of the girl's flesh. Although she may seem too shapely by today's standards, she is a perfect example of the aesthetic ideals of the (male!) public in the Baroque age.

The hilly landscape, with the wind blowing the clouds and the dark, leafy branches of the trees, also shows the influence of Venetian art, particularly Titian. By one of those strange coincidences that constantly occur throughout history, Rubens was born exactly nine months after Titian died.

Antwerp, Genoa, and London

1599-1641

Sir Anthony van Dyck

The Face and Soul of the European Aristocracy

A great specialist in Baroque portraiture, Van Dyck is one of the most refined painters of the early seventeenth century and a veritable child prodigy. In 1615, at the age of sixteen, he already had his own workshop. In 1618, as soon as he became a member of the Painters' Guild, he joined Rubens's studio, not as a student but as the master's assistant. They worked together, side by side, on several paintings. From 1620 on, Van Dyck's fame as a portraitist began to spread rapidly throughout Europe. In 1621, after a brief journey to England, he moved to Italy and decided to settle in Genoa, where he remained until 1626. During this long stay he spent time in Venice, Rome and Palermo, where he studied the masters, but continued to be based in Genoa, which had close commercial and cultural ties with Flanders. Upon his return to Antwerp, still only twenty-seven, he began to compete for supremacy with Rubens and encroached on the master's terrain. He painted several monumental and very successful altarpieces and was appointed court painter to the Regent Isabella in 1628. In 1632, despite his success in his homeland, he decided to move to England, and in London, became court painter to Charles I. Surrounded by a large group of pupils, during the years spent in England Van Dyck executed hundreds of portraits that were to have a strong influence on the future development of the English School. Except for two trips to the continent (to Antwerp in 1634 and to Paris during the last year of his life), Van Dyck settled permanently in England where he received a knighthood.

Sir Anthony van Dyck
James Stuart, Duke of Richmond and Lennox, c. 1634
Metropolitan Museum,
New York

Van Dyck's numerous English paintings are among the most important in the history of aristocratic portraiture. The tall, nonchalant figure of the young nobleman, dressed in an elegant black suit with delicate blue reflections, is accentuated by the lean greyhound at his side.

Sir Anthony van Dyck
Self-portrait, 1621-22
Alte Pinakothek, Munich

Van Dyck, a strikingly good-looking young man with a brilliant, precocious talent, often painted self-portraits. They are all very fresh works, executed with rapid brushstrokes and a free handling, and depict a smiling youth at the outset of his career, viewing the world with confidence and a keen sense of participation. There were inevitably many rumors about his love affairs with the beautiful noblewomen he received in his studio, like the alluring Elena Grimaldi Cattaneo, whose face is the background image on this page.

Sir Anthony van Dyck
Marchesa Balbi, 1622-23
National Gallery of Art,
Washington, D.C.

During his time in Genoa, Van Dyck portrayed many members of the aristocracy: decrepit old men and sweet children, young noblewomen and haughty gentlemen. Usually he painted the face and hands from life, adding the elaborate clothes in his studio. According to an old saying, seventeenth-century Genoa did not have a king, but many queens. The features and sumptuous gowns of the Genoese ladies in Van Dyck's portraits give them a truly regal air.

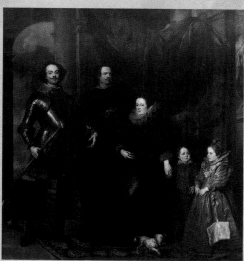

Sir Anthony van Dyck
The Lomellini Family, 1625
National Gallery of Scotland,
Edinburgh

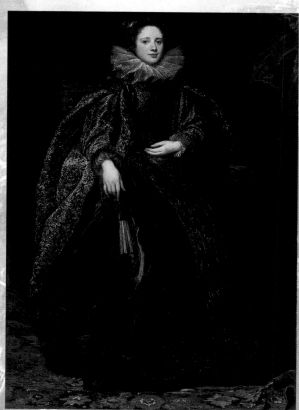

Seville and Madrid

1599-1660

Diego Velázquez

A Genius of Color in the Melancholy Splendor of Spain
Like the great literature of the same period, the works of Velázquez reflect an entire century, effectively portraying its way of life and government while capturing emotions, situations, and characters that stand out as timeless archetypes. Velázquez grew up in the lively cultural climate of Seville. At a very early age, he began painting *bodegónes* (everyday subjects with added elements of still life), whose compositions and play of light and shadow, reveal the influence of Caravaggio. In 1623, the Conde-Duque de Olivares, one of King Philip IV's most powerful ministers and a fellow-Sevillian, summoned Velázquez to Madrid to become the king's official painter. In this capacity, he began producing portraits in the style of Titian, but his technique became more varied and versatile after his first trip to Italy (1629-31). On his return to Madrid, he began a vast series of paintings for the royal residences and numerous portraits of the Madrid court—not only of the king and various princes, but also of dwarfs and jesters. After his second trip to Italy (1649-51), Velázquez's style changed radically, just as Rembrandt's also did at this time (though in a completely different personal and social context). He began painting with long, thick, separate brushstrokes, which conveyed great intensity. Later, this extremely free style was rediscovered by nineteenth-century French painters like Manet, and was even an inspiration for Picasso and the modern art movements.

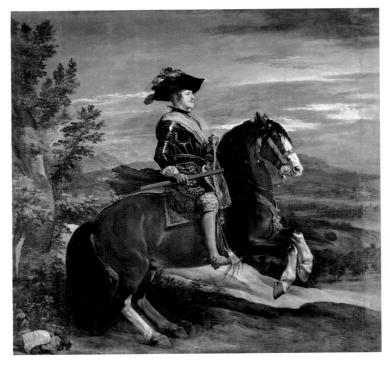

Diego Velázquez
Philip IV on Horseback,
c. 1635
Prado, Madrid

Velázquez based this work on Titian's equestrian portrait of Charles V (1548), where the king is also wearing armor and is shown in profile. Velázquez, however, replaces Titian's dramatic battle scene with the vast, clear serenity of a classic exercise in horsemanship, set against a sweeping backdrop of open countryside.

Diego Velázquez
*The Toilet of Venus
(The Rokeby Venus),* 1650
National Gallery, London

Throughout his life, Velázquez cultivated his own great, independent talent, though he constantly admired Italian art of the sixteenth and seventeenth centuries. Like other distinguished masters of his time (Rubens and Rembrandt especially), he closely studied the great paintings of the High Renaissance. This magnificent female nude (in fact, the only one Velázquez ever painted) is a stunning homage to Titian's rich flesh tones, free colors and palpable fullness of brushwork.

Diego Velázquez
Los Borrachos (The Topers or
The Triumph of Bacchus),
1628-29
Prado, Madrid

These happy drinkers recall
Flemish-Dutch genre
paintings, but without the
detached, almost scornful,
tone often conveyed in works
by other painters of the period.
On the contrary, the smiles
of the common folk reveal
Velázquez's empathy for
people, be they kings or
princes, peasants or buffoons.

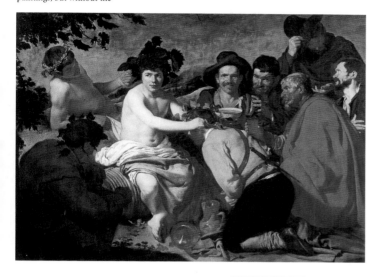

Court Jesters

*The bizarre "court of miracles", consisting of
dwarfs, comedians, buffoons, and jesters
whose job it was to entertain the royal fam-
ily, constitutes a very particular aspect of
Velázquez's work. Portraits of fools already
existed in the frescoes at the courts of the
Italian Renaissance (for example, in the
Camera degli Sposi (Bridal Chamber) in
Mantua and in Palazzo Schifanoia in Ferrara), but never before
had these characters been given so much importance. At times,
Velázquez portrays them full length in the same pose and format
he uses for the king. He depicts the whims, jests, grimaces, and
comic spirit of the buffoons without ever making them seem
pathetic or ridiculous. His portraits of dwarfs are the most impres-
sive of all his court buffoon paintings. Disconcertingly he leaves
absolutely no room for any sarcasm or mockery of their deformity.
On the contrary, he communicates the great dignity, sensitivity,
and keen intelligence of these luckless men. The faces, set on what
seem to be the bodies of puppets, have an expressive power and
moral strength that make the portraits of the enervated, wan
courtiers so prevalent in Baroque painting pale even further by
comparison.*

Diego Velázquez
Surrender of Breda, 1633-35
Prado, Madrid

This masterpiece of historic
painting commemorates
an episode in the war between
Spain and Holland in 1625.
The defeated Justin of Nassau
symbolically consigns the key
of the Breda fortress to the
victorious Ambrogio Spinola.
Against the background of
a desolate landscape with
the fires of battle still
smoldering, the two generals
have dismounted and meet
in a calm atmosphere of
mutual respect. Velázquez
avoids all rhetoric and
accentuates the heart of
the episode—its human
element. There is no
grandiloquent posturing in
the ranks of soldiers and
nothing distinguishes the
victor from the vanquished.
For soldiers, war is an
exhausting, dirty business
with little room for heroics.

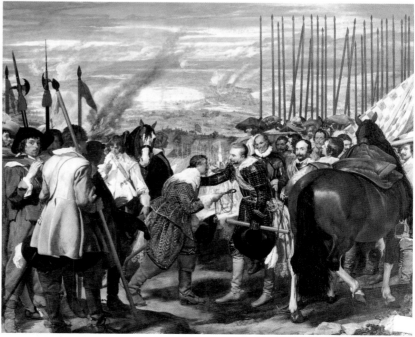

Diego Velázquez

1656

Las Meninas

This masterpiece, epitomizing seventeenth-century Spanish art, is rightly considered the jewel of the Prado Museum in Madrid. It was painted late in Velázquez's career, after his second trip to Italy, and depicts a recurrent scene at court: maids of honor attending to the Infanta Margarita, in a room of the palace where Velázquez had set up his studio. The little girl that dominates the center of the painting resembles a complacent, overdressed doll. She is clearly the focal point and driving force of the whole scene, as she is fussed over by her two very young maids. To the right, the dwarf Maribarbola is another striking portrait in Velázquez's series of court buffoons. A second dwarf, Nicolasito Pertusato, flaunts court etiquette by kicking the dog lying in the foreground. The apparently simple composition is made more complex by the reflection of the faces of the king and queen in the mirror on the rear wall. Velázquez has drawn us into a sophisticated game by unexpectedly reversing the space. The semblance of the "classic" court portrait proves to be a subtle, intellectual illusion.

The composition's ambiguity is underlined by the presence of a self-portrait of the artist in the act of painting this work. The vast canvas is turned away from us, however, and in this position Velázquez can only paint his models' backs. The cerebral interplay of inside and outside, in front and behind, becomes a veritable labyrinth.

The star of the scene is the Infanta Margarita, King Philip IV's first-born child, whom Velázquez painted many times over the last decade of his career. In *Las Meninas*, he portrays a dainty five-year-old girl who has inherited her father's beautiful blonde hair. Surrounded by affected simpering courtiers, she seems bound to become the perfect court puppet. Margarita's rosy face was gradually to assume the elongated, slightly horsey features of the Hapsburgs, and the unattractive protruding lower jaw (apparently in the genes of the Spanish royal family from Charles V onward) would soon put in an appearance.

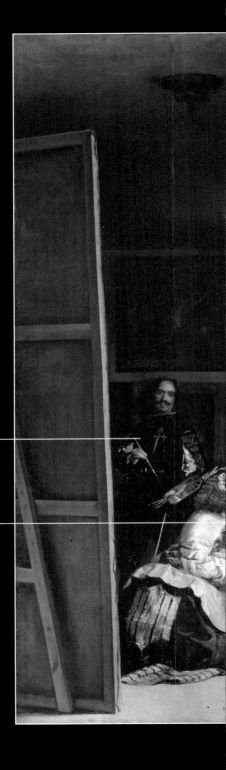

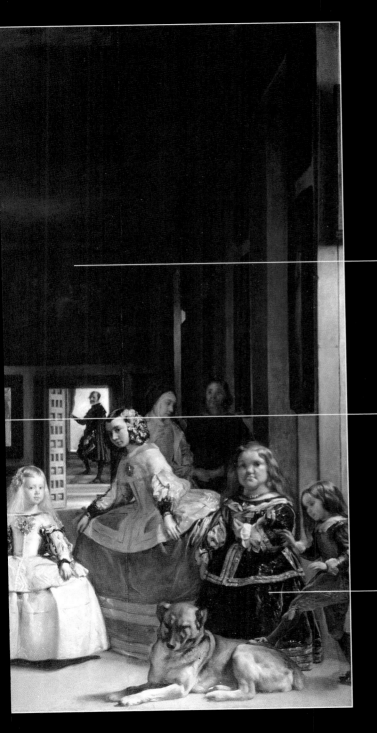

Velázquez sets the scene in a room in the Alcázar in Madrid that can be identified as the first-floor gallery of Prince Balthazar Charles's apartment, whose windows overlooked the Garden of the Emperors. This room, conveniently near the king's, was given to the painter as a studio after the young prince's untimely death. The large mythological paintings on the walls are copies of originals by Rubens and Jordaens painted by Velázquez's son-in-law, Juan Baptista del Mazo.

King Philip IV and Queen Marianne of Austria are both spectators and participants in the scene. Their reflection in the mirror implies their presence "outside" the painting, on the side of the viewer (like the technique used by Van Eyck in his celebrated *Arnolfini Portrait* centuries before).

The dwarfs Maribarbola and Nicolasito Pertusato are elegantly dressed, perhaps in cast-off clothes from the Infanta. Velázquez's portraits of court buffoons are a characteristic feature of his oeuvre, and were later greatly admired by Goya and Manet.

171

Spain
1598-1700
The "Siglo de Oro"

Glory and Disillusionment

In the context of world art and literature, the seventeenth century was Spain's *siglo de oro* (golden century). It was indeed a glorious century, whose cultural achievements made the country an essential reference point for understanding the dreams, anxieties, doubts, and splendor of the era. Undoubtedly, the most representative painter of the period was Velázquez, one of the truly great artists of the seventeenth century, and all Spanish painters (especially those from his native Seville) came under his influence. Many of the great masters, in fact, were from the Seville School, including Zubarán, Murillo, and Valdés Leal, however, each of these painters expressed his own vision of the world, thus reflecting the range of emotions in Spanish Baroque art. At the time, Spain was a country of great contradictions, torn between dreams of glory and a harsh reality, between its proud position as the hub of an intercontinental empire, and the daily misery of life in a sun-drenched land. One could take refuge in a tragicomic view of the world, like Cervantes' hero, or escape into mysticism or oblivion. In the words of Calderón de la Barca's desperate, epic poem, "Life is a dream". Seventeenth-century Spanish painting offers a touching image of dreams and life, of illusion and reality.

Bartolomé Esteban Murillo
Two Women at a Window,
c. 1670
National Gallery of Art,
Washington, D.C.

In addition to his passionately devout religious works, Murillo painted important images of the daily life of ordinary people, whom he generally portrays with amused sympathy using a highly refined technique.

Francisco de Zurbarán
St. Casilda, 1630-35
Thyssen-Bornemisza
Collection, Madrid

Zubarán (1598-1664) did not care for dynamic compositions, but his static scenes and figures have a spiritual intensity and inner life that outweigh action and unfolding events. Typical of his work are his series of paintings of monks, saints, and Virgins, with intense expressions, and frozen in eloquent poses. His images of infant and young girl saints, dressed in sumptuous garments, are particularly fascinating (if not disturbing). They gaze at the viewer in surprise or even astonishment, and are powerfully defined by a light reminiscent of Caravaggio.

Juan Sánchez Cotán
Still Life with Fruit and Vegetables,
1602-03
José Luis Várez Fisa Collection,
Madrid

Far-removed from the exuberant
magnificence of other paintings
of this period, Spanish still lifes
depict a moment of solitude and
contemplation, and an intense,
fascinating synthesis. Some fruit
and vegetables hanging in front
of a black backdrop, become a
window onto the Absolute for
the mystic Carthusian monk
Sánchez Cotán (1561-1627).
Such paintings reveal the opposite,
though no less meaningful face
of the more exultant and complex
religious compositions of
the Spanish Baroque.

Francisco de Zurbarán
St. Margaret, 1635-40
National Gallery, London

Juan Valdés Leal
Way to Calvary
1657-60
Prado, Madrid

Valdés Leal (1622-
1690) represents
the anguished side
of all-consuming
devoutness. Reminiscent
of a popular miracle
play and in keeping
with Spanish religious
feeling, this painting
clearly draws its inspiration
from the large groups
of figures carried in
processions. Christ seems
to loom over us, crushed
by the weight of the terrible
cross. The rough wood
extends out of the picture,
while the thorns cause
blood to run down His face.
Valdés Leal stands out in
seventeenth-century Spanish
painting by virtue of his bitter,
desperate religious sentiment,
and he has created some
of the most striking works
of Baroque art.

Naples

1606-1705

The Neapolitan School

From Caravaggio to Luca Giordano

The above dates define a particularly vibrant century of art and architecture in Naples. Caravaggio arrived there in 1606 for the first of his two stays; his second stay was from 1609-10, just before his tragic death. These were two exceptional periods, not only for the memorable works Caravaggio produced, but also for the rapid development of the local school. Luca Giordano, a brilliant and versatile artist whose work is the key to understanding the transition between the seventeenth and eighteenth centuries in Italian art, died in 1705. Throughout the entire seventeenth century, the Neapolitan School produced an uninterrupted series of outstanding painters and became renowned as one of the most exciting centers of figurative art in Europe. These artists worked in a wide variety of formats, from large-scale decorative frescoes in Baroque churches to still lifes and other canvases painted for private collectors. The Neapolitan painters rapidly assimilated the innovative elements of realism, use of light, and intense emotional involvement introduced by Caravaggio, as can be seen in the large number of altarpieces and religious works of the period. The Spanish artist Jusepe de Ribera (1591-1652) arrived in Naples in 1615, broadening the field of potential subjects and adding a down-to-earth note by depicting the life of the common people. The presence of recognized masters of classicism from the Emilia region, such as Guido Reni and Domenichino (who came to fresco the Chapel of San Gennaro), inspired Cavallino (1616-1654) and other painters to work toward a carefully studied refinement. Meanwhile, the imaginative painter Mattia Preti's influence led to the adoption of a brighter, richer palette and finally, Luca Giordano (1634-1705) crowned the century with his inexhaustible creativity.

Mattia Preti (1613-99)
The Banquet of Baldassare,
c. 1660
Museo di Capodimonte, Naples

Mattia Preti moved to Naples in 1656, the year of a terrible plague. His stay was brief but memorable, coinciding, in fact, with the central and most active period of his career. During his five years there, he painted nearly all of his most important works, demonstrating his remarkable inventiveness and technical expertise. By blending Caravaggio's use of light and the opulence of sixteenth-century painters in his own novel way, he marked a turning point in the style of the Neapolitan School and paved the way for Luca Giordano's eclecticism.

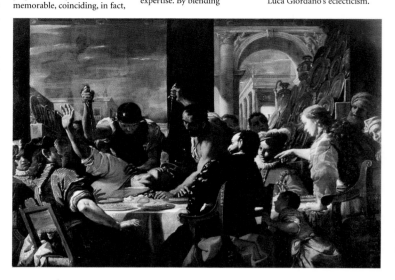

Jusepe de Ribera
Jacob's Dream, 1639
Prado, Madrid

Ribera, the link between Spanish painting and the Neapolitan School, was one of the most original Caravaggesque artists.

Although he spent much of his career in Italy, many of his works were commissioned by Spaniards. The Duke of Osuna, the Spanish viceroy in Naples, appointed him court painter, thus introducing him into Neapolitan artistic circles, and commissioned major works for Jativa (his hometown in Andalusia).

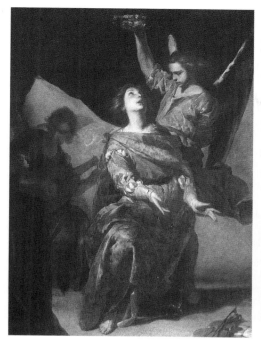

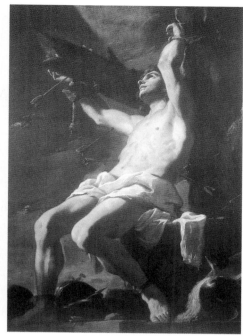

Mattia Preti
St. Sebastian, c. 1660
Museo di Capodimonte,
Naples

It is difficult to place Preti in
a particular school, although
he can generally be associated
with Neapolitan painting.
After studying art in his
family's rather traditional
workshop in Calabria,
he moved to Rome while
he was still quite young.
Being both extremely talented
and very sociable, he was
noted by artistic and noble
circles in the Eternal City
and success soon followed.
In 1642, at the early age of 29,
he was admitted to the
Order of the Knights of Malta
(Caravaggio had received
the same honor almost forty
years earlier). It is Caravaggio,
in fact, who inspires the
intense realism and use of
light in Preti's work.

Bernardo Cavallino
St. Cecilia in Ecstasy, 1645
Museo di Capodimonte,
Naples

Luca Giordano
*Perseus Turning Phineas and
his Followers to Stone,* 1680
National Gallery, London

Luca Giordano was attracted
to the spectacular quality
of Pietro da Cortona's work
and to the Venetian tradition
(which likewise inspired
Mattia Preti during the same
period). As a result,
Giordano abandoned his
initial chiaroscuro and
developed a more luminous,
imaginative and dynamic
approach in the many
paintings he executed for
churches in Naples. This new
style effectively combined
various currents and reached
its height during his second
trip to Florence and Venice.
Luca Giordano's free,
animated figures broke the
rules of classical painting,
providing a foretaste of
eighteenth-century art.

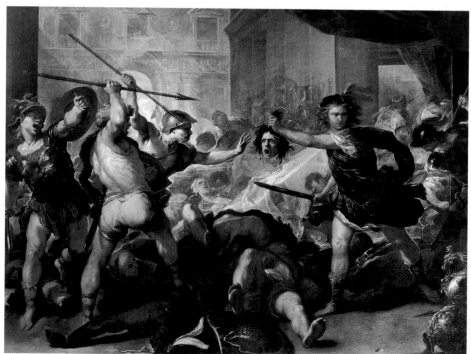

Lorraine

1593-1652

Georges de La Tour

Observing Life by the Still Light of a Candle

Lorraine, a region fought over by France and Germany for centuries, jealously guards the fascinating secret of the life of this leading, yet isolated, figure in seventeenth-century European painting. Only about thirty of La Tour's canvases, all of them astonishing, remain dispersed in museums throughout the world, but strangely, only two are precisely dated. Nicknamed *peintre du Roi*, La Tour lived quietly in Lunéville, his wife's hometown, however, we know very little about the life of an artist who was surely renowned in his day. We have no record of La Tour visiting Rome, but it seems evident that he had first-hand knowledge of Caravaggio and this influence is evident throughout his career. It is strongest, however, in his choice of subjects for his earliest works: cardsharps, gypsies, beggars, street musicians, and "rogues" in scenes depicting humanity adrift on the margins of society. Later, in his forties, La Tour discovered candlelight, a motif that was to render his work unmistakably unique. His nocturnal scenes are plunged in darkness, dimly lit by a flickering flame whose light defines faces, expressions, and gestures with striking precision, isolating them from the surrounding shadows. La Tour favored motionless, intent figures or slow, gentle movements, rendered with serene, poetic tenderness.

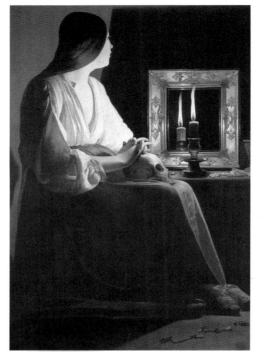

Georges de La Tour
The Penitent Magdalen,
1638-43
Metropolitan Museum of Art,
New York

Mary Magdalen's repentance is La Tour's favorite subject. This painting, with the double image of the candle reflected in the mirror, is probably the most intensely poetic version. The sinner has changed her life in a moment of profound solitude. Her hands are resting on a skull, the obvious symbol of Vanitas, the transitory nature of all earthly things. Using a very clever compositional device, La Tour gives the impression that Mary Magdalen is looking at herself in the mirror, even though we can only see the candle's reflection. Her meditation thus becomes a form of introspection and the depths of the mirror conceal an image of her soul.

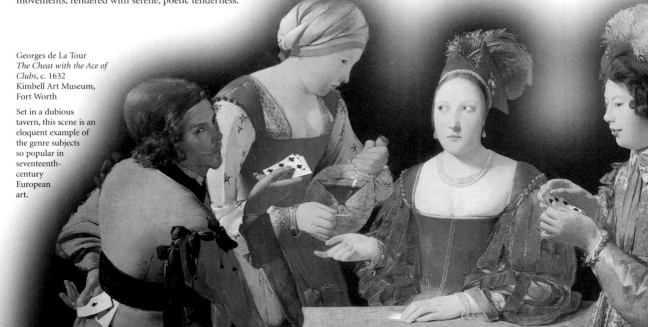

Georges de La Tour
The Cheat with the Ace of Clubs, c. 1632
Kimbell Art Museum,
Fort Worth

Set in a dubious tavern, this scene is an eloquent example of the genre subjects so popular in seventeenth-century European art.

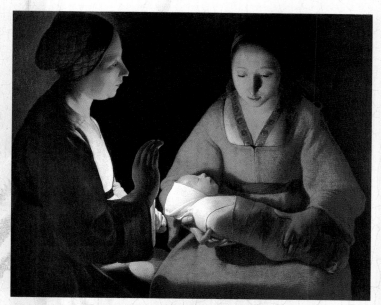

Georges de La Tour
The Newborn, c. 1648
Musée des Beaux-Arts, Rennes

Of all the seventeenth-century European painters, perhaps only Vermeer comes close to seeing such poetry in everyday life. This is no Madonna and Child, but an ordinary mother gently cradling her sleeping infant.

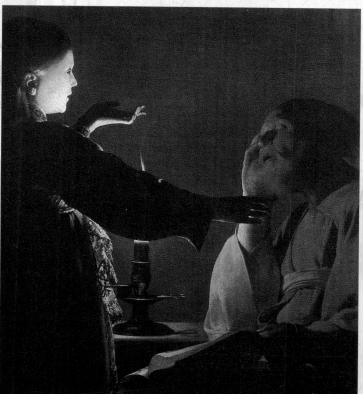

Georges de La Tour
The Dream of St. Joseph,
1640-45
Musée des Beaux-Arts, Nantes

Here La Tour adds a further touch of virtuosity as he elaborates the theme of the candle-lit nocturnal scene. The candle is partially hidden by the angel's hand and arm, thus creating magic effects of reflection and backlighting.

Candles and Confusion

A word of caution when it comes to sources of light. Very often on seeing a nocturnal scene with candles or torches painted by a seventeenth-century European artist Caravaggio immediately springs to mind. However, it must be remembered that the Italian painter hardly ever showed any light sources in his paintings.

He preferred lateral illumination, from outside the canvas. The presence of candles, so characteristic of La Tour, is an independent development of the style launched by Caravaggio and not a direct reference to him.

Rome and Bologna

1590-1642

The Bologna School

"Felsina pittrice": Two Generations of Great Artists

Classicism was largely popularized by the masters from the Emilia region, beginning with Annibale Carracci. It was then taken up and developed by French painters (like Nicolas Poussin), eventually becoming a major current in seventeenth-century painting. The classical style also gained ground thanks to the spread of the academies, where aspiring painters received a well-rounded education, acquiring specific technical training as well as an eclectic cultural background. They were taught to interpret complicated subjects taken from Greek and Roman mythology and literature. Bologna, the second most important city of the Papal State after Rome, produced a series of celebrated painters, many of whom subsequently spent years working in Rome. Guido Reni became the leader of the Bologna School after the Carraccis. His works are the consummate expression of art based on the Idea, the formal control of the emotions, and a perfect balance between the elements of painting: light, color, expression, draftsmanship, and composition. His utterly pure style achieved an ideal equilibrium between precision of form and density of expression, compositional harmony and fidelity to the subject. Until the second half of the nineteenth century, Reni was considered an essential model and point of reference.

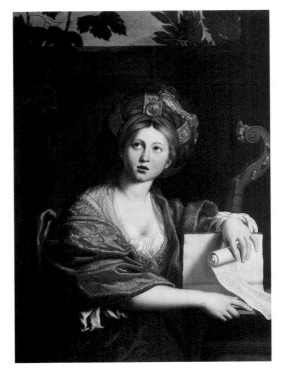

Domenichino
The Sibyl of Cumae, c. 1610
Pinacoteca Capitolina, Rome

Domenichino (1581-1641), an exemplary master among the Bolognese classical painters who settled in Rome, openly declared his admiration for Raphael, who was considered the insuperable model of "modern classicism".

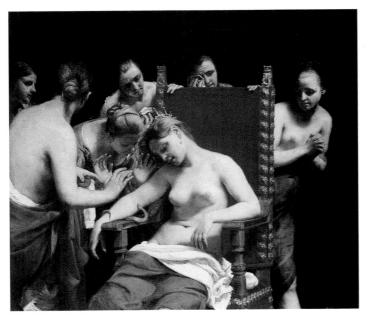

Guido Cagnacci
The Death of Cleopatra, 1658
Kunsthistorisches Museum, Vienna

Cagnacci (1601-1663) is the most sensual of the Emilian painters and his nudes introduced an overtly erotic note into the art of seventeenth-century Europe. Cagnacci's career ended rather unusually; while nearly all of his older colleagues chose to go to Rome or Naples, he went north and lived at the court of Leopold I in Vienna from 1658 until his death. This can be seen as a small but significant sign of the gradual decline of Italy's central role in the world of art.

Guercino
The Return of the Prodigal Son,
1619
Kunsthistorisches Museum,
Vienna

Guercino's oeuvre (1591-1666)
may at first appear
contradictory: while his early
paintings were impetuous and
full of dramatic chiaroscuro,
his mature works were polished,
clear, and absolutely classical.
However, his lengthy career
effectively sums up the general
evolution of Italian art
in the seventeenth century.
His youthful works,
characterized by very strong
chiaroscuro, intense contrasts,
and paint applied in patches,
were seemingly influenced
by Caravaggio, but actually are
a direct legacy of Titian and
the art of the town of Ferrara.

Annibale Carracci
Homage to Diana, detail
of the frescoes in the Galleria
Farnese, 1597-1602
Palazzo Farnese, Rome

The long and exhausting job
of decorating the Galleria
Farnese represents the high
point in the career of Annibale
Carracci (1560-1609), the
leading exponent of the
Bologna School and founder
of the Accademia degli
Incamminati. The grandiose
hall marks the end of the
Italian Renaissance and the
triumphant beginning of
classicism as one of the
main currents in the
European Baroque.

Guido Reni
Atalanta and Hippomenes,
1622-25
Museo di Capodimonte,
Naples

This is one of the most
essential and successful
of Guido Reni's (1575-1642)
mythological paintings.
Although the theme lends itself
to a dynamic interpretation,
Reni chooses a sophisticated
stylistic device: he makes the
glowing bodies of the two
contenders intersect in
counterbalanced positions
against a blue-brown
background of sky and
earth. The scene depicts the
mythic race between the
invincible, fleet-footed
Atalanta and the cunning
Hippomenes who drops
golden apples along
the path, hoping to tempt
Atalanta's feminine vanity.
As she stops to pick
them up, the slender young
man passes her and wins
the race. Only their fluttering
pepli give any idea of
motion in this studiedly
classical painting.

Italy

1600-1650

Cities and Masters of Baroque Painting

A Concert with Many Soloists

It may or may not be true that all roads lead to Rome, but the Eternal City was certainly the focus of Baroque painting. Nonetheless, the polycentrism of Italian art continued into the seventeenth century and there was a constant interchange of styles, experiences, and ideas between the still active local schools. Bologna and Naples during this period have already been described in separate sections. Venice and Florence went through a relatively quiet phase, although many of the leading painters were originally from Tuscany and the Veneto but had settled elsewhere. Milan, under the spiritual and cultural guidance of Federico and Saint Carlo Borromeo, produced an interesting generation of painters, who shared a desire to create a new kind of religious painting. Genoa's aristocracy supported the rise of a group of artists oriented toward Flemish models. In Turin, capital of the Savoy kingdom, new developments in architecture went hand-in-hand with a revival in painting. Finally, other independent "minor" centers of painting continued to develop in Italy, though less impressively than in the fifteenth century.

Domenico Fetti
Melancholy, c. 1622
Gallerie dell'Accademia, Venice

This painting relies on an intriguing cultural approach achieved by combining the realistic tangible portrayal of the shapely girl with erudite allegorical allusions. Fetti (1589-1624) gives a somewhat full-blown Baroque interpretation of the symbolism previously used in a famous engraving by Dürer. The woman is a personification of the particular state of mind known as the "melancholy humor" in the Renaissance medical-philosophical tradition.

Pietro da Cortona
Allegory of Divine Providence, 1633-39
Palazzo Barberini, Rome

Pietro da Cortona (1596-1669) was both an imaginative painter and a master of Baroque architecture in Rome. Here he gives a brilliant, sumptuous expression of the most theatrical and extravagant pictorial current in seventeenth-century Europe. In fact, he is the last stylistic model in the triad of the century's principal artistic trends: naturalism (Caravaggio), academic classicism (Carracci and Reni), and lavish Baroque (Bernini and Pietro da Cortona).

Tanzio da Varallo
*St. Carlo Borromeo Giving
Communion to the Plague
Victims,* 1611-12
Parish Church of Santi
Gervasio e Protasio,
Domodossola

Tanzio (c.1580-1635),
a "provincial" representative
of seventeenth-century
Lombard art, conveys
his deep sympathy for
the common people in
compositions that are truly
monumental. The prelates
behind the saint form a very
effective group of portraits.

Bernardo Strozzi
The Cook, 1620
Galleria di Palazzo Rosso,
Genoa

This work is a kind of link
between Italian and Flemish
art. In fact, kitchen scenes
were very common in
seventeenth-century Flemish
and Dutch painting, and this
cook from Genoa is similar to
her northern predecessors.
However, Strozzi (1581-1644)
is innovative in spirit and
style. He skillfully depicts
the feathers, metal objects,
and various surfaces like
the Flemish masters, but his
attention is focused on the
girl—a lively, likable presence
whose smile, flashing between
the fire and the utensils of
the well-run kitchen, conveys
a very human quality.

Orazio Gentileschi
Annunciation, 1623
Galleria Sabauda, Turin

This Tuscan painter strikes an
intelligent balance between the
demands of his aristocratic
clients and the "modernity" of
direct realism, which is warm
though never harsh or vulgar.

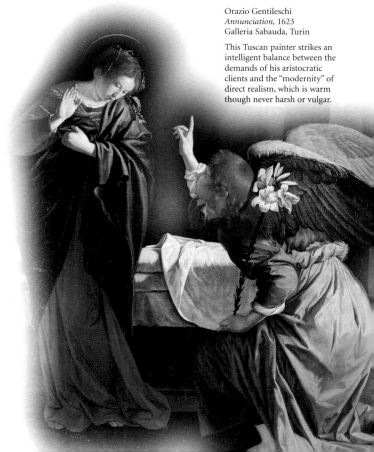

Paris and Rome
1594-1665
Nicolas Poussin

The Most "Classical" of the Baroque Painters

Although the seventeenth century was full of contradictions and excesses throughout Europe, such contrasts appear even more evident and extreme in France. Science and philosophy laid the foudations for the modern method of studying natural phenomena and exalted the potential of the spirit and the mind. Meanwhile, the court of Louis XIV, the Sun King, basked in extravagant, paradoxical luxury. Cultured and sophisticated, Nicolas Poussin was the perfect intellectual artist. He spent so much of his life in Rome he came to be known as "the most Italian of the French painters". His paintings are the highest expression of seventeenth-century classicism, based on reinterpretations of carefully selected ancient models and Italian Renaissance themes, especially those of Raphael and Titian. His landscapes are likewise exceptional; they are partially inspired by the Roman countryside but elevated to become expressions of universal harmony. Thanks to Poussin, the concepts put into practice by the painters from Emilia assumed the status of "official" painting *par excellence*. For at least two hundred years, until the end of the nineteenth century, the classical model was to dominate in fine arts academies throughout the world.

Nicolas Poussin
Self-Portrait, 1650
Louvre, Paris

Poussin was born into a noble but impoverished family. After a turbulent childhood in Paris he met the Italian poet Giambattista Marino, "virtuoso" of Baroque poetry. On Marino's advice, Poussin moved to Rome in 1624, entered the Bologna circle of classical painters and received commissions from Cardinal Barberini. He did not, however, lose contact with his French public. During the few years he spent back in Paris (1640-42), Cardinal Richelieu appointed him "first painter to the king".

Nicolas Poussin
*A Bacchanalian Revel Before
a Herm of Pan*, 1631-33
National Gallery, London

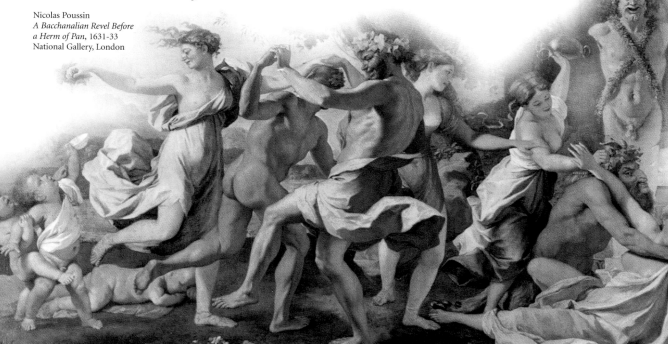

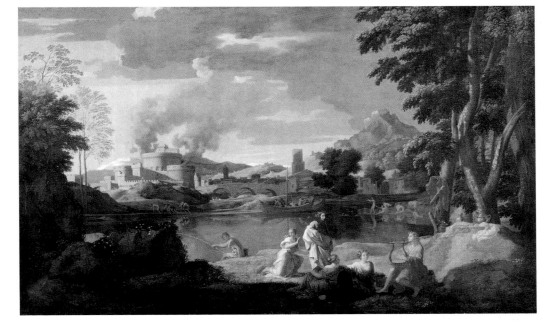

Nicolas Poussin
Landscape with Orpheus and Eurydice, 1648
Louvre, Paris

Poussin's landscapes epitomize classicism, a movement of refined high culture, almost in direct opposition to the violence and everyday subjects of Caravaggio. In addition to an impeccable painting technique, the classical masters had to be well-versed in humanism and demonstrate a thorough knowledge of literary, mythologic, and historic subjects. The ancient Roman roots of Poussin's classicism are constantly evident: here Castel Sant'Angelo appears in the background of the painting.

Nicolas Poussin
Landscape with Polyphemus,
1649
Hermitage, Saint Petersburg

This is one of Poussin's most celebrated landscapes. Typical of his way of interpreting antiquity, there is no trace of the drama of Homer's epic. The giant Polyphemus appears in the background, seen from behind seated on a hill playing the flute. If anything, the idyllic scene recalls the bucolic world of Virgil and a state of peaceful communion between man, nature, and the divine.

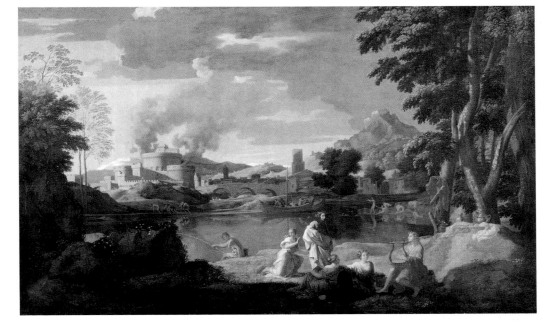

Lorraine and Rome

1600-1682

Claude Lorrain

Landscape: the Classical Ideal and the Magic of Light
Destined to serve as a fundamental model for all landscape painters at least until Corot and the English and German Romantics, Claude spent most of his life in Rome, where he had settled at the age of thirteen. He joined the circle of the Bolognese classical painters and was also in contact with the French *pensionnaires* in the city. He specialized exclusively in the natural landscape genre. The countryside of the Latium region, with its ancient ruins, tall trees, calm seas, lakes, and distant mountains, became the setting for an enchanted, idealized world. This direct observation of nature included figures, mythological episodes, and evocative architectural elements (including accurate depictions of existing ruins that anticipated the archaeological views of the following centuries), involving a studied use of light and a blend of reality and fantasy.

Claude Lorrain
Landscape with a Sacrifice to Apollo, 1662-63
Anglesey Abbey,
Cambridgeshire

Claude Lorrain
Seascape, 1674
Alte Pinakothek, Munich

The sun reflecting on the gentle waves of ports, coasts, and calm lakes is a recurrent theme in Claude's landscapes. In particular, these conditions allow him to experiment with an unbroken continuity of space and light. The resulting dazzling sun and landscape fading into the distance seem to anticipate Turner.

Claude Lorrain
*Landscape with the Marriage
of Isaac and Rebekah*, 1648
National Gallery, London

In his mature works, under
the influence of Annibale
Carracci and Domenichino,
Claude's landscapes become
more sweeping and serene.
The presence of country folk
dancing (obviously they too
are idealized) is a motif that
was to be overused in the
"Italian" landscapes of
the following centuries.

"Rome, how beautiful you are!"

*The "Roman landscape", which reworked the style
and settings invented in the "ideal landscapes" of
seventeenth-century painting in Emilia and
France, became established on the European art
market as a virtually separate genre. The birth of
the veduta around 1675 coincided with the arrival
in Rome of the Dutch artist Caspar van Wittel
(1651-1736; left, his veduta of St. Peter's Basilica).
Van Wittel had too strong a sense of reality to attempt any classically
oriented idealization. In fact, he was probably one of the first to use a
camera obscura, a viewing device whose system of projecting an image
onto a flat surface was technically similar to a photographic camera.
The "Roman landscape" genre continued to enjoy great favor until
Corot and Turner. It functioned on many different levels: as an exercise
in perspective for young artists, as a theme that was sure to sell well, as
a nostalgic evocation, or as a Romantic interpretation of nature and
the past.*

Paris and Versailles

1640-1715

The Years of Grandeur

"L'état, c'est moi"

The ambitions of the French court became manifest during the long, splendid period of Baroque painting. Thanks to an interchange with other countries (a respected group of French artists had settled in Rome, while Rubens and Bernini visited Paris), the Paris School of painting was one of the most varied and dynamic in Europe. Two trends dominated the first half of the century: the refined classicism of Poussin and the severely decorous, lofty tone of Philippe de Champaigne, Richelieu's favorite. However, Louis XIV's prolonged reign from 1661 to 1715 saw a shift in taste and in art, which became an expression of absolute power. The Sun King made himself and his image the focus of attention. The monarch was surrounded by an elaborate ceremonial system, in which even the most insignificant and intimate moments of his life became a spectacle to be played out before a select audience of courtiers—all part of the lavish celebration of the king's person. The favorite setting was Versailles, where the union between architecture, sculpture and painting begun in the Baroque churches of Rome was created in a secular context. Charles Le Brun, director of the Academy and the Royal Manufactories, received many painting commissions, while Hyacinthe Rigaud was the official court portraitist.

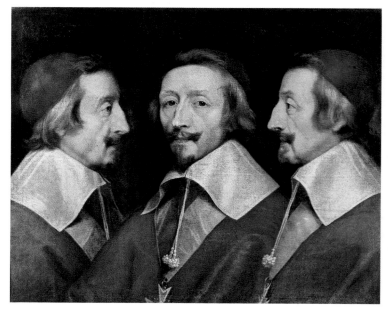

Philippe de Champaigne
Triple Portrait of Cardinal Richelieu, 1642
National Gallery, London

A cold, taciturn, and tenacious man, Cardinal Richelieu skillfully inspired and guided French politics during the reign of Louis XIII, subtly determining the destiny of individuals and the nation itself. He felt a particular affinity with the severe and keenly introspective art of Philippe de Champaigne (1602-1674), entrusting him with many prestigious commissions. This triple portrait was probably not intended as an exercise in virtuosity, but rather as a model for a sculpted bust of the Cardinal.

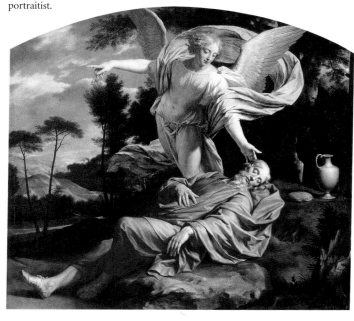

Philippe de Champaigne
Elijah's Dream, c. 1660
Musée de Tessé, Le Mans

The painter's strict moralism was similar to that of the Jansenites of Port Royal.

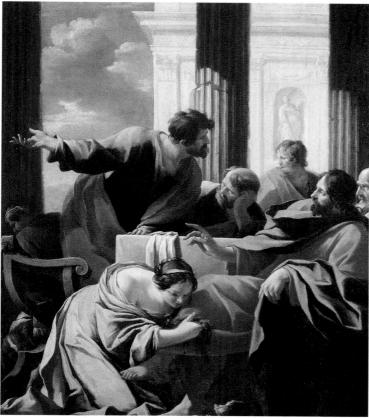

Simon Vouet
*Mary Magdalen in the House
of Simon*, c. 1630
Private Collection

Vouet (1590-1649) belongs
to a large group of French
Baroque painters who spent
a significant part of their
careers in Italy, and by 1613
he was already in Venice.
He soon moved to Rome,
where he quite successfully
combined Caravaggio's
luminism with grandiose
theatrical techniques. After
1627, when he was elected
president of the Accademia
di San Luca, his compositions
became more solemn and
luminous. Upon his return
to Paris, he was appointed
premier peintre to King
Louis XIII.

Hyacinthe Rigaud
Louis XIV, 1701
Louvre, Paris

Magnificent and solemn
to the point of absurdity,
the Sun King so perfectly
epitomizes the stereotype of
a monarch that he resembles
an actor in the Comédie
Française. Resplendent in
a cloak lined with ermine, the
king poses in an oppressive
setting heavy with fabrics and
is surrounded by the obsessive
heraldic device of
the state, the
golden fleurs-
de-lys on a
blue ground.

The Le Nain Brothers' Peasants

*The elegiac scenes of peasant life paint-
ed by the three brothers, Antoine,
Mathieu and Louis Le Nain, counter-
balance the pompous classicism of offi-
cial painting in seventeenth-century
France. The brothers grew up in the
provinces and based their paintings on
Flemish models. Yet, their particular
quiet mysticism and sober austerity seem to foreshadow
Millet's Romantic compositions, or even Van Gogh's miners.
Louis (1593-1648), the most talented of the three, had quite
a successful career. He traveled to Rome in 1629-30, and on
his return to Paris, was much in demand on the art market
and among collectors.*

Amsterdam, Delft, Leyden, and Utrecht
1582-1670
The Dutch Painters

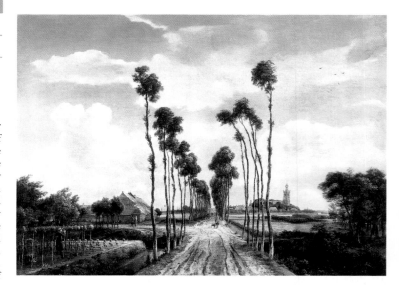

The Golden Age of a Young Nation

At the end of the sixteenth century, after a bitter war against Philip II of Spain, the seven United Provinces of the Low Countries gained independence. One of these was Holland, where the main cities and activities were concentrated. The United Provinces, a republic ruled by *stadtholders* (governors) of the House of Orange, though they had a great deal of local autonomy, suddenly found themselves a major European power. In the space of a few decades, this small population—living in a flat landscape crisscrossed by canals and dotted with windmills, and constantly battling against the sea—emerged from anonymity to become the envy of the entire continent. Thanks to the East India Company, the ports of Amsterdam and Rotterdam flourished as financial and trading centers. By the beginning of the seventeenth century, having established a secure basis of widespread wealth, the Dutch felt united and proud. The culture of seventeenth-century Holland is amply reflected in its painting. Thousands of small episodes depict distant, monotonous landscapes, with children skating happily on the frozen canals; the quiet life of the hard-working women, who sweep and scrub the house as they wait for their husbands; well-off, slightly hefty cavaliers easily tempted by the pleasures of the tavern and drinking sessions with their old comrades-in-arms. There are also images of craftsmen and professionals gathered in sedate meetings of confraternities and guilds; good-natured, reliable village doctors; cunning peasants and pipe smokers; adorable children in their starched caps; and young servant girls with shining eyes. The markets are displayed overflowing with merchandise and spices from the Orient are shown on the quayside of the ports. But above all, there are images of neat, bright rooms in perfectly-kept homes, with a child's forgotten toy on the polished floor; tables just abandoned by the diners, with a twist of lemon peel, a Chinese porcelain vase, crumbs of a clumsily-sliced cake, and some pieces of a broken walnut. The more closely one examines Dutch paintings, the more details one sees: light sparkling on pewter, shining glass windows, the immaculate lane in front of a house, the blue and white ceramic Delft tiles of a wainscot, the inlaid armoire scented with lavender, containing carefully-folded, bleached-white sheets. In very few cases in the history of art has an entire population been so fully revealed in their painting.

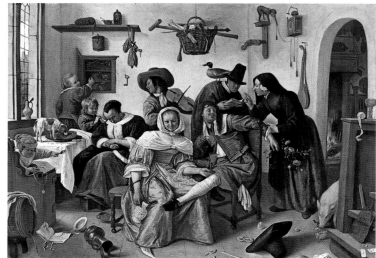

Meindert Hobbema
The Road to Middelharnis,
1689
National Gallery, London

The Dutch painters who specialized in landscapes exerted a strong influence on the genre, at least until the end of the nineteenth century.

Jan Steen
Beware of Luxury, c. 1665
Kunsthistorisches Museum, Vienna

Steen, a Catholic painter in a Calvinist country, depicts unusual, highly symbolic scenes, in which he completely subverts the natural and social order. Severe, moralizing harmony degenerates into

happy parties of drinkers, chaos that invades the home, whimpering children, disobedient dogs, and people sprawled in indecent positions. This is the other face of tidy, devout Holland: village festivals, merry-making, drinking sessions, and sensuality.

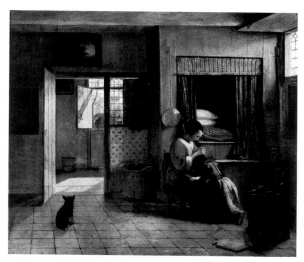

Pieter de Hooch
The Mother, c. 1660
Rijksmuseum, Amsterdam

The world of De Hooch (1629-c. 1684) is pervaded by an idyllic domestic poetry, where everything is part of a kind of superior order and unfolds according to peaceful, familiar rhythms. With quiet grace, he depicts spotlessly clean floors, armoires with their folded, perfumed linens, well cared-for gardens, and swept doorsteps. He is the most fervent, intimate painter of seventeenth-century Dutch society.

Frans Hals
The Laughing Cavalier, 1624
Wallace Collection, London

The earliest portraits by Frans Hals (c. 1580-1666) are virtually the quintessence of Baroque art: in sumptuous garments, the sitters strike majestic, theatrical poses. The details of their costumes, accessories, and above all, their bold expressions reveal confidence in their own resources and in the general situation at the time.

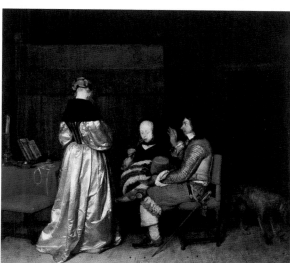

Gerard Ter Borch
*Gallant Conversation
(The Paternal Admonition)*
c. 1650
Rijksmuseum, Amsterdam

This is one of the painter's favorite subjects and he depicted it numerous times. Particularly characteristic of Ter Borch (1617-1681) is the silver, almost lunar reflection on the girl's silk dress, gleaming softly in the quiet shadows of this domestic interior.

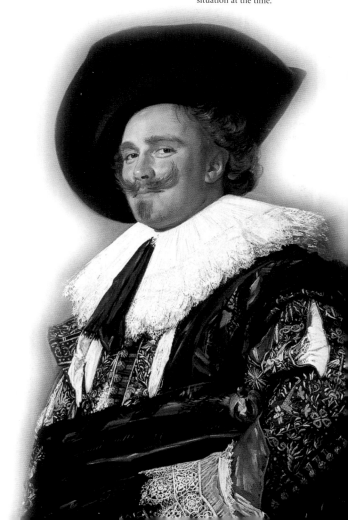

Leyden and Amsterdam
1606-1669
Rembrandt van Rijn

The Power of Color, the Intensity of the Soul

Rembrandt's art follows the course of his life, as is most eloquently and poignantly demonstrated by the series of self-portraits painted over a period of forty years. Son of a miller, Rembrandt's first paintings, portraying his hometown Leyden, were small, very finely-rendered works depicting biblical or literary subjects. After settling in Amsterdam, his fame steadily increased, as did his finances. His first years of marriage with Saskia van Uylenburch were the happiest of Rembrandt's life and he abandoned his small-format early paintings for monumental compositions, similar to those of Rubens and the Italian Renaissance masters. In 1642, his career reached a peak with *The Night Watch*. Saskia's death that same year, however, marked the beginning of a series of misfortunes that led Rembrandt to complete bankruptcy. His most mature style can be compared to Titian's late manner. Toward the end of his life, he produced timeless masterpieces that are intensely human and have a depth of feeling that becomes almost unbearable. The death of his beloved son Tito in 1668 was the last tragic blow in this moving human drama and also to a unique period in the history of art.

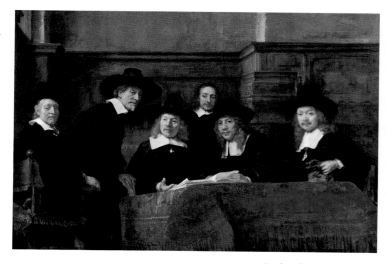

Rembrandt
The Syndics of the Drapers' Guild, 1662
Rijksmuseum, Amsterdam

Thirty years after *The Anatomy Lesson*, Rembrandt returned to the theme of the group portrait.

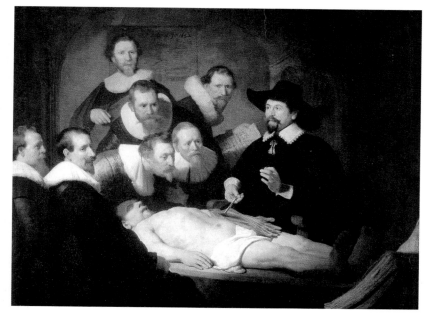

Rembrandt
The Anatomy Lesson of Dr. Nicolaes Tulp, 1632
Mauritshuis, The Hague

This painting, showing Dr. Tulp giving a lesson, was commissioned for the seat of the surgeons' guild in Amsterdam. He is dissecting the left arm of the corpse, exposing the tendons, while his left hand mimes the contractions and movements of the fingers. The anatomical accuracy is evidence of Rembrandt's direct observation. In fact, he is interested in movement and has a knowledge of the human body equal to that of Leonardo.

Rembrandt
Portrait of Jan Six, 1654
Six Collection, Amsterdam

Rembrandt did not paint
a single anonymous or
ordinary face. This penetrating
artist knew how to convey
expressions, gestures, and
even subtle emotion through
his supple, insistent brushwork.

Rembrandt
The Jewish Bride, detail, 1666
Rijksmuseum, Amsterdam

With an impressive mastery
of light, color, and the pigment
itself, Rembrandt strikes
the very chord of tenderness
and love.

The Story of a Life

*The beginning and end of
Rembrandt's career and life are
captured in these two paintings,
both in the Mauritshuis in The
Hague. The forty years between
the youthful Self-Portrait with
Collar (1629) and the Self-
Portrait in 1669 (painted the year
of the artist's death) have taken their toll on his face and body.
The confident and well-built youth has become a weak and hunched old
man with heavy, though still recognizable features marked by a prominent
nose. The application of the paint has also changed radically. The small,
precise strokes of his youth, with the striking note of light gleaming on met-
al, have been replaced by thick, heavy brushwork that absorbs the light.
Rembrandt does not conceal the ravages of time and adversity, though his
expression still possesses a touching dignity and the wisdom of the man and
the artist.*

Rembrandt van Rijn

1642

The Night Watch

The title of Rembrandt's most famous masterpiece
is not a true description of the scene, which depicts
a festive daytime parade rather than a night watch.
This painting was executed to decorate the assembly hall
of the Amsterdam civic militia. There was a tradition
of group portraits of citizen defense organizations,
which were essentially police corps and watchmen that
had been organized during the war of independence,
but were now merely symbolic. In the general dynamic
scheme, twenty-eight adults and three children move
confusedly, generating a sense of disorganized
animation. The striking contrasts of light and color,
the individual portrayal of each character, and the total
mastery of this complicated composition, establish this
painting as the absolute high point of Rembrandt's
career. By a fatal coincidence, the painting coincided
with the death of his beloved wife Saskia from
tuberculosis at the early age of thirty, the first of his
many grievous misfortunes. Thus, the year 1642 marks
a sad watershed in Rembrandt's art and life. From this
moment on, his private life plunged toward seemingly
endless disaster. His painting, however, soared toward
the Absolute, pervaded by awesome existential
intensity and infinite abandon.

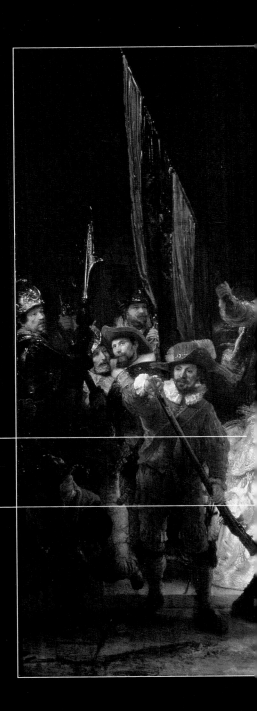

Thanks to the fact that
the contract and other
documents from the period
still exist, it has been possible
to identify many of
the figures in the painting.
The members of the civic
guard shared the artist's fees,
which they paid according
to their rank and prominence
within the painting.
Nonetheless, some
characters and details
remain mysterious, such
as the strange, radiant little
girl running away with
a chicken tied to her belt
(which might be an allusion
to the captain's surname).

The protagonist of the scene
is Captain Frans Banning
Cocq, sober and elegant in his
dark suit and red sash,
enlivened by a large lace
collar. With an authoritative
gesture, he calls on
the lieutenant to bring his
rowdy, unruly company of
harquebusiers to order.
By Rembrandt's time,
this civic militia played little
more than a symbolic role
in Dutch society.

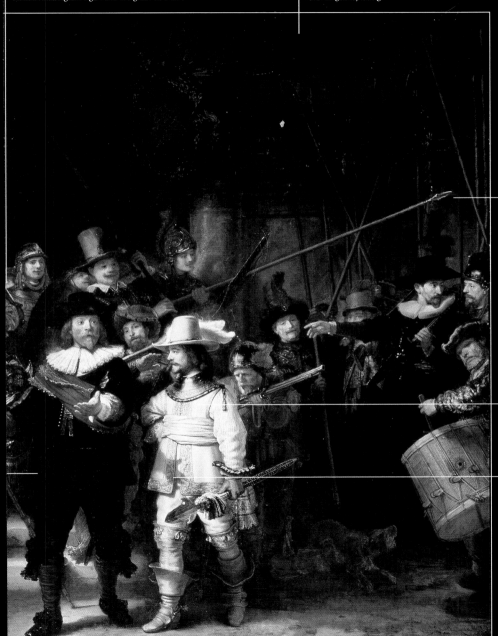

The face of a short man is just visible behind the standard bearer. Only his eyes and beret are recognizable, but these details are enough to identify the character without a doubt. Rembrandt painted himself among the figures in his greatest work.

The scene is set in front of a large hall with an arched entrance. This is the seat of the guild, where the work originally hung.

The Amsterdam volunteer militia consisted of wealthy, upper middle-class men. The group is keen, though somewhat undisciplined. Rembrandt ironically accentuates their unsoldierly conduct. The pikes are all held at random, giving a totally different impression from the perfectly aligned lances in Velázquez's Surrender of Breda. The long diagonal staff also serves to direct the viewer's eye toward the center of the scene.

The most resplendent figure is Lieutenant Willem van Ruytenburgh in his elegant embroidered uniform.

The shadow of Captain Cocq's hand can be clearly seen on the lower part of the ambitious lieutenant's fine jacket. This indicates the angle of the light and is evidence that the scene takes place during the day. The fact that the colors have darkened with time, led to the erroneous interpretation of this painting as a night scene.

Delft

1632-1675

Johannes Vermeer

The Everyday Miracle of Light

Vermeer was a painter of the soul, of peace and of light. He spent his short life in the town of Delft, where he supported his large family by working as an innkeeper and art dealer. This partly explains the very limited number of his known works. The earliest ones, already distinguished by their fine handling, depict religious and mythological scenes in medium- to large-format paintings, more or less in the style of the Delft school. From 1656 onward, Vermeer began devoting himself to motifs taken from everyday life, encouraged by the various artists of the time, including Gerard Ter Borch, with whom he was in contact. This choice resulted in unforgettable masterpieces, fruit of the artist's patient, meticulous technique. Although his work is reminiscent of fifteenth-century Flemish art, especially in his use of color and the value given to even the smallest details, Vermeer interpreted the scenes with his own novel sensibility. His was a simple life, but he established important friendships, particularly with Antonie van Leeuwehoek, the great Delft scientist who invented the microscope. This may be an interesting key to understanding the miracle of Vermeer's painting, which lies in the revelation of the secret life of little things that light unveils to those who have eyes, a heart, and patience.

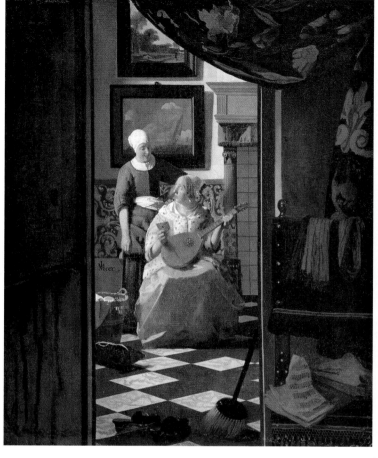

Johannes Vermeer
The Love Letter, 1669-70
Rijksmuseum, Amsterdam

Toward the end of his brief career, Vermeer adopted a somewhat unusual viewpoint. The observer has the impression of being in the shadows of an antechamber where the servant's broom and slippers have been casually abandoned. The room beyond the heavy drape is bathed in light and depicted in rigorous perspective. The love letter creates an atmosphere of female complicity that overcomes the usual social barriers, as the lady and her servant exchange enquiring looks.

Johannes Vermeer
The Lacemaker, c. 1670
Louvre, Paris

This is one of Vermeer's most famous paintings, though it is rather atypical. Unlike his interior scenes, the girl intent on her lacework is depicted in close-up. Thus the image focuses on the figure, while the surrounding space is reduced to a neutral ground. Perhaps it is this simplicity that gives the painting its exquisite delicate charm.

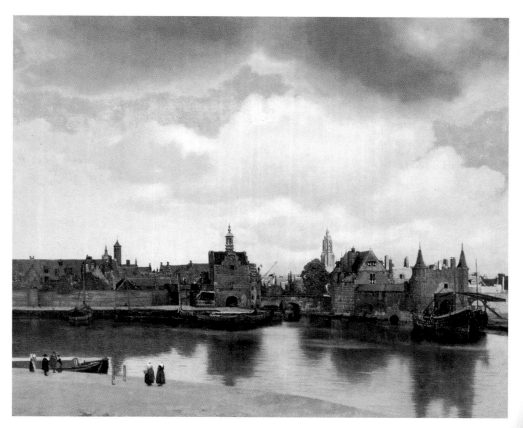

Johannes Vermeer
View of Delft, c. 1660-61
Mauritshuis, The Hague

Vermeer painted landscapes very rarely, but this vista of his hometown is his absolute masterpiece. Proust was particularly fond of this painting and it led to the general public's rediscovery of the artist. Typical of his poetic and stylistic choices, this is by no means a precise, objective view. Only a few buildings correspond to the actual architecture of Delft, which is depicted from outside the walls and beyond the canals that surround the historic center. Instead, Vermeer blends reality and fantasy, affection and free-ranging memory.

A Girl, a Pearl, a Secret

Vermeer should not be considered a portraitist, just as he cannot be strictly considered a landscape painter.
Nonetheless, his work includes such splendid examples of portraits, still lifes, and landscapes that they alone are sufficient to guarantee him a place of honor in each of these genres. With perfect grace and tact, Vermeer calmly and insistently delves into the secrets of the female soul.
Vermeer's female figures have given rise to a great deal of speculation in an attempt to identify them as his wife, sister or other relatives.
The classic example is this girl wearing a turban in a painting held by the Mauritshuis in The Hague.
Although the girl remains unidentified, she has become the symbol of Vermeer's work.
This is a painting of great precision and freshness, in which the light penetrates the pigment, seeming to give it an inner warmth and bringing it to life with details like the pearl earring gleaming in the girl's ear.

Johannes Vermeer
The Kitchen Maid,
c. 1658-60
Rijksmuseum, Amsterdam

Johannes Vermeer

c. 1670

Allegory of Painting

Held by the Kunsthistorisches Museum in Vienna, this painting is generally dated toward the end of Vermeer's brief career. Silence, concentration, and an almost metaphysical purity of image reign in a rarefied atmosphere, created by the perfect arrangement of each element in an ideal composition that alternates between colors and full and empty spaces. This magnificent work can be seen as a kind of spiritual testament. The painter has portrayed himself from behind, sitting at his easel, but at the same time, he shares the observer's viewpoint and has pulled the heavy drape to the left to allow us to see further into the interior of the studio. In the sharp clarity of the bright room, a young woman is posing in classical attire as an ancient muse. All is peace, beauty, and contemplation that becomes action.

The heavy drape acts as a stage curtain, placing the viewer in a different and darker space than the studio. This is a device Vermeer used quite frequently in his last works, as did other painters of interiors, like Pieter de Hooch.

From a compositional standpoint, the *Allegory of Painting* repeats the typical arrangement of Vermeer's interiors: the light enters from a window on the left, a still figure occupies the center of the space, and splendid still life elements lie in apparent disorder on a table. The luminous harmonies of yellow and blue are the Delft painter's favorite colors, while the black and white checkerboard floor seen in perspective gives the precise dimensions of the room.

In this poetic masterpiece where every element arouses emotions and sensations, an absence is felt. The empty chair in the foreground and the map on the back wall subtly suggest that the two people are expecting someone else to arrive.

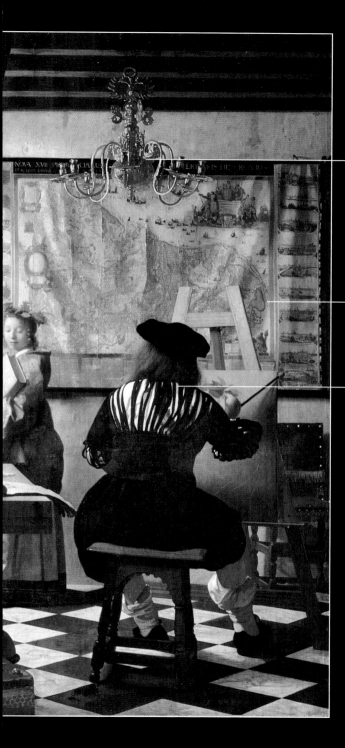

The gilded chandelier, focus of the perspective in the upper portion of the painting, is an exquisitely rendered detail. Its value within the composition is comparable to that of the famous ostrich egg hanging in Piero della Francesca's *Montefeltro Altarpiece,* and is not unlike the chandelier in Van Eyck's *Portrait of Giovanni (?) Arnolfini and his Wife.*

A large, meticulously rendered map of Holland hangs on the back wall. The undeniable skill of the Dutch cartographers expressed the United Provinces' pride in their hard-won independence. Maps frequently adorned Dutch houses as a symbol of national identity.

Strangely enough, we have no documentary evidence of Vermeer's physical appearance, other than this self-portrait… from behind. The artist is concentrating on his work, as he carefully paints his model's blue headdress. His hand is leaning on a stick, used by painters to ensure greater precision and to rest their wrist. The stool is not very comfortable and since the artist is leaning forward one leg is off the ground. This then is Vermeer. No one can say definitively whether this represents a true to life scene or is a free, poetic vision, removed from everyday reality. Nonetheless, it is certainly set in seventeenth-century Holland, since the furniture, ornaments, clothes, and other descriptive details are all depicted extremely realistically. However, Vermeer's paintings are not limited to a particular time or place, but are timeless images of feeling and passion. His consummate technique, based on his mastery of light, gives his works their enduring freshness and moving sense of immediacy.

Paris
1699-1779
Jean-Baptiste-Siméon Chardin

A Master of Silence and Light between Vermeer and Cézanne

The Parisian painter Chardin was the antithesis of court art and the dominant trends in eighteenth-century French painting. He was perhaps the only artist in the 1700s who did not make the customary journey to Rome, or do regular academic studies. His attention was drawn instead to seventeenth-century Flemish and Dutch genre painting, and under this influence, he developed a preference for the poetic aspect of the seemingly insignificant episodes of everyday life. Adverse to the bright, luminous tones of *fête galante* painting, he selected a subdued range of muted shades. While the court artists of his day portrayed piquant and seductive scenes set among the bushes in noble gardens and between the sheets in aristocratic bedrooms, Chardin sympathetically observed middle-class family life, alternating depictions of daily habits, routine gestures, tender feelings, and controlled emotions with still lifes of ordinary everyday objects. However, his art is far from being restrained. Quite the contrary, it is rich in human values and figurative choices that anticipate similar compositions in the nineteenth and part of the twentieth century.

Though an exception on the French artistic scene, Chardin was by no means an isolated artist. He sought to maintain a high profile in Parisian artistic circles and, thanks to the magnificent still lifes he exhibited in Place Dauphine in 1728, the Academy accepted him as a "painter of animals and fruit". In 1737 Chardin realized the importance of the Salons (annual exhibitions that brought artists directly into contact with the public by displaying the most recent works in the field of figurative art), and at the first Salon he showed a total of seven paintings, including the *Girl with Racket and Shuttlecock* (now housed in the Uffizi in Florence), reproduced in the background on this page. This exhibit brought him instant success, and he quickly became one of the leading figures at the Salons and the Academy, taking on heavy social responsibilities. Chardin apparently understood the importance of the visitors' consensus, and his exhibits sparked brilliant and sometimes controversial publicity, including articles and reviews by important men of letters and critics, like Diderot and other protagonists of the Enlightenment. The circulation of these writings also became a further channel of communication between artists and the cultured classes of society.

Jean-Baptiste-Siméon Chardin
The Cook, 1738
Alte Pinakothek, Munich

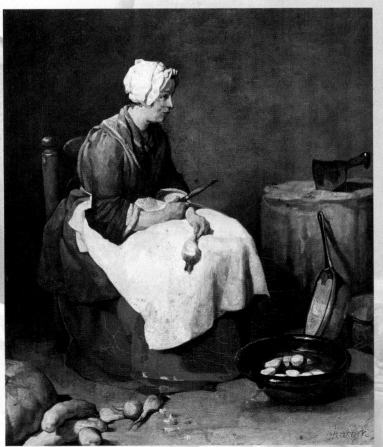

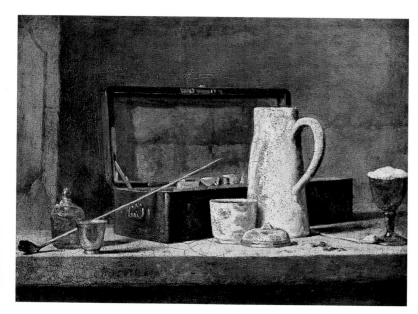

Jean-Baptiste-Siméon Chardin
Pipes and Drinking Pitcher,
c. 1737
Louvre, Paris

Chardin drew up a meticulous inventory of the possessions of his first wife who died in 1737. Among the list of paintings, a detailed description of *Pipes and Drinking Pitcher* appears, which he had evidently given her personally. This is a sign that Chardin was aware of the intimate, touching poetry of his still lifes, especially those that were less commercially accessible. Here Chardin creates a subtle, delicate harmony of blues and whites, and a slight blurring of the objects' outlines, like the dust of memory settling softly upon them.

Jean-Baptiste-Siméon Chardin
The Return from Market, 1739
Louvre, Paris

This painting, exhibited in the 1739 Salon, is particularly striking due to its brilliant composition. The doorway opening onto the copper water tank creates a perspective that projects the girl into the foreground. She has an absent-minded expression as if her thoughts have wandered far away from the simple, realistic everyday setting.

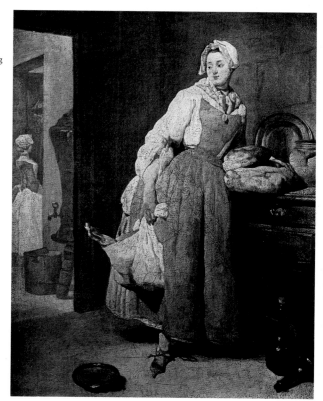

An Unusual Self-Portrait

When Chardin painted this self-portrait he was already 76 years old. Immediately after finishing it he decided to exhibit it at the 1775 Salon, together with the portrait of his second wife Marguerite Pouget, whom he had married thirty-one years earlier. It could have summed up his existence, been one of the last pages in the story of his life. Instead, the painter who showed such a delicate appreciation of reality, gives us an unusual, and unexpected interpretation of himself. At first glance, it appears to be a portrait of the artist exercising his profession, since he is wearing a large pair of eyeglasses, an eyeshade against the bright light, and a kind of turban-bandana. But this might be a disguise. When Marcel Proust saw this painting, he remarked on Chardin's eccentric originality in painting himself dressed as an elderly English tourist. It must be added that this portrait was executed in pastels, a medium Chardin had only begun to adopt a few years earlier. It remains undoubtedly an extremely fascinating work and proves that great artists are never predictable.

Paris
1684-1721
Jean-Antoine Watteau

Nostalgia for a Happy Island

Born in Valenciennes, Watteau moved to Paris when he was twenty-one. Here he mastered the detailed, subtle naturalism of seventeenth-century Flemish and Dutch artists, and also studied the great collections of masterpieces in the Luxembourg and Louvre palaces. His acute perception of historic and social developments caused Watteau to make fundamental choices regarding style and subject matter, making him one of the earliest *fête galante* painters in the European Rococo style. Against a backdrop of shady parks and delightful landscapes, small figures move with a gracefulness that is evoked, rather than painted, by light luminous brushstrokes. The themes treated are part of a vast repertoire of subjects that were popular in eighteenth-century painting, for example, the *Embarkation for Cythera* (the mythical island of love). Watteau painted two versions of this subject, now in the Louvre and in Berlin, which gained him admission to the Academy. The *fête galante* genre depicts seemingly carefree themes: aristocratic receptions, dances, amorous advances, garden amusements, masked balls, theatrical entertainments, and erotic games, usually featuring medium-sized or small figures. Nonetheless a closer examination of Watteau's paintings reveals a feeling of nostalgia, and a profound melancholy that pervades even the dreamiest scenes.

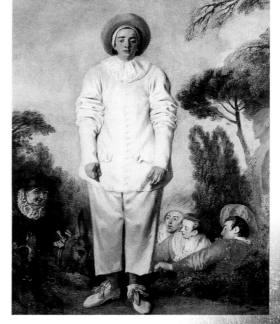

Jean-Antoine Watteau
Gilles
Louvre, Paris

A keen theater lover, Watteau was familiar with the rules of disguise, fiction, and formal relationships. The world of the Commedia dell'Arte masks becomes the theater of anxiety and ambiguity, pervaded by a transitory, precarious atmosphere. Gilles, a kind of pathetic Pulcinella, expresses an impending, deeply-felt loneliness.

Jean-Antoine Watteau
Réunion Champêtre,
1717-18
Gemäldegalerie, Dresden

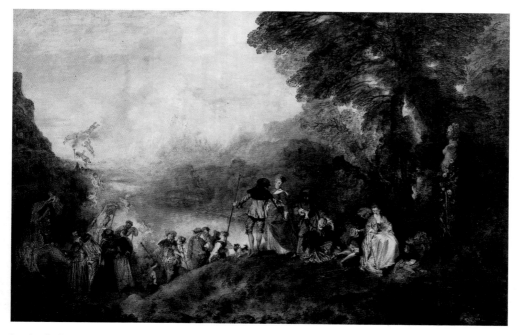

Jean-Antoine Watteau
Embarkation for Cythera,
1717
Louvre, Paris

This work symbolizes the
desire to escape from reality
and take refuge in the
Arcadian dream of a mythic
land of love that is identified
with the Island of Cythera.
The painting is read from
right to left, beginning with
the classical Herm of Venus
(to whom Cythera is
dedicated) decorated with
rambling roses. A couple of
lovers are seated before the
statue, while others are rising
to descend the short slope
leading to the landing stage.
Joyful cupids in flight
welcome the lovers as they
step into the light, elaborately
gilded gondola that will take
them to the island.

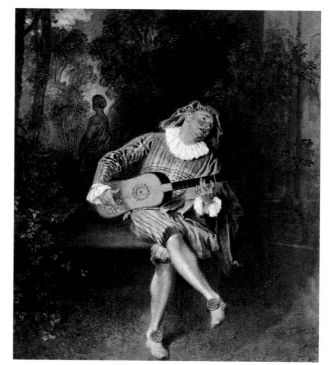

Jean-Antoine Watteau
Mezzetin,
1717-1719
Metropolitan Museum of Art,
New York

Mezzetin, a pathetic mask
from the Commedia dell'Arte,
is depicted here singing a
serenade that is probably
falling on deaf ears. The statue
of a woman with her back
turned in the background
seems to allude to his loved
one's coldness and rejection.

Jean-Antoine Watteau

1720

Gersaint's Shop Sign

One of the largest paintings in Gersaint's gallery depicts an erotic mythological scene with a satyr pursuing a nymph through the reeds. The themes and style of the works displayed here are evidence of popular taste at the beginning of the eighteenth century. Landscapes, mythological scenes, and nude women predominate, all painted with a light touch and in typically pale colors. The dark, sober portraits clearly date from the previous century. There are also religious paintings (two Adoration of the Magi—perhaps of the Italian school—and a monk praying), but they are primarily relegated to the upper, less visible rows.

Housed in the Castle of Charlottenburg in Berlin (a true "sanctuary" of Watteau's art), this work was executed toward the end of his short life, while he was already suffering from the tuberculosis that would lead to his death that same year. Over three meters wide (unusually large for a genre painting) and structured according to the strict rules of perspective, it is considered to be one of the most representative masterworks of eighteenth-century European painting. It originated modestly as a decorative work for the entrance to the "Au Grand Monarque" gallery, owned by the art dealer and Watteau's friend, Gersaint, with whom he went to live in 1719. This canvas has been interpreted in various ways: as Watteau's "spiritual" and stylistic testament; as the symbol of a transition between periods of history and art; or more simply as the vivid vibrant image of a new pictorial model and the developing art market, which was extending to the upper bourgeoisie. These many meanings, sustained by the brilliance of a light, luminous style, are typical of Watteau, as is the vein of disenchantment and bittersweet irony that runs through an apparently realistic and even banal subject.

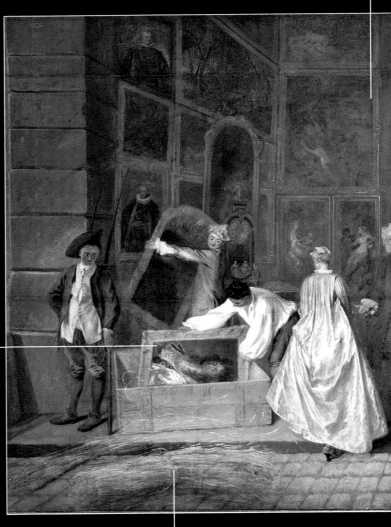

The name of Gersaint's art gallery was "Au Grand Monarque", a tribute to the Roi Soleil. The sovereign's long reign ended in 1715, therefore an assistant is symbolically placing an outmoded, seventeenth-century portrait of Louis XIV into a chest. This is an explicit reference to a radical change in taste and a turning point in the history of France.

The bundle of hay in the foreground is used as packing material, but it also serves the pictorial purpose of directing the viewer's eye toward the center of the painting.

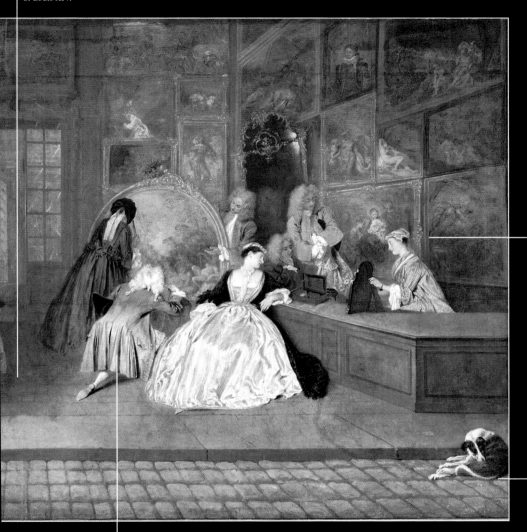

Almost at the center of the canvas, a young gentleman (perhaps a self-portrait of Watteau himself) is gallantly inviting a lady to enter the gallery. The silvery pink reflections of light on her gown enhance her elegant bearing as she crosses the threshold and turns left to observe the "deposition" of Louis XIV.

Madame Gersaint is describing the features of a small picture to a group of art lovers who appear to be rather bored. The angle of the counter creates a precise perspective; as can be seen from examining the architecture the painting is only apparently symmetrical, though the paving stones and glass door in the center give the impression of perfect regularity this is the result of an extremely skillful handling of the composition.

The dog removing its fleas adds an unexpected note of realism to this elegant Paris street, it is an indispensable detail that serves to bring down to earth a composition that might otherwise have seemed too stylized and sophisticated.

Various possibilities have been put forward regarding the real identity of the customers, experts, and collectors examining the paintings. Watteau anticipates Hogarth and, with more grace than the English painter, gives a slightly ironic image of contemporary high society. The two connoisseurs armed with lorgnettes closely examine a large oval canvas depicting nude nymphs bathing, an example of the *fête galante* vogue that was spreading through French Rococo. Behind the canvas, Gersaint in person is singing its praises.

The Eighteenth Century
The Europe of the Grand Tour

In Search of a "Sentimental Education"

During the eighteenth century, European gentlemen and artists began to travel, fueling a general desire to become directly acquainted with other cultures and develop international contacts. Long itineraries, which were often uncomfortable to follow, ran the length and breadth of the continent and were deemed indispensable for the development of "good taste". The main destination for the English, French and Germans on their Grand Tour was Italy, although some did not hesitate to venture as far afield as Russia and its magnificent new capital Saint Petersburg. The recommendations of the first guidebooks and the advice of eminent men of culture led to the development of a series of "obligatory" places to visit en route. In Italy, in particular, the major destinations were not to be missed. However, in previous centuries, visitors had discovered the novelties that a country in the vanguard had produced; now they saw a magnificent though backward nation, the partially unaware custodian of the treasures of the past, immersed in breathtaking landscapes. Although the social life in some cities was scintillating with princely receptions and magnificent theatrical entertainments, Italy was experiencing a growing social and economic crisis in diverse sectors, and the conservation of its monuments left much to be desired. Coming from nations where the industrial revolution and the culture of the Enlightenment were in full swing, by contrast these travelers found an agricultural Italy, with peasants and shepherdesses dressed in outlandish costumes. Here foreigners could make excellent purchases of artworks, not only recent pictures and sculptures (the canvases of the Venetian *vedutisti* were very much in demand, and the painters were later invited abroad), but also collections of masterpieces sold by longstanding noble families who had been reduced to dire poverty.

Giambattista Tiepolo
Investiture of Bishop Harold,
1751-53
Kaisersaal, Residenz, Würzburg

While European intellectuals were visiting Italy, Italian artists were being engaged by foreign courts. Tiepolo's long stay at the court of the prince and bishop of Würzburg opened with an explosion of joy and light in the frescoes in the imperial hall. The abstruse iconographic program (a mix of Greek mythology, allusions to the German Middle Ages and the local bishop's power) becomes a dazzling decorative scheme thanks to the white and gold stuccoes by the Ticinese artist Solari, which resemble open drapes. Tiepolo creates austere architectural backdrops against which he sets crowds of figures in sumptuous costumes.

Caspar van Wittel
*View of Florence from the
Via Bolognese*, c. 1695
Duke of Devonshire
Collection,
Chatsworth

Bernardo Bellotto
*View of the New Market
in Dresden*, 1751
Gemäldegalerie, Dresden

The *veduta* is probably the
most typical artistic genre
designed for the public of
international travelers.
Born in the second half of
the seventeenth century as
a branch of landscape
painting, the *veduta*
rapidly developed its own
independent characteristics,
favored by its extraordinary
popularity with collectors
and aristocrats on the
Grand Tour. The Venetian
Bellotto (1720-80), nephew
of Canaletto, is one of the
greatest European *vedutisti*.
Having a truly cosmopolitan
spirit, he left Italy when he
was only twenty-seven and
spent his entire career at the
Central European courts
of Vienna, Munich,
Dresden, and Warsaw.

Bernardo Bellotto
*View of Vienna from the
Belvedere*, 1759-60
Kunsthistorisches Museum,
Vienna

Commissioned by Empress
Maria Theresa, this vast
canvas presents a traditional
view of the capital of Austria.

Mengs: from the Grand Tour to Neoclassicism

*During the eighteenth century, artists expressed
the two different emotions that the sight of
ancient monuments produced in travelers:
regret at seeing such magnificence in ruin or a
cultural urge to study them at leisure. The acad-
emic painting appreciated by travelers was dom-
inated by a formal and intellectual control that
was sober, elegant, yet not too restrained. These
concepts were taken up and developed by Anton
Raphael Mengs (1728-79), who trained in Dresden, but was subse-
quently active in Rome. While Winckelmann handled classical art in
a classifying manner, Mengs studied a scheme within which to fix pic-
torial references. Thus toward 1770 a very severe norm was
adopted in the choice and application of subjects and mod-
els: this marked the beginning of the Neoclassical period.*

The Delights of French Rococo

During the reign of Louis XV the erotic-galante style of painting became established, which was particularly appreciated in courtly circles and was epitomized by the personality and tastes of the Marquise de Pompadour. François Boucher, a painter whose style was fresh, light, and luminous, was the leading exponent of this genre. In Arcadian settings, far-removed from the ideal landscapes of the seventeenth-century Neoclassical artists, ladies and gallants in peasant costume play artificially naive games. There is an evident link here with the contemporary development of pastoral plays. Greater spontaneity is found in Boucher's domestic interiors—furtive glimpses of bourgeois rooms, bedrooms and boudoirs—where he successfully captures the intimate, secret aspects of everyday life, depicted with a touch of pleasurable voyeurism. Meanwhile Jean Honoré Fragonard returned to certain aspects of sixteenth-century painting. Like Tiepolo, Fragonard was inspired by the Venetian tradition from which he takes its vivid colors and nervous brushwork. By limiting himself to allusions and hints he creates a subtle, insinuating atmosphere. After 1770, in step with the general evolution in French art, Fragonard also gradually abandoned sensual themes and turned toward a delicate, pre-Romantic expression of emotions.

François Boucher
Morning Coffee, 1739
Louvre, Paris

Influenced by seventeenth-century Dutch painting, this charming canvas probably depicts the artist's family at home at a relaxed moment. The meticulous handling of the furnishings, clothes, and objects, inspired by the recent Rococo fashion, is fascinating.

François Boucher
Portrait of Marquise de Pompadour, 1759
Wallace Collection, London

The Marquise de Pompadour, Louis XV's mistress, absolute arbiter of taste in the mid-eighteenth century, and ambitious patron of the arts, was one of Boucher's major clients.

François Boucher
Nude Lying on a Sofa, 1752
Alte Pinakothek, Munich

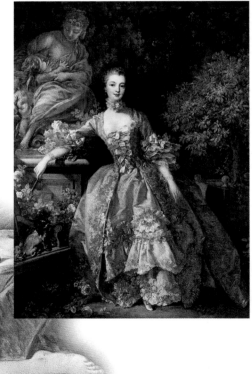

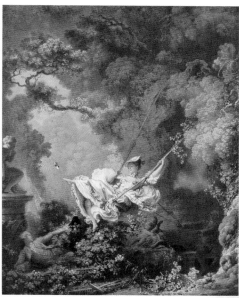

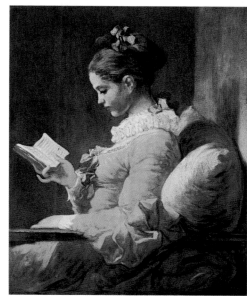

Honoré Fragonard
The Reader, c. 1776
National Gallery of Art,
Washington, D.C.

This delicate and
enchantingly intimate
scene is one of the most
celebrated paintings of the
late eighteenth century.
Fragonard's light touch
(the result of his familiarity
with Venetian painting)
seems here to anticipate
Renoir.

Honoré Fragonard
The Swing, 1766
Wallace Collection, London

Fragonard relaunches the *fête
galante* genre, but replaces
Watteau's subtle melancholy
with a bold, amused sensuality.
This painting depicts the
typical love triangle. While the
husband, quite unaware, pulls
the ropes of the swing, the
furtive lover hides in the
flowering shrub watching the
young woman from a choice
vantage point. The flying shoe
adds a mischievous touch.

Honoré Fragonard
La Gimblette
(*The Ring-Biscuit*),
c. 1770
Fondation Cailleux, Paris

This provocative, allusive
painting portrays a semi-
nude young girl, playing with
a lapdog on an unmade bed.

Southern Germany and Austria
1700-1780
German Rococo

An Explosion of Fantasy and Color

During the seventeenth century, painting in war-ravaged Central Europe was not the expression of a unified school, though there were several interesting artists. A school, however, emerged during the following century when there was a great ferment in the fields of architecture, ornamental sculpture (stuccoes and wooden carvings), and painting, in Austria and the Catholic regions of Germany. This marked the beginning of an extremely fertile period in art. On the one hand artists like the Asam brothers, painted monumental decorative schemes for princely clients and the great reconstructed Benedictine abbeys, while on the other, many small paintings, sketches for larger works, or even independent compositions, painted with a fresh immediacy, were being produced. Among the many great, eighteenth-century, Austrian Rococo masters, special mention must be made of Paul Troger (1698-1782) and Franz Anton Maulbertsch, perhaps the most inventive of all. After the middle of the century a movement for the "moralization" of art began in Germany. The country with the most original and inventive Rococo works laid the theoretical foundations for and produced concrete examples of an austere art based on classical models.

Franz Anton Maulbertsch
The Education of Mary,
c. 1755
Kunsthalle, Karlsruhe

Maulbertsch's (1724-1796) most characteristic works are easel paintings as lively and rapid as sketches, but they are to be considered independent compositions in their own right. In Maulbertsch's hands this theme becomes an explosion of fantasy, featuring a flight of angels in the sky, a handling of light that brightly illuminates some areas and leaves others in shadow, in an all-enveloping sense of dynamism that is brilliantly controlled.

Paul Troger
Christ Comforted by an Angel,
c. 1730
Museo Diocesano, Bressanone

The intense pathos and dramatic emphasis develops within a very refined pictorial form featuring elongated figures bathed in light.

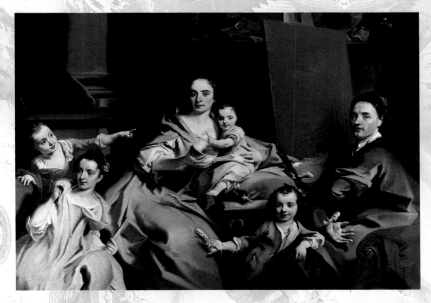

Carlo Innocenzo Carloni
Self-Portrait with the Family,
1728
Private Collection

Carloni (1696-1775) trained in
Rome and was in contact with
many of the most advanced
late Baroque artists, including
Maratta and Luca Giordano,
though he was principally active
in German-speaking countries.
He was launched on the
international scene in 1715
when Prince Eugene of Savoy
engaged him to work in the
Belvedere in Vienna. During the
thirty years of his brilliantly
successful career in Bohemia,
Austria, and Germany, Carloni
developed an international
language that was typically
Rococo, with a preference for
grandiose and celebratory
allegories, featuring a free
composition, light touch,
and luminous colors.

Cosmas Damian and Egid
Quirin Asam
*Frescoes in the Abbey Church
of Aldersbach*, 1720-25
Abbey Church, Aldersbach

The Asam brothers played
a leading role in the period
of great Rococo decoration
in Southern Germany. Egid
Quirin (1692-1750) specialized
in altars, groups of statues,
and ornamental stuccoes;
Cosmas Damian (1686-1739)
preferred painting, at first in
a style based on his studies in
Rome, but then developed
freely to include forms, colors,
and perspectives leading away
into the open sky. Since they
are particularly theatrical,
the luminous interiors of
the Rococo abbeys, built
and decorated by the Asam
brothers, should be seen
and appreciated dynamically
by moving around inside
the vast spaces and
enjoying the succession
of spectacular views.

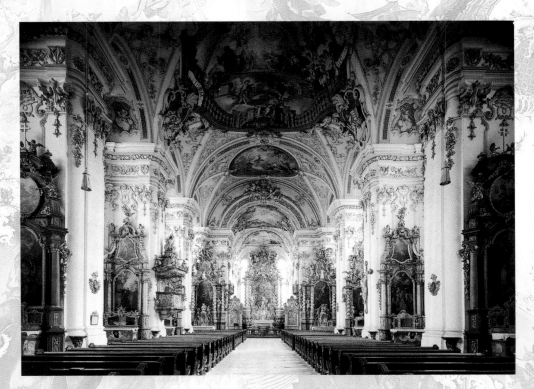

London
1697-1764
William Hogarth

"Castigat ridendo mores": Social Satire is Born
During the whole of the seventeenth century British painters were not particularly outstanding. All pictorial works of any importance, including portraits and royal commissions, were assigned to foreign artists, who spent various periods of time in England. At the beginning of the eighteenth century, however, William Hogarth, the first unquestionably original English painter appeared on the scene. He was also a famous engraver and the author of an important treatise on aesthetics, *The Analysis of Beauty*. In addition to being a pleasing portraitist who was very much in demand, Hogarth invented a new theme: social satire, or as the painter himself describes it, the "modern moral subject". Without hiding his didactic purpose and his amused yet bitterly provoking attitude, Hogarth harshly criticizes the customs of all the social classes including ruined aristocrats, clumsy bourgeois social climbers seeking to enter "high society", greedy clerics, slovenly soldiers, and the ragged populace. His scenes are teeming with people captured in poses and with expressions that verge on caricature, and so crammed with descriptive details that even Hogarth himself at times felt the need to add explanatory captions, which are especially useful for a complete understanding of his notable and successful engravings.

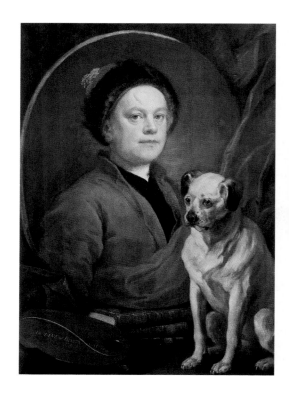

William Hogarth
Self-Portrait with Pug,
1745
Tate Gallery, London

This self-portrait is a complex statement of Hogarth's poetics. Many of his works demand a detailed reading of the cleverly arranged emblematic objects. The portrait of the artist is placed on a pile of books by Shakespeare, Milton, and Swift. The dog symbolizes his loyalty to nature and the painter's palette is engraved with the words "The Line of Beauty and Grace", which according to Hogarth is the basis of beauty and harmony in painting.

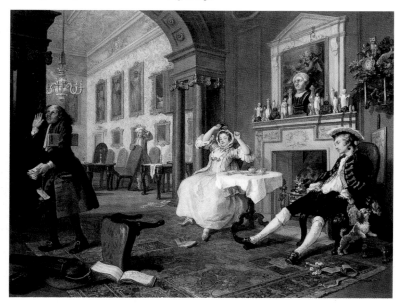

William Hogarth
After the Wedding,
an episode in the series
Marriage à la Mode
1743-45
National Gallery, London

The series *Marriage à la Mode*, comprising six scenes on his favorite theme of social climbing, is Hogarth's most mature work. Pictures of domestic interiors became so fashionable in English painting that the independent genre of the "conversation piece" began to develop as an alternative to the portrait.

William Hogarth
The Shrimp Girl,
c. 1740
National Gallery, London

Hogarth's technique derives from his study of seventeenth-century Dutch painting and is characterized by fresh, rapid, free brushstrokes, which here are reminiscent of Frans Hals.

William Hogarth

1733-1735

The Rake's Progress

This harsh parable of the depravation of a social climber has hung in Soane's Museum in London since 1802. Sir John Soane purchased these eight canvases from a severe colonel for the price of 508 pounds and 10 shillings, almost one hundred pounds less than the regretful gentleman himself had paid. Their first owner was Lord Beckford, the mayor of London, who had bought the canvases directly from Hogarth. It is very difficult to find a parallel to Hogarth's biting, ironic, and didactic narrative style in the "continental" art of the same period. It is a highly independent style that is free from any influence, prejudice or model. Hogarth was a great theater lover and friend and portraitist of many directors, managers and famous actors of the time; he seems to have used this experience for this work, creating a kind of stage play that unfolds in a sequence of scenes. He gives the main characters an easily recognizable name and personality, and places them in settings that are full of explicit or subtly allusive references. Igor Stravinsky "translated" this theatrical series of paintings into the libretto for the opera of the same name.

The first scene, *The Young Heir Taking Possession*, introduces the protagonist, the young Tom Rakewell, whose extremely miserly father has just died. The smallest details of the room reflect the deceased's stinginess. While a zealous tailor is taking the young heir's measurements and an accountant filches some coins, Sarah Young, who is pregnant with Tom's child, appears in the doorway in tears, accompanied by her determined mother. Tom has promised to marry Sarah, but now he awkwardly offers her a handful of coins as compensation.

In the second scene, *Surrounded by Artists and Professors*, Tom is swept up in a whirlwind of activity. The brilliant musician plays his latest composition on the harpsichord, while two experts in self-defense demonstrate their respective services. The elderly fencing master shows the *en garde* position under the more than perplexed gaze of a boxer armed with sticks. In contrast to the heavily-built and bewigged boxer, the elegantly dressed dancing master advances with pointed toes holding a *pochette* or practice violin. Behind him a landscape gardener displays a project for an English-style park. In the foreground Tom, still wearing his nightcap, is holding a letter of introduction from the threatening looking man who is offering his services as a bodyguard. On the right the master of the hounds blows his horn desperately, while a jockey with a long whip is kneeling in front of Tom, holding a huge cup. The comic effect of this scene is striking though bitter; the rake's wealth will soon be dissipated.

In the third scene, *The Tavern*, the rake is sprawled on a chair after a brawl and the two prostitutes attending to him do not pass up the chance to steal his watch. The place is squalid, a couple is flirting, while other loose women are drinking, spitting, and chatting. In the foreground, one of them is undressing, while a pregnant girl near the door is singing.

In the fourth scene, *Arrested for Debt*, St. James's Palace, which is still today a royal residence, appears in the background and the rake is heading there for the queen's birthday audience. The Welshman on the right is wearing a leek in his hat, an indication that it is March 1 the Welsh national day. Two magistrates discover Tom by opening the sedan chair and arrest him for insolvency. Sarah Young tries to come to his aid in vain.

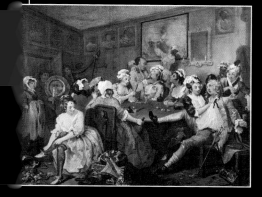

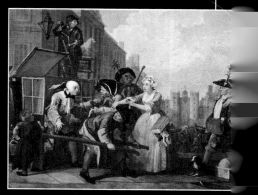

In the fifth scene, *Marries an Old Maid*, being in need of money Tom enters into a marriage of convenience. Before a fat celebrant, the rake slips a ring on the finger of an old cross-eyed woman wearing a garland, as he eyes the pretty maid. While two little dogs imitate the scene (one is Trump, Hogarth's pug), in the background Sarah Young and her mother attempt to interrupt the ceremony, but are pushed back by the furious guard.

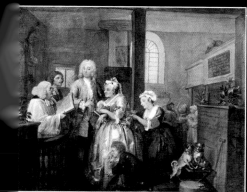

The sixth scene, *In a Gaming House*, contains striking figures their features corrupted by vice. Hardly anyone is aware of the imminent catastrophe: smoke from the fire that will burn the place to the ground can be seen coming from the back of the room.

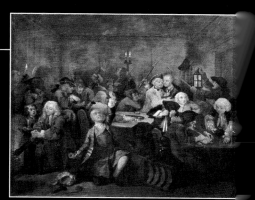

In the seventh scene, *Prison*, Tom is in jail for gambling debts; he looks terrified and his eyes are bulging. The old woman who has become his wife is howling in his ear, Sarah Young faints at the sight of her former seducer.

In the last scene, *In Bedlam*, Tom is rolling on the ground almost naked. Two nurses are tying his wrists and ankles. The weeping Sarah Young has become the tragic heroine of the story. Two women are visiting the mad people as an amusing pastime; their grotesque smiles are the most inhuman element in the whole series of paintings.

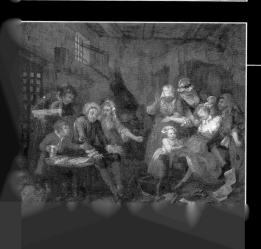

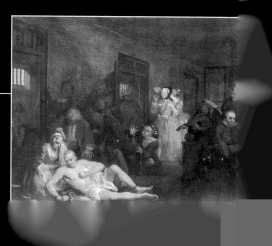

Venice

1700-1797

The Rise and Fall of the Serenissima

The Last Leap of the Winged Lion

Impoverished by a change in trade routes, weakened and reduced in size due to the erosion of its territories by the Ottoman Empire, Venice spent the eighteenth century waiting for the inevitable end, which came with the Napoleonic conquest in 1797. This political decline, however, was countered by an exceptional flourishing of literature, music, theater, and the arts, and for a few decades, the Venetian Republic was once again the capital of European culture, imposing its models on the rest of the continent. During this time, Venice remained one of the main destinations of the Grand Tour and its artistic production (painting, glass, fabrics, lace, furniture and so on) was considered synonymous with refinement, elegance, and wealth. Until 1770, before the spread of Neoclassicism, Venice rivaled Paris as the capital of aristocratic taste and the principal art and collectors' market. The key to the exceptional popularity of the "Venetian style" with the European courts was its revival of the most magnificent, celebratory sixteenth-century models (especially Titian and Veronese), thus resuscitating a tradition that had gone into decline during the seventeenth century. The Venetian School produced excellent artists in every field of painting. Ricci, Piazzetta, and Tiepolo were the masters of religious and secular decoration; Canaletto, Bellotto, and Guardi produced incomparable *veduta* masterpieces; Pietro Longhi and Giandomenico Tiepolo tackled social satire; and the portraitist Rosalba Carriera (a specialist in the medium of pastel) was acclaimed throughout Europe.

Giambattista Piazzetta
Saints Louis Bertrand, Vincent Ferrer, and Hyacinth, 1738
Church of Santa Maria dei Gesuati, Venice

The beautiful Church of Santa Maria dei Gesuati at the Zattere, is one of the sanctuaries of eighteenth-century Venetian painting. It contains magnificent altarpieces by Sebastiano Ricci, Giambattista Tiepolo (who also painted the frescoes on the ceiling), and Piazzetta. Piazzetta displays great energy in his invention of the angel in backward flight, in the play of the three colors of the habits (white, black, and brown), and in the impassioned expressions of the three saints.

Canaletto
The Doge's Procession to the Church of San Rocco, 1735
National Gallery, London

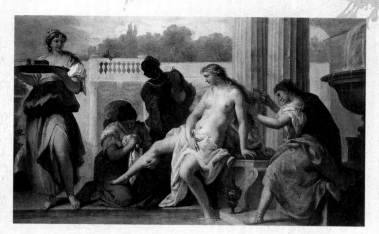

Sebastiano Ricci
Bathsheba Bathing, 1720
Museum of Fine Arts,
Budapest

This luminous composition,
repeated in various versions
by Ricci, is an effective blend
of the characteristic features
of eighteenth-century
painting. The biblical subject
is merely a pretext for a
spectacular, captivating
profane scene that focuses
on the beautiful, luminous
nude girl waited on by a
group of handmaidens.

Francesco Guardi
Gondola on the Lagoon, c. 1770
Museo Poldi Pezzoli, Milan

Unlike Canaletto's resplendent
Venice with its wonderful
palaces reflected in the canals,
Guardi (1712-1793) depicts
a subdued and faded city,
inhabited by poor people who
have to struggle for a living as
the imminent crisis looms.

Pietro Longhi
The Rhinoceros, c. 1751
Museo del Settecento
Veneziano, Ca' Rezzonico,
Venice

This painting depicts
the sensational exhibition
of the exotic animal that
became a celebrated
European attraction; a text
commemorating the event is
displayed on the right-hand
side of the composition.
Longhi's (1702-1785) image,
in addition to the brutish
bulk of the rhinoceros
(whose impressive feces the
painter has also included
in the picture), conveys the
excitement of the spectators
who attended these shows.

215

Venice and London
1697-1768
Antonio Canal, Canaletto

The Image of Venice Becomes a Legend

Canaletto and Giambattista Tiepolo, contemporaries and both Venetians, illuminated European painting with the brilliant light of Venetian art. Canaletto's cityscapes, nearly all of which were exported (there are very few of his works still in Venice), were soon in great demand on an art market that, after two and a half centuries, showed no sign of slowing. Son of an artist, Canaletto began his career as assistant to his father, who was a theatrical scene painter in Venice and Rome. This work was to leave an indelible mark on the young artist; in fact, his fine, deep scenographic perspectives are one of his most outstanding features. Canaletto's *vedute* were executed with the help of a camera obscura (an instrument that projected the artist's view onto a kind of screen) and thanks to this device, but also thanks to his sure hand and brilliant use of light, Canaletto played a pivotal role in European art. In 1746 he moved to London where he remained for many years alternating views of Venice (based on finely detailed sketches) with sweeping scenes of the capital and English country houses. After returning to Venice in 1757 he was acclaimed as the unrivaled master of perspective and continued to draw and paint until his death.

Canaletto
Stonemason's Yard, c. 1727
National Gallery, London

In this painting the relationship between the stonecutters and the architecture marks Canaletto's new mastery of space and light.

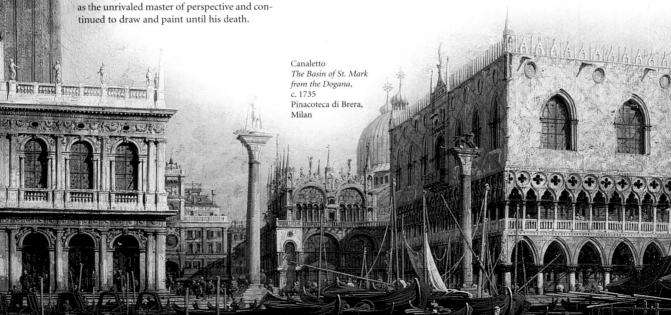

Canaletto
The Basin of St. Mark from the Dogana,
c. 1735
Pinacoteca di Brera,
Milan

Canaletto
The Eastern Façade of Warwick Castle, c. 1751
Museum and Art Gallery, Birmingham

In choosing to depict clear days bathed in light, Canaletto celebrated the beauty of the English landscape by clearly focusing on the relationship between natural parks and historic buildings. This becomes the key to a reading of all landscape painting in England, up to Constable and Bonington.

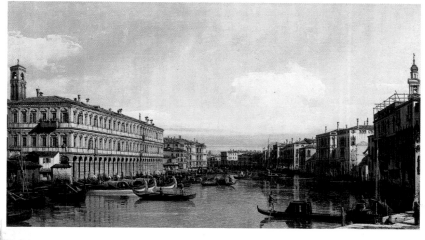

Canaletto
Grand Canal, 1730-35
Wallraf-Richartz Museum, Cologne

Toward 1728, Canaletto began to paint views of Venice for foreign travelers and chose monumental scenes depicted in fine weather. He was a resounding success, so much so that Joseph Smith, the English consul in Venice, commissioned dozens of paintings (later bought *en bloc* by King George III) thus promoting his fame among British collectors.

Venice, Würzburg, Madrid

1696-1770

Giambattista Tiepolo

On the Wings of Fantasy

Although Tiepolo is chiefly famous for his frescoes in palaces and princely courts, he should be considered, first and foremost, a versatile painter, capable of turning his hand to many fields of art and adapting to the most varied subjects, media, and formats. Attracted to the work of Piazzetta and Sebastiano Ricci, he abandoned Baroque "shadows" for sunlit scenes inspired by the revival of the Venetian Renaissance. Tiepolo's first success, an explosion of festive luminosity, was the decoration of the gallery in the Bishop's Palace in Udine in 1726. From then on he received commissions from both private and religious clients, for whom he executed canvases and frescoes full of fantasy and joy, combining Paolo Veronese's influence with deliberate theatrical effects. At the height of his fame, his paintings, including the great Venetian works in the Scuola del Carmine and Palazzo Labia, became even more inventive and surprising, and he gave his imagination and his fondness for allegory free rein. In 1750 he moved to Würzburg, where his frescoes in the Residenz mark the height of European Rococo and, as such, the beginning of the crisis. In 1762, accompanied by various assistants, including his son Giandomenico, he left for Madrid where he frescoed several rooms in the Royal Palace, including the throne room. However, the birth of Neoclassicism rendered Tiepolo's transfiguring fantasy outmoded and the great painter died virtually forgotten in Madrid.

Giambattista Tiepolo
The Chariot of the Sun,
detail, 1740
Palazzo Clerici, Milan

Painted during one of his numerous stays in Lombardy, the vast ceiling of the large room in Palazzo Clerici marks the beginning of Tiepolo's full maturity of expression. The composition is imaginative and light though the individual figures are robust, warm, and tangible.

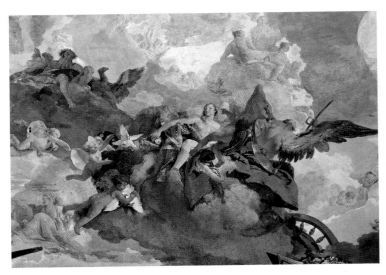

Giambattista Tiepolo
Neptune Offering Gifts to Venice, 1748-50
Palazzo Ducale, Venice

Tiepolo contributed to the "legend" of Venice by painting one of the last allegories of the Serenissima, queen of the sea, for the Doge's Palace.

Giambattista Tiepolo
Rinaldo in Armida's Garden,
c. 1745
Art Institute of Chicago

This painting is one of
a series of four canvases
(all housed at the Art Institute
of Chicago) portraying the
romantic episode in Torquato
Tasso's *Jerusalem Delivered*,
much loved by Tiepolo. He
depicted it several times
creating an atmosphere of
seduction and nostalgia,
magic and passionate
abandon in a setting of
moving beauty.

Giambattista Tiepolo
Woman with Parrot, 1761
Ashmolean Museum, Oxford

This luminous painting,
almost representative of
eighteenth-century grace,
is not a portrait, even though
Tiepolo sometimes worked
in this genre. The pretty girl's
rosy breast recalls the sensual
female half-figures painted by
Titian two centuries earlier.

Giambattista Tiepolo
*Maecenas Presenting the Arts
to Augustus*, 1744
Hermitage, Saint Petersburg

This painting was
commissioned by the
authoritative connoisseur
Francesco Algarotti for
Count Brühl, a leading
dignitary at the Saxony court.
The building in the
background is the count's
residence located on the banks
of the River Elba in Dresden.
The Corinthian portico, clearly
influenced by Palladio, is
reminiscent of the backdrops
in Paolo Veronese's paintings
of banquets, and thus
an allusion to Venetian
Renaissance art. The brilliant
colors, diffused light ("a sun
that perhaps has no equal",
according to an eighteenth-
century critic), theatricality
of the costumes and gestures,
and delightful "minor"
episodes that enrich the scene,
all justify Tiepolo's fame
as the principal master of
great Rococo decoration
in Europe.

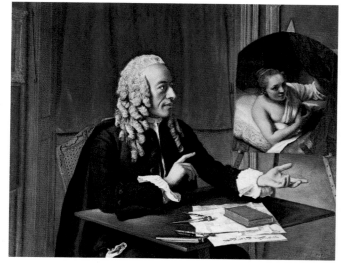

1750-1780
The Enlightenment

Firm Faith in Enlightened Thought

In the figurative arts, the eighteenth century saw the gradual decline of Baroque and the development of new forms of collecting, decoration, and art. There was also a significant broadening of horizons in national artistic schools that began in Great Britain. The sumptuous Baroque "global work of art" (a scenographic composition of architecture, painting, and sculpture) was replaced by a more rational, controlled, and measured form, especially from the mid-eighteenth century onward. The sense of "wonder" aroused by the unpredictability of art and nature—parallel to developments in literature, philosophy and the sciences—gave way to a serene, clear, and sometimes ironic way of observing the world and history, utilizing the new instruments of analysis and the systematic organization of the *Encyclopédie* by Diderot and D'Alembert. The Enlightenment, in art, cannot be considered a unified international movement, but a response that was consistent with local cultural developments in a certain area during a particular age. However, some aspects of eighteenth-century European painting shared similarities, not so much stylistically as in content, for example, there was a general interest in science, social morality, and the pleasure of reading and traveling.

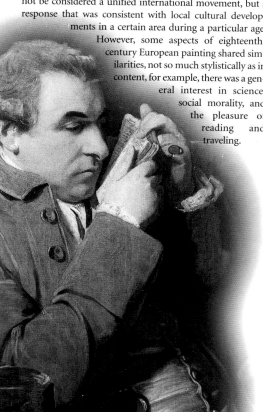

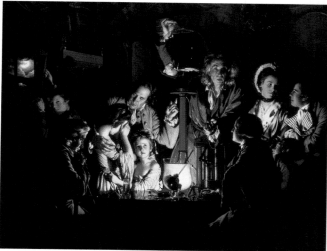

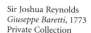

Jean-Étienne Liotard
François Tronchin, 1757
Musée d'Art et d'Histoire,
Geneva

Liotard (1702-1789) was born and trained in Geneva. He was a cosmopolitan painter and skilled in a variety of media. His portraits are spirited and full of life. The gentleman in this painting is explaining a work by Rembrandt.

Joseph Wright of Derby
An Experiment on a Bird in the Air Pump, 1768
National Gallery, London

Influenced by Rembrandt's *Anatomy Lesson*, the painter focuses on the curious and fearful expressions of the public, thus adding a pleasant touch of irony. In fact, the scientist disturbingly resembles a diabolical magician.

Sir Joshua Reynolds
Giuseppe Baretti, 1773
Private Collection

An intellectual of international repute and a feared literary critic, Baretti had the honor of having his portrait painted by the "prince" of English enlightenment painters.

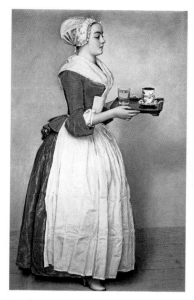

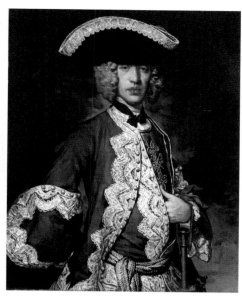

Fra Galgario
Portrait of a Knight of the Constantinian Order (Gentleman in a Tricorn Hat),
c. 1745
Museo Poldi Pezzoli, Milan

This pale gentleman, despicable defender of an old, sick, and weakened social class, is a brilliant example of Bergamo artist Fra Galgario's (1655-1743) skill in portraiture and also of the early introduction of "social" themes into the art and culture of northern Italy.

Jean-Étienne Liotard
The Chocolate Girl, 1744-45
Gemäldegalerie, Dresden

Purchased in Venice by Count Algarotti for the Dresden royal collection, this is a delightful and unusually experimental painting. From a purely technical standpoint, the work is pastel on parchment, which, however, is the size of a canvas and has the shiny appearance of painted porcelain. The bright and alert young servant girl seems to anticipate the spirit of similar characters used by Mozart in his operas.

Maurice Quentin de Latour
Portrait of Mlle. Ferrand, 1753
Alte Pinakothek, Munich

In her comfortable silk *robe de chambre*, this young woman displays the typical "enlightened smile" as she looks up for a moment from her reading of a weighty tome on Newton. It must be mentioned here that in 1737 (ten years after the death of the English scientist) the erudite Count Francesco Algarotti published a successful compendium entitled *Newtonianismo per le dame* (*The Science of Newton for Ladies*), an important example of a pre-Enlightenment publication addressed to a female readership.

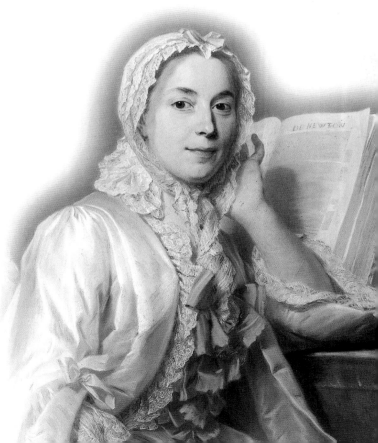

London

1723-1792 1727-1788

Reynolds and Gainsborough

The Great Era of English Portrait Painting

The English Industrial Revolution during the second half of the eighteenth century changed the social situation and established a new relationship between the middle classes and art. Portraiture, previously confined to the aristocracy and higher clergy, also became accessible to the bourgeoisie. The emphatic and celebratory style typical of the aristocratic portrait was now replaced by a more faithful likeness. The greatest exponents of English portraiture, a genre that derived from Holbein's and Van Dyck's stays in London, are Sir Joshua Reynolds (1723-1792) and Thomas Gainsborough (1727-1788). Reynolds, the first president of the Royal Academy in London, considered portraiture to be a genre that was "vulgar and limited", on which only the hand of a genius could confer dignity. He favored full-length, life-size portraits and he sometimes painted his models in the guise of historic or mythological personages. By contrast, Gainsborough set his figures in landscapes and sought to paint a true likeness of his subject in a natural manner. This difference between Reynolds and Gainsborough sparked an artistic debate that led to the development of an independent school of English portraiture.

Sir Joshua Reynolds
Colonel George K. H. Coussmaker, Grenadier Guards, 1782
Metropolitan Museum of Art, New York

This is a typical example of the painter's noble style. The aristocratic figure of the young colonel is captured in a pose of studied nonchalance and the figure's noble bearing is accentuated by the line of the tree trunk and the horse's neck.

Sir Joshua Reynolds
Portrait of Miss Bowles with her Dog, 1775
Wallace Collection, London

Master Hare, 1788-1789
Louvre, Paris

Reynolds was unrivaled in child portraiture (a genre that generally distinguishes English painters from their continental colleagues). These two refined and enchanting examples illustrate the artist's fantasy, delicate touch, clever use of light, and smiling freshness, a pleasant contrast to his more composed and studied "official" paintings.

Reynolds's allegory of theory has welcomed visitors to the Royal Academy in London since 1780. This institution, which was crucial in the establishment of the English School, was the inspiration of the architect William Chambers and opened in Burlington House in London in 1768. Reynolds was the Academy's first president and proved to have exceptional organizational and teaching skills. After a long period of study in Italy, he promoted the noble and self-confident "grand style", which was inspired by Raphael's consummate model and far removed from the "studied carelessness" of Rococo. Reynolds's decision was not the result of a conventional or conformist attitude, but the precise awareness of a need: to provide young English artists with those essential technical and cultural bases that had been neglected for a century. This choice was to become pivotal, especially for the first students coming from the North American colonies, like Benjamin West and Singleton Copley. During the early development of the Royal Academy, young artists received a general training that was in line with incipient Neoclassicism, but due to the lack of a great local tradition, the English academics enjoyed greater freedom of expression than their colleagues on the continent. Between the eighteenth and nineteenth centuries in England there was an exceptionally close dialogue between painting and literature, anticipating what was to happen in the rest of Europe during the nineteenth century. English painters were concerned not so much with the "classics" of art as with those of literature, ranging from Ossian to Shakespeare, Milton and Dante. They were also inspired by the poetry of the previous centuries to explore the nightmare, the subconscious, and the fantastic.

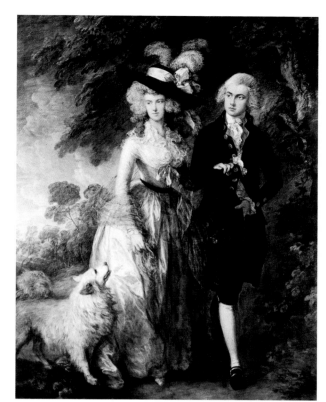

Thomas Gainsborough
The Morning Walk, 1785
National Gallery, London

In contrast to Reynolds, whose work is sharp, precise, and motionless, Gainsborough's possesses mobility, vivacity, and vibrancy. Gainsborough was interested in reflections of light on silk and satin, the deep tones of velvet, and the delicacy of lace. He often painted full-length figures, but unlike Reynolds's static models, his are figures in motion in a natural setting. The feeling for landscape is one of the painter's distinctive features and he anticipates the development of a genre that was to become extremely popular in England during the Romantic period.

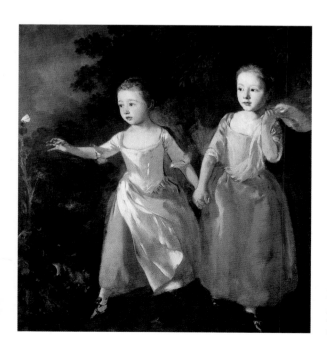

Thomas Gainsborough
Painter's Daughters,
1755-56
National Gallery, London

Gainsborough frequently painted his two daughters to record their physical and psychological development. Here the children are still small, but the elder girl already seems less interested in her younger sister's game of chasing a butterfly.

The United States
1776-1800
The Birth of the American School

Art and History: from English Models to Independence
After winning independence in 1776, the artists of the young America still sought inspiration in Europe and continued to train at the Royal Academy in London. However, during this period, a new school also began to emerge and the latest developments in figurative art were applied with considerable talent to completely novel themes. The main model for young American artists was Benjamin West (1738-1820), who moved from America to London, after a stay in Rome. West, who was elected president of the Royal Academy after Reynolds's death, devoted himself to the depiction of contemporary events ennobled by his high-flown neoclassical style. He invited many American painters to stay in his home and aided them in their development as artists, urging them to make the great European pictorial tradition known in their own country. Encouraged by West, the Bostonian John Singleton Copley (1738-1815) also moved to London, where he became a successful portraitist, and painter of current events and scenes from contemporary history. Copley's typically American realistic style gives his portraits a vivid immediacy that was particularly appreciated by New England middle-class society.

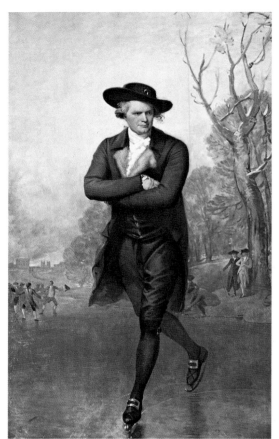

Gilbert Stuart
Portrait of a Gentleman Skating, 1782
National Gallery of Art, Washington, D.C.

The success of portraiture in the United States was assured by two artists, Gilbert Stuart and John Trumbull, who returned to their home country after the customary apprenticeship under Benjamin West in London. Gilbert Stuart (1755-1828) painted numerous portraits of English and American political figures, including the official portrait of the first president and national hero George Washington. John Trumbull (1756-1843) also devoted himself to history painting and depicted the recent events of the War of Independence in a series of works for the Capitol rotunda.

Benjamin West
Penn's Treaty with the Indians, 1771-72
Pennsylvania Academy of Fine Arts, Philadelphia

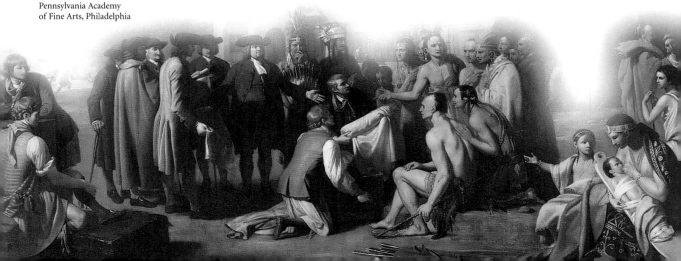

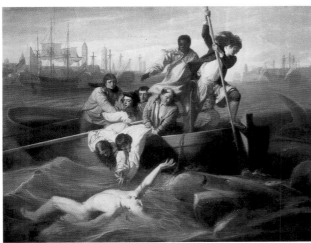

John Singleton Copley
Brook Watson and the Shark,
1778
National Gallery of Art,
Washington, D.C.

This painting was
commissioned by Watson
himself to remind him of the
terrible adventure of his youth:
while swimming in the sea just
beyond the port of Havana, he
was attacked by a shark and lost
his right leg. It was executed
in London and exhibited at the
Royal Academy. The tone is epic
and exotic. Here a dramatic
personal event takes on the
grandeur of a biblical scene.
This narrative emphasis, always
supported by an excellent
technique, became typical of
American visual arts, and in the
twentieth century passed from
painting to cinema.

Benjamin West
Portrait of Colonel Guy Johnson,
c. 1776
National Gallery of Art,
Washington, D.C.

Guy Johnson was the English
official in charge of Indian affairs
in the American colonies and, on
his return to England, he took with
him as his secretary the chief of
the Mohawk tribe, idealized here
with his benevolent expression as
the typical "noble savage". Some
details of the colonel's clothes
such as the moccasins and
feathered hat are also Indian.

John Trumbull
*Signing of the Declaration
of Independence*, 1776,
with additions in 1820
Yale University Art Gallery,
New Haven

After the victory of the
American colonies in the War
of Independence,
celebratory paintings of the
event were commissioned
for city halls throughout the
United States. The official
iconography of facts and
personages became fixed
using the canons of European
historical painting.

England
1770-1820
Visionary Painting

When Reason no Longer Suffices

The intellectual and social transition from the Enlightenment to Neoclassicism at the end of the eighteenth century involved the search for pure ideal forms and classical simplicity, together with an outburst of emotional and irrational elements that marked the emergence of a new pre-Romantic sensibility. The desire to discover the hidden depths of man's being and enter into the realm of the unconscious stemmed from a rejection of Enlightenment ideas and an irresistible urge to go beyond reason. The artist thus expressed the restlessness of a changing generation through a fantastic and unreal style of introspective painting. This current spread through Europe at the turn of the nineteenth century and was principally represented by two English artists, Henry Fuseli (1741-1825), of Swiss origin, and William Blake (1757-1827). The former developed visionary themes in a style that reveals two main influences: the gestures and physical appearance of his figures recall classical models, while the dramatically visionary atmosphere reflects a Romantic taste for the irrational, satanic, and macabre. These features can also be found in Blake's work, which is pervaded by symbolic and literary references to the Bible, Dante, Milton, and Shakespeare. Freedom of the imagination reigns in his canvases and illustrations, along with an unquestionable admiration for purity of line and the beauty of classical figures.

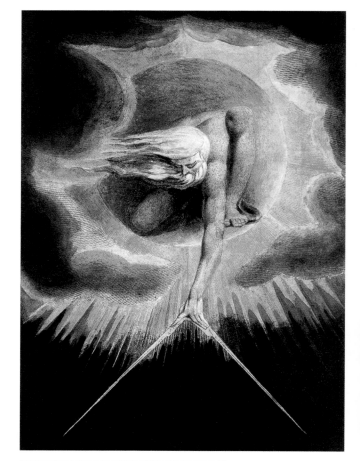

William Blake
The Omnipotent, 1794
British Museum, London

Blake's mystic inspiration produced completely novel images without iconographic precedents.

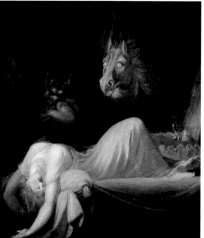

Henry Fuseli
The Nightmare, 1790-91
Goethe Museum, Frankfurt

The theme of dream and nightmare, inspired by the great English poets like Shakespeare and Milton, is a constant feature in Fuseli's oeuvre. He was the first painter to analytically explore and study the depths of the subconscious and in his work, the spirits and ghosts of the night become terrifying concrete presences. In this famous painting the girl's sleep is disturbed by two disquieting apparitions: a frightening horse's head with staring white eyes and a small monster that is half devil, half monkey. However, the strict intellectual control Fuseli exercises over his works is typical of the Enlightenment, in fact, the disturbing aspect of the painting is offset by the studied pose of the girl, inspired by Roman sculptures the artist had observed during his stay in Italy.

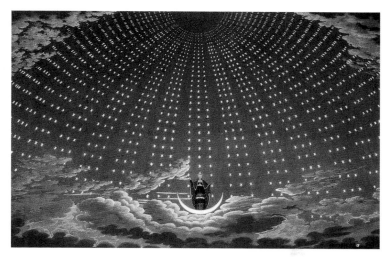

Friedrich Schinkel
The Queen of the Night, 1815
Hochschulbibliothek, Berlin

An interesting painter,
but above all a great architect
and set designer, Schinkel
(1781-1841) was one of
the leading exponents of
German figurative art at the
beginning of the nineteenth
century. Romantic and
classical elements coexist in
his work, and as can be seen
from his memorable set
designs for Mozart's *Magic
Flute*, Schinkel draws freely
on the past, achieving a
mysterious balance of
Neoclassical and Neo-Gothic,
with Egyptian allusions
and cosmic fantasies.

Francisco Goya y Lucientes
The Colossus, 1808-12
Prado, Madrid

Goya, clouded with doom as
a result of his loss of hearing
and the harrowing disasters
of the Napoleonic occupation
of Spain, created horrifying
visions of monsters from whom
terrified mankind desperately
seeks to escape.

Henry Fuseli
Titania and Bottom, 1780-90
Kunsthaus, Zurich

A keen reader of Shakespeare,
Fuseli illustrates with great
refinement the fairy revels,
an enchanting and enchanted
scene from Shakespeare's
A Midsummer Night's Dream.

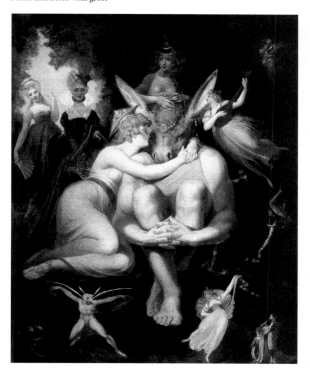

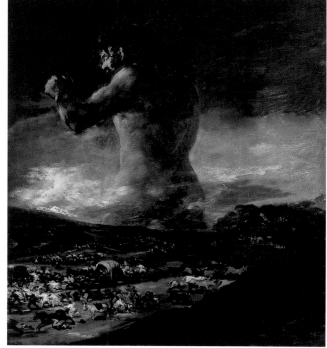

Madrid

1746-1828

Francisco Goya y Lucientes

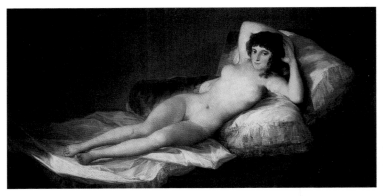

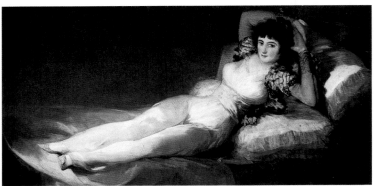

The Disenchanted Image of a New World

Closely linked to the political affairs of the Bourbon court and very sensitive to moral and social issues, Goya received an eclectic training that ranged over the most varied means of expression, from monumental frescoes to miniatures, engravings, and altarpieces. After his initial apprenticeship at Saragozza, he moved to Madrid where he became familiar with the latest trends. Goya's career began in court and aristocratic circles and his early realism was gradually replaced by a vein of biting sarcasm that sometimes resulted in distortion. He is not an impartial portraitist and his feelings toward his models are easily perceived. By the end of the century he had become isolated from the style then in vogue and tended toward moral subjects, dramatic allusions to the human condition, and visionary scenes. His engravings also depict the dark images of a macabre and tortured imagination, but the nightmarish culmination of this period are the murals executed for his country villa "Quinta del Sordo" in 1820. In 1823 the painter left Spain secretly and settled in Bordeaux where he spent the rest of his active life.

Francisco Goya y Lucientes
Maja Nude
Maja Clothed, c. 1803
Prado, Madrid

It is very likely that Maja clothed was a kind of "cover" for the canvas depicting the nude girl. The identity of the model is uncertain, though she may be the Duchess of Alba and the painting may have been commissioned by the extremely powerful and demanding Minister Godoy.

Francisco Goya y Lucientes
The Parasol, 1777
Prado, Madrid

The Parasol is one of a series of cartoons for the royal tapestry manufactory (1776-80), which included serene Arcadian scenes depicting tranquil games and pleasant amusements in a courtly atmosphere. These cartoons, partly influenced by Rococo, anticipate the disillusionment and irony of Giandomenico Tiepolo, who had come to Madrid with his father Giambattista.

Francisco Goya y Lucientes
May 3, 1808, 1814
Prado, Madrid

In 1808 the population of
Madrid rebelled against
Napoleon's occupying troops,
but the revolt was suppressed
in a bloodbath. In 1814 when
the Bourbons finally returned
to the throne, Goya was
appointed to illustrate "the
heroic actions of our glorious
insurrection against the tyrant
of Europe", a celebratory
subject that the painter
handled in an anti-heroic
manner. In this scene,
depicting a firing squad in the
darkness of a night that had
also descended on individual
consciences, faceless soldiers
carry out an execution order
as the condemned wait in
terror. These figures are not
heroes giving their lives for
their country, but ordinary
people swept up in the turmoil
of war and pleading for mercy.
In this scene Goya emphasizes
how the history of mankind
is marked by bloodshed.
A white shirt, about to be
pierced by bullets, becomes
the banner of a universal
denunciation of war.

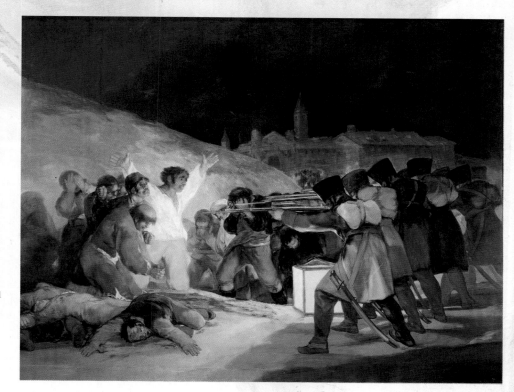

Francisco Goya y Lucientes
1820-1821
The "Black Paintings"

Tired, depressed, and alone, Goya was well over seventy when, between 1820 and 1821, he spent a long period of convalescence in his country villa, just outside Madrid, where he used to go hunting (his favorite sport) when he was younger. The villa was known as the "Quinta del Sordo" or "Country House of the Deaf Man", because of Goya's infirmity. On the walls of two of the rooms, Goya painted a striking and terrifying series of visionary scenes in oil on plaster. They have been called his "Black Paintings" because of the predominance of dark tones and their grim subject matter. These paintings were detached from the walls in 1873 and are now rearranged in their original order in special rooms in the Prado in Madrid. However, the sequence does not follow a single narrative thread, rather every scene is separate like a terrible nightmare, or a sequence of satanic apparitions terrorizing a coarse and crushed mankind. In several cases it is not even possible to distinguish a precise subject; the paintings simply create an atmosphere of tragedy and utter depression, reflecting the famous sentence Goya wrote on the front page of a celebrated collection of engravings: "The dream of reason generates monsters".

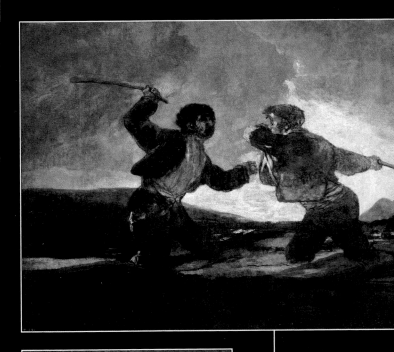

In the absolute creative freedom of a pictorial cycle that was painted strictly for himself, Goya alternates large scenes crowded with figures, macabre panels, mysterious images, and seemingly simple smaller paintings. But it is one of the latter that perhaps represents the most heart-rending image of the whole series. A little dog is sinking in quicksand, its dazed, innocent face can still be seen but soon it will be swallowed up and forgotten, buried in an opaque setting of gray-browns under an immense leaden sky, without depth or memory.

Up to their knees in mud, two peasants are attacking each other with sticks. The situation is dramatic and paradoxical; instead of trying to help each other out of the swamp the two men are hopelessly trying to kill each other. This image may be interpreted as a political metaphor for the European countries ravaged by bloody wars, but—even more bitterly—it may also be read as an image of human madness and blind violence that annihilates everything in its path.

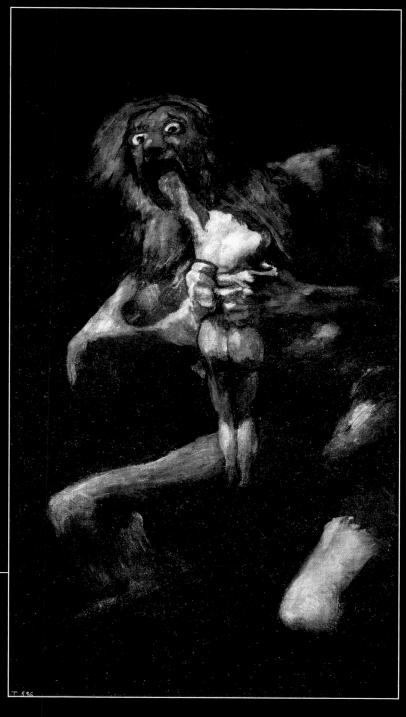

One of the most horrifying images in the whole history of art is inspired by the myth of the god Saturn who devours his sons. However, this literary allusion becomes a visionary nightmare—a huge, horrendous monster tearing at a mangled and bloody human body.

1770-1820

Neoclassicism

The Official Image of Culture and Power

Neoclassical art, establishing itself as the dominant style between the last quarter of the eighteenth century and the Napoleonic era, brought to fulfillment the premises of the Enlightenment. Neoclassicism was primarily aimed at bringing to an end the "irrational" exuberance of Baroque art, by strongly proposing a return to the study of antiquity. This cultural move was supported by vast archaeological campaigns in Italy, Greece, and Egypt, which gave the cultured public confirmation of the greatness of ancient civilizations and noble figurative models to admire. The greatest scholars and supporters of Neoclassical culture were from German-speaking countries. An archaeologist (Winkelmann) and a painter (Mengs) were among the first and most important champions of a methodical and impassioned revival of ancient art, seen as the indispensable antidote to the excesses of Rococo. Well received both by intellectuals and the courts, Neoclassicism spread rapidly throughout Europe. In the field of painting, the French artist Jacques-Louis David (1748-1825) became the model for at least two generations of European artists. David was also a very fine portraitist, as can be seen from his painting of the chemist Lavoisier and his wife, reproduced in the background on the opposite page. He combined many aspects of Neoclassical art, including an admiration for antiquity, the desire to communicate political and moral messages, a meticulous rendering of the formal aspects of his work and, in later years, the celebration of Napoleon. During the Napoleonic era, in fact, Neoclassicism reached its height in the Empire style, which became the sole model of taste and decorum. Neoclassical art is sometimes considered "cold" and intellectual, but it had the great merit of drawing from history and classical poetry eternal figures, themes, and feelings that have always been part of the human experience.

Jacques-Louis David
The Oath of the Horatii,
1784-85
Louvre, Paris

This painting, executed in Rome, has come to represent the birth of Neoclassicism. Here David illustrates an episode from ancient history, but it is interwoven with contemporary feelings and ideas, such as unanimity of intention, political determination, and the contrasting attitudes of warriors and wives.

Andrea Appiani
Parnassus, 1811
Villa Reale, Milan

During the Napoleonic era Milan was one of the capitals of art and furniture.

Johann Friedrich Overbeck
Italy and Germany, 1812-28
Neue Pinakothek, Munich

The theme and the long
time it took to execute this
painting, virtually span the
life of the group known as the
Nazarenes. In 1810, Overbeck
and other young German
painters moved to Rome
and settled in a deserted
monastery on the Pincian
Hill. Here they established an
unusual artistic community,
governed by rules that were
almost monastic, which
aimed to revive the aesthetic
and religious values of
fifteenth-century Italian art
and combine them with
German Gothic traditions.

Wilhelm von Schadow
*Self-Portrait with Brother
Rudolph and Bertel
Thorvaldsen*, 1815-16
Staatliche Museen, Berlin

The theme of the accord
between the Germanic and
classical Mediterranean worlds
recurs obsessively in German
culture from the Ottonian
"renaissances" to the twentieth
century. In the Neoclassical
period, Goethe's example was
followed by many intellectuals
and the most admired artist
of the time was the Danish
sculptor Thorvaldsen,
a meticulous copyist and
restorer of ancient marbles.

Paris

1789-1815

Napoleon's Epic Deeds

Propaganda, Rhetoric, Art in the Service of the Tyrant
The transition from the eighteenth to the nineteenth century marked a profound change in cultural and figurative realms with regard to both the artist's profession, and the tastes and expectations of the public. During this period, the eyes of the world were on Napoleon. Half a century after the Enlightenment and its precepts of moderation and restraint, Napoleon launched a grandiose and celebratory style of art, of imperial proportions and magnificence. A series of symbols (eagles, laurels, scepters, thrones, monograms, and allusions to military campaigns), insistently repeated, were employed in the emperor's impressive image-boosting campaign. In reviving the splendors and emblems of the past, Napoleon became the first "modern" dictator. The numerous sculpted or painted portraits of him also play a key role in the propaganda and strategy of aggrandizement, that perhaps reaches its pinnacle in the equestrian portrait by David, reproduced in the background on the opposite page.

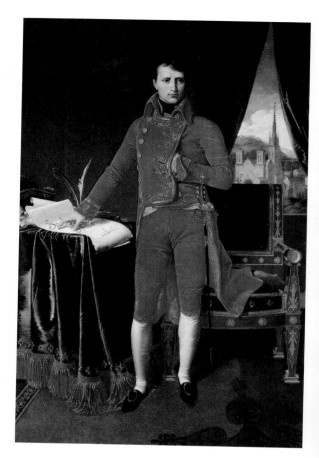

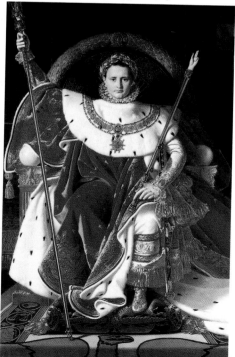

Jean-Auguste-Dominque Ingres
Napoleon on his Imperial Throne, 1806
Musée de l'Armée, Paris

Ingres had won the Prix de Rome in 1801, but political events prevented him from going to Italy. This magnificent portrait of the Emperor Napoleon was painted at the height of his political success. After this painting was completed he finally gave Ingres permission to leave for Rome. The painter lived in the Eternal City for eighteen years, and therefore was only able to follow the trajectory, eclipse and fall of the Napoleonic star from a distance.

Jean-Auguste-Dominque Ingres
Napoleon as First Consul, 1804
Musée d'Armes, Liège

This work was commissioned by the city of Liège (a view of it appears in the background) as a tribute to the still young, though already very powerful, Napoleon. The portrait is enriched by its precise details of costume and furnishings.

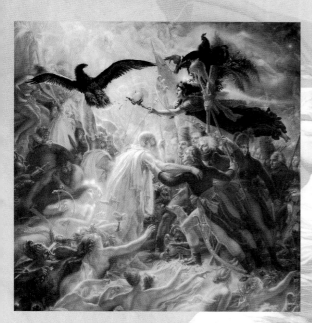

Anne-Louise Girodet-Trioson
*The Apotheosis of the French
Heroes who Died for their
Country During the War
for Freedom*, 1802
Château de la Malmaison,
Paris

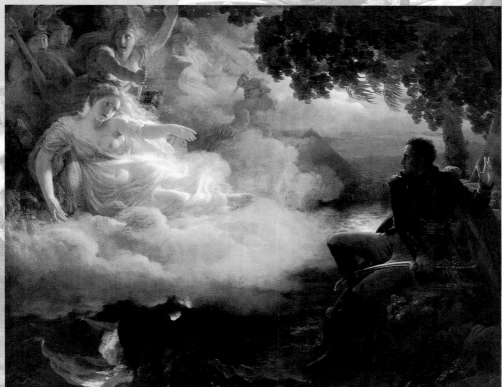

Jean-Pierre Franque
*Allegory of the State of France
before Napoleon's Return
from Egypt*, 1810
Louvre, Paris

235

Dresden

1774-1840

Caspar David Friedrich

Aesthetics and the Frisson of the Sublime

Friedrich succeeded in transferring to canvas the concepts of German Idealism and Romanticism. Immanuel Kant, the greatest Idealist philosopher, used the word "sublime" to describe the feeling that spread throughout Europe during this period and resulted in masterpieces of literature and art.

When man is faced with powerful natural phenomena like storms, snow-covered peaks, and impenetrable fog, he experiences conflicting feelings of wonder and helplessness. A mystic spirit, a great universal soul pervades the world of nature and we must abandon ourselves in order to intuit and experience a part of this mystery.

In 1798, after completing his studies at the Copenhagen academy, Friedrich moved to Dresden, the city where he spent the rest of his life. The staunch champion of an authentically "German" art, he countered bright light and classical ruins with the fascination of Germanic landscapes and a return to the Gothic, deliberately refusing to take the customary journey to Italy. A mysterious atmosphere and the contemplation of nature contribute to the great appeal of Friedrich's landscapes, which, as the years passed, became increasingly rich in symbolic elements.

Caspar David Friedrich
Chalk Cliffs on Rügen, c. 1818
Oskar Reinhart Foundation,
Winterthur

Friedrich's perfectly still landscapes are spiritual images imbued with symbolism.

Caspar David Friedrich
Capuchin Friar by the Sea,
1808-10
Nationalgalerie, Berlin

This is Friedrich's most
"abstract" work and it is
unusual in its almost total
lack of forms and colors.
A looming, gray, cloudy sky

hangs heavily over a thin strip
of sand and the dark waves
lapping at the water's edge.
In this oppressive setting, the
tiny figure of the monk alludes
yet again to the relationship
between divine mysticism
and nature.

Caspar David Friedrich
Abbey in an Oak Forest, 1809
Castle of Charlottenburg, Berlin

This painting has become
emblematic of German
Romanticism, expressing a
sense of desolation, but
offering an alternative to the
sun-drenched Mediterranean

ruins in the Neoclassical style.
The bare trees are reminiscent
of gravestones in a cemetery
surrounding the deserted
ruined abbey, while the
extremely limited range of
gray-brown tints conveys an
impression of disconsolate
sadness.

Caspar David Friedrich
Sunset (Brothers),
1830-35
Hermitage, Saint Petersburg

Like many German Romantic
poets such as Novalis and
Goethe, Friedrich is attracted
to the idea of infinity.
The spectator's gaze
traverses the painting until
it becomes lost in the distant
haze that swallows up
the last rays of the sun
and blurs the horizon.

The Patriotic Fervor and Exotic Perfumes of Romanticism
Romanticism was not an organized movement in the true sense of the word, but a mood that spread throughout Europe at the beginning of the nineteenth century. Although the groups of artists and writers in different countries were independent and their local characteristics differed greatly, they were fired by the same ideals. They illustrated a need to express emotions that had been repressed for too long; first by the flamboyance of Baroque, then by the rationality of the Enlightenment, and finally by the rules of Neoclassicism. For this reason, poets and artists gave free rein to their romantic passions and patriotic fervor, their fear and ardor. In France, Delacroix was the brilliant leading exponent of Romanticism. He painted the pictorial manifesto of Romanticism, *Liberty Leading the People*, in which the heroine, who is the personification of liberated France, is portrayed seminude, wearing a Phrygian cap (emblem of the French Revolution), with a flag in one hand and a gun in the other. By contrast, in his portraits of the mentally ill, Géricault captures dark looks, glazed eyes and vague expressions, giving a disillusioned view of their marginalized and lonely condition. Just as the wreck of the Medusa could be the symbol of Napoleon's decline, the monomaniacs are a metaphor of the ordinary individual who is a prisoner of his own vices.

Théodore Géricault
Raft of the Medusa,
1818-19
Louvre, Paris

In 1816, the *Medusa* sank off the west coast of Africa. 150 people crowded onto a miserable raft faced days and days at sea in terrible conditions. In the end, only fifteen survived. Struck by this dramatic event, which could also be seen as a metaphor for Napoleon's ruinous fall, Géricault executed this large and powerful painting.

Théodore Géricault
The Madman,
1822-23
Oskar Reinhart Foundation,
Winterthur

Théodore Géricault
The Madman: Kidnapper,
1821
Museum of Fine Arts,
Springfield

Théodore Géricault
The Woman with Gambling Mania, 1820-24
Louvre, Paris

Eugène Delacroix
Women of Algiers, 1834
Louvre, Paris

The exotic costumes, cool shadows, soft light of the harem, and the languid sexuality and dark skin of the Algerian women make this painting one of the earliest and most important examples of Orientalism, a trend that began in the Romantic period, and continued through the nineteenth century right up to the present. Delacroix, at the height of his maturity, handles an unusual theme redolent with forbidden sensuality.

Eugène Delacroix
Liberty Leading the People, 1830
Louvre, Paris

The fruit of an eclectic, Romantic, and literary culture, this canvas is an unusual blend of realism, propaganda, rhetoric, and a record of contemporary events.

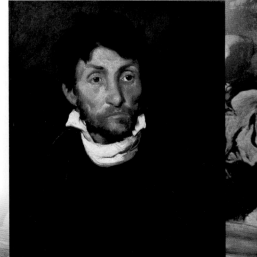

Théodore Géricault
The Insane Woman (Envy), 1820-24
Musée des Beaux-Arts, Lyons

Théodore Géricault
Portrait of a Kleptomaniac, 1821-24
Museum voor Schone Kunsten, Ghent

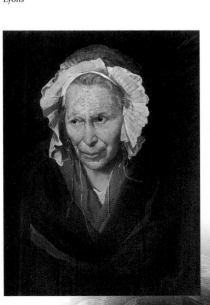

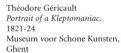

Germany, Denmark, Austria

1810-1860

Biedermeier

Private Virtues, Honest Pleasures

Usually the name of an artistic movement reflects its essence or the intellectual program of its founders; sometimes it even criticizes past movements. The name Biedermeier, on the other hand, is the name of a fictional character (an upright and respectable Swedish school teacher) that regularly appeared in a satirical magazine of the time. In this case, the character of Biedermeier is a metaphor for the German middle class because the Biedermeier style was directed at this public. After the Napoleonic "storm" had abated and the staid bourgeoisie had come to terms with Romanticism, Biedermeier gave a "domestic" interpretation of the noble Empire style. The formal language of the furniture and interior space resembles Neoclassicism, but the syntax between the different elements is plain, flowing, and simplified. Biedermeier developed in painting mainly in Germany and the vast territories of the Austro-Hungarian Empire. The subjects are so accessible that they verge on the banal and the emotions that they convey are moderate and controlled. They include composed family portraits, meticulously executed still lifes, and small, everyday scenes reminiscent of seventeenth-century Dutch painting. As a whole they depict a complacent society without great flights of fancy, but with clearly defined limitations. It is important to note that a feeling of national pride—not expressed in a heroic and individual way, but shared by the whole community—also permeates these works.

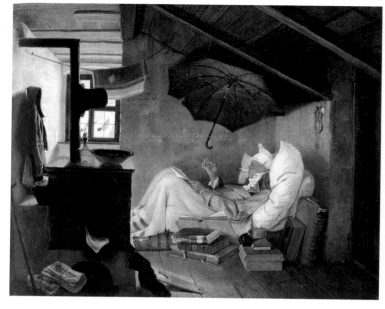

Carl Spitzweg
The Poor Poet, 1837
Neue Pinakothek, Munich

Very well-known in Germany, Spitzweg's (1808-1885) paintings are often good-natured caricatures of contemporary society.

David Conrad Blunck
Danish Artists in a Roman Tavern, 1836
Frederiksbormuseet, Hillerod

The Biedermeier period saw the establishment of a rich and important Danish school of painting, consisting of artists who had been to study in Rome and shared an admiration for the "patriarch" Thorvaldsen (the man with gray hair seated at the head of the table).

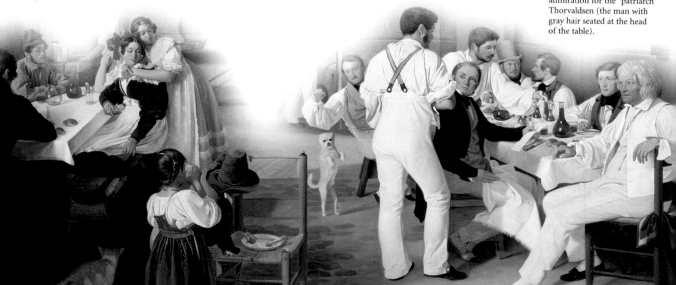

Johann Friedrich
August Tischbein
*Anne-Pauline Dufour-Ferance
and her Son Jean-Marc Albert*,
1802
Neue Galerie, Kassel

Born into a family of
important German artists,
Tischbein (1750-1818) was
a forerunner of Biedermeier
simplicity during
the Neoclassical period.

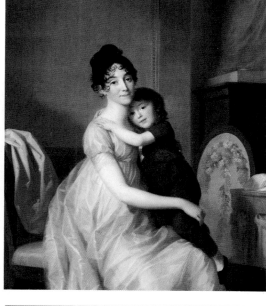

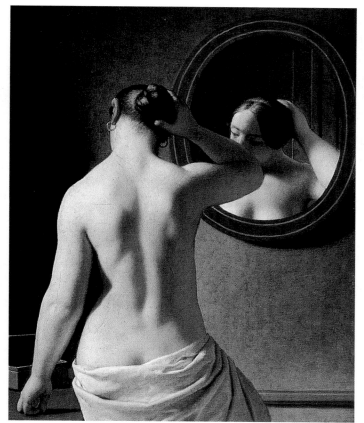

Christoffer Wilhelm
Eckersberg
*Woman Standing in Front
of a Mirror*, 1841
Hirschsprung Collection,
Copenhagen

Eckersberg (1783-1853),
the most sensitive of the
Danish Biedermeier painters,
had an excellent technique
that evoked the gentle
feelings and light gestures
of bourgeois *intimisme*.

Giuseppe Tominz
The Engaged Couple, 1830
Musei Provinciali, Gorizia

The world of domestic
affection is depicted by
early nineteenth-century
portraitists like Tominz
(1790-1866), a painter from
Gorizia and exponent of
provincial figurative art in
the Hapsburg Empire. In this
painting, he also offers the
viewer an example of fine
Biedermeier furnishings.

Great Britain
1770-1840
English Landscape Painters

The Concept of "Picturesque"

Between the eighteenth and nineteenth century, landscape painting in England developed into a true "national style", thanks to a string of extremely talented artists, stretching from Canaletto, who lived in London in the mid-eighteenth century, to Turner. The reasons for this success, besides the training offered by the Royal Academy, included the poetry of the period. In fact, the "ballads" of Coleridge and Wordsworth gave a new interpretation of nature, one that was full of emotion and mystery. The English artists enthusiastically adhered to the pre-Romantic and Romantic aesthetic, seeking out places that would arouse emotions and memories. Thus the concept of the "picturesque" landscape emerged—a term that has become so banal that it now has virtually the same meaning as "postcard"—that originally indicated the presence of features in the landscape that appealed to the painter's sensibility. Watercolor was the favorite medium of English landscape painters.

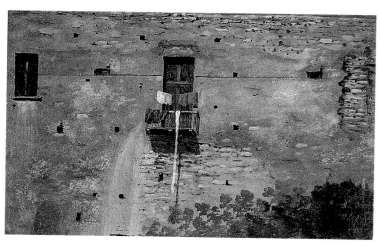

Thomas Jones
A Wall in Naples, 1782
National Gallery, London

In his departure from the tranquil paintings of the Grand Tour, Jones proves to be unusually sensitive toward silent, deserted scenes of poverty.

John Robert Cozens
Isola Bella on Lago Maggiore, 1783
British Museum, London

Cozens is a forerunner of the English pre-Romantic landscape, particularly in his choice of "picturesque" sites in Switzerland and Italy. However, his career was cut short by serious mental illness, which led to his death in an asylum in 1797. Nonetheless his influence was pivotal in the development of the English School. Both Constable and Turner practiced copying Cozens's watercolors during the years of their formation.

John Constable
Wivenhoe Park, Essex, 1816
National Gallery of Art,
Washington

This is one of Constable's
favorite parts of the English
countryside. In his various
versions of the same subject,
painted over a long period
of time, the painter seeks to
achieve an "objective", true
rendering that is meticulously
accurate in every detail and in
the reflections of light.

John Constable
Flatford Mill, 1817
Tate Gallery, London

Unlike many of his colleagues
Constable did not travel
to different countries. In fact,
most of his landscapes are
inspired by Suffolk, the
county where he was born.
Though he sought to create
a limpid, precise image of
nature, the painter could
not conceal his affection
for rural scenes with a few
quiet figures, often bathed
in sunlight.

243

London

1775-1851

Joseph Mallord William Turner

A Radical Turning Point in Landscape Painting

Although he possessed the natural talent of a child prodigy, Turner also had the intelligence and the patience to attend courses at the Royal Academy in drawing, engraving, watercolor, topography, and painting—all studies that paved the way to his landscape painting. Turner was a great admirer of nature and the traditional masters like Claude Lorrain, Poussin and the Dutch painters. He was also a step ahead of the group of English landscape painters. Stirred by the sight of the snow-capped Alps during a trip to Switzerland in 1803 (the first of his many journeys to continental Europe), Turner experienced the Romantic emotion of the "sublime". He subsequently began his pictorial research into atmospheric effects and the wonders of nature, departing from the analytical position of Constable (and Canaletto before him) to communicate feelings and emotions. At the center of the critical debate, appreciated by collectors, and a leading figure at the Royal Academy, Turner looked to the art of the past, comparing it to the new possibilities offered by technological and mechanical innovations. During the final phase of his career when he sought to depict rain and steam, the artist who, in his youth, had portrayed Hannibal and Aeneas, now painted a speeding steam train for the first time in history.

J.M. William Turner
Buttermere Lake with Part of Cromack Water, a Shower, 1798
Tate Gallery, London

From his earliest works on, Turner showed an intense interest in the effects of light on water. The rainbow, created by the color spectrum produced by the sun's rays on suspended particles of rain, is a quintessential example of the wonders of nature that so appealed to this painter.

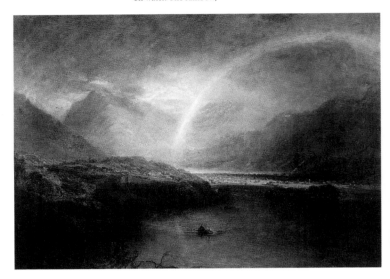

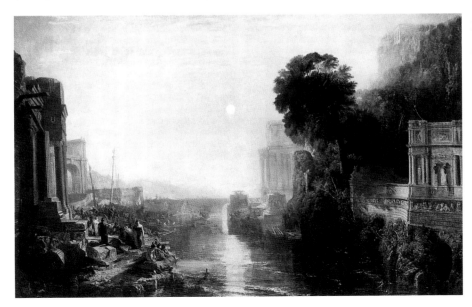

J.M. William Turner
Dido Building Carthage, 1815
National Gallery, London

Turner was particularly attached to this painting, which he considered his absolute masterpiece. In the first draft of his will, he indicated that he was to be buried wrapped in this canvas. Despite many offers, he never wanted to sell it and eventually donated it to the National Gallery in London, on the condition that it be displayed beside a seascape by Claude Lorrain that had evidently inspired him. Classical themes are frequent in Turner's work, and he often chose historic events or literary and narrative scenes as the "content" of his landscapes. Moreover, when he showed his paintings in the Royal Academy exhibits he accompanied them with quotations from ancient and modern poets.

J.M. William Turner
Juliet and her Nurse, 1836
Private Collection

Turner made three trips to
Venice, in 1819, 1833, and
1840, and he cherished the
memory of this city with its
sparkling water, melancholy
and splendor. It must be
remembered that he also had
a conflicting relationship with
Canaletto, an artist pivotal in
the birth of English landscape
painting and from whom
Turner chose to distance
himself.

J.M. William Turner
*Slave Traders Throwing the
Dead and Dying into the Sea –
The Typhoon Approaches*,
1839-40
Museum of Fine Arts, Boston

Inspired by a dramatic
contemporary event, this
painting caused a sharp rift
between the critics and the
public. Ruskin described it as
"the noblest sea ever painted
by man". The fiery sunset,
typical of Turner's mature
period, creates a sinister
atmosphere.

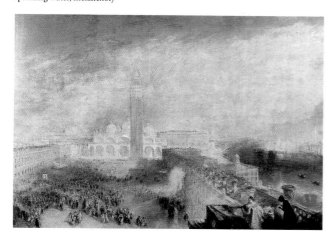

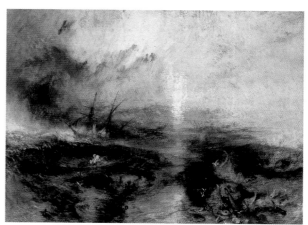

J.M. William Turner
Fiery Sunset, 1825-27
Tate Gallery, London

Attracted by the force
of the primordial elements,
Turner often contemplates
natural energy with a
mixture of enthusiasm
and anguish. In works like
this, his painting verges
on abstraction.

The Golden Age of the Academies

Does Practice Make a Master?

At the beginning of the nineteenth century, an important phenomenon took place in Europe. Prompted, in part, by the desire to develop new forms of expression and make them official, fine arts academies began springing up all over the continent. These academies became an alternative to apprenticeship for many young artists. They taught the rules of media and expression, with a specific emphasis on history and literature. Many academies also studied and conserved the art of their city or surrounding region through theoretical teaching and the establishment of local museums. The academies generally, of necessity, provided a standardized program of study that left little space for individual creativity. The focus on the masters and aesthetic norms of the past restricted the imagination of many artists, who, during the second half of the century, became increasingly dissatisfied and began to reject academic precepts. One of the explicit consequences of this attitude is the Impressionists' *en plein air* painting, which focused on the effects of light and color.

Jean-Auguste-Dominique Ingres
Madame Moitessier, 1856
National Gallery, London

In its absolute technical and stylistic perfection Ingres's (1780-1867) art is typical of the nineteenth-century academies. His painting is the expression of a search for higher, lasting values, obtained through the classical and Raphaelesque tradition to which he was committed.

Anselm Feuerbach
Paolo and Francesca, 1863
Schack-Galerie, Munich

A cosmopolitan artist, active in Munich, Antwerp, Paris, Venice, and Rome, Feuerbach (1827-1888) interprets—in the key of an elegant and eclectic academic culture—many different styles, from that of the Venetian Renaissance to the grandiose manner of Rubens and Van Dyck.

Jean-Auguste-Dominique Ingres
Great Odalisque, 1814
Louvre, Paris

Ingres, aware that he is challenging history, proposes his version of a theme that has been repeatedly explored in painting, that of the reclining nude. Here he relates it to contemporary life by incorporating the growing fashion of the exotic and the seduction of the Orient. While Delacroix tended toward the Romantic, Ingres maintained the elevated tone of classical purity.

Francesco Hayez
The Kiss, 1859
Pinacoteca di Brera, Milan

This painting by Hayez (1791-1882), in which the emotions are barely veiled by the medieval costumes worn by the protagonists, is the emblematic image of Italian Romanticism. As often occurred in Verdi's operas of the same period, the apparent spontaneity of the gesture and the perfect technical mastery conceal a political allegory, the kiss of alliance between Italy and France.

Jean-Auguste-Dominique Ingres
The Contesse d'Haussonville, 1845
Frick Collection, New York

Ingres's portraits are extraordinary works of nineteenth-century painting. The discreet charm of his gentle smiles dares us to take sides in the never-ending struggle between art and nature—a crescendo of virtuosity played out among mirrors, fabrics, perfectly rendered skin tones, jewels, lights, flowers, cushions, and porcelain, with an attention to detail that is almost miniaturistic.

The United States
1830-1900
The Nineteenth Century in America

The New Frontier of Western Art

For the United States, the nineteenth century was the century of industry and mass immigration. By 1860 New York's population already topped one million, putting America on its way to becoming the proverbial "melting pot". During the first half of the nineteenth century, American painting continued to rely on European currents and trends. London, the fashionable center for artistic training at the end of the eighteenth century, was replaced by Paris, which stayed in vogue until the outbreak of World War II. The influences of Constable, French Realism, and the Barbizon School, however, contributed to the emergence of the Hudson River School, the first truly American artistic movement. Led by the talented Thomas Cole (1801-1848), the school flourished between 1825 and 1875, using the Hudson River valley and many other unspoiled natural areas throughout the country (including rivers, mountains, and valleys) as its subject matter. This style of painting took reality as its starting point, but transformed it into an idealized, Romantic vision, with a strong dose of American national pride. Parallel to landscape painting, genre painting also developed around the mid-nineteenth century. The leading exponent of this style was George Caleb Bingham (1811-1879), who devoted himself to depicting the men who sailed the barges on the Mississippi and Missouri Rivers, the same characters that appear in Mark Twain's famous tales. In the same spirit, Winslow Homer (1836-1910) painted striking seascapes illustrating the lives of Atlantic fishermen. His anti-academic stance and free, unconventional style made him one of America's most brilliant masters. During the second half of the nineteenth century several of the major American artists (including Mary Cassatt, John Singer Sargent, and James A. Whistler) moved to Paris and London where they came into contact with Im-pressionism and later trends.

Thomas Cole
*View from Mount Holyoke,
Northampton, Massachusetts,
After a Thunderstorm
(The Oxbow)*, 1846
Metropolitan Museum of Art,
New York

This lush landscape glittering in the pale light of the sun after a violent storm is a celebrated example of Cole's spiritual approach to nature.

Emanuel Gottlieb Leutze
*Washington Crossing
the Delaware*, 1851
Metropolitan Museum of Art,
New York

The American tradition of large historical paintings continued into the nineteenth century and the themes chosen were still linked to independence and the birth of the United States. In a grandiose and elevated style Leutze depicts Washington crossing the Delaware on Christmas night 1776. This painting was executed in Düsseldorf, Germany, where young American artists often went for their training.

John Singer Sargent
Children of E.D. Boit, 1882
National Gallery of Art,
Washington, D.C.

Sargent's (1856-1925) magnificent
portraits of American high
society, influenced by Velázquez
and Manet and reminiscent of the
characters described in Henry
James's novels of the same period,
offer a view of a ruling class that
is aware of the United States'
rapid rise to the top of the global
economy.

James A. Whistler
*Arrangement in Gray and Black
(Portrait of the Artist's Mother)*,
1871
Musée d'Orsay, Paris

This painting has become
an icon of American art.
However, it was executed in
the London neighborhood of
Chelsea where the painter had
moved in 1859. In opposition
to the Pre-Raphaelites,
Whistler proposed a style
based on vibrations of
color, often describing his
paintings as "arrangements"
or "symphonies" of
chromatic tones.

Portraying Sports and Sportsmen

A keen oarsman, Thomas Eakins (1844-1919) painted this work around 1872, shortly after his return to America from a customary period of study in Paris (where he met Manet).
In this painting, Eakins depicts the Biglen brothers, a famous team of rowers. While Degas mingled with the crowd at the Longchamp racetrack in Paris, Eakins made a vital contribution to the development of a new pictorial genre: sporting competitions. No longer a strictly elitist, aristocratic pastime, sports were gradually gaining popularity among the masses. In fact, by the late nineteenth century, sports dominated the newfound leisure time of the English-speaking world.
The first modern Olympic Games, held in Athens in 1896, marked the dawn of a new era. In the portrayal of modern sporting events, artists of the period looked to the idealized bodies of ancient Greek art for inspiration. Rowers, runners, boxers, tennis and rugby players inspired a novel observation of the human body that also involved the development of a technique for rendering an image in motion. Similarly, pole jumpers and horse riders are among the first subjects of the earliest photographic sequences.

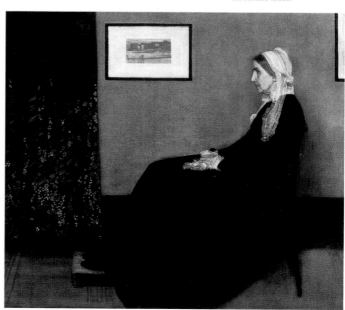

London

1848-1898

The Pre-Raphaelites

The Refinement, Rhetoric, and Anxieties of the Victorian Age

On 28 June 1838, at the age of 19, Queen Victoria became sovereign of an empire that, during her reign, extended to all five continents. The so-called Victorian Age was a long and important period in English history characterized by intense economic development and a growing concern for morality. This period, marked by a firm belief in the importance of science and technological progress, also witnessed to great social and economic upheaval. The Pre-Raphaelite Brotherhood, founded in 1848, was emblematic of the art of the Victorian Age. Influenced by the Nazarenes, the Pre-Raphaelites (whose membership included William Holman Hunt, Dante Gabriel Rossetti, and John Everett Millais) proposed a return to a pure style of painting that looked back to medieval art and the Italian masters, before the "modern manner" of Raphael, for inspiration. Moved by an uneasy religiousness often mixed with a disturbing sensuality, the Pre-Raphaelites triggered conflicting reactions from both critics and the public.

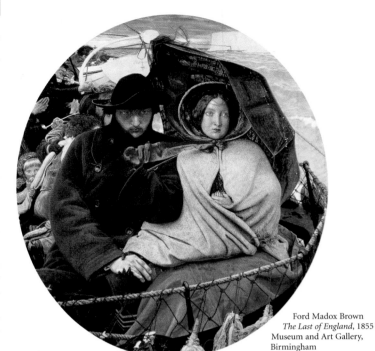

Ford Madox Brown
The Last of England, 1855
Museum and Art Gallery,
Birmingham

This sad, but tender portrait of the emigrating couple shows an unusual aspect of industrial, working-class society in Victorian England. Brown (1821-1893) himself had planned to emigrate to India. He never joined the Pre-Raphaelite Brotherhood, but was constantly in contact with members of the group. He was also the only painter who had been to Italy.

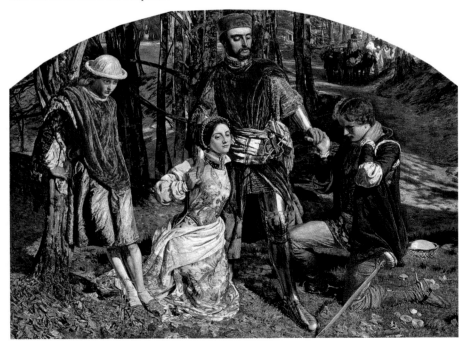

William Holman Hunt
*Valentine Freeing Sylvia
from Proteus*, 1850-51
Museum and Art Gallery,
Birmingham

This painting illustrates a scene from Shakespeare's *Two Gentlemen of Verona*. Before beginning work on the painting, Hunt (1827-1910) carefully gathered precise information on the costumes and arms of the period. This meticulous attention to detail characterizes all the artist's work.

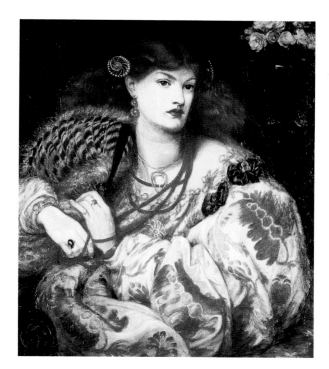

Dante Gabriel Rossetti
Monna Vanna, 1866
Tate Gallery, London

Clearly inspired by Titian's
painting, this portrait should
have been called *Venetian
Venus*. Rossetti's (1828-1882)
femmes fatales reflect his
relationship with women.
He was extremely disturbed
by the death of his wife
Elizabeth in 1862, who
committed suicide after giving
birth to a still-born daughter.
Rossetti felt remorse for the rest
of his life and suffered from
nightmares and depression.
A note of profound melancholy
can be sensed beneath the
lavish pictorial style.

John Everett Millais
The Blind Girl, 1854-56
Museum and Art Gallery,
Birmingham

A child prodigy, Millais (1829-
1896) introduced sentimental
themes and touching portraits
of children into the art of the
Pre-Raphaelite group.

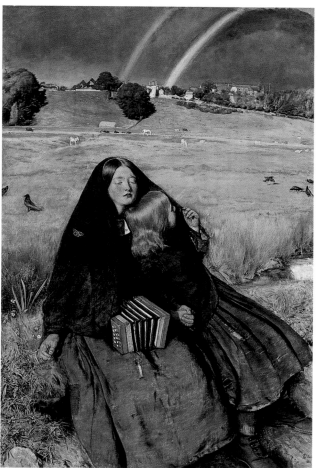

The Awakening Conscience

*This painting by Hunt, executed between
1853 and 1854 and held by the Tate Gallery
in London, has come to symbolize the literary
and "philanthropic" moralism of Victorian
society.*
The title The Awakening Conscience *refers
to the revelation of a young prostitute who
suddenly recognizes that she is on the path to
eternal damnation. The girl is sitting on the lap of a young hedo-
nist who is singing and playing a tune on the piano with his left
hand. Hunt painstakingly describes every detail of the furnishings,
as if to underscore the overabundance of decoration, ornaments,
screens, and carpets so typical of Victorian taste. The painter also
includes symbols of aggression, seduction, and lost honor. Some of
these are difficult to see, for example, to emphasize the fact that the
couple is not married, Hunt has painted a ring on every finger of
the girl's hand except her ring finger. The girl is also clasping her
hands as if she has had a sudden awakening, while the man seems
to be attempting to seduce her.*

Germany
1840-1880
Menzel and German Realism

Consistency, Credibility, and Progress in the Age of Bismarck

Around 1840 the ardors of Romanticism were cooling in Germany and throughout Europe. The ideals of the Nazarenes were beginning to seem completely irrelevant and the public no longer identified with Friedrich's anxiety. While the Biedermeier style was a tasteful response to the demands of a growing bourgeoisie, the upper classes (particularly the Junkers of the Prussian aristocracy) sought a concrete, realistic style that conveyed the image of a strong German society, similar to the one described in Theodor Fontane's novels. The artists of German Realism substantially identified—both culturally and on a socio-economic level—with their public, unlike in France where artists like Courbet, Daumier, and the Impressionists represented a provocation to their viewers. The leading exponent of German Realism, Adolf von Menzel, was born in Wroclaw in 1815 and died at the age of ninety in Berlin. He was an active protagonist on the European cultural scene in the second half of the century when his personal and artistic life mirrored the evolution of the Realist movement. From a humble background, he began his career as an illustrator, went to study in Italy, supported the revolutionary movements of 1848, taught at the Berlin academy, and was in contact with the Parisian Impressionists. He also admired technological progress and participated—by producing highly successful celebratory paintings—in the consolidation of German power under Bismarck.

Hans Thoma
Bunch of Wild Flowers, 1872
Nationalgalerie, Berlin

Influenced by Courbet's naturalism, Thoma (1839-1924) sought simplicity in the pictorial handling of his subjects. He declared: "Good paintings always look as if they have grown by themselves or as if nature had created them".

Johann Erdmann Hummel
Polishing the Granite Bowl, c. 1830
Nationalgalerie, Berlin

This painting by Hummel, depicting (almost hyper-realistically) the final stages of work on a large tub, is one of the earliest "industrial" paintings. Made from a block of granite hewn from the mountains of Rauen, it found its final resting place in the square in front of the Altes Museum in Berlin.

Adolf von Menzel
The French Window, 1845
Nationalgalerie, Berlin

In this work, from the (relatively late) beginning of his career as a painter, Menzel is apparently intolerant of the Nazarenes' glorification of the past. Here, the artist depicts a Biedermeier-style bedroom (partially reflected in the large mirror on the right) rendered with warmth and simplicity, and great sensitivity to the effects of light on the scene.

Adolf von Menzel
*Flute Concert of Frederick
the Great at Sanssouci*, 1852
Nationalgalerie, Berlin

The political, military, and
economic growth of Berlin and
Prussia was also spurred by the
return of Frederick the Great,
considered the "father of the
fatherland" and a model of
virtue, both on a personal level
and in his rule over the country.

Adolf von Menzel
The Foundry, 1875
Nationalgalerie, Berlin

Attracted by modern subjects,
Menzel confers an epic tone
on the work depicted here.
The workers around the
furnace resemble the
Cyclopses at Vulcan's forge.
Menzel declares: "The heat,
effort, noise, and agitation
literally burst out of the
painting onto the viewer".

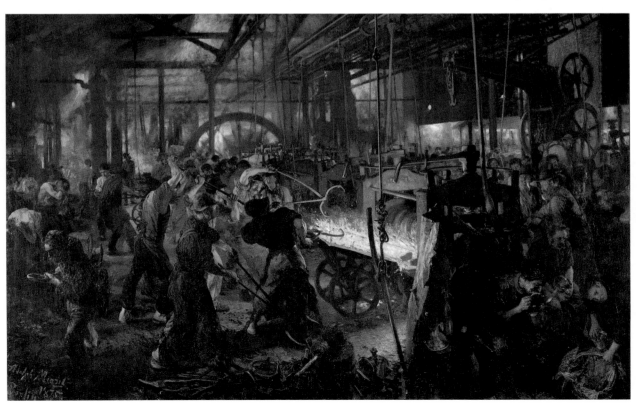

Paris

1840-1870

Courbet and French Realism

In Search of New Heroes

1855 can be considered the pivotal year of the Realist Movement in France. This was the year that Gustave Courbet (1819-1877) set up his own makeshift pavilion, the *Pavillon du Réalisme*, opposite the Paris Salon, to show a large number of works that had been rejected by the official exhibit. His initiative pointed to the existence of a movement that had already been active for several years, but had not yet been given a name or acknowledged by the critics. The word "realism" can simply mean the faithful reproduction of reality in a work of art. Courbet, however, does not produce a mere external imitation, but attempts to identify with all aspects of reality. Realist painting emerged in opposition to the moralistic ideals that had characterized academic art. Now, the working-class, the poor and the derelict were depicted on canvas, and it was not by chance that Realism became popular and widespread in Europe after the political and social uprisings of 1848. The exotic, sublime, and spiritual themes of Romanticism were replaced by concrete situations closer to everyday life. Courbet's dark, heavy paintings of subjects that were often unsavory or even obscene were in conflict with bourgeois ideals and, therefore, not well received by critics. The Realist movement also included the mystic Jean François Millet (1814-1875) and Honoré Daumier (1808-1879), a biting caricaturist of the political and legal world, but also a painter who depicted the lowest classes of society.

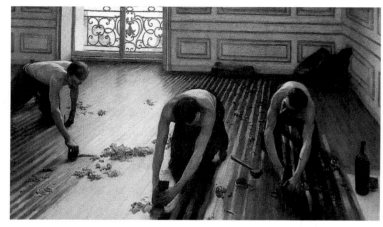

Gustave Caillebotte
The Floor Scrapers, 1875
Musée d'Orsay, Paris

An important realist component remained in French painting for a long time, and is even to be found in Impressionism.

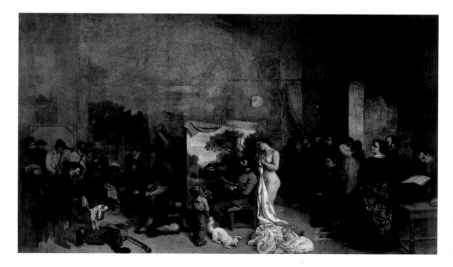

Gustave Courbet
Painter's Studio, 1854-55
Musée d'Orsay, Paris

This self-portrait, charged with ideological and moral significance, became the manifesto for a new way of conceiving the artist's role in society. Courbet is at his easel painting a landscape. Next to him is a nude model, a large white cat, and a child, symbolizing purity and innocence. He is surrounded by two symmetrical groups of figures: on the right are his relatives, friends and pupils; and on the left, are characters from daily life. These two separate groups represent the eternal conflict between winners and losers, rich and poor. The artist in the center of the scene is the interpreter and mediator of this reality.

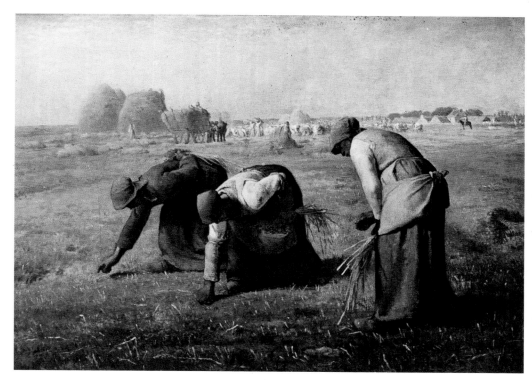

Jean-François Millet
Gleaners, 1848
Louvre, Paris

Millet's most characteristic large paintings of peasants date from the 1850s. Here, the workers in the fields are exalted by a composition that turns them into heroic protagonists, bathed in a solemn and sacred atmosphere. In this famous painting, the depth of the horizon and the quiet hour in the fields confers Romantic nobility on the back-breaking labor of the poor gleaners.

Gustave Courbet
The Grain Sifters, 1854-55
Musée des Beaux-Arts, Nantes

There is a sharp difference between these exhausted workers and Millet's priestess-like gleaners.

"Courbet in vinculis faciebat"

This Latin phrase "Made by Courbet in chains" is the signature on this extremely unusual painting, dated 1871, and held by the Kunsthaus in Zurich.
The remains of this large trout caught on a hook conceal a dramatic self-portrait, the last of the many self-portraits the artist has left behind.

Jailed for political and moral reasons and forced into exile in Switzerland, Courbet identifies with the agonizing, bleeding fish dragged out of its element without any possibility of escape. Even without knowing its background, it remains a masterpiece of immediacy in the pulsating sympathetic handling of the gasping fish and Courbet's typical palette of dull, dark earthy tones of gray-brown.

Paris

1832-1883

Édouard Manet

The Love of the Classics, the Scandal of Modernity

Manet is the most cultured of the Impressionists, preferring the atmosphere of museums to the open air. Having grown up in a respectable bourgeois Parisian family, he was expected to make a career as a naval officer, and was only allowed to devote himself to painting on the condition that he followed regular classical studies. During the 1850s, his long journeys to visit the museums of Europe, led him to admire Titian, Rembrandt, Velázquez, and Goya. Upon his return to Paris, he became involved in the literary realism of Baudelaire and Zola and began painting large canvases inspired by real people. In a very short time Manet became one of the most celebrated and controversial artists in Europe. Around 1863, through "scandalous" works like *Olympia* and *Déjeuner sur l'herbe* he affirmed the principle of the artist's freedom to depict any subject without having to resort to "elevated" and traditional themes. Although this concept was still in embryo, it was to become the very foundation of modern art. In the 1870s Manet joined the Impressionist movement. During this period, his palette became lighter, though his style continued to re-flect a studied, personal interpretation of the great masters.

Édouard Manet
Le Chemin de Fer (The Railroad), 1873
National Gallery of Art, Washington, D.C.

During the years in which he was most closely in contact with the Impressionists, Manet's palette became lighter and he chose subjects from Parisian life. However, he never abandoned himself to "the impression"; the rigor of his compositions and his formal control remain impeccable.

Édouard Manet
Boating, 1874
Metropolitan Museum of Art, New York

Unlike Renoir and Monet, Manet is not interested in reflections of light on water. He prefers to concentrate on the figures, but not without a touch of humor. The girl wearing the veil looks somewhat perplexed by the maneuvers of the improvised Sunday skipper in t-shirt and straw hat.

Édouard Manet
Olympia, 1863
Musée d'Orsay, Paris

Olympia is Manet's most scandalous work. Never before had a prostitute been portrayed so shamelessly and directly. The artist declares, in an extremely elevated manner, the supreme dignity of art whatever the subject matter. The person or theme may be risqué but the absolute purity of painting is inviolable.

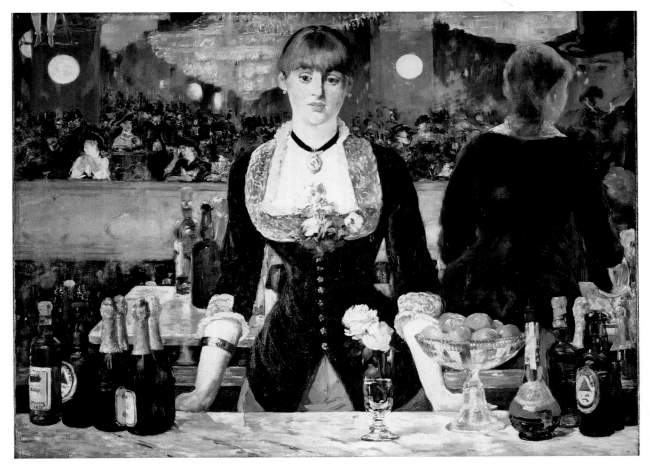

Édouard Manet
Bar at the Folies-Bergère, 1881
Courtauld Institute of Art,
London

This is Manet's final
masterwork and perhaps
one of the most intensely
poetic paintings of the
nineteenth century. In this
scene, set in one of the
popular Paris nightspots, one
can almost hear the amused
murmur of the audience,

the festive fizz of the
champagne, and smell the
aromatic smoke of the cigars.
But the tired, worn-out
expression of the young
barmaid dominates the
painting. She is a working-class
girl who, among the shiny
bottles, sparkling glasses,
marble surfaces, and bright
chandeliers, lives in the shadow
of inescapable solitude and
sadness.

Manet and Magritte, a Balcony 82 Years Later

*Inspired by one of Manet's most celebrated works,
painted in 1868 and held by the Musée d'Orsay
in Paris, 82 years later René Magritte made a
macabre parody of it (in the Museum voor
Schone Kunsten in Ghent).*
*This disconcerting reinterpretation is a signifi-
cant example of the Belgian Surrealist's attitude
toward the painting tradition. Magritte uses the*
masterpieces of the past to illustrate a new theory of reality, a novel view of the world and
the images that represent it.
*Magritte himself stated: "What made me see coffins where Manet saw white figures is the
image presented in my painting, where the decoration of the balcony was suitable for
coffins. The 'mechanism' at work here might be the subject of a learned explanation', of
which I am not capable. This explanation may be valid, even definite, but this does not
mean it would cease to be a mystery".* It must be added that Manet himself was inspired
by a similar painting by Goya of two girls and a man leaning over the railing of a balcony.
The history of art proceeds through these allusions, through the eras, styles, and intuitions
of the great masters.

Édouard Manet

1863

Déjeuner sur l'herbe

Housed in the Musée d'Orsay in Paris, this is one of the most famous masterpieces of the nineteenth century. Completed at the beginning of the Impressionist era, this composition is directly inspired by a painting by Titian (in the Louvre). However, this homage to the painting of the past (frequent in the works of the highly cultured Manet) is not expressed in academic terms, but as a stimulus toward freedom in art. The scene depicts a group of friends having a Sunday picnic in a park on the outskirts of Paris. The food is painted in the foreground, partly placed on the discarded dress of the woman in the center of the painting. The obvious, suggestive eroticism of the nude girl seated between two fully dressed men is toned down by the natural surroundings, and the cool shadows and bright sunlight filtering through the branches of the trees. Manet presented this work to the 1863 Salon, but it was rejected by the very severe and reactionary jury (as were three-fifths of the approximately 5,000 works presented). It was shown in the embarrassing Salon des Refusés and triggered an enormous scandal, which went way beyond the author's intentions. However, the outrage provoked by this canvas drove Manet to continue in the direction of forthright, realistic painting. His follow-up work was the even more direct and explicitly shameless *Olympia*.

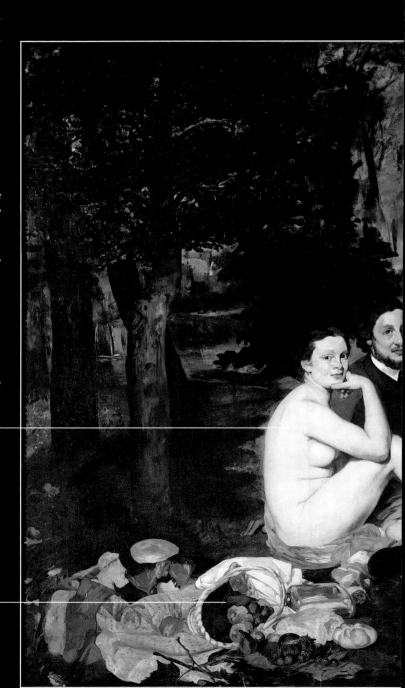

The nude woman, deliberately and rather brazenly turning to face the observer, is Victorine Meurant, a guitarist in third-rate dives, who became the model for many of Manet's important works. Victorine is certainly no classical beauty, but her free spirit and irregular features attracted Manet. Victorine's questionable background was the subject of further scandal, for which Manet received abuse from respectable critics and the bourgeoisie that the artist himself originally came from.

A very fine painter of still lifes, Manet places a tipped basket with bread and fruit from the picnic in the foreground. This is a remarkable section of the painting and an excellent example of Manet's extremely fine handling even by academic standards. The makeshift tablecloth is Victorine's dress.

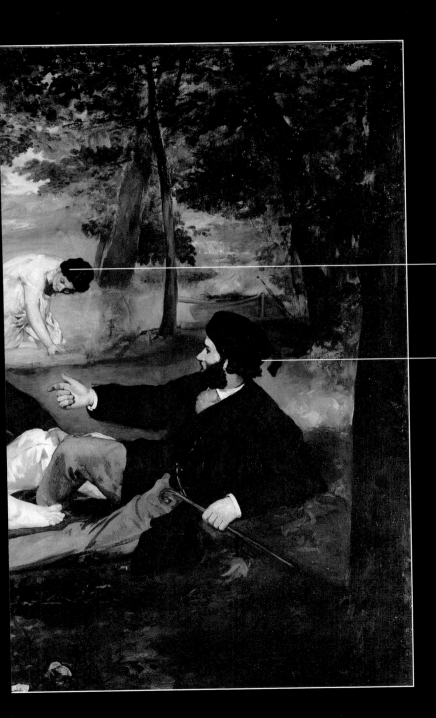

The presence of a second woman dressed only in a shift, completes the allusion to Titian's *Concert Champêtre* and makes the number of figures symmetrical. For Manet this is also a pictorial device to lengthen the planes of the painting and draw attention to the luminous background, where the dark green trees open onto a clearing bathed in sunlight.

For the public and critics of 1803 (who went into rapture over Gérome's and Cabanel's frigidly erotic nudes) the most offensive and immoral aspect of the painting was the presence of the two men fully dressed in the bourgeois clothes of the day in the company of the nude girl. The young man facing the spectator is Eugène Manet, the painter's brother. As occurred in other forms of art like opera and the novel, the public felt reassured by the historic distance placed between themselves and the scene. They could only accept suggestive subjects that were set in the past. Works depicting real life were still regarded with extreme uneasiness.

Paris, Giverny
1840-1926
Claude Monet

The Father of Impressionism

While French literature was abandoning the historic novel and turning to stories about real people set in modern Paris and the surrounding countryside, a group of painters felt the need to free themselves from monotonous academic training to give vent to their personal emotions and "impressions". During the 1860s, Monet, Renoir, and Sisley left the academy and the museum to capture *en plein air* (in the open air) the lights, colors, and atmosphere of the landscape. Monet is the true founder of Impressionism. He organized the historic group exhibition at the studio of the photographer Nadar in 1874, and the movement was named for one of his paintings. Monet alternated scenes of Parisian life with landscapes and seascapes, showing an insistence on the effects of color and the refraction of light, and increasingly blurring the outlines. As the Impressionist group gradually disbanded, Monet left Paris for Giverny. From 1890 on he produced series of canvases on the same subject seen in a different light (Rouen cathedral, haystacks, the cliffs of Brittany, and the Houses of Parliament in London). During his last years he passionately and poetically devoted himself to painting water lilies.

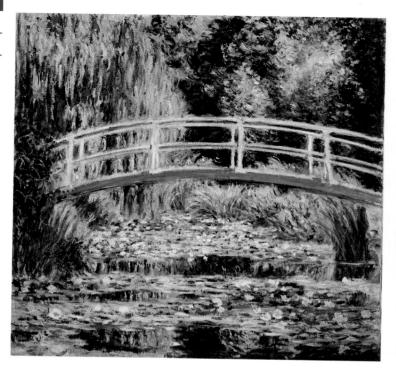

Claude Monet
White Water Lilies, 1899
Pushkin Museum of Fine
Arts, Moscow

In the enchanting, lovingly tended garden at Giverny Monet began to execute the series of paintings of water lilies floating on the pond with its Japanese-style bridge. This long series of canvases was to take him to the verge of abstraction.

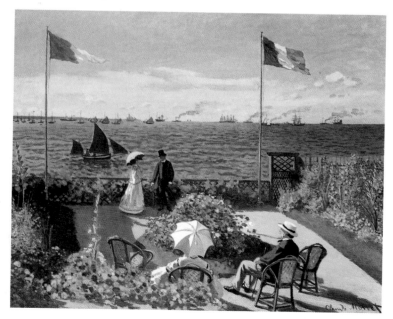

Claude Monet
Terrace at Sainte-Adresse,
1866
Metropolitan Museum
of Art, New York

In this spectacular terrace overlooking the sea, with steamships and sailboats on the horizon, the apparent freedom and immediacy are the result of a precise study. The whole painting is based on the chromatic harmonies (yellow-red; blue-white-red) of the two fluttering flags.

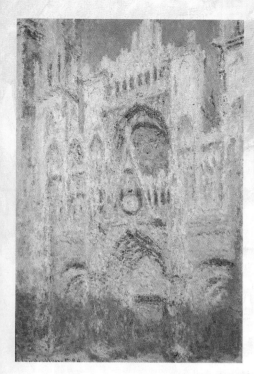

Claude Monet
Rouen Cathedral at Sunset,
1894
Pushkin Museum of Fine
Arts, Moscow

The characteristic that still
makes the Impressionists
so popular is their diffused
luminosity, achieved at the
same time as the birth of
photography (where the
image is fixed when the plate
is "impressed" by light)
and scientific research into
the properties of light.

Claude Monet
Déjeuner sur l'herbe, 1865
Pushkin Museum of Fine
Arts, Moscow

Inspired by the painting
of the same title by Manet
(1863), Monet also painted
a "picnic on the grass".
Before tackling the final
version of this large canvas
(later cut and reduced to
fragments), Monet executed
this preparatory sketch
that renders the moving
beauty of the masterpiece
that launched
Impressionism.

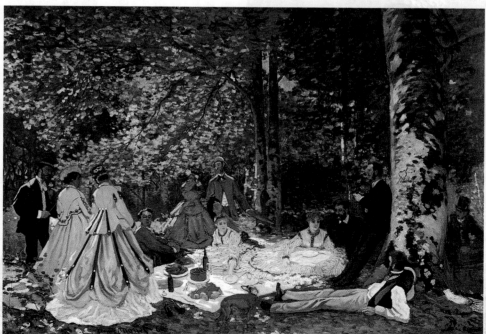

Claude Monet

1873

Impression: Sunrise

Jewel of the Musée Marmottan Monet in Paris, this relatively unassuming painting has the unique privilege of having given its name to the Impressionist movement. The term was initially used disdainfully by critics seeking to stigmatize the feeling of personal immediacy that countered the studied formality of the academic tradition.

Monet's painting was shown in 1874 with other Impressionist masterpieces in a historic Parisian exhibit at the studio of the photographer Nadar. It aroused heated and generally negative reactions in both the public and critics. As the painting's title states, it was not intended to be a realistic "description" of the landscape, but rather the painter's "impression" of a particular moment of the day. Here Monet painted the sun rising over an outer harbor, perhaps at Le Havre. Water and sky intermingle in a single blue tonality, dominated by the red sun.

Toward the center of the composition, the blurred outline of a small boat with two people aboard can also be identified. Monet's painting was met with opposition because it was distinctly outside the realm of academic tradition. His desire to evoke the sensations of light and color led him to reject the classical rules of composition. In this sense, Impressionist painting can be compared to late nineteenth-century French literature, which also placed emphasis on sensory experience.

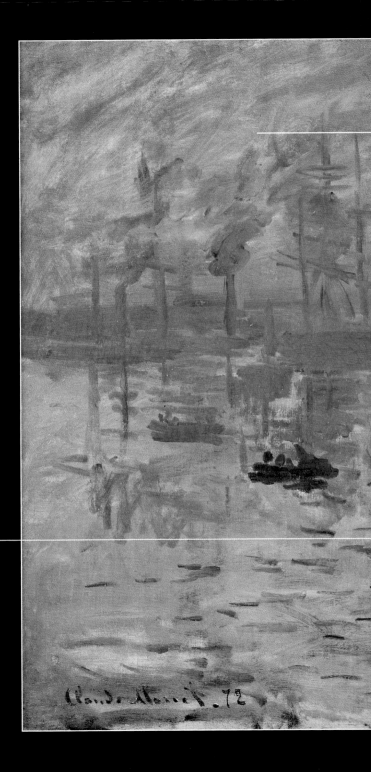

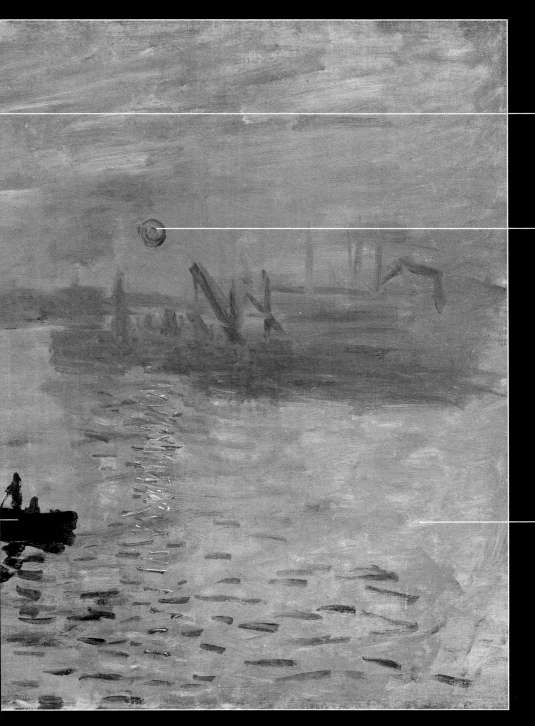

In the background, half-hidden by the haze, one can just make out the silhouette of a bustling port filled with ships, fishing boats and cranes. The smoke blends with the mist creating extraordinary light effects.

The round reddish-orange sun dominates the painting chromatically and reverberates over the cooler blue-gray tones. Monet's exceptional feel for color is evident in his rendition of both the elongated reflection of the sun across the water and the faint pink tonalities of the clouds.

Water was one of Monet's favorite subjects and he interpreted it in a great variety of ways. He painted the luminous bank of the Seine on a summer Sunday; the furious crashing of waves against the Brittany coast; the sweeping horizons of Atlantic beach resorts; the Ligurian Sea; the canals of Venice; the Thames flowing past the Houses of Parliament; and his famous waterlily pond at Giverny.

Paris, Côte d'Azur
1841-1919
Pierre-Auguste Renoir

The Smile of Impressionism

Born in Limoges into a family of craftsmen (and thus from a lower class than Manet, Cézanne, and Degas), Renoir brought to the Impressionists a refreshing and instinctive joie de vivre. This spirit was conveyed in his paintings of popular Sunday diversions of the period, such as outdoor dances, boat trips on the Seine, and summer strolls in shady parks. Renoir began studying painting at the École des Beaux-Arts in 1862 and was in the same class as Monet and Sisley. Feeling oppressed by academic conventions, he and his classmates began to go outdoors (*en plein air*) and fill their paintings with the natural colors and light of the surrounding countryside. And so Impressionism was born. In contrast to the country scenes frequently chosen by Sisley and Monet, Renoir looked to Paris for inspiration, focusing on the everyday life of its inhabitants. He quickly distinguished himself as an excellent portrait painter, with a unique sensibility for young women and children.

In 1881 Renoir took a long trip to Italy, where his style began to evolve and change profoundly. The joyous, spontaneous images of the previous years gave way to large compositions filled with monumental, almost Rubens-like, female nudes (especially after he moved to the Côte d'Azur). Suffering from arthritis and confined to a wheelchair, the aging Renoir continued to paint courageously (his paintbrush tied to his hand) until the end of his life, celebrating youth and beauty in the dazzling light of the French Riviera.

Pierre-Auguste Renoir
Madame Charpentier and Her Children, 1878
Metropolitan Museum of Art, New York

Pierre-Auguste Renoir
Le Moulin de la Galette, 1876
Musée d'Orsay, Paris

Renoir joyfully participated in the revelry of the popular Sunday dances. This masterpiece, unquestionably one of the most famous Impressionist works, was painted during a crucial period in Renoir's career, when ideas he shared with other painters in the group (e.g., his preference for subjects from everyday life, colored shadows, and painting outdoors) began to evolve into his own unmistakable style, characterized by brushstrokes laden with color.

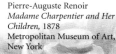

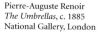

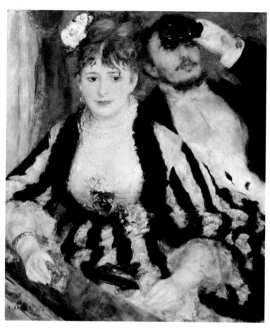

Pierre-Auguste Renoir
La loge (The Theater Box), 1874
Courtauld Institute of Art, London

The man intently peering through opera glasses at members of high society at the Opéra is Renoir's brother, Edmond. He is in the company of the resplendent Nini, a well-known model, portrayed here with great freshness and luminosity. As always, Renoir focuses on the eyes and lips of his female subjects, leaving the rest of the face almost neutral. The flower slipped into the neckline of her striped dress reveals his exceptionally sensitive use of pictorial material.

Pierre-Auguste Renoir
The Umbrellas, c. 1885
National Gallery, London

With his usual sense of chromatic harmony, Renoir has based this entire painting on the gray-blue color of open umbrellas and autumn dresses. The dominant dark tones are counterbalanced by the luminous faces of the young women, who are relieved that the rain is finally stopping. The two children placed in the lower right-hand corner of the composition are the actual focus of the painter's attention and also serve to lighten the mood.

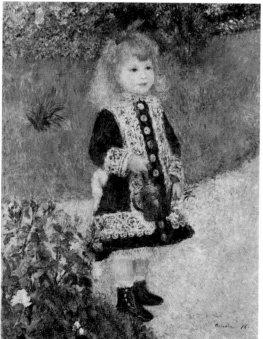

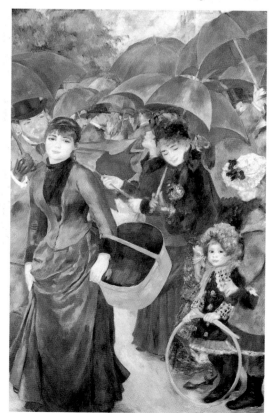

Pierre-Auguste Renoir
A Girl with a Watering Can, 1876
National Gallery of Art, Washington, D.C.

Few artists have been able to convey the tenderness and innocence of children as well as Renoir. Never resorting to the rigid poses that have so often spoiled "official" portraits of children done up in their Sunday best, Renoir allows his young models to laugh and play. Here the painter creates an enchanting harmony between the sunlit flower garden and the little blonde girl who proudly holds a tiny green watering can, smiling happily as if she alone were responsible for the spectacular garden in bloom.

265

Elegant Drawing, a Taste for Life

Degas, son of a banker of noble origin, showed little interest in landscape painting, but instead devoted his attention to capturing the expressions, gestures, and emotions of human beings, particularly women. By the 1860s, Degas had become part of the Parisian art world. Here he met and befriended Manet, with whom he shared a similar social and cultural background. He was also drawn to the many new forms of expression that were beginning to gain popularity in Paris, including photography and elegant Japanese printmaking. During the early 1870s, he began to focus on two of his favorite subjects: the Opéra (particularly its ballerinas), and the horse races at the Longchamp racetrack. Following his trip to New Orleans in 1873, Degas began to find inspiration in the plain, everyday life of washerwomen, housemaids, and dressmakers living in humble quarters. As part of his study of the human form, he portrayed women ironing, combing their hair or bathing. Partly due to an eye disease that eventually left him blind, Degas began using rapid, more visible brushstrokes as almost a kind of shorthand. He also began sculpting in clay and bronze.

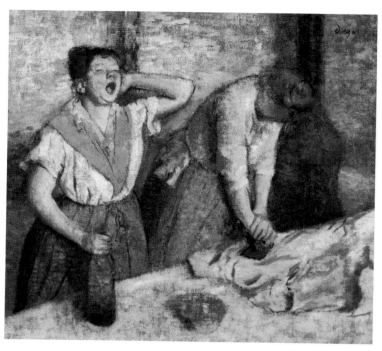

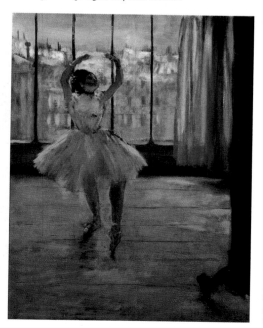

Edgar Degas
Dancer at the Photographer's Studio, 1875
Pushkin Museum of Fine Arts, Moscow

Degas was an extremely fine draftsman, who did not share the same interest in color and light as the other Impressionists. He was interested in the subtle combination of the movement and balance of a ballerina *en pointe*. The recent development of photography suggested new and unexpected ways of viewing the image. Memorable indeed are the rooftops of Paris visible through the studio windows. The skylight, chimneys, and gray sky irresistibly recall the first scene of Puccini's *La Bohème*.

Edgar Degas
Women Ironing, 1884-86
Musée d'Orsay, Paris

As time passed, Degas increasingly abandoned elegant settings and turned his attention to the working-class world. The gestures of the two women—one bent over her ironing, the other caught yawning—are perhaps somewhat coarse, but the aristocratic Degas manages nonetheless to offer us an image full of human sympathy and truth, with no trace of vulgarity.

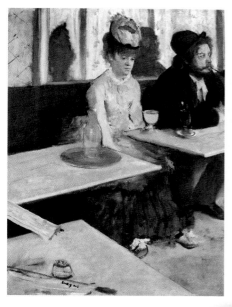

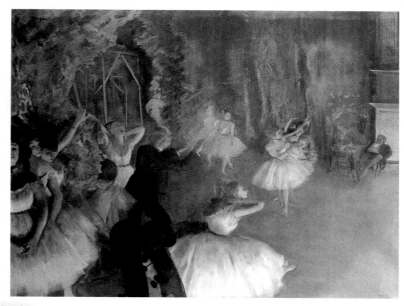

Edgar Degas
The Absinthe Drinker, 1875-76
Musée d'Orsay, Paris

The historic exhibit held in
Nadar's studio in 1874 marked
the height of the Impressionist
movement. For some artists it
also marked the end of their
most creative period, but this
was not true for Degas.
Here, the squalor of the bar
is reflected in the hopeless
expression of this distressed
young woman, who is lost in
the solitude of drink.

Edgar Degas
*The Rehearsal of the Ballet
Onstage*, 1874
Metropolitan Museum of Art,
New York

Degas, an habitué of the
Opéra, conveys the frenetic
and exciting atmosphere
that inevitably precedes
opening night by taking
the viewer backstage.

Egdar Degas
The Bellelli Family, 1858
Musée d'Orsay, Paris

Taking his inspiration from
Renaissance painting, Degas
portrays his Italian relatives
in a serene, decorous
manner. His mix of
spontaneous composition
and traditional technique
contributes to the
intrigue of this
painting, which
manages to be
solemn without
being overly rigid.

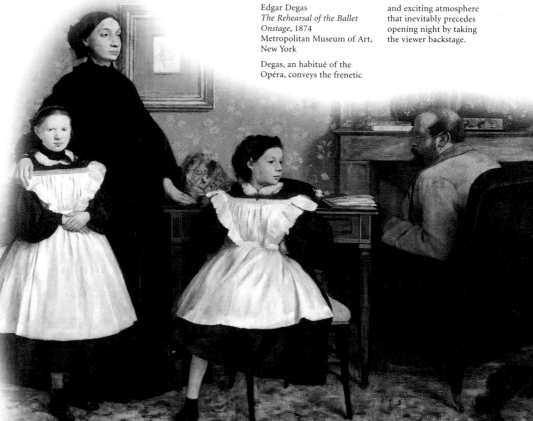

Paris
1841-1895 1845-1925
Berthe Morisot and Mary Cassatt

Impressionism's Other Half

At the very height of Impressionism, two women in Paris achieved the highest degree of artistic excellence, a phenomenon that had no equivalent in the literature or music of France at that time. Morisot, Manet's sister-in-law who studied under Corot, was a member of the Impressionist movement from its inception. In contrast with the lively canvases of Renoir and Degas, she captures the tender, silent moments of domestic life indoors, where she repeatedly portrays her sister and other relatives. Her subtle technique and suffused *intimisme* anticipate the work of Vuillard and Bonnard. Although she chose to become an artist—hardly usual for a girl from a good family—Berthe Morisot was the antithesis of the *peintre maudit* (cursed artist). On the contrary, her paintings reflect her own tranquil, bourgeois background.

Mary Cassatt, daughter of a Pittsburgh banker, went to Paris during the 1870s to complete her academic training. Singled out by Degas, she joined the Impressionist group and spent the remainder of her long life in France. Her style, based on precise, confident draftsmanship, also reveals her interest in Japanese prints.

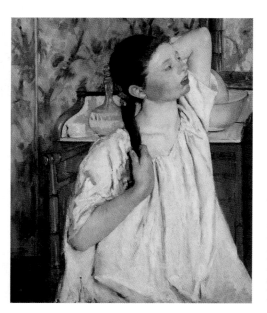

Berthe Morisot
The Cheval Glass, 1876
Thyssen-Bornemisza
Collection, Madrid

The delicacy of Berthe Morisot's brushwork added a touch of lightness and elegance to the Impressionist movement, of which she was a member from the very beginning. The light tones give the interior a diffused luminosity that suggests a psychological interplay of relationships.

Mary Cassatt
Girl Arranging her Hair, 1886
National Gallery of Art,
Washington, D.C.

Despite having spent most of her life in Paris, Mary Cassatt was highly renowned in her native country as well. With the help of her banker father's well-placed friends, she played a crucial role in bringing the works of French painters to the United States.

Mary Cassatt
Children Playing on the Beach,
1884
National Gallery of Art,
Washington, D.C.

Mary Cassatt's paintings always draw attention to the emotions and a subtle, typically feminine psychology. In portraying the two young girls quietly playing in the sand, the painter has carefully set herself to one side, so as to be able to observe the children without disturbing them.

Florence, Livorno, Maremma
1860-1890
The Macchiaioli

The Sense of Realism in History and Daily Life

Italian art of the nineteenth century was largely set in the past and used historic figures, scenes, and episodes to help boost national pride. Art based on historic subjects (in music, literature, and painting) played a major role in raising the awareness of Italians on their journey to national independence. Only after the uprisings of 1848 did art begin to depict the present, thanks to Tuscan and Lombard artists who participated in the battles for independence and Garibaldi's conquest of the Two Sicilies. The Macchiaioli group, active in Florence and the Maremma region of Tuscany, was spearheaded by Giovanni Fattori and focused on the portrayal of contemporary events. Fattori's battle scenes do not show heroic episodes, but rather the confusion and exhaustion of anonymous soldiers and rearguard troops. Later, inspired by the isolated and sun-drenched countryside, he made simple, sympathetic paintings of peasants at work. Here Fattori can be connected to Social Realism, the artistic movement that illustrated the social and economic upheaval created by the Unification of Italy in 1870 and the country's increasing industrialization.

Giovanni Fattori
In vedetta (On Patrol), 1872
Private Collection, Rome

Fattori was a great painter of battle scenes, but sentries making their rounds in the solitude of the Italian countryside were also among his favorite subjects. These light cavalrymen seem lost or abandoned, employed in pointless tasks as the war passes them by.

Giovanni Fattori
La rotonda di Palmieri
(Palmieri Terrace), 1866
Palazzo Pitti, Galleria d'Arte
Moderna, Florence

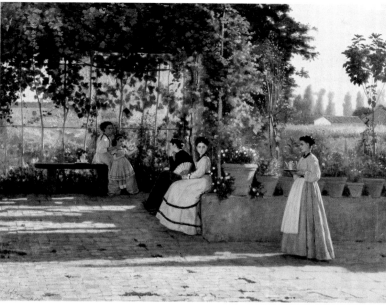

Silvestro Lega
Il pergolato (The Trellis), 1868
Pinacoteca di Brera, Milan

This lovely painting expertly illustrates the concept of the "*macchia*" or "patch" of light and color on which the Macchiaioli style is based. Here, a dense arbor shelters a group of women from the sultry heat of a slightly hazy summer afternoon. This masterpiece of chromatic harmonies recalls similar developments that were taking place during the same period in the newly-formed Impressionist movement in Paris.

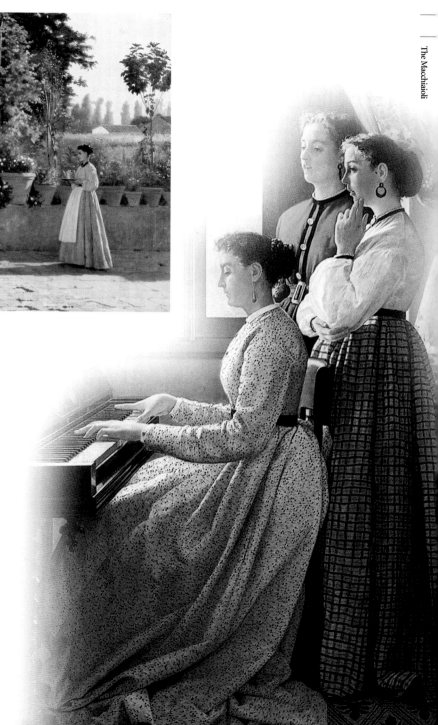

Silvestro Lega
*Canto dello stornello
(Singing of the Ballad)*, 1867
Palazzo Pitti, Galleria d'Arte
Moderna, Florence

This painting is a fine example of the sweet, lyrical *intimisme* of Silvestro Lega (1826-1895) who had a special talent for capturing life's quiet and tender moments.

Low Countries, Paris, Provence
1853-1890
Vincent van Gogh

"I will paint with red and with green the terrible passions of humanity."

Son of a Protestant minister, Vincent studied theology in his youth. There followed numerous yet vain attempts to enter the world of the art market in London, Paris and the Hague. Thus, he decided to leave for Borinage, a mining region in Belgium, where he returned to preaching. There Vincent's natural talent for painting began to mature. The budding artist soon moved to Brussels and eventually to Antwerp where he began attending classes at the École des Beaux-Arts. However, no academic training can suppress his instinctive desire to express himself free from the traditional rules of perspective and technique. Daumier influenced Van Gogh's early works, which often commented on the social and economic conditions of the lower class.

In 1886, thanks to the hospitality of his brother Théo, Van Gogh returned to Paris, where the controversy over the new Impressionist style was still raging. In 1888, he settled in Arles, where he was joined by Gauguin. Many masterpieces were born of this extraordinary union, though it lasted only a few drama-filled months. During this time Van Gogh began to suffer from anxiety attacks and fits of violence, which eventually led him to be hospitalized. While in hospital, he continued to paint, but his condition began to deteriorate rapidly until he finally committed suicide by shooting himself in the chest.

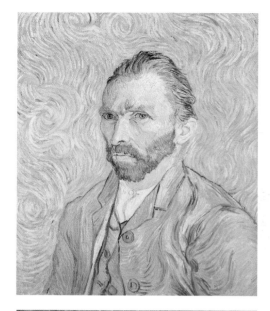

Vincent van Gogh
Self-Portrait, 1890
Musée d'Orsay, Paris

The tragic and tortured course of Van Gogh's life is reflected in his self-portraits. During his brief, feverish sojourn in France, before committing suicide on the edge of a wheat field, Van Gogh pushed far beyond the pleasant atmosphere of the Impressionist paintings, infusing each individual brushstroke with existential significance.

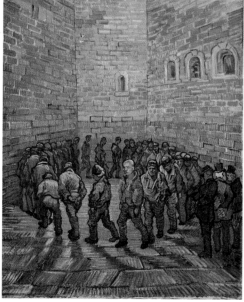

Vincent van Gogh
Prisoners' Round, 1890
Pushkin Museum of Fine Arts, Moscow

Obsessed by the need for truth, Van Gogh saw reality as a challenge, which tragically led to madness and suicide.

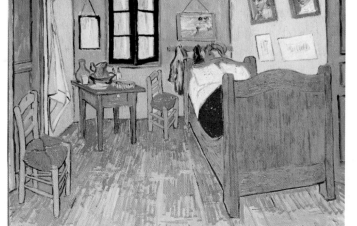

Vincent van Gogh
The Bedroom, 1888
Art Institute of Chicago

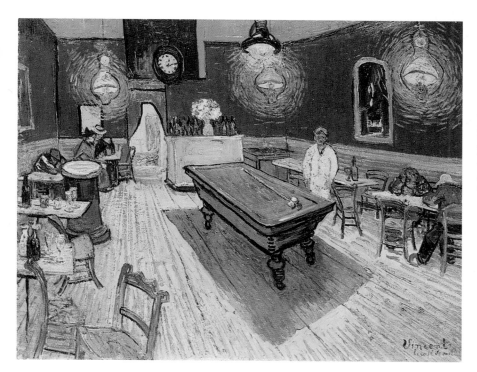

Vincent van Gogh
The Night Café, 1888
Yale University Art Gallery,
New Haven

The domain of night-owls,
drifters, and artists in search of
solace, this café is dominated by
a bulky, obliquely placed billiard
table. The café owner, in his white
jacket, serves as a visual break
from the bright colors, further
intensified by the artificial light.
Works like this one demonstrate
Van Gogh's vital importance
in the subsequent development
of Expressionism.

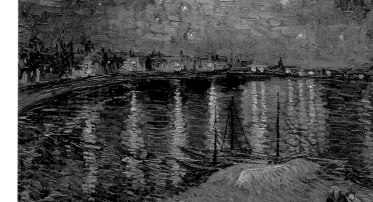

Vincent van Gogh
Starry Night Over the Rhone,
1888
Musée d'Orsay, Paris

The image of the stars
reflected in the water of
the Rhone on a serene night
in Arles is transformed here
into a cosmic spectacle,
shot through with an
unprecedented energy
that reflects the artist's
inner tension.

Vincent van Gogh

1890

Wheat Field with Crows

On display in the Van Gogh Museum, Amsterdam, this painting is certainly one of the artist's most dramatic and foreboding, as Van Gogh commited suicide in July of the same year at the edge of the same wheat field. During this period Van Gogh was seized by a terrible creative frenzy and began working at a frantic pace, which only served to aggravate his growing anxiety. The distorted landscape and sinister black crows, roughly sketched with minimal brushstrokes, allude to the intense inner turmoil that would soon cause the artist to end his life.

The colors are not mixed or diluted and each stroke is deliberate and clearly visible. The bright yellow wheat contrasts with the brown earth and the looming dark blue sky as if the elements were at war with each other. This sense of conflict is further accentuated by the artist's use of rough lines, and the complete absence of "classical" harmony and tonal subtleties. A simple wheat field is completely transformed into a reflection of the artist's disturbed mental state, and its pictorial rendition is only vaguely linked to the external reality.

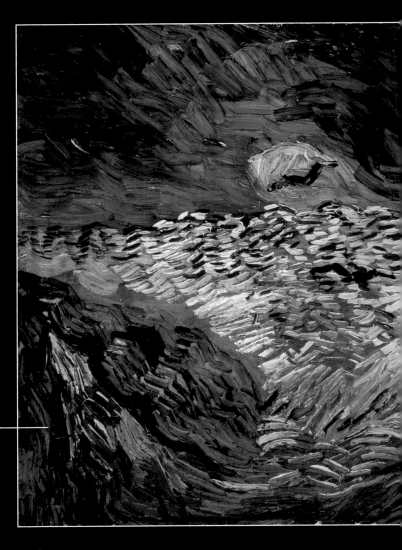

Van Gogh almost never made preliminary sketches of his landscapes and his brushstrokes seem to have the desperate energy of a knife stabbing directly into the canvas.

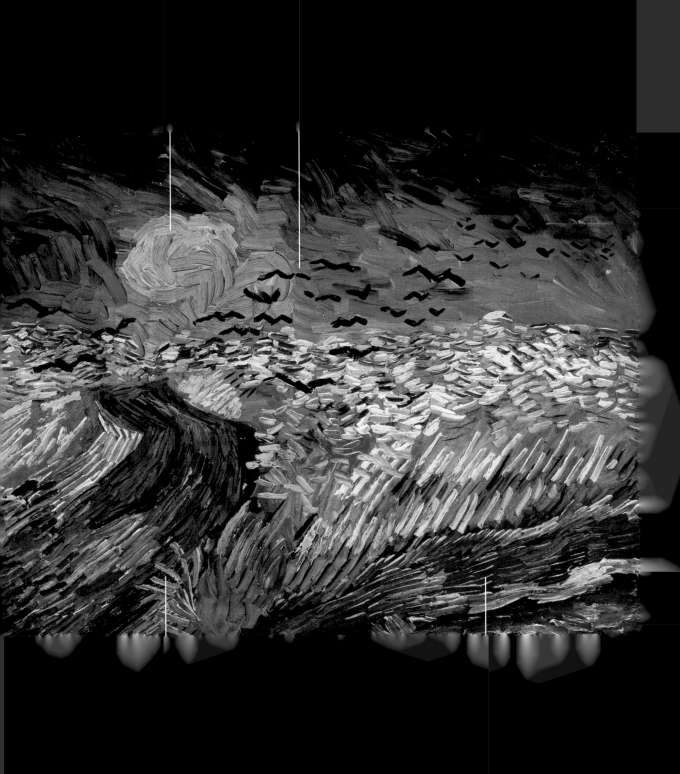

Paul Gauguin
Vision After the Sermon, Jacob Wrestling with the Angel, 1888
National Gallery of Scotland, Edinburgh

This key work from Gauguin's period in Brittany is a fine example of the style known as Synthetism, which combines a realistic scene of women in traditional Breton dress with an imaginary vision of the biblical struggle between Jacob and the angel.

Brittany, Tahiti
1848-1903
Paul Gauguin

To the End of the Earth, in Search of Purity

With his inclination for adventure and sincerity, Gauguin saw Paris in a completely different light from the Impressionists; for him, the *Ville Lumière* was a stifling prison from which he needed to escape. In 1885, in the remote region of Brittany, Gauguin painted his first important works. Rejecting the seductive light and muted colors of the Impressionists, the artist used simple forms and vivid colors to achieve "suggestion, rather than description". In 1888, Gauguin stayed with Van Gogh in Arles, but the brief friendship between the two *peintres maudits* of Post-Impressionism ended abruptly. Gauguin returned to Pont-Aven in Brittany, and soon set sail for Tahiti, in search of something more authentic and immediate. Here he withdrew completely from modern society, which he believed no longer left room for the imagination. In fact, when electricity came to Tahiti, Gauguin fled to the Marquesas Islands, where he died, attended by a medicine man and a missionary.

Paul Gauguin
Are You Jealous?, 1892
Pushkin Museum of Fine Arts, Moscow

Gauguin poured all his passion for the exotic and the primitive into the warm skin tones of the beautiful young Polynesian women, creating an image of a kind of lost paradise, far from the increasingly gray and oppressive modern world.

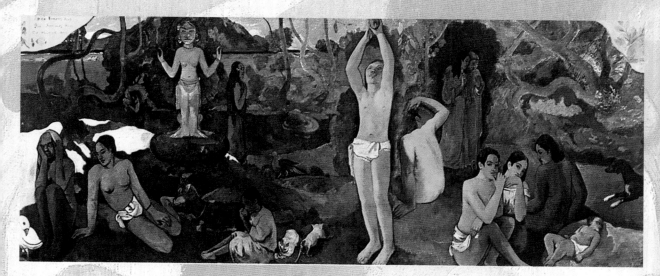

Paul Gauguin
Fatata te Miti (By the Sea),
1892
National Gallery of Art,
Washington, D.C.

The works Gauguin painted
during his many years in the
South Pacific are a symbolic
expression of natural and
moral purity. This scene
by the sea combines
description and suggestion.
The bold, unusual colors
of nature, the naked brown
bodies of the natives, and
the lush vegetation were
unfamiliar to the eyes
of Europeans at the time.

Paul Gauguin
*Where Do We Come From?
What Are We? Where Are
We Going?*, 1897-98
Museum of Fine Arts, Boston

The simplified forms,
synthetic and almost
geometric contours, and
strong contrasts of light
and shade allude to a simple,
arcane world, stripped of
all conventionality.

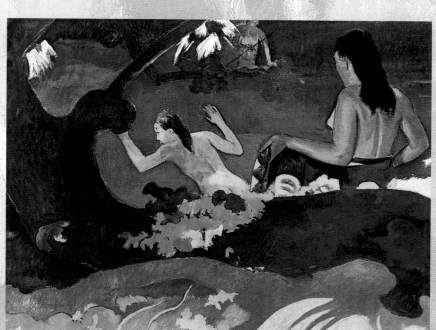

The Talisman of the Nabis

*During the 1880s, Madame
Gloanec's inn in the Breton vil-
lage of Pont-Aven was recog-
nized as one of the most
advanced art "centers" of the
time. There a group, including
writer Émile Bernard and
painters Maurice Denis and
Paul Sérusier, gathered around the expansive and
prophetic Gauguin. Greatly influenced by the
Symbolists, the Nabis believed that painting was a
fusion between nature and personal metaphor. The
group took the name Nabis from the Hebrew word
"navi" meaning "prophet". A small landscape by
Sérusier became known as the "talisman" of the
Nabis group. In this painting, colors are applied in
long, flat, widely separated layers, without merging
the tones or aiming for depth through perspective or
light. The painting demonstrates quite effectively the
Nabis' motto, also adopted by Gauguin: "a picture…
is essentially a surface covered by colors".*

Paris, Saint-Tropez
1880-1900
Seurat and Pointillism

Like the Silver Particles on Photographic Film

By the end of the 1870s, the Impressionist movement was beginning to wane, although many of its leading figures were still actively painting. Some Impressionists, like Pissarro, remained scrupulously faithful to the principle of the "impression" of light and color while others, like Monet, explored new territory, pursuing strictly personal investigations bordering on abstraction. In European painting, the powerful echo of Impressionism continued to sound until the first decade of the twentieth century, though it was nearly overtaken by exciting new ideas, some of which proved to be influential and long-lasting. The premise of Impressionism concerning the relationship between natural light and the application of paint, took a very interesting turn in the technique of Pointillism, whose principle exponent, Georges Seurat (1859-1891), was also a fine photographer. Obeying the laws of optics, every color was patiently and painstakingly applied in the form of thousands of tiny distinct dots. Seen from a distance, these touches of color merge, exquisitely recreating the transitions of light. His scenes were not painted "live", but meticulously studied; the figures are not in motion but captured in absolute and perfect stillness.

A number of artists followed in Seurat's wake, including Paul Signac (1863-1935), who was especially attracted to seascapes and the colors of the Mediterranean coast.

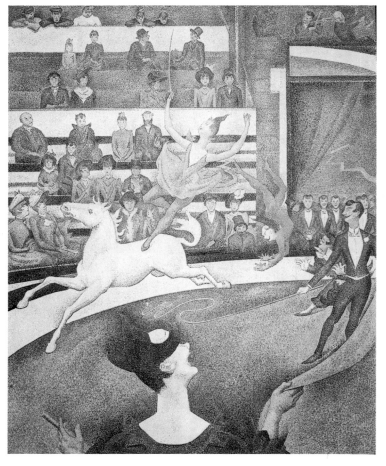

Georges Seurat
The Circus, 1890
Musée d'Orsay, Paris

Seurat moved on from the vibrations of afternoon light to the unnatural, electric, vivid colors of the circus, in which gestures, expressions, and movements are intentionally exaggerated. This painting remained unfinished at the artist's untimely death.

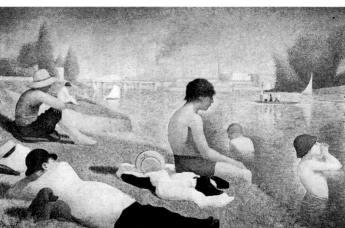

Georges Seurat
Une Baignade, Asnières, 1884
National Gallery, London

In this large, painstakingly studied painting, Seurat continues along the poetic, stylistic path he began with *Sunday Afternoon on the Island of La Grande Jatte* (1884-86). Here, the stillness of the poses seems almost metaphysical.

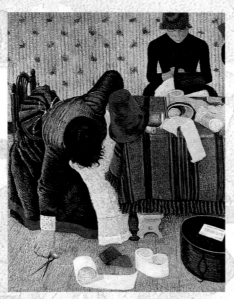

Paul Signac
The Modistes, 1885
E.G. Bührle Collection, Zurich

After being invited to the 1884
Salon des Indépendents, Signac
quickly became one of the
leading painters of the new
generation. He adopted
Seurat's Pointillism in 1886,
when he also began writing
theoretical texts on the
division of colors. He put
this analysis into practice
in a pictorial style in which
Seurat's "point" was enlarged
into a small patch or touch
of color. However, Signac's
encounter with Van Gogh and
the untimely death of Seurat
in 1891 pushed the artist
toward an independent style
known as Neo-Impressionism,
a cross between the calculated
rhythm of Seurat's
compositions and the color
and bright light of the
Impressionist tradition.

Paul Signac
Riverbend, Les Andelys, 1886
Musée d'Orsay, Paris

Signac first studied
architecture and began his
career, like countless amateurs,
by painting along the banks
of the Seine. He remained
fond of this subject even
after he became famous.

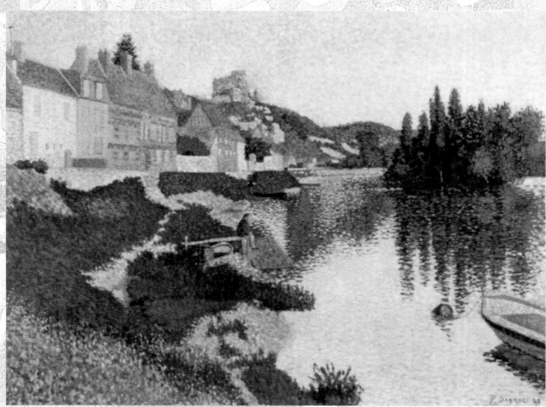

Georges Seurat

1884-1886

A Sunday on La Grande Jatte

Completed after an endless series of sketches, studies, and experiments, this large composition (2 × 3 m), whose full title is *Sunday Afternoon on the Island of La Grande Jatte*, held by the Art Institute of Chicago, is a key work in the history of art and certainly Seurat's most famous painting.

La Grande Jatte is a small island park on the Seine where the Parisians used to stroll in the summer. Although Seurat depicts a sunny afternoon, the atmosphere is anything but festive. The silent stillness of the figures suggests a melancholy solitude and a lack of communication that openly contrasts with the joie de vivre conveyed in Renoir's depiction of Sunday diversions.

While his choice of subject matter and the painting's diffused luminosity are reminiscent of the Impressionist style, Seurat's sensitivity, technique and calculated compositional rhythm are radically at odds with the fleeting moment focused on by the Impressionists. Seurat constructs a solemn, studied scene, which assumes a rhythmic cadence produced by the still monumentality of its figures. The suspended, almost sacred aura of the poses has led to a comparison with the fifteenth-century paintings of Piero della Francesca, in particular, his frescoes in Arezzo.

This painting is the technical manifesto of Pointillism (the Neo-Impressionist style created by Seurat), where color is applied to the canvas in an endless series of small, separate dots that almost imperceptibly form the transitions between light and shade.

Seurat's meticulous and painstakingly slow method of applying color was based on his in-depth study of optics, inspired quite explicitly by the chemo-physical process by which light stimulated the silver particles on photographic film in order to capture the image. Seurat was also one of the pioneers of photography as an art form.

A sharp contrast with Impressionism is evident in Seurat's treatment of water. Monet, Sisley, and Renoir frequently faced the challenge of painting rivers, seas, and ponds, by attempting to capture the *panta rei* of water's eternal flow. By contrast, Seurat paints an almost still expanse, focusing on the colored reflections of the boats, sails, and riverbanks. The cerebral, calculated quality of Seurat's work anticipates abstract art.

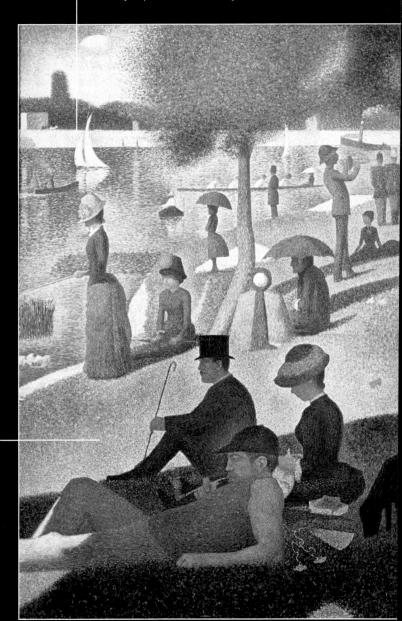

Depth is obtained through the methodical juxtaposition of light and shade. In the background of the painting, this alternation assumes the regularity of a chessboard, on which the figures have been laid out like pawns. Although the scene depicts daily life, here it acquires a suspended, almost surreal tone. Seurat's influence on artists like Delvaux, Balthus, and Magritte is evident.

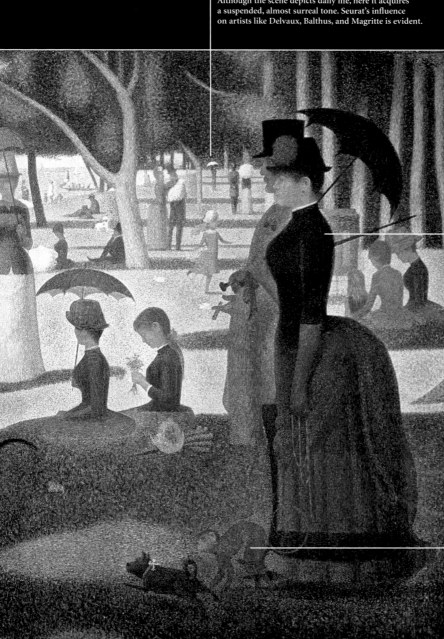

Seurat depicts slight, almost imperceptible distortions in the bearing, physiognomy, and dress of his figures whose profiles and silhouettes take on a ceremonial air.

The well-educated and intellectual Seurat died at the young age of thirty-two, passing through the star-studded sky of history like a comet, brilliant but sadly swift. His few works succeeded nonetheless in triggering a profound re-interpretation of painting and the role of the image. Methodical and tremendously patient, Seurat invites the viewer to share in the length of the actual painting process by calling attention to each meticulously applied dot. The viewer is forced to slow down and is given a chance to appreciate the painting's less conspicuous elements, such as the little monkey on a leash.

Northern Italy

1880-1910

Divisionism

Divided Color for a United Italy

The most interesting movement in Italian painting between the end of the nineteenth and the beginning of the twentieth centuries was Divisionism, a highly original evolution of French Pointillism. Like pointillism, the pictorial technique consists of a dense mesh of small touches of color (in this case, short dashes), each one separate and clearly visible from up close, but capable of evoking forms, figures, and colors when seen from further away. In its first phase, Divisionism was used to create refined compositions of a Symbolist nature. Segantini's paintings, for example, depict rarefied mountain scenes in which nature becomes mystic and there is a search for purity in light and in the soul. Even more important, however, was the adoption of the Divisionist technique for large-scale scenes dealing with social issues and denouncing the hardships of the recently-united nation. A pronounced drive toward industry, especially in the north, was replacing the archaic structure of the peasant world. The innovative Futurist movement was soon to represent the new world of *The City Rises* (Boccioni) with its large-scale construction projects and the expectations born of the new century.

Giuseppe Pellizza
da Volpedo
*Passeggiata amorosa
(Romantic Walk)*, 1902
Pinacoteca Civica,
Ascoli Piceno

Giuseppe Pellizza da Volpedo
Il Quarto Stato (The Fourth State), 1898-1901
Galleria d'Arte Moderna, Milan

This painting-manifesto was elaborated over a decade of studies and depicts the industrial transformation of Italian society. In search of economic stability, a new class of workers leave the countryside to find work in the new industrial areas of the cities.

Angelo Morbelli
In risaia (In the Rice Field),
1898-1901
Museum of Fine Arts,
Boston

Morbelli (1853-1919)
represented the human
and social themes of Italy
following the Unification,
without literary symbolism
or pious paternalism.

Giovanni Segantini
*Ave Maria al trasbordo
(Mary Crossing the Lake)*, 1886
Private Collection, San Gallo

The metaphorical significance
of this painting goes far
deeper than the depiction
of an idyllic moment. The
flock on the boat crossing
the still lake is a symbol of
the destiny of all mankind,
who are entrusted to
the Good Shepherd during
their earthly passage. Segantini
(1858-1899) was a native
of Trento and a great lover
of nature and the mountains.
He gives a highly expressive
illustration of peasant life,
closely linked to nature's
eternal rhythms and
untouched by the growing
cities where industrialization
was forging ahead.

Symbolism

Dreams and Nightmares: Between Literary Allusion and the Aesthetics of the Decadent Movement

The year 1886 gave birth to the Symbolist movement with the publication of the Symbolist Manifesto by poet Jean Moreas in the newspaper *Le Figaro*. It is certainly no coincidence that 1886 was also the year of the Impressionists' last group exhibit. Symbolism, a sophisticated and elitist, visual counterpart to contemporary literary movements, evolved in firm opposition to the colorful, natural images of the Impressionists and looked beyond reality for the true meaning of existence. Symbolism spread throughout Europe without generating a common style. Its widely varying results are due in part to its neurotic and fiercely individualistic character and to the influence of writers and philosophers (e.g. Oscar Wilde, Maeterlinck, Huysmans, D'Annunzio, Schopenhauer, Freud, and Bergson) on their respective countries. At the turn of the century, a number of similar movements, inspired by Symbolism, began to spring up throughout Europe: Jugendstil in Germany, Art Nouveau in France and England, Modernismo in Spain, and Liberty in Italy. These elegant and decorative styles looked to nature for inspiration, favoring vigorous and sinuous lines.

Arnold Böcklin
The Isle of the Dead, 1880
Kunstmuseum, Basel

The Swiss artist Arnold Böcklin (1827-1901) painted numerous versions of the voyage of the soul—wrapped in a white cloak—into the next world. A small boat slowly glides on the calm, boundless sea in silence, as it approaches a mysterious island with high, rocky cliffs. The tall, dark cypresses suggest a cemetery and the architecture is reminiscent of funerary monuments. Working in Italy and drawing on his background in the humanities, Böcklin painted imaginary places with precision, integrating symbolic elements into realistic landscapes.

Fernand Khnopff
Art (or *The Sphinx* or *The Caresses*), 1896
Musées Royeaux des Beaux-Arts, Brussels

A great number of possible interpretations is typical of Symbolism and Khnopff (1858-1921) was one of the leading exponents of this movement.

Gustave Moreau
The Apparition, 1876
Musée Gustave Moreau, Paris

The presence of exotic
allusions and a blend of
mysticism and eroticism are
key elements in the work of
Moreau (1826-1898), a Parisian
painter in close contact with
the *fin de siècle* writers.

Gaetano Previati
*Il giorno sveglia la notte
(Day Awakens Night)*, 1905
Museo Revoltella, Trieste

Previati (1852-1920) used
the technique of Divisionism
to brillintly render light
and imperceptible transitions
of color in highly evocative,
symbolic scenes.

Ferdinand Hodler
Die Nacht (The Night), 1890
Kunstmuseum, Bern

Inspired by the dazzling light
found at high altitudes,
the Swiss painter Hodler
(1853-1918) set his mostly
still figures in large
compositions bathed

in a dreamlike, mystic
atmosphere. The frightening
apparitions are linked to
the *fin de siècle* anxieties
that passed like an electric
shock through the painting
of northern Europe, from
Austria to Norway.

Aix-en-Provence

1839-1906

Paul Cézanne

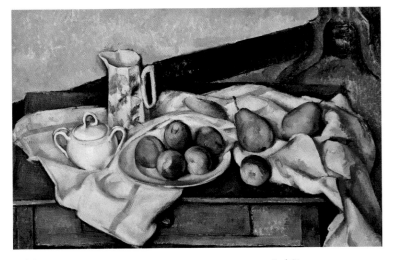

"To do Poussin again from nature"

Cézanne was born into a well-to-do bourgeois family in Provence. The young Cézanne enrolled in law school at his banker father's urging, but he soon became dissatisfied and moved to Paris in 1861. Here he was exposed to the Impressionist movement, but his profound respect for the painting of the past made him little inclined to abandon himself to the pure pleasure of light and color. His early vigor, expressed in broad, somber brushstrokes, became increasingly controlled and subtle. Over the years, Cézanne moved away from the Impressionists. He conceived painting not as an "impression" of light and color, but as a cerebral construction of regular, geometric solids. He limited his subjects to portraits of his family, self-portraits, still lifes, and landscapes of particular locations like Mont Sainte-Victoire in Provence. The large, wide-open landscapes of his mature period convey the meaning of the project Cézanne had set for himself: "To do Poussin again from nature." These two underlying choices (the use of past art as a formal model, and the use of nature's own luminosity) might have remained generic characteristics, applicable to other painters as well, if Cézanne had not added his own exceptional talent for synthesizing volume and color. Respected by painters but little-known to the public, it was not until after his death that Cézanne received recognition for his pivotal role in anticipating twentieth-century art.

Paul Cézanne
Peaches and Pears, 1890-94
Pushkin Museum of Fine Arts, Moscow

Ignoring the texture of surfaces (glazed pottery, cloth, unfinished wood and fruit peel), and rejecting the rules of linear perspective, Cézanne depicted fruit and objects as regular, geometric solids, paving the way for Cubism.

Paul Cézanne
The Card Players, 1890-92
Louvre, Paris

It is likely that Cézanne identified with these figures, who think calmly as they seek winning combinations and new solutions to the same, recurring problems.

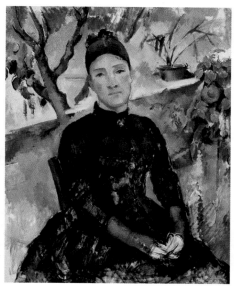

Paul Cézanne
The Gulf of Marseilles Seen from L'Estaque, 1883-85
Metropolitan Museum of Art, New York

This landscape makes the difference between Cézanne and the Impressionists eminently clear. It is hard to imagine a less attractive view of the French Riviera, with this anonymous village dominated by a tall, out-of-place smokestack in front of a still, flat, compact sea. Although the light and color belong to the Impressionist repertoire, Cézanne has already set off in a different direction.

Paul Cézanne
Madame Cézanne in the Conservatory, 1891
Metropolitan Museum of Art, New York

In this unforgettable image of Cézanne's wife, the diffused light, verdant plants and flowers, and diagonal composition create an fascinating scene with great depth.

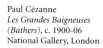

Paul Cézanne
Les Grandes Baigneuses (Bathers), c. 1900-06
National Gallery, London

The monumental female nudes are inspired by a long history of precedents, beginning with the mythological Renaissance scenes of Diana bathing, and extending through a good part of the nineteenth century in France to Ingres and Manet. Cézanne represents a turning point in the history of modern painting, since he explicitly anticipates the simplification of volumes typical of Cubism as well as the Expressionist emphasis on outlines.

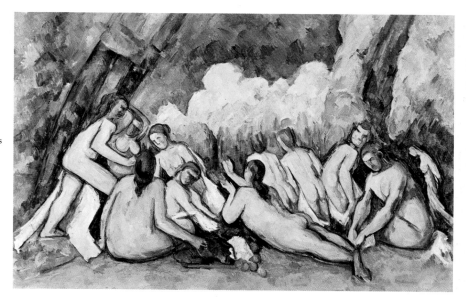

Paul Cézanne

1885-1904

Mont Sainte-Victoire

The first renditions, from around 1885, convey the meaning of the project Cézanne had set for himself: "To do Poussin again from nature". The distant viewpoint that opens out onto a light-filled vista can be seen as an allusion to the great paintings of the seventeenth century, whereas the light and colors recall Impressionism.

From the 1880s onward, Cézanne chose his subjects with great care, limiting himself to a few motifs that he reworked again and again, just as Turner did with Mount Rigi and Monet with haystacks, the façade of Rouen Cathedral, and the cliffs of Normandy. The massive, squat outline of the mountain, visible from the windows of Cézanne's studio, is a looming presence throughout the painter's mature and late work. It provides an excellent demonstration of Cézanne's capacity to concentrate on a single theme and approach it analytically, with the patience and meticulousness of a chess player, in his search for increasingly effective solutions.

This sequence of images of Mont Sainte-Victoire illustrates Cézanne's gradual abandonment of Impressionism and the faithful representation of reality in favor of a deliberate disintegration, to the point where the landscape becomes a mere pretext for exercises in composition. The paintings communicate a feeling of restless dissatisfaction and a need to explore, eroding the luminous reassurance of the Impressionists. Forms are increasingly rendered as simple geometric patterns, in an atmospheric light that is bright and refulgent.

The four canvases shown here are held respectively by the Courtauld Institute of Art in London, the Stedelijk Museum in Amsterdam, the Baltimore Museum of Art, and the Philadelphia Museum of Art.

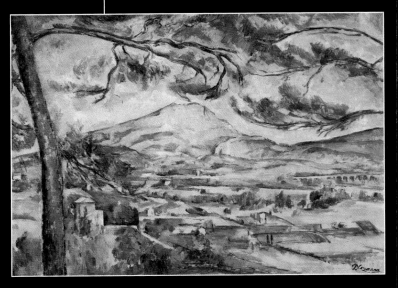

In this version (c. 1887), the form of the mountain begins to lose solidity. Here, the artist has chosen a closer viewpoint and has eliminated the pine tree that framed the London canvas (a motif from a more banal repertoire of landscape painting). As a result, the image loses its "picturesque" and descriptive values.

A decade later (c. 1897), the image has undergone further simplification. The tree trunks and lines of the landscape begin to form a regular grid. Nature is observed through the rigorous filter of an inner geometry, though the artist's interest in atmospheric luminosity is still evident.

This painting (c. 1904) is one of the final variations on the Mont Sainte-Victoire landscape. Unlike his other works, Cézanne's range of colors here is somewhat dark. The geological solidity of the mountain and the countryside below is broken up into large, regular patches of color, and the artist has even left some unpainted canvas visible.

Henri de Toulouse-Lautrec

Cabaret Stars and "Ladies of the Night" in Paris

Toulouse-Lautrec came from one of France's oldest aristocratic families. When, as a young man, he began attending painting courses in Paris he was drawn to the work of the Impressionists and shared their taste for real-life events and their stylistic appreciation of Oriental prints. He related most closely to Degas, who was focusing his attention on dancers and washerwomen, whom he painted sympathetically, without turning them into caricatures. In the same period as Van Gogh, Toulouse-Lautrec found his own way of going beyond Impressionism by analyzing and accentuating the use of line and graphics, and by simplifying the means of expression. This noble descendant of the Lautrec family found his inspiration in working-class, even disreputable, places like *café-chantants*, brothels, squalid dance halls, and small-time circuses.

Toulouse-Lautrec produced paintings, drawings, lithographs, and posters. He often combined these diverse media to create a very free art that never shrank from risqué subjects. In his all too brief career, he laid the foundations for important artistic developments. On the one hand, his explicit departure from Impressionism made him a source of inspiration for Expressionism, while on the other, his effective synthesis of image, word and color, has caused him to be considered the founder of a new artistic genre: the advertisement.

Henri de Toulouse-Lautrec
At the Moulin Rouge, 1892
Art Institute of Chicago

Only a few years after Renoir painted the popular dances at the Moulin de la Galette and other lower-middle-class places of entertainment in Paris, Toulouse-Lautrec gave a very different interpretation. No longer do we find the radiant joie de vivre of Impressionism, but rather something forced, precarious, and unexpressed, as suggested in the pallid skin tones of the women seen under artificial lights. Echoes of the drawings of Daumier and Degas, along with the aristocratic melancholy of Manet's late works, combine here with Toulouse-Lautrec's unique evocative capacity.

Henri de Toulouse-Lautrec
*Yvette Guilbert Saluant
Le Public,* 1894
Musée Toulouse-Lautrec, Albi

Toulouse-Lautrec is the illustrator of *fin de siècle* Parisian life: dances, shows, nighttime entertainment, lights, theaters, laughter, and applause for cabaret stars, dancers, and chansonniers. These images were often taken directly from real life and reworked into paintings or colored lithographs.

Henri de Toulouse-Lautrec
Salon de la rue des Moulins,
1894
Musée Toulouse-Lautrec, Albi

Thanks to Toulouse-Lautrec,
the red couch in the *maison
close* on the rue des Moulins
in Paris has become one
of the typical elements in
late nineteenth-century
painting. It is easy to imagine
de Maupassant's stories
taking place in this setting.
A number of prostitutes
await clients in a brightly-
illuminated room with
ostentatiously luxurious
furnishings. Toulouse-Lautrec
presents this very real group
of women without the least
intention of caricaturing
them. Private lives surface,
glow bright for an instant
and then suddenly fade.
The painter hints at the
women's moods (ill-at-ease,
sluggish, bored or tired)
through their faces, clothes,
poses, and gestures.

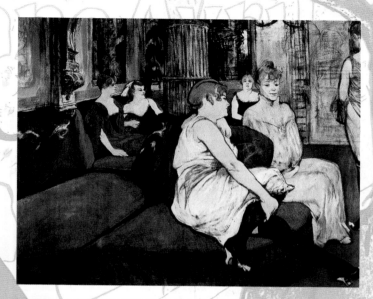

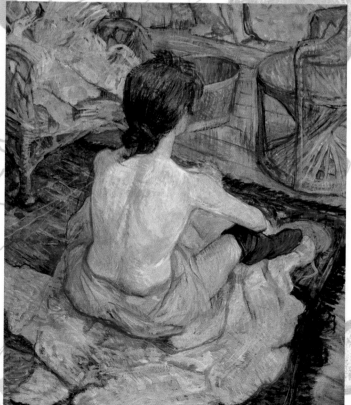

Henri de Toulouse-Lautrec
The Toilette, 1889
Musée d'Orsay, Paris

Toulouse-Lautrec's paintings
are characterized by their
free yet incisive draftsmanship.
Here Toulouse-Lautrec
manages to convey the
character, physiognomy,
and well-defined personality
of the figure seated with
her back to the viewer.
This painting belongs to
the *Elles* series of portraits
of prostitutes, painted
sympathetically and
with great respect.

"The sun was setting and the clouds were tinged blood red. I heard a scream that pierced through nature."

Edvard Munch, the artist who depicted the anguished scream of human solitude, exposing the illusory nature of positivistic optimism, trained at the Oslo School of Design. His early works throbbed with a desire to plumb the innermost depths of the human soul and his style was influenced by his various trips to France, Germany, and Italy. Thus, despite living and working in Norway, Munch was not at all isolated as an artist. He was in contact with the most exciting painters of his time and had a keen interest in the developments of psychoanalysis. Inspired by the plays of fellow Norwegian Henrik Ibsen, Munch entered a period of strained intensity in the last decade of the nineteenth century, delving into the drama of the psyche and expressing an acute, tortured inner sensitivity in his paintings. Many aspects of his work can be interpreted as reflecting his own psychological distress. The present merges with the past in an agonizing nostalgia that anticipates Scandinavian theater and cinema, like Ingmar Bergman's *Wild Strawberries*.

Immediately after finishing *The Scream*, one of the most frequently reproduced and universally recognized paintings in the entire history of art, Munch began his ambitious *Frieze of Life*, a sequence of connected panels intended to form a great allegory, a kind of popular ballad of life from birth to death. Though the project was never finished, the completed panels, conserved in Oslo, can nonetheless be fully appreciated in themselves. Munch's style, which combined closed, continuous, undulating designs with vivid, unnatural, exaggerated colors had a profound impact on the development German Expressionism. In addition to painting, Munch also produced a vast quantity of graphic works, some of which were created as illustrations for contemporary poetry. In 1905, he suffered a nervous breakdown from which it took him three years to recover. He began painting again, but his work never completely regained its expressive power.

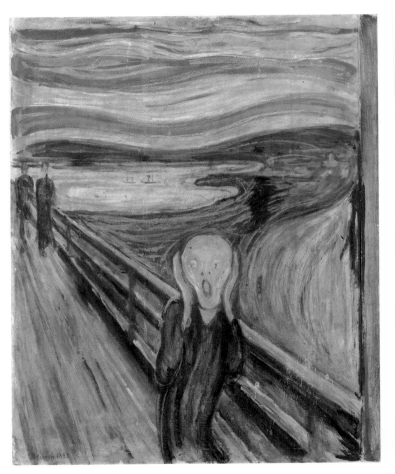

Edvard Munch
The Scream, 1893
National Gallery, Oslo

This famous work has been interpreted to represent the transition from the nineteenth to the twentieth century in the wake of explorations into the depths of the psyche. This is a powerful painting, for which it is difficult to identify precise precedents, except perhaps in the influence of van Gogh and the Symbolists. Munch uses a continuous, undulating line that envelops everything in a suffocating grasp from which there is no escape. The scene is set on a bridge, while the strange sunset creates a dramatic, anguished—one might even say "deafening"—atmosphere in a violent burst of colors. The figure of the man screaming, and covering his ears, is reduced to a larva, a highly simplified suggestion of a body with humanoid features. This tense work was painted well before the synthetic, harsh style of German Expressionism.

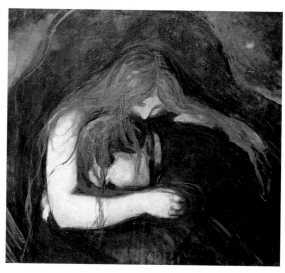

Edvard Munch
Vampire, 1893-94
Munch Museet, Oslo

This painting is representative
of Munch's growing neurosis.
In this disturbing scene
(comparable to the equally
powerful works of Egon
Schiele), Munch openly
reveals his problems in love
relationships.

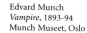

Edvard Munch
Four Girls on a Bridge, 1905
Wallraf-Richartz Museum,
Cologne

Although Munch's most
famous work is his harsh,
lonely, and desperate
The Scream, his apparently
more serene paintings are
no less interesting. The brief
northern summer, whose
crystal-clear light enhances the
brilliant colors, is represented
with a sense of transience.
This brief moment of pause
contemplates the fleeting
quality of summer, beauty,
youth, and the fullness of life.

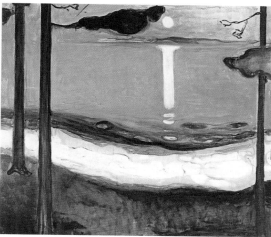

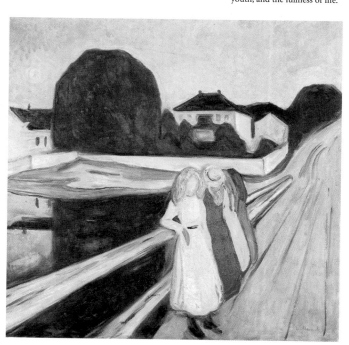

Edvard Munch
Moonlight, 1895
National Gallery, Oslo

This painting is a poetic,
though deliberately anti-
romantic, interpretation of
a successful theme. The moon
on the cold Norwegian sea
illuminates a motionless scene,
framed almost like a theater
stage by the slim, black
trunks of the trees. The solid
impression of the moon's
reflection on the still waters
is quite unusual.

Vienna

1862-1918 1890-1918

Gustav Klimt and Egon Schiele

"To each time its art; to each art its freedom"
This is the epigraph found on the entrance to the
Secession Building in Vienna, built by Otto Wagner in
1898 and decorated by Klimt with the *Beethoven Frieze*, a
detail of which is reproduced in the background on this
page. The Viennese Secession is the most renowned of all
the Secessions (free associations of artists opposed to the
official academic organizations) that emerged in central
Europe at the end of the nineteenth century. These orga-
nizations were a sign of an irreversible crisis in state-
sponsored art and the reassuring image so dear to the
bourgeois positivism of central Europe. The grand and
imperial Vienna of waltzes and stately buildings was also
the city of Mahler and Freud, of literary investigation,
innovative architecture, and industrial design where a
completely new geography was taking shape. Like Paris
(still the creative center of the avant-garde), Vienna was
an exciting hub of experimentation in many different
artistic fields and Klimt expressed the last gleams and
shadows of the waning empire. Classically trained, Klimt
began his career doing official decorative painting, but in
the last decade of the nineteenth century he became
(along with architects Wagner and Olbrich) an advocate
of the Secession (a term borrowed from politics that
recalled the aspirations of the many countries joined
under the two-headed eagle of the Hapsburg Empire).
His was a resplendent and highly decorative style that
echoed classical and Byzantine art and alluded to
Japanese prints and the Symbolist linear style. Klimt's
mysterious and seductive female figures superbly mark
the end of an era. The artists and writers involved in the
Secession became the increasingly distressed witnesses to
the *finis Austriae*, the carnage of the war that broke out in
1914, and the dissolution of the Austrian dynasty to the
tune of the *Radetzky March*.

Egon Schiele's desperate, all-consuming eroticism and
his almost morbid desire to cling to life, is one of the
most dramatic episodes in early twentieth-century
European art. Schiele's style, while initially similar to
Klimt's, soon became the antithesis of the dazzling colors
and sophisticated elegance of the Secession's leading
exponent. Influenced by his friendship with Oskar
Kokoschka and his links to international circles of
Expressionism, Schiele revived motifs and elements from
Gothic art, relying largely on a tense and incisive drafts-
manship. His relationship with his beloved Edith Harms
began during the tortured war years. His young wife, in
fact, became a recurring, almost obsessive, subject of the
painter's erotic canvases, drawings, and watercolors. By
1918, Edith was slowly succumbing to Spanish influenza,
which thrust the conflict between life and death into the
fore of Schiele's art. Three days after his wife's death,
Schiele followed her into the same tomb.

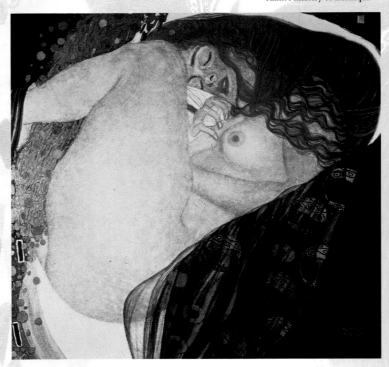

Gustav Klimt
Danaë, 1907-08
Private Collection, Graz

The curled position of the
legendary young woman who
receives the shower of gold is
a stunning demonstration of
Klimt's mastery of technique.

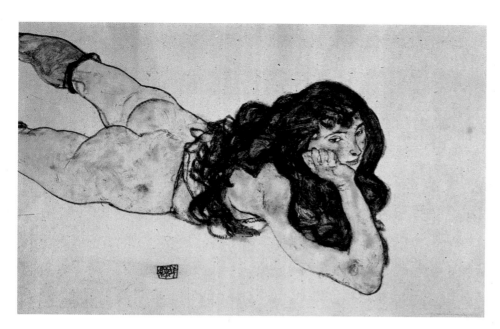

Egon Schiele
Reclining Female Nude, 1917
Graphische Sammlung Albertina,
Vienna

Schiele's eroticism expressed
itself in unforgettable female
figures, whose powerful
sensuality was at times
positively obscene. This work,
one of the most acclaimed
in this genre, was painted
during the only serene period
in the painter's brief and
tormented career. In 1917
when the war was drawing
to a close, Schiele was among
the founders of a vast
interdisciplinary movement
to revitalize the arts in Vienna.

Egon Schiele
Death and the Maiden, 1915
Österreichische Galerie,
Vienna

Love and death intertwine
dramatically in all of
Schiele's work, but in 1915
this contrast acquired a
terrible, personal, and
tangible reality. That year,
the painter hurriedly
married his beloved Edith
Harms, just before being
drafted into the imperial
army, where, however,
he was only assigned duties
in the rearguard.

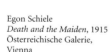

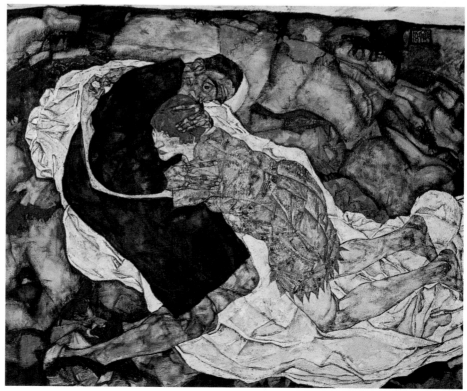

Gustav Klimt

1908

The Kiss

Housed in the Österreichische Galerie in the Upper Belvedere in Vienna, this is one of the most intriguing paintings of the early twentieth century. Klimt brings to perfection his highly personal, rich study of the relationship between figure and background, creating a unique atmosphere of total sensuous abandonment and a lush backdrop to the two embracing lovers that is a triumph of his meticulously decorative style, and reminiscent of the mosaics in Ravenna.

The two lovers seem to be encased in a golden cocoon, from which only their heads and hands emerge. With his unparalleled taste for colored and gilded decoration (in line with the developments of Art Nouveau), Klimt created a masterpiece which fused Symbolism and Secession. A kiss is one of the very few gestures that has kept its significance over the millennia. Its power is further increased by the painting's richness and its range of symbolic meanings and emotional implications. Klimt's painting offers an intensely "romantic" view of the relationship between a man and a woman, and a feeling of timelessness. Meanwhile, works from the same period by painters like Munch, Schiele and Toulouse-Lautrec, were moving in an entirely different direction. After centuries of modesty and delicacy these artists showed the other side of the kiss: one that is brutal, possessive, and vampire-like, where one partner dominates the other to the point of total possession. Klimt, like Chagall and Matisse, restored poetry and sweetness to the kiss. Nonetheless, the kiss of death and the kiss of true love share the same moral: afterward one is never the same.

The rigorously two-dimensional clothes of the two lovers are depicted as free, decorative additions, full of symbolic meaning. The outside of the man's cloak alternates black and white rectangular patches on a gold ground, while the lining (visible behind the female figure) is decorated with spiral motifs that accentuate the circular gesture of the embrace.

Klimt's highly cultured background offers numerous allusions to other artistic traditions. The flowering field is surely a tribute to the Byzantine mosaics of Sant'Apollinare in Classe near Ravenna, while it also recalls the humanist allegory of Botticelli's *Primavera*. Klimt evokes not only a time of the year, but also a season of the soul.

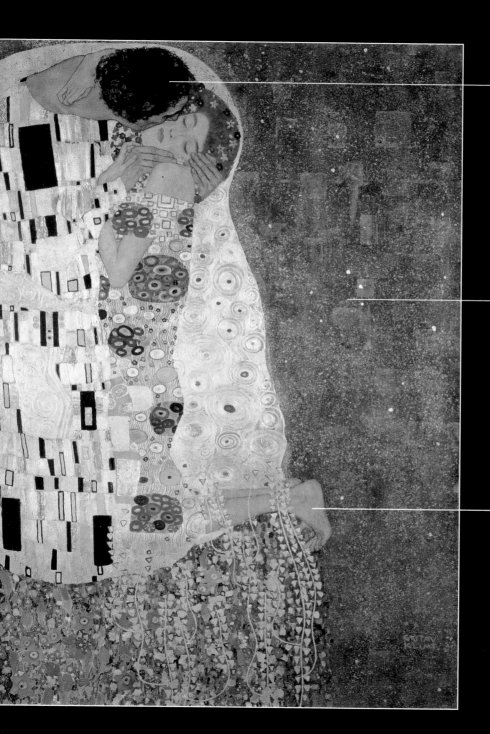

The faces of the two lovers emerge from the golden cocoon of their clothing. Here Klimt chooses a pictorial technique completely different from the rest of the painting to accentuate their expressions and feelings. Like the heroes of Symbolism, the two figures wear garlands of flowers on their heads.

The Kiss appeared at the height of Klimt's so-called "golden age". The meticulous texture of the background distinctly suggests a mosaic with gold tesserae, creating a sumptuously luminous, ornamental effect. Klimt experimented with this decorative technique again in his friezes for the Palais Stoclet in Brussels, a monument that epitomizes Art Nouveau in Europe.

Again in this case, a symbolic interpretation is not lacking. The field studded with flowers ends abruptly and the girl's feet cling to the very edge of the ground, while the golden backdrop gives the impression of a precipice gaping beyond. The signature of the artist floats in the void. The two lovers are therefore in a precarious position. Thus Klimt invokes the classic theme of the fleeting nature of youth and the rapid passing of the "season" most favorable to love.

Dresden, Berlin
1905-1913
Die Brücke

An Anguished Presentiment of the German Tragedy

The dawn of the twentieth century marked a time of increased anxiety, tension, and neurosis for Germany. The Expressionist movement, originating in the German cultural centers, spread rapidly through Europe, illustrating the growing anguish and frustration of modern man. Not confined to the visual arts, Expressionism also took hold in literature, theater and cinema. The first official Expressionist group, *Die Brücke* (The Bridge), was founded in Dresden around 1905 by Ernst Ludwig Kirchner. The movement was characterized by its use of tormented, angular lines, distorting its figures almost to the point of caricature, and a taste for harsh, emotionally charged colors. *Die Brücke* moved from Dresden to Berlin in 1911, but disbanded in 1913. Its members all went on to pursue independent artistic careers.

Karl Schmidt-Rottluff
Double Portrait of S. and L.,
1925
Museum am Ostwall,
Dortmund

Karl Schmidt-Rottluff (1884-1976), the youngest member of *Die Brücke*, developed a style based on free brushwork, bold outlines, and large fields of color. The stylized and deformed features of his subjects are reminiscent of African and Polynesian sculpture.

Ernst Ludwig Kirchner
Berlin Street Scene, 1913
Brücke-Museum, Berlin

Die Brücke founder Ernst
Ludwig Kirchner (1880-1938)
was clearly inspired by

Munch, Van Gogh, and
Gauguin, as well as by
primitive art, but his use
of rhythmic lines give
his paintings an almost
Art Nouveau quality.

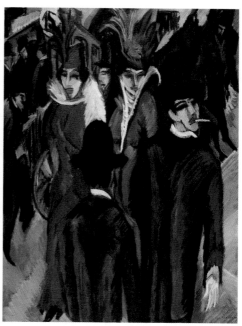

Emil Nolde
Flower Garden, 1908
Erbengemeinschaft, Krefeld

Emil Nolde, a solitary figure
who developed a dreamy,
mystic style of painting, was
only briefly associated with
the movement. In his studio
in Seebüll, an isolated village
on the north coast of
Germany, Nolde created an
almost magic vision of nature
with the vivid, vibrant colors
typical of Expressionism.

Erich Heckel
Spring in Flanders, 1916
Museum der Stadt, Hagen

Heckel, like many of the
other members of *Die Brücke*,
was trained in technical
design and architecture.
His landscapes recall Van
Gogh, who was often cited
by the Expressionists as being
one of the movement's
most important precursors.

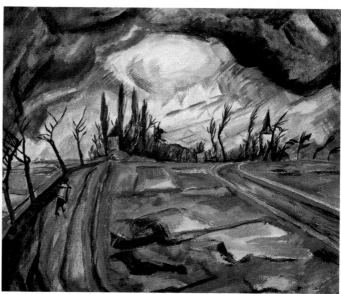

Moscow, Munich, Weimar

1866-1944

Wassily Kandinsky

The Overwhelming Power of Abstract Expressionism

A brilliant Moscow lawyer and keen student of Russian folk culture, the young Kandinsky seemed headed for a career as a law professor. However, completely unexpectedly, at the age of thirty, he abandoned law and moved to Munich to study painting, where he began a long-lasting friendship with fellow student Paul Klee (thirteen years his junior). Kandinsky is one of the most revolutionary artists of the twentieth century. His early paintings can be described as poetic and magic illustrations of the traditional Russian folktales. His art reached a crucial turning point, however, in 1908, when at the age of forty-two, he left Munich for the mountain village of Murnau and began painting the landscape. These naturalistic images soon began to dissolve into patches and streaks of violently contrasting colors and forms, which became increasingly abstract as time passed. This visual expression was also accompanied by theoretical texts. Kandinsky cultivated relationships with many of the other avant-garde artists and groups. In 1911, he founded *Der Blaue Reiter* (The Blue Rider) with fellow artists Franz Marc and August Macke, who through their art journal of the same name made Abstract Expressionism one of the most exciting movements in Europe. At the outbreak of World War I (in which Marc and Macke both tragically lost their lives), Kandinsky returned to Russia, where he eagerly participated in the revolution and was appointed professor of art in Moscow. Again, his style changed dramatically, heavily influenced by the new Constructivist movement of Vladimir Tatlin and Aleksandr Mikhailovich Rodchenko. In 1922, Kandinsky returned to Germany where he was invited by his friend Klee to conduct research at the Bauhaus in Weimar and later in Dessau. By this time, Kandinsky had adopted a controlled, geometric style, although he continued to experiment with color throughout his career. In 1926, his relationship with the Bauhaus came to an end when, following the publication of his important theoretical and philosophical treatise, *Point and Line to Plane*, he moved to Neuilly-sur-Seine, near Paris, where he died in 1944.

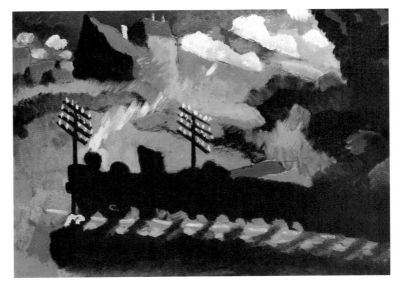

Wassily Kandinsky
The Railroad at Murnau, 1909
Lenbachhaus, Munich

Trains appealed to the imagination of many European artists, such as Turner, Monet and Boccioni. In Kandinsky's work, the train's dynamism, steam, and advanced technology create a field of energy that reverberates through the landscape.

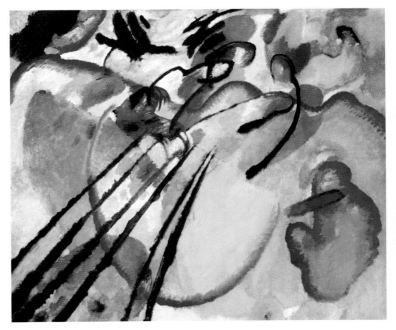

Wassily Kandinsky
Improvisation 26
Lenbachhaus, Munich

The idea for an "improvised" visual composition was inspired by Kandinsky's encounters with avant-garde musician Arnold Schönberg. What Schönberg expressed through atonal music, Kandinsky attempted to convey through Abstract Art.

Wassily Kandinsky
Several Circles, 1926
Solomon R. Guggenheim
Museum, New York

The Bauhaus years marked
the peak of his geometric
research. Kandinsky
founded the Blue Four
with Paul Klee, Alexey
von Jawlensky, and Lyonel
Feininger, who combined
painting with theoretical texts.

Wassily Kandinsky
Landscape with Church, 1913
Museum Folkwang, Essen

Here the Alpine peaks
surrounding Murnau are still
an identifiable, figurative
presence. Kandinsky did not
decompose his landscapes
along geometric lines like
Cézanne and the Cubists,
but rather on the basis of his
own instinctive sense of color.

Wassily Kandinsky

1914

Painting with Red Spot

This famous work, held by the Centre Pompidou in Paris, clearly marks the boundary between the apparent "randomness" of his paintings and their actual meticulously studied quality based on a superior compositional structure. In fact, in 1913, Kandinsky changed the title of his works from "improvisations" to "compositions". This choice of terminology revealed his interest in contemporary musical composition and his attempt to bring those ideas into the visual realm. During the most exciting and intense phase of Abstract Expressionism, after detaching himself from the dynamics of *Der Blaue Reiter*, Kandinsky's paintings were frequently accompanied by theoretical texts. Excerpts from an article he wrote in 1912 on the *Question of Form* could be used to describe this painting (although he did not complete this work until February of 1914). Here Kandinsky states that form can exist in and of itself, while color demands fixed limits. Each element, therefore, enhances and reinforces the value of the other: "The value of a given color is enhanced by one given form and attenuated by another. The qualities of 'sharp' colors resonate better from within pointed forms—yellow, for example, in a triangle—and the colors that could be labeled 'deep' are made stronger and their action is intensified by rounded forms. Blue, for example, in a circle".

In the top section of the painting, to the right of the large circular red patch, one can identify a pointed motif made with a double line. This visual sign was also used by Kandinsky in other paintings from this period. While its form may draw on elements from his figurative phase (a peaked roof, a mountain, a tall tower, the leaves of a tree, or a sail), it has become an abstract motif around which the artist arranges a lavish and harmonious series of colors.

The title of the painting refers to "a" red spot, but this color is repeated throughout the composition in varying levels of intensity and combinations of color.

Kandinsky's relationship with Arnold Schönberg, one of the great composers of the twentieth century and a talented painter in his own right, was both profitable and mutually stimulating. In fact, music played a pivotal role in the birth of abstract painting, especially for Kandinsky. Music was seen as the model for any art seeking to focus on the raw materials, their properties and possible combinations. The musician combines sounds just as the painter combines colors and forms.

Kandinsky mainly focused on the three primary colors (red, yellow, and blue), as if to expose the chromatic foundations on which the entire universe of color and light is based.

303

Munich
1910-1916
Der Blaue Reiter

The Magic of Color and the Poetry of the Sign

Within the overall dynamics of German Expressionism, the group in Munich centered around the publication *Der Blaue Reiter* (The Blue Rider) and strongly contrasted with Kirchner and the artists of the Berlin avant-garde. *Der Blaue Reiter*, co-founded by Kandinsky, was a movement based first and foremost on color. In this respect, there are strong similarities between this group and the parallel explorations of Matisse, the Fauves, Delaunay, and Klee. Along with Kandinsky, whose work was already moving toward Abstract Art, this historic group included Franz Marc (1880-1916), August Macke (1887-1914) and, to a lesser degree, Aleksey von Jawlensky (1864-1941). Marc was a great lover of animals and would have preferred the movement to be named after the horse, but Kandinsky insisted on the rider. They agreed, however, on the choice of blue, as it was the favorite color of both artists.

The most intense period of Macke's life spanned a mere few months in 1914. The year began with an exhilarating trip to Tunisia with Klee and ended with his death on the French front. Even on the front, however, the painters of *Der Blaue Reiter* sought moments of relief from the anguish of the trenches in their favorite motifs: Marc painted animals while Macke painted figures communing with nature.

Aleksey von Jawlensky
Peonies, 1909
Von der Heydt Museum, Wuppertal

Jawlensky, a friend of Kandinsky's, also of Russian origin, only participated in one *Der Blaue Reiter* exhibit and can, therefore, merely be considered a "sympathizer" of the movement.

Franz Marc
Blue Horse I, 1911
Lenbachhaus, Munich

Franz Marc
The Dream, 1912
Thyssen-Bornemisza Collection, Madrid

While Marc conveyed the movements and forms of animals very effectively, displaying an anatomic and ethological realism worthy of a keen zoologist, he tended to place these elements on flat backgrounds, framed by areas of limpid color, creating the impression of a resplendent stained glass window.

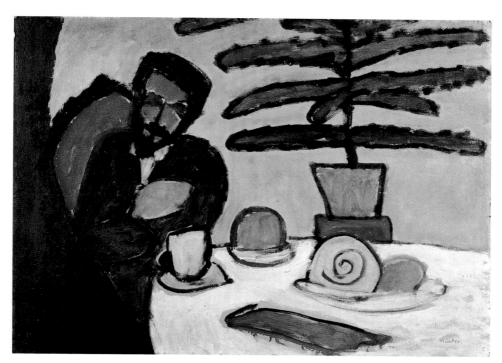

Gabriele Münter
*Man Seated at a Table
(Portrait of Kandinsky)*, 1911
Lenbachhaus, Munich

Gabriele Münter, born in Berlin in 1877, became romantically involved with Kandinsky in 1904, sharing in his turbulent creative growth and private life. Münter's paintings, clearly influenced by Matisse, contributed a touch of spirituality to the Blue Rider group. Her relationship with Kandinsky ended in 1916, when he returned to Russia. Marc's death at Verdun that same year marked the demise of *Der Blaue Reiter*.

August Macke
Large Zoological Garden, 1912
Museum am Ostwall,
Dortmund

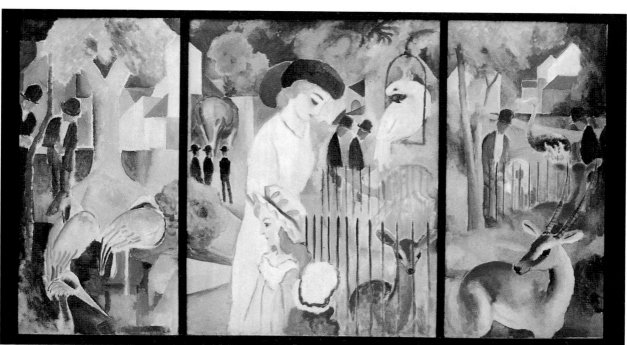

Milan

1909-1916

Futurism

**"A speeding automobile is more beautiful than
the Victory of Samothrace"**

In the years preceding World War I, the group of Futurist
painters, writers, and musicians was one of the most active
and exciting avant-garde movements in Europe. Founded by
Umberto Boccioni (1882-1916) and Filippo Tommaso
Marinetti (an original and brilliant writer), Futurism reject-
ed the past and embraced movement, action, noise, and
dynamism, with its vivid and energetic expression of the
world. Boccioni produced the key works of Futurist painting,
as well as many theoretical writings on the rationale and
aspirations of the movement. During the period in which
Cubism was also evolving, Boccioni sought a "simultaneous
vision" of figures and objects in painting and sculpture. The
vivid colors, vibrant brushstrokes, and the motifs themselves,
obviously chosen for their strong symbolic impact, commu-
nicate a positive creativity that celebrates progress, technolo-
gy, steel, and all things modern. Futurism, the most signifi-
cant artistic movement in twentieth-century Italian art, con-
tinued after Boccioni, its most brilliant artist, was tragically
killed in a horse riding accident during World War I.

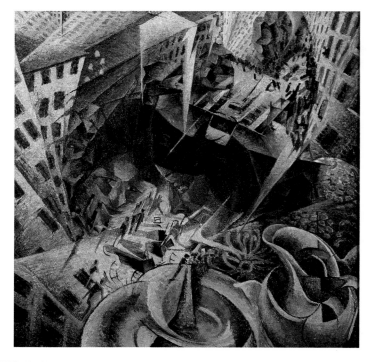

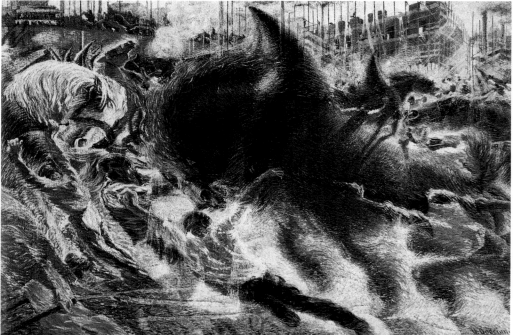

Umberto Boccioni
Simultaneous Visions, 1911
Von der Heydt Museum,
Wuppertal

This painting epitomizes
the Futurist worldview
through its portrayal of
the city, the dynamic
decomposition of objects,
and a close rapport between
architecture and the figure.
The "simultaneity" of
vision is created by the
concurrent presence
of objects, figures, and
backgrounds, while the
illusion of motion is
conveyed by a whirling
vortex.

Umberto Boccioni
The City Rises, 1910-11
Museum of Modern Art,
New York

Boccioni was born in
Calabria, but in 1907
he moved to Milan,
where he enthusiastically
witnessed the growth of
the new working-class
neighborhoods on the
city's industrial outskirts.

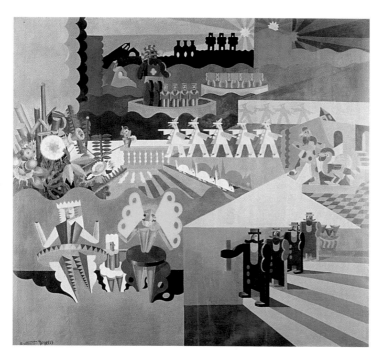

Fortunato Depero
My "Plastic Dances", 1921
Private Collection

In this amusing painting,
Depero creates the idea of
mechanical ballerinas and
marionettes on stage. After
the first period of Futurism
came to an end, swept away
by World War I, Depero
(1892-1960, born in Trentino)
kept the joyful utopia of the
*Futurist Reconstruction of
the Universe* alive, thanks to
his exceptional talent for
the applied arts.

Carlo Carrà
The Red Horseman, 1913
Jucker Collection,
Civico Museo d'Arte
Contemporanea, Milan

This figure in motion has
been dynamically decomposed
like a sequence of movie
frames. Carrà (1881-1966)
threw himself intensely into
the Futurist experience, later
becoming one of the founders
of the Metaphysical Painting
movement.

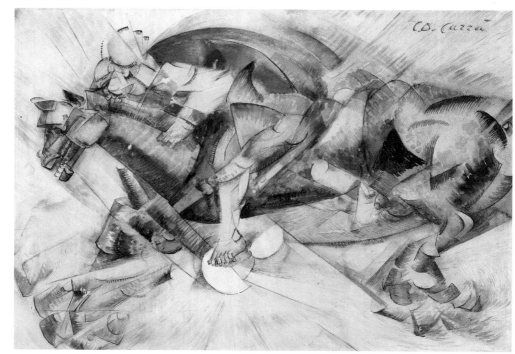

Paris, Côte d'Azur

1869-1954

Henri Matisse

"Color must be thought, dreamed, and imagined"

Matisse, one of the pillars of twentieth-century art, was a
great poet of color and the curved line, and had a wonder-
ful sense of the decorative. He studied art under the
Symbolist painter Gustave Moreau toward the end of the
nineteenth century, when the memory of the pure colors of
Van Gogh and Gauguin was still fresh.

After a brief, but intense, experience with the Fauves, in
1907 Matisse began a kind of dialogue with Picasso and the
Cubist movement. He also studied Japanese prints, Persian
ceramics, and the designs of the Arab world, which all con-
tributed to the evolution of his own unique style. Although
his human figures became increasingly geometric, he main-
tained a taste for bright color, the evocation of a particular
setting, and a relationship with the decorative that led him,
in subsequent years, to seek inspiration in Spain and
Morocco. In 1911, he oversaw the installation of his paint-
ings in galleries in Moscow and contributed to the evolu-
tion of its avant-garde. Throughout his long career, he nev-
er ceased to expand his own visual horizons in an inex-
haustible crescendo of creativity that extended to tapestry,
ceramics, the murals of Saint Paul de Vence, and his final,
touching, colored paper cutouts.

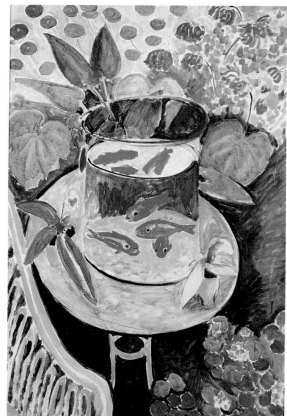

Henri Matisse
Goldfish, 1912
Pushkin Museum of Fine Arts,
Moscow

The motif of the goldfish
bowl, a recurring symbol in
Matisse's work, was inspired
by a trip to Morocco, which
is also recalled in the lush
depiction of the plants
and flowers.

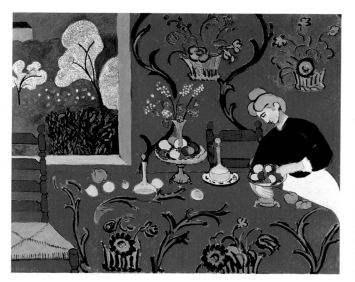

Henri Matisse
The Red Room, 1908-09
Hermitage, Saint Petersburg

In the painting's preliminary
stage, Matisse had painted the
room with a predominantly
blue-green tone, which he
later changed because (as the
artist himself wrote in a letter
to the Russian collector Sergei
Shchukin), "It began to seem
not decorative enough."

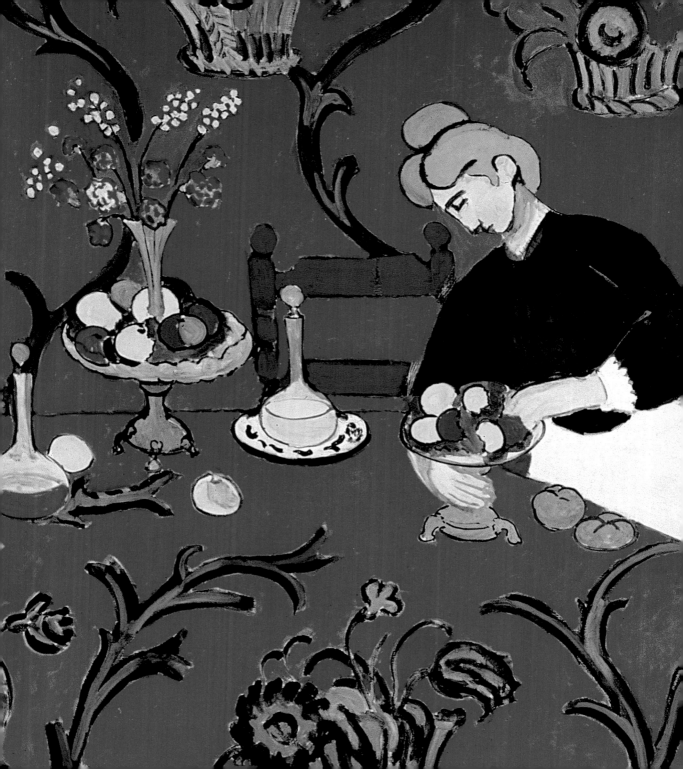

Henri Matisse

1910

La Danse (Dance)

La Danse was commissioned by the renowned Moscow collector Sergei Shchukin, who did not balk at the scandalous idea of hanging a huge painting with nude women in his own home. While Matisse was still working on the painting, Shchukin wrote to him, "I find that the panel of the dance possesses such grandeur that I have decided to defy bourgeois opinion and hang a work with nudes above my staircase".

Housed in the Hermitage in Saint Petersburg, this painting is one of the icons of modern art. Matisse himself, aware of its importance, made reference to it in many of his other works. By simplifying the figures' outlines and reducing the range of colors, Matisse succeeds in creating a serene, poetic atmosphere. The ring of faceless, timeless girls engages the spectator in a simple and natural circular rhythm that seems never-ending. Matisse described how the painting originated as follows: "I really love dance. It is a truly extraordinary thing—life and rhythm. For me it is easy to live with dance. When I had to paint a dance for Moscow, I simply went one Sunday afternoon to the Moulin de la Galette. I watched how they danced... The dancers ran through the hall, holding hands, winding like a ribbon around the rather disconcerted public... As soon as I got home, I composed my dance on a four-meter surface, humming the same tune I had heard at the Moulin de la Galette, so that the entire composition and all the dancers would be moving to the same rhythm".

The focal point of the composition is the lack of contact between the hands of the dancers on the painting's far left. From the two figures' mutual attempt to grasp hands—so as not to break the circular rhythm of the dance—emerge the counterbalanced diagonals, elastic curves, and unceasing, almost insistent, movement that traverses the entire painting.

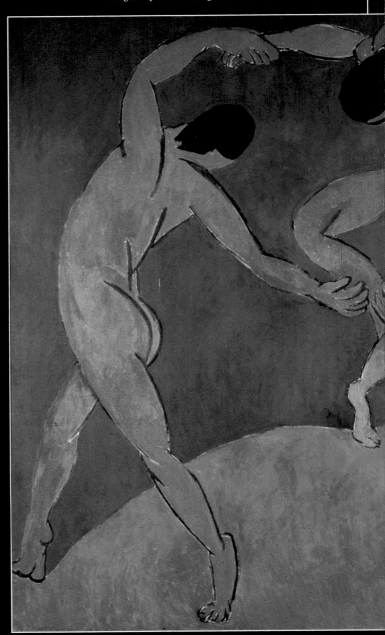

On seeing the painting after several years, Matisse noted, "I was surprised to discover that I had varied the thickness of the colors as I applied them, so that the white of the canvas showed through in places creating a rather lovely, ever-changing effect".

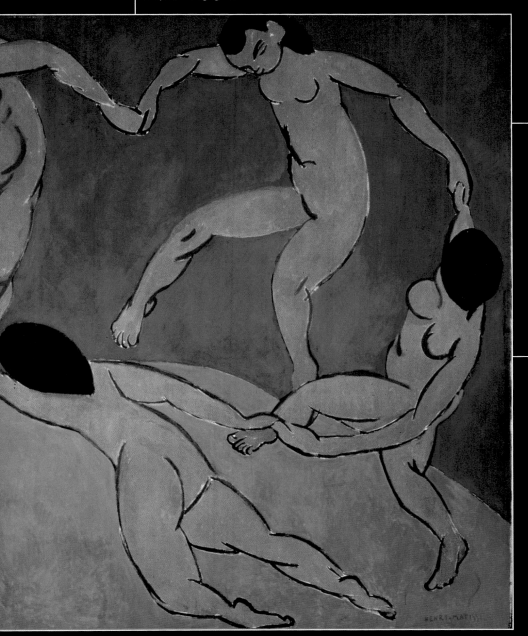

The words of Walter Otto on dance in general provide a fitting commentary for this canvas: "It does not teach anything, nor does it discuss anything. It advances majestically and with its majestic gait reveals the foundation of all things: not will and power, not anxiety and pain, not any of that which seeks to impose itself on existence, but rather that which is eternally lord over itself and divine. Dance is the truth of that which is—but, in the most instinctive way, the truth of that which has life."

The energy released by the painting is reinforced by the absolute simplicity of the elements (earth, sky, and the human figure), precisely identified and emphasized by the artist's use of the colors red, blue and green. According to Giulio Carlo Argan, "The painting has a mythic-cosmic meaning: the ground is the earthly horizon, the curve of the world; the sky has the deep blue depth of interstellar spaces; the figures dance like giants between the Earth and the firmament".

Paris
1907-1914
The Birth of Cubism

A New Vision

After seeing Cézanne's disturbing retrospective, Pablo Picasso (1881-1973), a painter from Andalusia who had been living in Paris for years, began laying the foundations for the most important art movement of the twentieth-century. Rejecting the logic of the pleasant and the reassuring, Picasso sought to reveal the inner geometry of objects and the human figure. He began to create harsh paintings where the decomposition of the objects into geometric lines and contours is carried to such an extreme that the material loses its solidity, bordering on abstraction. Around 1909, in search of even greater purity, Picasso eliminated color, replacing it with a range of gray and brown tones to which he added paper cutouts, numbers, and letters, applied with the technique of collage. This period, Analytic Cubism, was initiated by Picasso and his friend, Georges Braque (1882-1963), with whom he shared a studio in Montmartre. This phase was then followed by the period of Synthetic Cubism (1912-1914), in which objects gradually became recognizable again. Cubism also achieved such resounding success thanks to the courage of important gallery owners, the support of open-minded intellectuals, and the patronage of pioneer collectors of contemporary art.

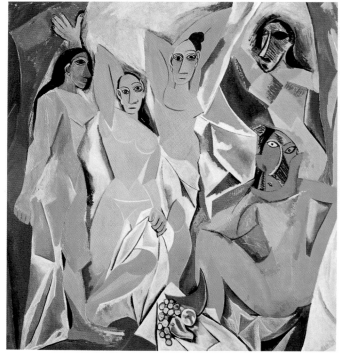

Pablo Picasso
Les Demoiselles d'Avignon, 1907
Museum of Modern Art,
New York

This painting, a defining work in early twentieth-century art, created a sensation in the highly emotional climate of Cézanne's retrospective. Picasso was not concerned with making attractive paintings and deliberately undermined the academic rules of "fine painting". Here, Cézanne's *Bathers*, made more risqué and harsh by the influence of African art, have become prostitutes waiting for clients. The painting extends over the flat surface and is charged with an aggressive presence.

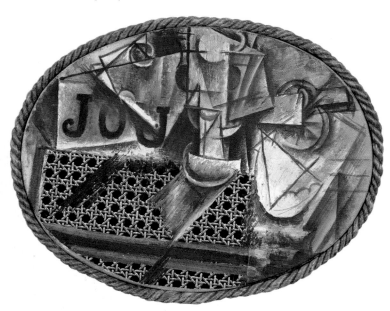

Pablo Picasso
Nature morte à la chaise cannée, 1912
Musée Picasso, Paris

Picasso brought important new elements into play, like his use of the *objet trouvé* (found object)—in this case it is a piece of woven cane rescued from the garbage—and the inclusion of letters and words.

Georges Braque
Houses at l'Estaque, 1908
Kunstmuseum, Bern

Just as Monet, Renoir, and Sisley, working side by side, abandoned their studios to devote themselves to landscape painting produced directly *en plein air*, so too Picasso and Braque (who worked together in the legendary Bateau Lavoir in Montmartre during the winter) went to the countryside of l'Estaque in the summer to paint landscapes in the sun-drenched south of France. During this period of close symbiosis, the two artists applied the stylistic and technical innovations of Cubism not only to inanimate objects in their studio, but also to trees, landscapes, and houses in the woods. Here the influence of Cézanne is even more pivotal than in the still-life compositions. This painting illustrates Braque's search for a sober simplification of colors and geometric blocks.

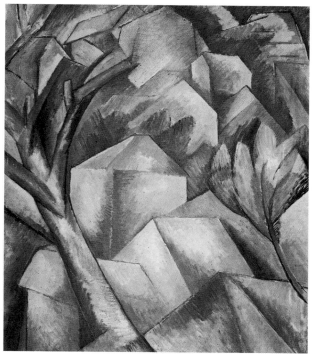

Pablo Picasso
Portrait of Ambroise Vollard,
1909-1910
Pushkin Museum of Fine Arts,
Moscow

The face of the well-known art dealer and critic, fragmented into planes and sections, is proof that Analytic Cubism can also be extraordinarily effective in portraiture.

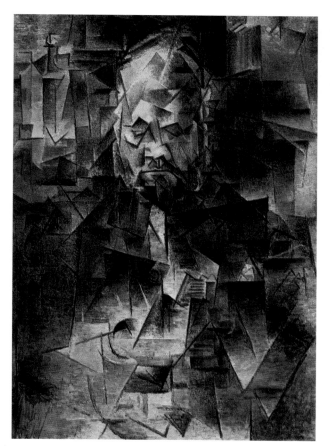

The Influence of African Art

African and Polynesian sculpture played a pivotal role in the avant-garde movements of the early twentieth century—particularly Cubism and German Expressionism. Beginning in the late nineteenth century, the European countries' race to colonize Africa and other parts of the world made powerful new kinds of art available to artists. These works were completely different from the polished academic style and excessive atmosphere of the Decadent Movement. The stark simplification of their volumes and their assertive expressions provided an indispensable lesson in synthesis and essentiality.

Moscow

1910-1924

The Russian Avant-garde Movements

**Impetus, Experimentation, and Passion
at the Time of the Revolution**

The presence of important private collections of Post-Impressionist works in Moscow aroused the curiosity of young Russian artists, who decided to abandon the Realist tradition, and look instead to Paris, the center of avant-garde art. Rayonism, the first Russian avant-garde movement, was founded by Mikhail Larionov (1881-1964) and his wife Natalia Goncharova (1881-1962). The Rayonist experience was also a point of reference for Kasimir Malevich (1878-1935), who evolved from Cubism to found Suprematism in 1913, an intellectual expression of pure sensibility. The events of the 1917 Bolshevik Revolution, which ended the czar's reign and led to the establishment of a socialist government, demanded the participation of artists in the creation of a new society. Constructivism, founded by Tatlin and Rodchenko, sought to create a better world by expressing the aspirations of the revolutionary proletariat and improving the conditions of the masses. Their generous, utopian ideas, however, came up against the tough reality of the times. The death of Lenin (1924) and Stalin's rise to power marked the triumph of Social Realism, a dull, official language similar to the art of many other dictatorships.

Kasimir Malevich
Suprematism-Abstract Composition, 1915
Museum of Figurative Arts,
Yekaterinenburg

Natalia Goncharova
The Cyclist, 1913
Russian Museum,
Saint Petersburg

As this famous painting shows, the avant-garde Rayonist movement proposed an original synthesis of Cubism, Futurism, and Orphism. Goncharova left Russia for Paris in 1914, where she pursued an artistic career alongside the French avant-garde. Part of her activity in Paris was devoted to the creation of sets and costumes for Sergei Diaghilev's Russian ballets.

Natalia Goncharova
Spring in the City, 1911
Cudnovsky Collection,
Moscow

Even before Rayonism and
Suprematism, the tradition
of nineteenth-century
Realism among the Russian
"roving painters" developed
into a dynamic, open style.
It was not unlike the
Expressionism of the same
period, but showed greater
delicacy in the creation of
atmospheres and subtle
relationships between the
figures. Goncharova's synthetic
volumes and focus on the
contemporary city place
her directly in line with the
Cubists and Futurists.

Kasimir Malevich
*Black Square on a White
Ground*, 1915
Russian Museum,
Saint Petersburg

Malevich sought to express
the "supremacy" of form by
abandoning figurative painting
in favor of the pure elements
of geometry. The essentiality
of this painting would only
be surpassed by the absolute
clarity of his next painting,
White on White.

Mikhail Larionov
Rayonist Landscape, 1912
Russian Museum, Saint Petersburg

Defined in the movement's
manifesto (1913) as "a synthesis
of Cubism, Futurism, and
Orphism", Rayonism took its
name from the intermingling
of brightly colored "rays",
which create dynamic, expressive
compositions and pulsating
visions of the modern world.

Ferrara, Rome

1917-1930

De Chirico and Metaphysical Painting

The Enigma of Silence

The painting reproduced here is the key work of Italian Metaphysical Painting, of which Giorgio de Chirico (1888-1979) was the first and leading exponent. The term, taken from ancient Greek, means "beyond real things". De Chirico was born in Greece and always drew inspiration from classical culture. His paintings portray evocative, unreal situations, based on improbable, illusive, and ambiguous combinations of objects, landscapes, light, and perspective.

Metaphysical Painting emerged from a chance meeting during World War II in a military hospital in Ferrara, where Giorgio de Chirico, Alberto Savinio, Carlo Carrà, and Filippo De Pisis were all patients at the same time. This meeting led to the development of an artistic and intellectual movement that sought to represent situations of stillness and reflection, in direct opposition to the dynamic and sometimes incoherent activism of the Futurists. The *Disquieting Muses* are two mannequins, abandoned with other colorful objects in the complete silence of a deserted square whose paving is shown in steep perspective, like the stage of a theater. The distinct, clear-cut shadows seem to be cast with the precision of a sundial, while making no exact reference to a particular time or season. The sky is heavy and dense. The imposing turreted building is the Castello Estense in Ferrara, likewise celebrated by the Symbolist poet Gabriele D'Annunzio as the "city of silence" par excellence. Here, de Chirico uses the city as the setting for a completely motionless composition, in which the sharply outlined, brilliantly-colored forms are like gigantic chess pieces. De Chirico continued to develop this motif in his *Piazze d'Italia* series of static cityscapes, which are vaguely reminiscent of fifteenth-century painting.

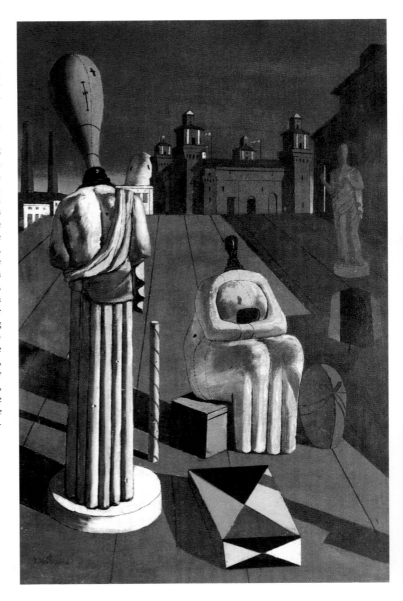

Giorgio de Chirico
The Disquieting Muses, 1918
Private Collection, Milan

Giorgio Morandi
Still Life with Mannequin, 1918
Hermitage, Saint Petersburg

Before withdrawing into
his own solitary, poetic
exploration, the Bolognese
painter Morandi (1890-1964),
participated briefly in the
Metaphysical Painting
movement.

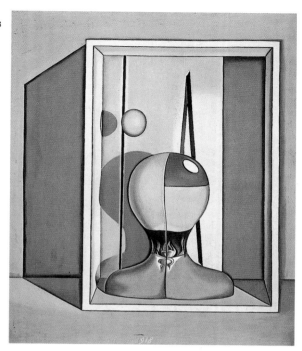

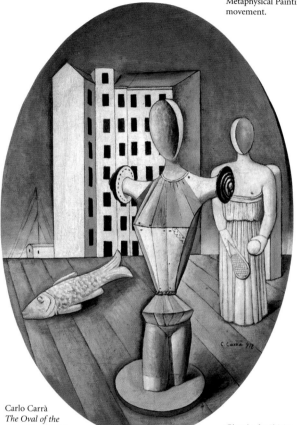

Carlo Carrà
*The Oval of the
Apparitions*, 1918
Galleria Nazionale d'Arte
Moderna, Rome

The mannequin, a recurring
figure in Metaphysical
Painting as well as in Surrealist
literature, gives the idea of
a human presence, but as
a soulless, mechanical form,
incapable of motion or
human expression.

Giorgio de Chirico
Le Chant d'Amour, 1914
Museum of Modern Art,
New York

This painting, inspired by
a Guillaume Apollinaire poem,
was completed a few years
before the official inception
of Metaphysical Painting.
In this painting, de Chirico
incongruously juxtaposes
a plaster cast head of the
Apollo Belvedere with
a rubber glove. The train
in the background is a tribute
to his father, a railroad
engineer.

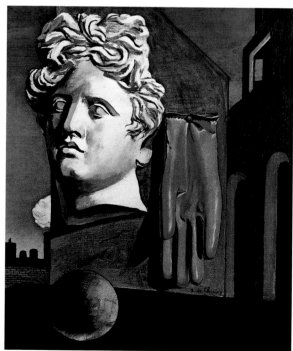

Tuscany, Paris
1884-1920
Amedeo Modigliani

The Aristocratic Melancholy of the Great "Modì"

Born in Livorno in 1884, Modigliani learned to paint in the tradition of the Tuscan Macchiaioli, but a visit to the Venice Biennale exposed him to the works of Munch, Toulouse-Lautrec, and Klimt. In the spring of 1906 he moved to Paris, but he had a difficult relationship with the city. Modigliani lived on the fringe of artistic circles, reluctant to join any of the groups that were forming around him (e.g. the Fauves and the Cubists), despite their shared admiration for Cézanne and African sculpture. His closest friends, Soutine, Kisling, Brancusi, and Chagall, were artists from Eastern Europe, and all Jewish like himself. Despite the efforts of gallery owners like Paul Guillaume and Leopold Zborowsky, Modigliani remained artistically isolated, drowning his sorrows in drink. He had the strength of character, however, to stick to his chosen style, obsessively painting the same two subjects: female nudes and portraits. Then, in 1917, his world brightened when he fell in love with Jeanne Hébuterne, a promising nineteen-year-old artist. However, on his return to Paris from a stay on the Côte d'Azur, Modigliani's health began to deteriorate rapidly. He died of tubercular meningitis on 20 January 1920 and, just a few hours later, Hébuterne committed suicide by throwing herself out of a window. The two passionate, desperate lovers lie side by side in the Père Lachaise cemetery. Their funeral was attended by every artist in Paris, who only then fully realized the grandeur and poetry of the brilliant Tuscan who had arrived in the *Ville Lumière* fifteen years earlier.

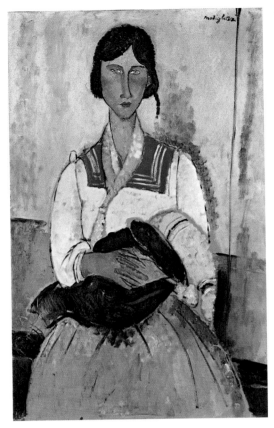

Amedeo Modigliani
Gypsy Woman with Baby, 1918
National Gallery of Art, Washington, D.C.

At the beginning of 1918 Zborowsky organized a move to Nice for Modigliani and Hébuterne, as well as other painters, like Soutine and Foujita, who all wished to get away from Paris. The French Riviera had become a hospitable refuge for many artists, including Picasso, Matisse and the "patriarch" Renoir. Even in the Mediterranean light of his childhood, however, Modigliani remained largely indifferent to the landscape, painting more portraits than ever, including several memorable images of children and common people.

Amedeo Modigliani
Large Nude, 1913-14
Museum of Modern Art, New York

The influence of Tuscan Renaissance painting adds an indefinable almost classical, yet timeless, quality to Modigliani's style.

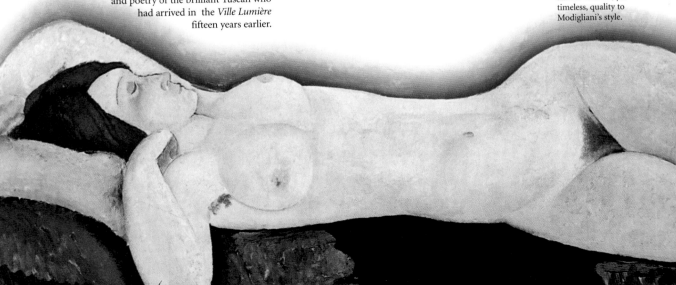

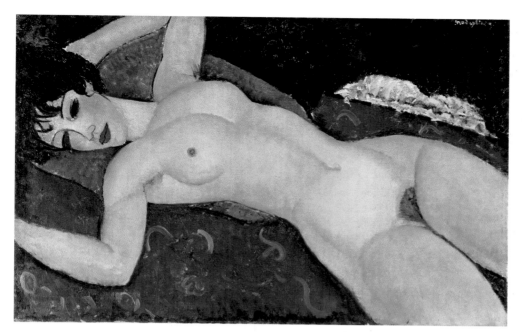

Amedeo Modigliani
Reclining Nude, 1917
Private Collection, Milan

Modigliani had his first solo show at the Galerie Berthe Weill in Paris in 1910. However, it was forced to close after only a few days, following charges of indecency that were made because several paintings of female nudes were exhibited in the window.

Amedeo Modigliani
Self-Portrait, 1919
Museo de Arte Contemporanea de Universidade, São Paulo

Throughout his life, Modigliani repeatedly battled with serious illnesses, including pleurisy, typhoid, and tuberculosis. These irremediably undermined his strength, but they did not alter his striking good looks or irresistible charm.

Amedeo Modigliani
Portrait of Paul Guillaume, 1916
Civico Museo d'Arte Contemporanea, Milan

As Jean Cocteau wrote, Modigliani's portraits are a reflection "of his inner quality, of his noble, sharp, agile, and dangerous grace, not unlike the horn of the unicorn". In every painting one feels a spiritual touch, conveyed by the artist with penetrating sensitivity. Paul Guillaume, one of the most astute gallery owners in Paris, was one of the artist's few true friends throughout his stormy years at *La Ruche* in Montparnasse, the run-down neighborhood that was nonetheless a hive of activity where many foreign artists lived and worked.

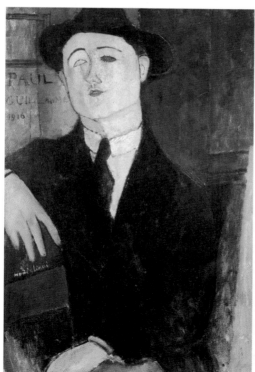

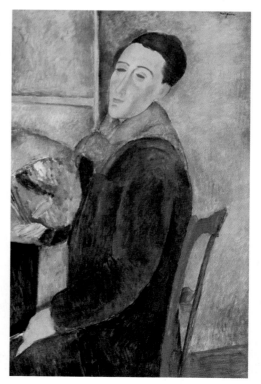

Vitebsk, Paris, Moscow
1887-1985
Marc Chagall

Fairy-tale Enchantment at the Heart of Modern Art

Artistic life in Paris during the "avant-garde years" was enlivened by personalities from many different cultures and backgrounds, who converged on the banks of the Seine. The poetic, idealized memory of a religious, provincial Russia permeates the work of Marc Chagall, where the sacred, the profane, the real and the miraculous joyfully merge. He faithfully followed his own path, never joining any of the various artistic movements. In 1910, after studying in Vitebsk and Saint Petersburg, Chagall moved to Paris, bringing the sacred beauty of Jewish ritual and the Russian countryside to the artists of Montparnasse. He returned to Russia when the October Revolution broke out and stayed there until 1923. During this period he painted vast compositions, including murals for the Jewish Theater in Moscow. On returning to Paris, he began a series of etchings, including his celebrated biblical illustrations. In 1940 he moved to Provence and executed large-scale works, like the stained glass windows at Metz and Mainz, and the decorations for New York's Metropolitan Opera House and the Paris Opéra.

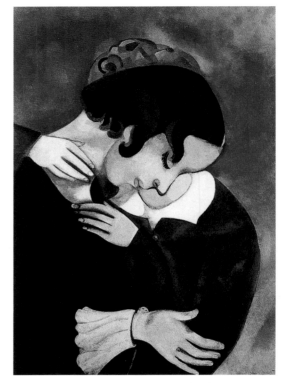

Marc Chagall
Pink Lovers, 1916
Tchounovskaya Collection,
Saint Petersburg

In this painting, small traces of the Parisian avant-garde movements (e.g. the colors of Orphism) and a certain geometric quality of the form, akin to Cubism, can be found. Nonetheless, Chagall always maintained his own unmistakable, personal style.

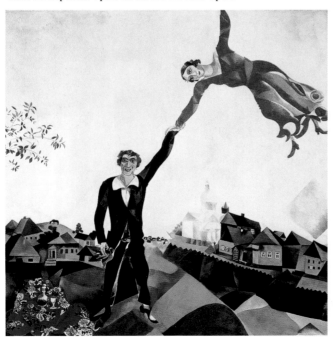

Marc Chagall
The Promenade, 1917-18
Russian Museum,
Saint Petersburg

The love between Chagall and his wife Bella inspired paintings full of infectious joy. Here Chagall holds Bella suspended in mid-air, like a kite, against a landscape that recalls his native Vitebsk.

Marc Chagall
Window Facing a Garden, 1917
Brodsky Museum,
Saint Petersburg

Chagall, ever faithful to
figurative painting, loved
warm colors and soft light.
He was also fond of
extremely large compositions.

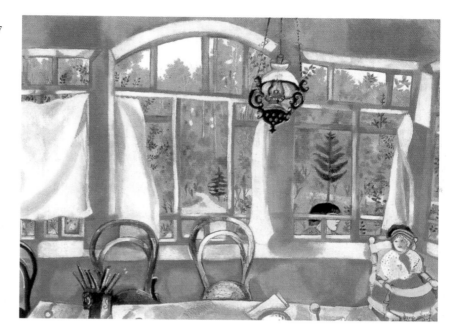

Marc Chagall
Paris through the Window, 1913
Peggy Guggenheim Collection,
Venice

The two-faced figure at
the window emphasizes
the relationship between
the interior and the exterior.
During this period, Chagall
was living in the Montparnasse
neighborhood, a hive of
artistic expression, swarming
with artists from many
different countries.

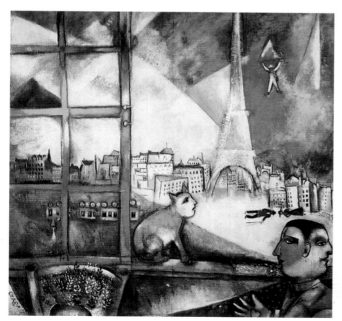

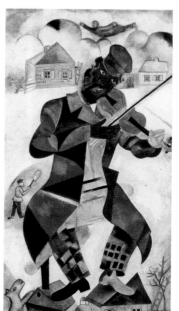

Marc Chagall
The Green Violinist, 1923
Solomon R. Guggenheim
Museum, New York

This jovial street musician
is part of the series of
characters Chagall painted
for the Jewish Theater
in Moscow.

Holland

1872-1944

Piet Mondrian

"I saw the ocean as a series of pluses and minuses"
Unlike many of the other avant-garde trends that emerged around 1910, Abstract Art was never a clear-cut, organized movement. It was divided into three different currents from the beginning: Malevich and Mondrian's pure surfaces, divided by geometric lines; Klee, Sonya and Robert Delaunay's research into the diffusion of light; and Kandinsky's absolute freedom of gesture, sign, and color. After his academic studies in Amsterdam, Mondrian felt the need to isolate himself in order seek out the laws of pure order and symmetry. His trips to Paris familiarized him with the primary colors of the Fauves and the compositional studies of the Cubists. During World War I, his landscapes began to dissolve into a series of mathematical signs, abandoning any depth. In 1917, he founded *De Stijl* with Van Dongen, and painted his first canvases of solid blue, yellow, and red rectangles on a white background. From this point on, Mondrian was a defining presence in the international art world. Though he was interested in Constructivism and the Bauhaus, he still preferred to work independently. At the outbreak of World War II, he relocated to New York, where he died of pneumonia in 1944.

Piet Mondrian
The Silver Tree, 1911
Gemeentemuseum, The Hague

It is possible to trace Mondrian's path as he abandoned reality and moved toward total abstraction. He repeatedly studied a few select landscape motifs, like lighthouses and trees, which he gradually reduced to an abstract grid of lines.

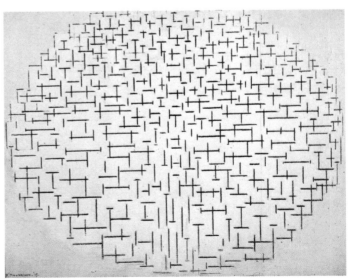

Piet Mondrian
Lighthouse at Westkapelle, 1910
Jucker Collection, Civico
Museo d'Arte Contemporanea,
Milan

Piet Mondrian
*Pier and Ocean
(Composition no. 10)*, 1915
Kröller-Müller Rijksmuseum,
Otterlo

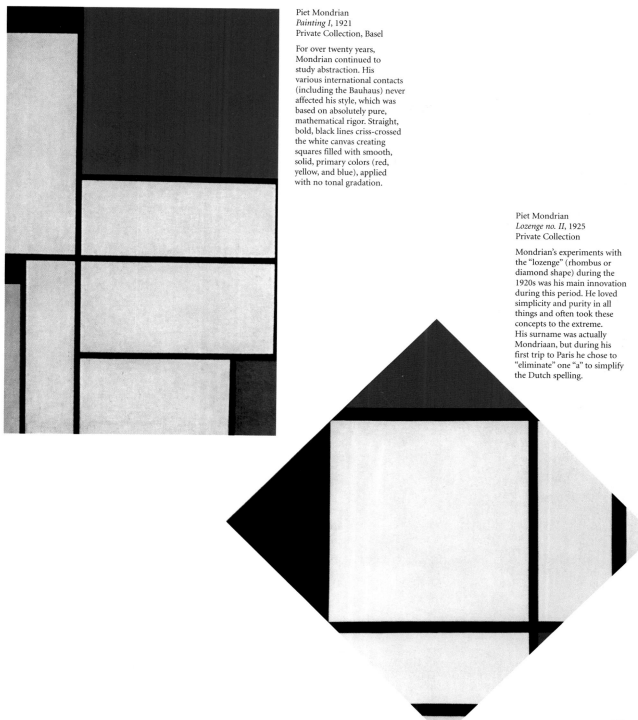

Piet Mondrian
Painting I, 1921
Private Collection, Basel

For over twenty years, Mondrian continued to study abstraction. His various international contacts (including the Bauhaus) never affected his style, which was based on absolutely pure, mathematical rigor. Straight, bold, black lines criss-crossed the white canvas creating squares filled with smooth, solid, primary colors (red, yellow, and blue), applied with no tonal gradation.

Piet Mondrian
Lozenge no. II, 1925
Private Collection

Mondrian's experiments with the "lozenge" (rhombus or diamond shape) during the 1920s was his main innovation during this period. He loved simplicity and purity in all things and often took these concepts to the extreme. His surname was actually Mondriaan, but during his first trip to Paris he chose to "eliminate" one "a" to simplify the Dutch spelling.

Piet Mondrian

1942-1944

Victory Boogie-Woogie
Broadway Boogie-Woogie

Mondrian, whose work had already undergone a radical transformation as a result of World War I, was anguished by the Nazi advance on Paris, and in 1939 he fled to London. While in London, however, he experienced the nightmare of the bombings, which prompted him to seek refuge across the Atlantic, in New York. Over the previous decade, New York had become a safe haven for European artists, many of whom had suffered political or racial persecution in their home countries, such as the German masters of "degenerate art". The center of the artistic debate had clearly shifted from the banks of the Seine, the Thames, the Danube, and the Sprea to the banks of the Hudson. Although Mondrian was already seventy years old and in poor health, he made an unexpected comeback during this period. Stimulated by New York's vitality, he replaced straight black lines with linear sequences of small, brightly colored squares. His firm belief in a victorious outcome of the war charged his American paintings with a fast and joyous rhythm.

Mondrian chose the rhomboid format he liked so much for his last painting, *Victory Boogie-Woogie* (private collection), which remained unfinished at the time of his death from pneumonia in early 1944. Encouraged by the news from the various war fronts, this painting seems to celebrate a victory that he would never witness personally. The patches of color move in rapid succession, like flags in a victory parade, or the "full dressing" raised by a ship on special occasions.

Housed in the Museum of Modern Art in New York, *Broadway Boogie Woogie* marks the final turning point in Mondrian's style of painting. In addition to having eliminated the black lines, Mondrian has painted countless yellow tiles and (unusually) several gray, square and rectangular forms on a large square canvas. As its title indicates, this painting is a tribute to the dizzying height of Manhattan's skyscrapers and the rhythm of George Gershwin's music. Nonetheless, a sense of meditation, geometry, and intellectual construction, characteristic of Mondrian's oeuvre, still remains. Mondrian's methodical approach is radically different from the "action painting" of Pollock and the painters of the New York School, however, it greatly influenced the scientific color research conducted by some of the newly immigrated European artists (e.g., Albers and Rothko).

Bern, Munich, Weimar
1879-1940
Paul Klee

"Color and I are one and the same: I am a painter!"

Klee is the most surprising case of precociousness in the field of painting: the drawings and watercolors he made as a child already reveal his powerful and original style. After studying art in Bern and Munich, Klee spent most of the first decade of the twentieth century traveling to see the paintings of the old masters and learning more about the artistic currents of the time. He made contact with the painters of *Der Blaue Reiter* and traveled with August Macke to Tunisia in 1914, which provided him with new experiences of light and color. A patient, invaluable study of the gradation of tones of light, that was a cross between poetic intuition and scientific method, characterized Klee's middle period. In 1920, he joined the Bauhaus, and in 1924, he co-founded the Blue Four with Kandinsky, Jawlensky, and Feininger. His paintings from the 1920s are small, delicate idylls, whose colors are applied in smooth geometric patterns, while their graphic features vaguely evoke real objects and figures. Later, after being condemned by the Nazis as a "degenerate" artist, Klee returned to Switzerland. The last years of his life were plagued with serious illness, a suffering that is apparent in the heavy, dark lines of his last, bitter canvases.

Paul Klee
Saint Germain near Tunis,
1914
Centre Pompidou, Paris

This splendid watercolor documents the emotions Klee experienced during his trip to Tunisia with August Macke in 1914. For Klee, his stay in North Africa was a chance to discover light, which he immediately captured and reproduced in exquisitely subtle paintings.

Paul Klee
Colored Composition with Black Graphic Elements, 1919
Berggruen Collection, Geneva

Immediately after the war, Klee began his own personal study of the order and rationalization of the image. Here we are still in a chaotic phase in which the painter introduces diverse elements, including letters and irregular outlines, into his compositions in an attempt to test their impact on a style that is still being formulated.

Paul Klee
Separation in the Evening,
1929
Felix Klee Collection, Bern

This famous work is
emblematic of Klee's art.
The two arrows introduced
into the regular, methodically
applied, overlapping bands
of color communicate an
emotion and magically
convey the sense of
subdued evening light.

Paul Klee
Light and Other Things, 1931
Private Collection

This work is a classic example of
Klee's patient analysis of every
element of the composition,
following a secret path of lines,
points, lights, and colors.
Although it may appear
to be a kind of mathematical
exercise, upon closer
observation, the sweetness,
lyricism, and hidden beauty
of Klee's world is revealed.

1919-1933
Form and Rationality

The Desire for Order and the Eternal Call of the Classical

After experiencing the avant-garde years and the tragedy of World War I, European art entered a period of reflection and renewed appreciation for traditional forms and motifs. Picasso, who throughout his long life consistently demonstrated his capacity to change styles (even radically at times), abandoned Cubism after a trip to Italy, moving into an overtly "classical" phase, characterized by clearly outlined forms and figures. In this same period, Matisse devoted himself to the theme of the "odalisques". In these seductive, exotic female figures, he rediscovered his love for decoration, light, and the evocation of a setting centered on the eternal feminine mystique.

After Germany's defeat, its artists were in need of a profound regeneration. The Bauhaus School, founded in Weimar in 1919 by the architect Walter Gropius (1883-1969), offered a rich and complex development of structure, geometry, and the functional simplicity of line. The artistic and cultural philosophy of the Bauhaus called for the constant collaboration and exchange between sculptors, painters, architects, and designers, promoting a union of arts and crafts that led to the creation of everyday objects that were both functional and aesthetically pleasing. The artists thus became familiar with various techniques and materials, in accordance with the concept of "total" training, which made no clear distinction between the "fine arts" and the "applied arts". The school moved to Dessau in 1925 and was closed definitively by the Nazi regime in 1933, but the diaspora of its teachers in Europe and the United States spread Constructivist ideas throughout the Western world. Also during this period, Kandinsky, Klee, Feininger, and Jawlensky formed the group known as the Blue Four.

Lyonel Feininger
Street at Night, 1929
Gemäldegalerie Neue Meister, Dresden

Feininger, an American artist of German origin (1871-1956), was a member of the Bauhaus School.

The Bauhaus style is visible in the regularity and geometry of these constructions, which nonetheless succeed in giving the impression of variety and movement, thanks to the diverse intensities of light and shade.

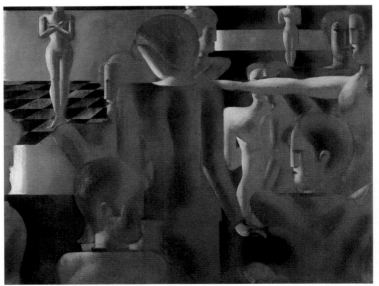

Oskar Schlemmer
Group of Fourteen in an Imaginary Architectural Setting, 1930
Wallraf-Richartz Museum, Cologne

The human figure, interpreted in its essence, is the central motif in this work by Oskar Schlemmer (1888-1943)— painter, stage designer, and sculpture instructor at the Bauhaus.

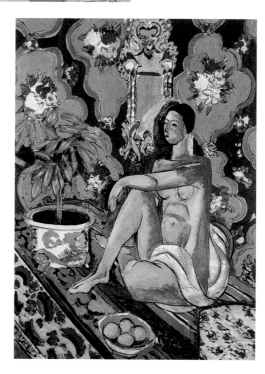

Pablo Picasso
The Lovers, 1922
National Gallery of Art,
Washington, D.C.

The figures of this young couple are softly drawn, with no trace of harshness or abstraction. Through their gestures and expressions, one senses an amorous interplay and an intermingling of desire and reluctance. In this very classical-feeling composition, Picasso succeeds in giving his figures volume, depth, and a delicate movement, while restricting himself to simple outlines. The color does not "fill" the figures, but is freely spread in patches that do not correspond to natural reality. The solid blocks of color in pale tones come together to further suggest an atmosphere of suffused emotion.

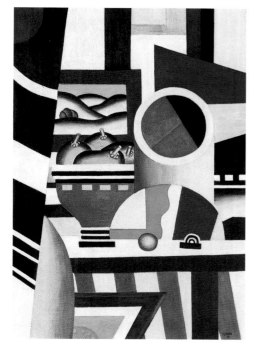

Fernand Léger
Still Life with Fruit Bowl, 1923
Musée d'Art Moderne,
Villeneuve-d'Ascq

This painting is informed by the conflict between figuration and abstraction. The easily recognizable fruit bowl seems "besieged" by pure geometric forms that drastically compress the space devoted to the representation of the table, the fruit bowl, and the open window in the background. This continual alternation, even within a single composition, is perhaps the most interesting feature of all Léger's work.

Henri Matisse
*Decorative Figure on an
Ornamental Background*,
1925-26
Musée National d'Art
Moderne, Paris

Chromatic and decorative elements inspired by the Orient dominate Matisse's work of the 1920s.

Berlin
1918-1933
Germany between Two Tragedies

The Caustic Criticism of a World Adrift

World War I, a watershed for many artistic movements and currents, did not interrupt the development of German Expressionism. On the contrary, it exacerbated some of its vitriolic criticism. During this period, the Berlin school *Neue Sachlichkeit* (New Objectivity) emerged. Brilliant but pitiless artists like Grosz and Dix depicted the human, material, and moral disasters of the war, lashing out against post-war German society. Streams of poor invalids, veterans and disabled flood the streets in a frenzied puppet theater of black market profiteers, prostitutes, obsequious state bureaucrats, and fat industrialists who made their fortunes supplying armaments. Many artists active in Berlin during the 1920s, with its cabarets and Expressionist cinema, predicted what was about to happen on the political scene. In fact, when Hitler came to power, Dix was arrested and other artists were forced to emigrate to the United States.

Otto Dix
Metropolis, 1927-28
Galerie der Stadt, Stuttgart

This triptych is one of the most powerful depictions of the mood in Berlin during this period. In the central panel, a tuxedoed member of the band plays the saxophone as elegant couples dance in a surreal atmosphere where the façade of luxury and good times, conveyed by the women's heavy make-up and fashionable clothing, cannot conceal the spreading tension of the approaching war. The side panels depict two very different scenes. On the left, a disabled war veteran drags himself along the cobblestones on his crutches, while on the right, prostitutes wait for clients in a lurid composition that combines sensual indulgence with brutish bestiality.

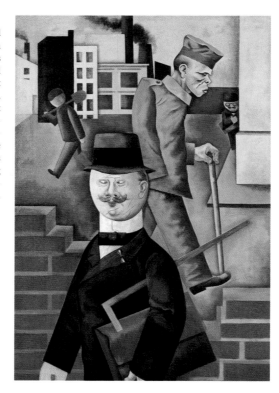

Georg Grosz
Gray Day, 1921
Staatliche Museen, Berlin

This desolate image of the postwar period depicts a morning on the outskirts of Berlin. In the foreground, a cross-eyed state official for disabled veterans' pensions, dressed immaculately (a decoration is pinned to his lapel) and wearing a *pince-nez,* is the very image of the elusive and ineffectual assistance he has closed in the folder under his arm. Symbolically, a brick wall of indifference divides the functionary from the veteran who should be receiving the pension. A black market speculator—the actual, behind-the-scenes "director" of this squalid scene—peeks furtively round the corner, while a man heads to work.

Otto Dix
Flanders, 1936
Nationalgalerie, Berlin

Dix, born in 1893, fought in World War I, a horrendous experience that scarred him for life. Here, the subdued, leaden light is clouded by the dispersing smoke. Uprooted barbed wire, ravaged nature, and macabre human remains are all that is left behind by the blind fury of battle. It was inevitable that paintings like this, clearly inspired by antimilitarist beliefs and denouncing the brutality of war, would be censured by the Nazi regime. In 1933, approximately 250 of Dix's paintings were burned in public bonfires. The painter was dismissed from the Berlin academy, arrested for conspiring against Hitler and imprisoned in Dresden. Upon his release in 1935 he escaped to Switzerland.

Max Beckmann
Self-portrait in Tuxedo, 1927
Harvard University Art Museum, Cambridge, Massachusetts

The hard lines of his face, the volume clearly delineated by the use of black and white, and the highly graphic form, are all aspects that place Beckmann unquestionably within the realm of German Expressionism. Nonetheless, in his choice of clothes here, he depicts himself as a refined and ironic artist, well established in Berlin society.

Christian Schad,
Operation, 1929
Lenbachhaus, Munich

In addition to the pitiless (in this case, even "surgical") realism, typical of the exponents of the *Neue Sachlichkeit*, Schad displays his profound knowledge of fifteenth-century Italian art, which he acquired while living in Rome from 1920 to 1925.

1916-1940

From Dada to Surrealism

A Worldwide Movement of Pure Fantasy

The Dada movement originated in 1916 in Zurich, where many artists and intellectuals had sought refuge during the war. Dada proposed a provocative, total defiance of all values and models, in the name of a completely unrestrained, creative freedom, led by Marcel Duchamp's ready-mades. The movement spread throughout Europe, from Paris to Berlin, and to the United States, adopting a wide variety of languages and means of expression. Nonetheless, by 1922, it was already in decline. Many artists, in fact, slipped into Surrealism, the "grand finale" of the avant-garde era. Born in Paris and theorized by André Breton, Surrealism was a new movement defined by its exploration of the innermost recesses of the psyche. The Surrealist painter let his brush flow freely over the canvas, allowing his deepest impulses and desires to reveal themselves spontaneously, as in the Freudian process of "automatic writing". The works of Joan Miró and André Masson are good examples of this process. A more "figurative" current was represented by Balthus, Dalí, and Delvaux who, influenced by Metaphysical Painting, created absurd, disturbing compositions with objects taken from everyday life.

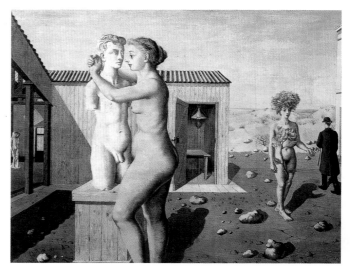

Paul Delvaux
Pygmalion, 1939
Musées Royaux des Beaux-Arts, Brussels

Belgian painter Paul Delvaux (1897-1994) turns the myth of Pygmalion around. Here, the woman attempts to breathe life into a male statue with a kiss.

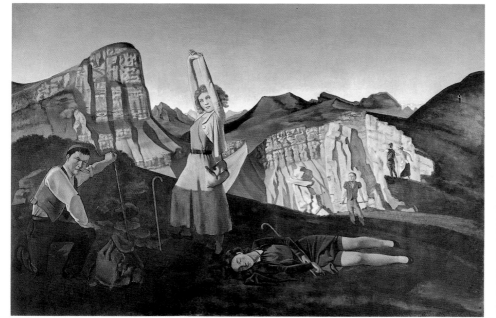

Balthus
The Mountain, 1937
Metropolitan Museum of Art, New York

Balthus (1908-2001), whose real name was Balthazar Klossowski, was of Polish origin, but lived mostly in Paris. He is one of the most acclaimed and enigmatic painters of the twentieth-century, although criticized at times for his portrayal of young girls in dubious situations. To his critics he replied, "My paintings, whether they portray adolescents or landscapes, are dominated by one and the same idea: life, or more precisely, the awakening of life".

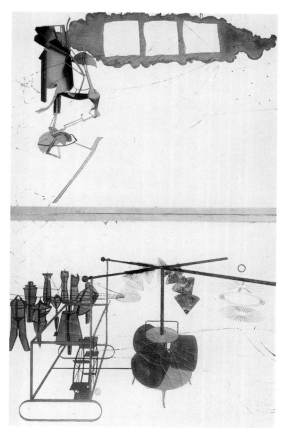

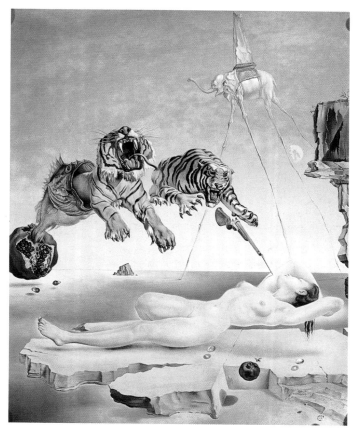

Marcel Duchamp
The Bride Stripped Bare by her Bachelors, Even, 1915-23
Philadelphia Museum of Art

This large, complex work, completed after a very lengthy creative process and later restored after the glass panel was broken, is a true synthesis of the art of Duchamp (1887-1968). In fact, after its completion, he virtually stopped painting altogether. With the logic and cerebral symbolism of his adored chess game, Duchamp arranges the "pieces" over the free surface of a transparent plate of glass, challenging critics and spectators to offer their own free interpretation of the bizarre machinery, lines, forms, groups of objects and references. The complicated title alludes to the two halves into which the piece has been divided: the bottom half is occupied by metallic mechanisms and instruments, while the rarefied and elusive top half is occupied by the "bride".

Salvador Dalí
One Second before Awakening from a Dream Caused by the Flight of a Bee around a Pomegranate, 1944
Thyssen-Bornemisza Collection, Madrid

The work of Dalí (1904-1989), brimming with conspicuous literary references and obsessive sexual allusions, is a direct result of the artist's pictorial method, which he himself described as "paranoid-critical"; that is, bent on exposing the intrinsic irrationality of the everyday world.

Brussels

1898-1967

René Magritte

Paradox, Contradiction, and the Interplay of Images

Art criticism is still today divided about whether Magritte should be considered "merely" an extraordinary, if cold, creator of images or one of the most representative masters of the twentieth century. The public, on the other hand, has no doubt. The expressive power of Magritte's images—so simple to "recognize" but impossible to "understand"—has made him one of the best loved, most reproduced, and well-known painters of all time. After working briefly in advertising (a background that is reflected in all his work), Magritte discovered the Metaphysical paintings of de Chirico, which proved to be a great revelation. From then on, he portrayed "impossible" juxtapositions of objects, landscapes, and people, painted with absolute, still clarity. He relocated to Paris and befriended Dalí, participating in the Surrealist movement and even drafting articles and essays. During this period, Magritte continued to carefully observe recent masters, like Seurat, as well as old masters from fifteenth-century Italian painting. By the time he returned to Brussels in 1930 his style, based on oppositions and enigmatic presences, was fully consolidated, except for a short period when he painted in the manner of Renoir.

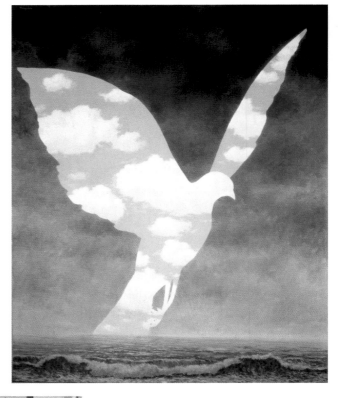

René Magritte
The Great Family, 1963
Private Collection

Magritte's works are almost timeless. The painter reworked images, motifs, silhouettes, characters, and objects he had used many years before to achieve new, alienating effects. As always, the titles are deliberately misleading, never describing the subject that is actually represented.

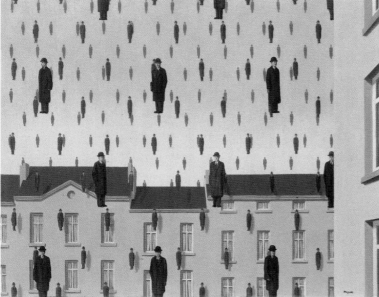

René Magritte
Golconde, 1953
Menil Collection, Houston

This famous painting has been reproduced countless times. The "shower" of little men in their bowler hats and dark gray clothes has become a metaphor for the human condition in the twentieth century, when people began to suffer from a loss of individual identity and the monotonous banality of everyday life.

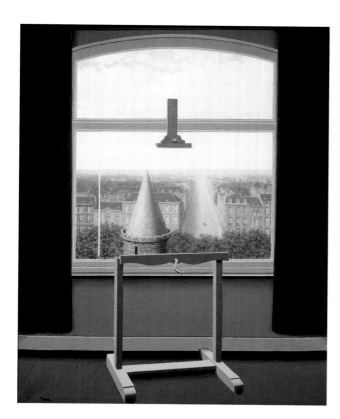

René Magritte
Euclidean Promenades, 1955
Minneapolis Institute of Arts

The superimposition of interiors and exteriors is a recurring theme in Magritte's work. Here, a canvas on an easel is perfectly superimposed on the "real" view from the window. This is an easily legible symbol of the illusion and ambiguity of painting itself.

René Magritte
The Treachery of Images, 1929
Los Angeles County Museum of Art

This painting provides the key to understanding Magritte's Surrealism. The artist painted a pipe, and then wrote the words "This is not a pipe" underneath; indicating a "betrayal" of reality, a parallel universe where nothing is as it seems.

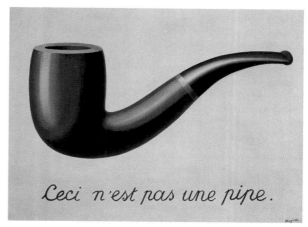

René Magritte
Homesickness, 1940
Private Collection

Magritte painted this work in Carcassonne, a famous medieval town in the south of France, when the Nazi advance was crushing both France and Belgium—the two countries dearest to his heart. Here, in addition to the usual features of stillness and silence, there is a feeling of separation and incommunicability, and even impending menace, conveyed by the presence of the lion. Magritte identifies with the man dressed in black (a recurring character in his work) who, in this case, has wings he longs to use to escape from this disquieting reality.

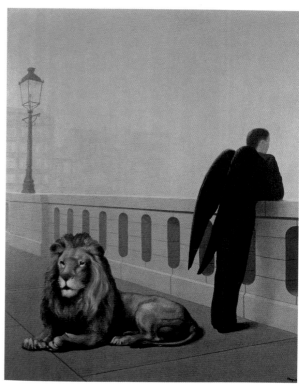

"This train does not stop"

Miró found a rusty, old railroad sign with these words written on it in a dump and hung it on the wall of his studio, as a kind of self-imposed "program". The life and work of this Catalan artist was marked by his unstoppable creativity and extraordinary ability to invent colorful images teeming with life. Although he was in contact with various artistic currents and avant-garde movements (especially Surrealism), Miró remained a highly individual painter.

He left Catalonia for a long stay in Paris in 1919 where he came into contact with members of the various avant-garde movements, including fellow-Catalan Picasso, Dadaist Tristan Tzara, and the emergent Surrealists (in 1921). His works from this period were still figurative (portraits, rural themes and scenes), but were moving toward abstraction. More precisely, Miró was evolving an original combination of fragments—at times disturbing, at times playful—that plumbed the depths of instinct, memory, and the subconscious. The great tragedies of war (the Spanish Civil War, followed by World War II) prompted Miró to experiment with new styles and materials, like cutouts and collage. After passing through a dramatic phase, a lighter side resurfaced with the intriguing and poetic *Constellations* series. Miró's exhibits in the United States were immensely successful. His free, creative style made a strong impression on the painters of the New York School, especially Jackson Pollock. In the 1950s, Miró focused on sculpture, street art, and large-scale decoration, but returned to painting with his *Blue* series (Centre Pompidou, Paris). In 1976, the Miró Foundation opened in Barcelona. It is a wonderful collection that displays the ebullient, multi-faceted creativity of one of the twentieth century's greatest artists.

Joan Miró
Personage and Bird before the Moon, 1944
Perls Galleries, New York

During the war years, Miró often included phallic symbols in his work, almost as if to allude to the sexual act as being able to generate a new kind of man, born from paint.

Joan Miró
Harlequin's Carnival, 1924-25
Albright-Knox Art Gallery, Buffalo

In this fantastic game, bizarre characters crowd the transfigured space of the artist's studio, creating a mechanical ballet full of color and joy, to the sound of the guitar played by Harlequin (the pop-up puppet at the center of the painting). This work, from Miró's Surrealist period, marks his transition from the figurative to the abstract.

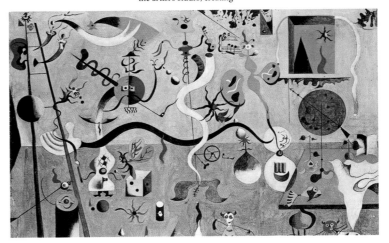

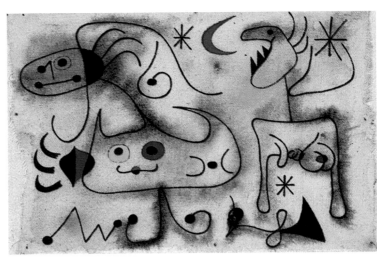

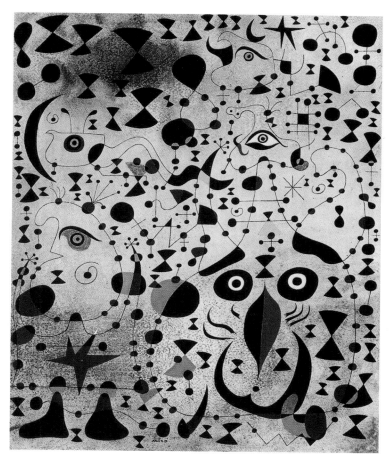

Joan Miró
The Beautiful Bird Reveals the Unknown to a Couple of Lovers, 1941
Museum of Modern Art, New York

During World War II, Miró made a series of paintings called *Constellations*, characterized by a pattern of signs and images on a light background. The paintings in this series constitute an interlude of pure lyricism, a moving love song that, gently and with great humanity, opposes the savage violence of war.

Joan Miró
Personages and Birds, 1974-76
Private Collection

Miró executed this large painting (162 × 316 cm) as a model for the impressive mosaic (9 × 17 m) that decorates the façade of the Art Museum at Wichita State University (explaining the artist's use of thick black outlines and large fields of color). The scene is both joyful and serene, charged with imagination and poetry, as was characteristic of the Catalan artist's later work.

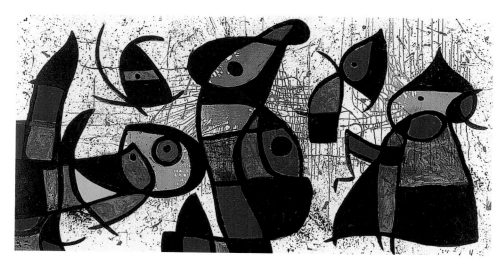

1933-1956
Art, Dictatorships, and Ideologies

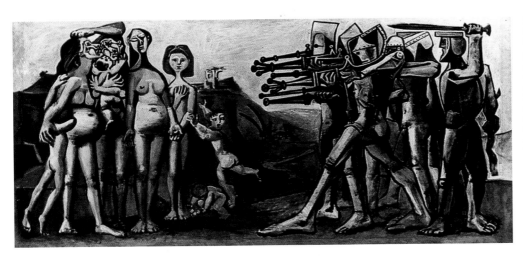

Pablo Picasso
Massacre in Korea, 1951
Musée Picasso, Paris

Picasso himself repeated the style of *Guernica*, along with its historic and social message, in later paintings. In this case, he added a dramatic allusion to the execution painted by Goya almost a century and a half earlier, thereby underscoring the recurrent violence in the history of mankind.

Between Denunciation and Propaganda

Dictators do not like abstract art, since it is hardly suited to glorifying icons and heroes.

In the 1930s, the arts under the various autocracies looked to poster art and cinema, adapting their language to these powerful means of propaganda. Similar models spread beyond Europe, as can be seen from the period of post-revolutionary murals in Mexico. Thus, in the 1930s, parallel phenomena occurred in Germany, Italy, and Russia (three countries that less than thirty years before had produced the avant-garde movements of Expressionism, Futurism, and Suprematism). The "official" art of these regimes depicted realistic, recognizable situations and people, often with the addition of bombastic rhetoric. Meanwhile, any form of free artistic expression was banned by a censorship that made brutal, anti-historic choices. During this same period, international Neo-Cubism proved Realism to be an alternative form capable of conveying "messages" with a powerful political impact. The style originated with Picasso's painting, *Guernica* (1937), whose universal value soon made it the obligatory stylistic model of artistic movements with a Communist leaning. During World War II, this "political" reference to Picasso opened an ideological rift between Realism, inspired by social-Communist sympathies, and the Abstract Art movements (including *Informel*), which were generally labeled "reactionary".

Fernand Léger
The Builders, 1950
Musée Fernand Léger, Biot

Inspired by a sincere social and political commitment, especially in his large murals, Léger (1881-1955) abandoned the semi-abstract compositions of his youth and returned to the human figure. He celebrated craftsmen, manual laborers, and construction workers, delineated by thick, clear-cut outlines, in dignified Post-Cubist paintings based on the three primary colors (blue, yellow, and red).

David Alfaro Siqueiros,
Self-Portrait (El Coronelazo),
1945
Museo Nacional de Arte,
Mexico City

The fundamental theme of
the work of Siqueiros (1898-
1974) is man's role in society
and his struggle for freedom.
Here, during the Mexican
Revolution, the painter
depicts himself as the
demigod of reconstruction.
His language combines
the influence of the Italian
classical and Renaissance
tradition (which he had
studied in Europe) with
Expressionist and Surrealist
elements and ideas, resulting
in dramatic paintings that
had a great visual impact
on the masses.

Renato Guttuso
Crucifixion, 1940-41
Galleria Nazionale d'Arte
Moderna, Rome

With this painting, the Sicilian
painter Renato Guttuso (1912-
1987) takes a resolute stand
against the Fascist regime and
becomes one of the founders
of the artistic movement
Fronte Nuovo delle Arti.
Here, the allusion to Guernica
is quite explicit, including the
horse placed at the center of
the scene.

Dictatorships and Satire

*Very early on, vitriolic caricatures of Hitler
appeared in some works by Grosz and Dix.
Therefore, it is hardly surprising that the
works of the New Objectivity (like those of the
Expressionist movement) were denounced as
"degenerate" and banned by the Nazi regime.
Hundreds of such paintings were burned
publicly in the streets.*
*Fortunately Dix's large painting of the Seven Deadly Sins (a detail
of which is shown on the left) was saved from destruction.*
*Dix completed this work in 1933, the year Hitler came to power in
Germany.*

Pablo Picasso

1937

Guernica

This exceptionally famous work, and treasure of the Centro de Arte Reina Sofia in Madrid, may well be the best-known painting of the twentieth century. The vast canvas (3.45 × 7.70 m) draws its inspiration from a tragic, military event: the bombing of the Basque town of Guernica during the civil war that in 1937 was tearing Spain apart. Remarkable proof of Picasso's brilliant creativity, it was completed in a mere five weeks (1 May-4 June 1937), just in time for the Exposition Universelle in Paris, where it decorated the pavilion of the Spanish Republican government. A series of photographs taken by Dora Maar, with whom Picasso was romantically involved at the time, document the rapid phases of its conception and execution. By reworking some elements of Synthetic Cubism and adapting them to a new historic and artistic context, Picasso composed a vast allegory, charged with meaning and symbolism. In contrast to the propagandistic Realism imposed by the totalitarian regimes, Picasso pushed the image well beyond a pedantic illustration of the actual event, transforming it into a universal condemnation of brutality and violence. To those who questioned him about his political beliefs, the artist responded, "I am on the side of life against death, on the side of peace against war".

The heart-rending figure of the wailing mother with her dead child in her arms is the image *par excellence* of the horror of unbearable grief. In this image, Picasso succeeds in transposing a classical motif from the history of art into a modern key. In addition to recalling the iconography of the Slaughter of the Innocents, Picasso also creates a kind of secular *Pietà*.

The image of the solemn and majestic bull (in the upper left-hand corner of the composition) was repeatedly used by Picasso throughout the 1930s. Here, the quintessential mythic animal appears less devastated than the other figures, and seems to represent the strength and nobility of the Spanish people, who are distraught but not defeated.

Two sources of light, painted very close together, appear in the upper portion of the canvas. These images take the form of a lantern, held by a woman leaning out of a window, and a light bulb. They have been interpreted as representing the light of truth that exposes atrocity.

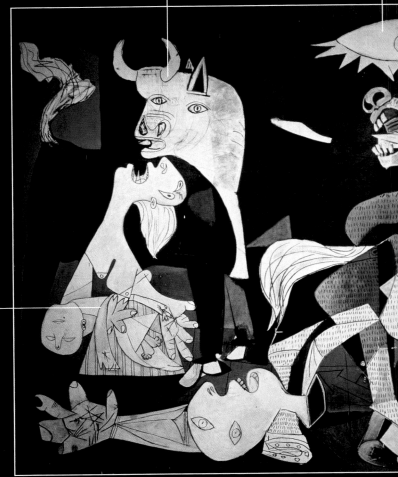

Critics have interpreted the animals and details included in the painting in various ways; indeed, Picasso himself gave several different explanations. The large horse at the center of the scene recalls the horrifying image painted by Picasso four years earlier in *Death of a Torero*, with a terrorized horse impaled on the horns of a bull. Even more than the human figures, this horse has become a symbol of incomprehensible, gratuitous cruelty.

Although Picasso had added a few color highlights in some preliminary sketches, in the final version he kept to rigorous black and white, with a full range of intermediate grays. In this way, he achieved a crisp, incisive effect that may be influenced by the rise of cinema and photography. In fact, it was during the Spanish Civil War that Robert Capa took his memorable photographs.

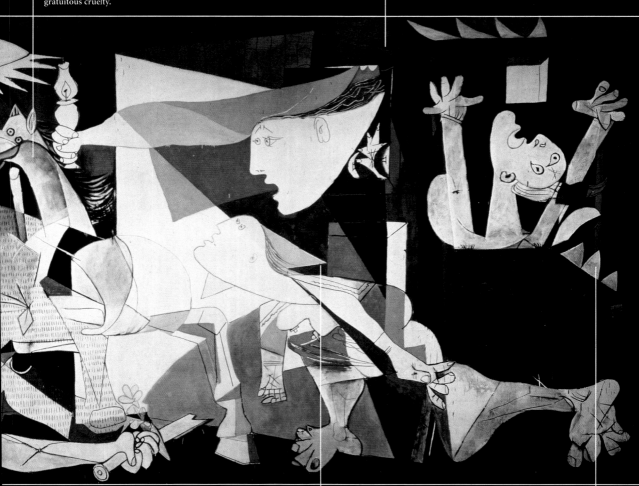

The fallen warrior grasps a broken sword, a weapon that is completely useless in modern warfare. With this image Picasso evokes the memory of Homer's ancient heroes, underscoring once again that war is an evil that has accompanied man through the millennia. A flower seems to have sprung up beside the hand clasping the hilt of the sword. In an early phase of the extraordinarily rapid execution of the painting, this detail was actually the warrior's hand, which Picasso later ingeniously transformed into a new symbol.

All of the figures in *Guernica* are united in a sublime lament that is somewhat reminiscent of Mediterranean funeral rites. On the far right, beside and above the woman with the upraised arms, one can make out the flames of burning houses.

The United States
1913-1940
The American Scene

Grant Wood
Daughters of Revolution, 1932
Museum of Art, Cincinnati

With amusing irony, Wood poses the three women in front of a reproduction of a famous historic painting.

Grant Wood
American Gothic, 1930
Art Institute of Chicago

Wood painted the heart of America, countering the many cityscapes with figures and scenes from the rural Midwest.

From the Armory Show to the New Deal: Faces of Reality
February 17, 1913 is a memorable date in the history of American painting: a vast public exhibition of contemporary art, comprising nearly 1,100 European and American works, was hung in the armory of the 69th infantry regiment in New York City. The Armory Show marks the assertion of independence on the part of American art movements. New York became the cultural center of the United States and a hub of international art. New proposals, groups, and movements rapidly began to develop (the Eight, Urban Realism, Precisionism, etc.), but Realism remained the predominant trend. This style satisfied a desire to document the new American scene, depicting places and characters that served as "icons" of the conflicting relationship between city and country. There was a growing preference for detail, urban views, industrial complexes, and the new machines of technology. The socio-economic crisis of 1929 helped to consolidate the American image. The state needed a type of art that would back its efforts to re-launch the economy and sponsored a vast program, commissioning works and paying artists to decorate post offices, banks, schools, stations, and government buildings. During the New Deal, American painting developed a rapport with the Mexican mural movement, which made it even more independent of European art. Nonetheless, a strong dialogue with Europe resumed in the 1930s, since many artists fled war and despotism seeking refuge in the United States, particularly New York. They joined other European masters who had been living in the States for years. Artists like Grosz, Feininger, Duchamp, Ernst, Miró, and Mondrian helped to make New York a melting pot.

Charles Sheeler
Classical Landscape, 1931
Barney Ebsworth Foundation, Saint Louis

The titles of some paintings reflected an awareness of the autonomy of American art, freed from European models.

Sheeler does not hesitate to describe this landscape of an industrial area with smokestacks and railroad tracks as "classical". Obviously, this "classicism" is completely different from that of the Old World, but it is visible

nonetheless in the fine composition, the confidently executed clear-cut lines, the balanced volumes, and the tonal harmony.

Charles Demuth
I Saw the Figure 5 in Gold,
1928
Metropolitan Museum of Art,
New York

This unusual painting,
which at first appears to be
associated with Futurism,
is actually part of a series of
canvases painted by Demuth
as a figurative tribute to
certain personalities of his
day. The work, inspired by
a poem by William Carlos
Williams, depicts a red fire
engine (clearly marked with
the number five) speeding
through the city during a
downpour, its siren blaring.
Demuth creates an image of
great symbolic power, with
vivid colors and perfectly
integrated letters, numbers,
and words.

George Bellows
Dempsey and Firpo, 1924
Whitney Museum, New York

Continuing a trend that first
appeared in the United States
at the end of the nineteenth
century, Bellows often painted
sporting events, rendering
them as episodes in a modern
epic. One of his favorite
subjects was the boxing
match, particularly the tension
created between the boxers'
violent exertion and the
spectators' wild, sometimes
even savage, expressions.

The United States
1882-1967
Edward Hopper

The "Classic" Master of American Realism

The disenchantment and solitude created by the spaces, light, and silences of provincial America imbue Hopper's canvases with an evocative power that seems to anticipate cinematic scenarios, situations, and characters. After studying in New York, Hopper spent from 1905 to 1910 in Europe completing his figurative studies without, however, establishing any contact with the avant-garde movements. On his return to New York, he devoted himself to engraving, and only between 1924 and 1927 did he paint watercolors and oils. He was an instant success and became the foremost American painter between the Great Depression and the New Deal. The distant horizons of his landscapes, the ordinariness of the offices and hotel rooms, and the alienation of the city at night are all depicted with a still, graphic clarity, while maintaining a sense of elusiveness. Hopper was also a master of composition who calculated the geometry of his scenes— spaces between figures, and angles of light—exploiting these elements as a means of conveying intensely poetic moments.

Edward Hopper
Gas, 1940
Metropolitan Museum
of Art, New York

A lonely, remote atmosphere pervades Hopper's landscapes, that are generally anonymous views, not linked to any precise geographic location.

Edward Hopper
Hotel Room, 1931
Thyssen-Bornemisza Collection, Madrid

Hopper was attracted to hotel rooms, where faces, presences, and emotions are constantly changing. One immediately feels the contrast between the functional, monotonous, and utterly impersonal setting, and the woman who brings it temporarily to life. Hopper contrasts the "nameless" environment with the unopened suitcases that bear the owner's nametag.

Edward Hopper
Office at Night, 1940
Walker Art Center,
Minneapolis

Edward Hopper
The Lighthouse at Two Lights,
1929
Metropolitan Museum of Art,
New York

This painting reveals the
European influences (silent,
still Metaphysical Painting
and German Realism) on
which Hopper based his own
unique interpretation
of the world.

Edward Hopper

1942

Nighthawks

Housed in the Art Institute of Chicago, *Nighthawks*
is perhaps the most famous of Hopper's extraordinary
images of urban isolation. The painter himself
described the origins of this work: "I got the idea
from a restaurant on a corner of Greenwich Avenue.
I simplified the scene and enlarged the diner.
My unconscious probably saw the solitude of the big
city in there."
Clearly inspired by cinema in his use of lighting and
the particular angle he has chosen, Hopper evokes a
situation reminiscent of Hemingway's short stories.
He does not give us a plot, however, but rather captures
a single frame, an isolated scene, that leaves the viewer
to invent a story line.

Through the darkened windows
of an anonymous storefront
(there is no way of knowing
what it sells), one can just make
out a cash register, a silent but
meaningful symbol of money's
dominant and indispensable role
in modern society.

The feeling of incommunicability
and distance conveyed by the
contrasting light and dark of the
unlit shop windows and the harsh,
artificial light of the diner, is a
motif that Hopper reinterpreted
from Metaphysical Painting.

A fairly subtle but very
important detail is the series
of round stools at the
counter. These empty stools
wait for other customers,
other stories, and other
secrets to emerge from the
night. They also embody
what is probably the most
bitter aspect of Hopper's
urban scenes: the chance
encounters, the fleeting
contacts, and the hidden
recesses of private lives, all set
in anonymous, monotonous,
soulless contexts.

The wide, deserted sidewalk
makes the scene strangely
unbalanced, with all of the
figures pushed to the right of
the composition, in the shelter
of the all-night diner, while
the ample stretch of "empty"
street conveys a sense of
loneliness and uneasiness.

The mysterious character seen from behind with his hat pulled down seems to be staring into the glass in his hand, lost in thought. He resembles the classic Hollywood stereotype of the "stranger".

The customers on the far side of the counter also inevitably recall images from American cinema of the period: the woman is checking her nail polish, while the man with a cigarette is staring into space. The hands of the two figures are almost touching, but Hopper gives no clue as to whether or not this contact is intentional.

The barman is the only character who shows any vitality at all, although one has the impression that this is the result of a mechanical, "professional" habit, rather than any real desire for human contact.

New York
1912-1956
Jackson Pollock

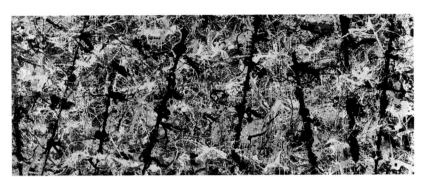

Jackson Pollock
Blue Posts, 1952
Heller Collection, New York

The "posts" are represented by the oblique rhythmic element that divides the surface of the canvas at regular intervals, creating a cadence that is also played out through the apparently improvised sign.

All the Energy of the New World Breaks with a Thousand-Year-Old Tradition

The history of art usually advances in gradual stages. It can happen, however, that the creativity of an individual master succeeds in "breaking the rhythm", producing unforeseen, violent leaps. Jackson Pollock was undoubtedly one of these "revolutionary" painters. Every now and then in his paintings, which are often very large, one can identify the influence of other twentieth-century masters, but there is no question that, all in all, Pollock's explosive entrance onto the international painting scene led to a crucial break with tradition. Pollock attributed extreme importance to the role of chance. Using his "drip" technique, he freely splashed paint (or even poured whole cans) onto the canvas, which was stretched out on the floor. Aspects of Pollock's life seem to be taken from a novel, for instance, he grew up with the Navajo Indians and their ritual drawings sketched in the sand left a lasting impression on him. He arrived in New York in 1929, the year of the Stock Market Crash. Here he came into contact with European art and his particular admiration for Miró's freedom of expression led him to move in the direction of Abstract Art. His direct knowledge of tribal and "primitive" art encouraged him to ascribe symbolic significance even to the very act of painting. His way of working, with its extremely powerful physical and gestural component, became known as "action painting", and was characterized by a kind of "dance" around the canvas laid out on the floor. Thus Pollock became one of the founding fathers of Abstract Expressionism and anticipated the concept of performance art. Followed by other painters of the so-called New York School, Pollock held that the movements made by the artist while working are an integral part of painting. Thus, gesture and action become crucial in the making of art.

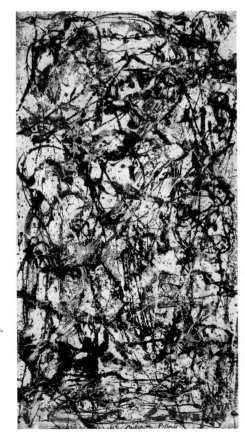

Jackson Pollock
Enchanted Forest, 1947
Peggy Guggenheim Collection, Venice

Pollock's paintings in Palazzo Venier dei Leoni, facing the Grand Canal in Venice, were personally commissioned by the great collector Peggy Guggenheim, who was truly responsible for recognizing the painter's singular talent.

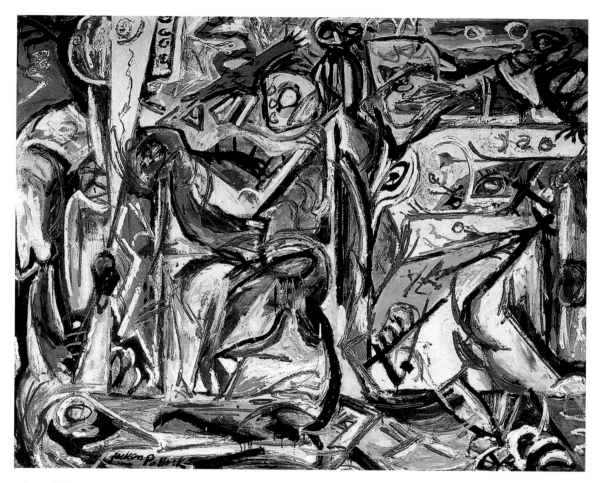

Jackson Pollock
Circumcision, 1947
Peggy Guggenheim Collection,
Venice

Thanks primarily to his most
expressive paintings, Pollock's
example attracted many
followers. Other Abstract
Expressionist artists, including
William De Kooning, Sam
Francis, and Franz Kline,
were inspired by his concept
of action painting.

Informel (Abstract Expressionism)

The Sign, the Gesture, the Material

The term *Informel* includes a series of artistic experimentations happening in Europe and the United States between World War II and the 1960s. *Informel* is the expression of a climate of distrust in rational, cognitive values. It has a powerful irrational element that is manifested in painting as an absolute rejection of form and the pictorial surface, which is at times subjected to violence (slashed, torn, and burned). The traditional means of expression are also deprived of their significance, leaving room for the artist to explore new possibilities and discover new materials. *Informel* evolved simultaneously in Europe and the United States, though with conspicuous differences. In the States, it was represented by the New York School, where the gestural component (action painting) predominated in artists like Jackson Pollock, William De Kooning, Sam Francis, and Franz Kline, although other painters (Rothko and Albers) also produced meditations on color. In Europe, *Informel* was not as sensational or radical as its American counterpart. It was still influenced by movements of the previous decades, such as Surrealist Automatism—especially as regards color and gesture—and the chromatic energy of Expressionism. Most of the works of *Informel* are based on an exploration of the sign (Tapies, Fautrier, and Dubuffet) or materials (Klein and Burri).

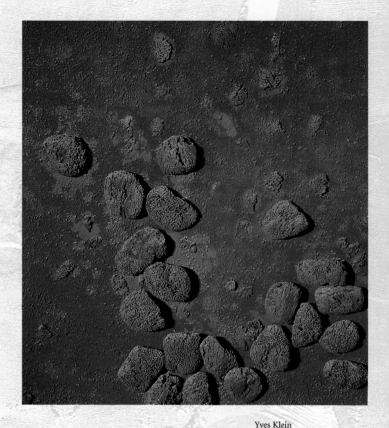

Yves Klein
Blue Sponge Relief, 1958
Ludwig Museum, Cologne

Klein (1928-1972) was a painter, sculptor, musician, and theorist of the "evolution of art toward the immaterial". From 1955 on, he used the unmistakable sponges uniformly soaked in blue to create what he described as "landscapes of freedom".

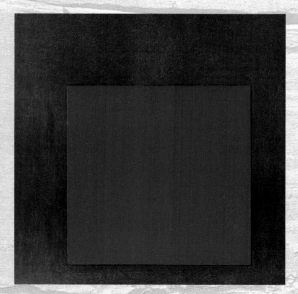

Josef Albers
Homage to the Square, 1958
Sidney Janis Gallery,
New York

Albers (1888-1976) was born in Germany, worked at the Bauhaus, and then moved to the United States in 1932. He was a great expert of perception, the chromatic scale, and the interaction of colors. His works were often conceived in cycles, as a sequence of variations and possibilities.

Mark Rothko
No. 19, 1960
Private Collection

Rothko (1903-1970)
was born in Estonia
(his original surname
was Rotchkowitz), but he
emigrated to the United States
at the age of ten. He painted
large canvases covered with
dense fields of color, arranged
according to a rigorous
geometric order, yet
nonetheless charged with an
exceptional expressive power.
The leading exponent of
Color-Field Abstraction, he is
diametrically opposed to
Pollock's action painting.

Lucio Fontana
Spatial Concept. Expectations,
1962
Private Collection

The "slashes" Fontana
(1899-1968) inflicts on the
monochrome canvas are one
of the most characteristic,
violent "gestures" of
European *Informel*.

Alberto Burri
Red Plastic, 1964
Palazzo Albizzini Foundation,
Città di Castello (Perugia)

Burri (1915-97) used old torn
and patched jute sacks and
scrap material that he then
burned, sewed, or painted.

Manzoni and the "Artist's Shit"

*Provocative and blasphemous, while at
the same time amusing and ironic, Piero
Manzoni's work represents a profound
reflection on the very nature of art.
Having achieved acclaim while still
quite young (he died in 1963 at the age
of twenty-nine), Manzoni clearly recog-
nized the crisis art had passed through*
in the 1950s as well as the precariousness of success. With a
sharp polemical instinct, which surfaced however from a
deeper malaise, Manzoni showed that "everything" an artist
produces can be considered "art" and placed on the market
(where prices were soaring). Thus, in a number of historic
performances, he signed his name directly on the visitor's
arm, made his thumbprint on hard-boiled eggs, and blew up
balloons to create "bodies of air". He pushed this kind of
provocation to the extreme by canning "artist's shit", complete
with a certificate of guarantee, and selling it, literally, for its
weight in gold.

The United States
1958-1968
Pop Art

Against the Casual, Predictable Banality of Everyday Life
The term Pop Art is an abbreviation of the expression "popular art", to be understood here in the sense of consumer art for the general public. This movement, which burst onto the scene at the beginning of the 1960s, draws inspiration from the world of mass communication. The language of advertising steps out of television, billboards, and comic strips to assume its own intrinsic validity as a form of expression. Images of celebrities (which have since become legendary) and objects from daily life (Coca-Cola bottles and soup cans) were reproduced, almost desperately, in mass quantities. These images became part of a new artistic language, depicting a depersonalized world, dominated by consumer goods, but with a subtle vein of irony. The artists reproduced aspects of everyday life devoid of emotion, coldly and somewhat obsessively. The images themselves lose their meaning and become merely signs of the world of consumerism in which we live.

Although Pop Art originated in London with painters like Richard Hamilton (1922) and Allen Jones (1937), it developed mainly in the United States, thanks to artists like Andy Warhol (1930-1987), Roy Lichtenstein (1923), and Claes Oldenburg (1929). Warhol, the most eccentric and radical among them, manipulated and distorted images from the mass media, reworking them against colored backgrounds to "cool them down", and remove all emotional content. Lichtenstein, on the other hand, took the technique of comic strips and applied it to the canvas, working on a large-scale so that the painting resembles a photographic enlargement. Oldenburg proposed commonplace objects made out of unexpected materials, thus creating an amusing ambiguity. Pop Art foreshadowed the cultural watershed of 1968, which, however, also marked the end of the movement.

Robert Rauschenberg
Spot, 1963
Staatsgalerie, Stuttgart

Rauschenberg is only partially linked to Pop Art in his use of fragments of commonplace images, decontextualized, and arranged on the canvas in an idiosyncratic way. He took up and personalized a number of trends from American art of the second half of the twentieth century. Born in Texas in 1925, during the 1950s he evolved a technique called "combine painting", a loose blend of Abstract Expressionism, drip technique, and collage with different objects and materials.

Jasper Johns
Three Flags, 1958
Barton Tremaine Collection, Connecticut

Johns was born in 1930. He and Rauschenberg founded the Neo-Dada movement in 1954, which is considered the immediate precursor of Pop Art. The themes of the flag and the United States recur obsessively in his work.

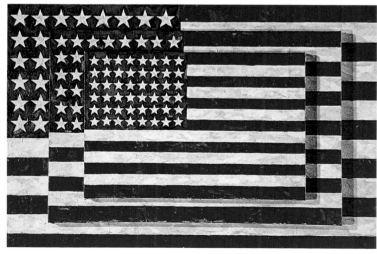

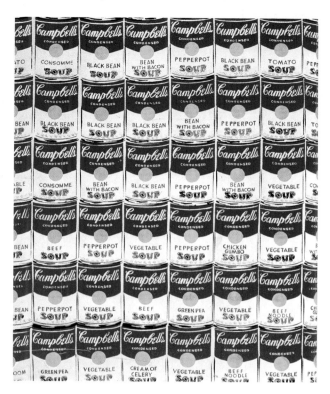

Andy Warhol
Campbell's Soup Cans, 1962
Kikimo and John Powers
Collection, Colorado

Warhol organized his first solo show at the Ferus Gallery in Los Angeles in 1962. During this period, there were thirty different kinds of the popular Campbell's canned soups on sale in major supermarkets. Warhol took his cue from this number and painted a can of soup thirty times, as an image of the obsessive repetition of the product and its promotion in consumer society. Fully aware of what he was doing, Warhol proceeded to transform his own work into a mass-produced product. In 1965 he executed a series of canvases in which these same soup cans appeared in different shades of color.

Roy Lichtenstein
We Rose up Slowly, 1964
Museum für moderne Kunst, Frankfurt

A comparison of this work with Warhol's *Campbell's Soup Cans* indicates the technical and expressive variety of Pop Art. By duplicating an object, Warhol stripped the object of its meaning. Lichtenstein obtained the same effect by enlarging images taken from comic strips in an ironic commentary on contemporary life. Lichtenstein's works are not actual photographic enlargements of comic strips. Rather, they are reproductions on canvas of an image produced with an imitation typographic half-tone screen—a perforated grid through which the paint is applied to obtain the effect of a printed reproduction.

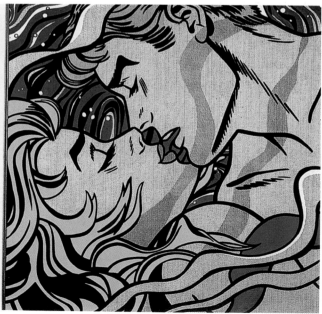

Andy Warhol

Twenty-five Colored Marilyns, 1962
Marilyn, 1967

The *Marilyn* series, which Warhol began shortly after the Hollywood star committed suicide in August 1962, has become one of the most important cult-images of recent decades. For Warhol, Marilyn Monroe was the perfect symbol of the stereotyped creation of a legend, but also of the dramatic decline of a celebrity. The artist fixes this idolized actress and suffering woman in a typical expression, intentionally poster-like or reminiscent of a movie. Here, the human dimension is eliminated by advertising's relentless need for schematic simplification, whereby Marilyn always "had to" look pert and seductive.

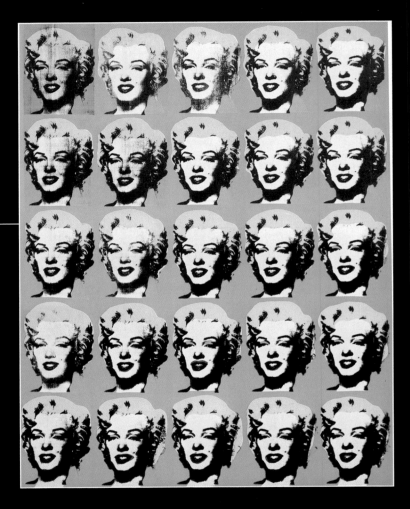

Housed in the Modern Art Museum in Fort Worth, Texas, the panel with *Twenty-Five Colored Marilyns* is one of Warhol's first paintings of the actress. Warhol's obsessive repetition of his subjects (Coca-Cola bottles, Campbell's soup cans, and the series of Mona Lisas with the mocking title *Thirty is Better than One*) is typical of his work. The effect is like that obtained by mechanically repeating the same word: it gradually loses its meaning and becomes merely an empty container. By transferring a publicity photo of the actress onto canvas and using silkscreen, Warhol transformed the real-life, unhappy Marilyn, who constantly suffered the conflict between her public image and her tormented private life, into a radiant but vacuous icon, with a slightly absent expression. Her hair, eyes, and mouth are highlighted with touches of color that do not fit perfectly within the contours, further accentuating the image's sense of artificiality.

Warhol continued to focus on the image of Marilyn in subsequent years, as can be seen in this painting from 1967. His other portraits of celebrities, elaborated from photographs or posters, include Elvis Presley, Liz Taylor, Jacqueline Kennedy, and Chairman Mao. Warhol's fondness for chromatic changes and superimposed transparencies is a legacy from his early days in New York as a graphic artist. He was aware of the commercial misinterpretation at the heart of Pop Art's success. In the very act of recognizing and calling attention to an "image/symbol" of mass consumption, Warhol in turn helped to reinforce these legends, becoming an accomplice to the same consumerism he was supposedly condemning. Later, Warhol created The Factory—a group of assistants—in order to keep up with the frenetic pace of his images and creative performances. Their experience in his studio made a crucial impact on many artists of the younger generation.

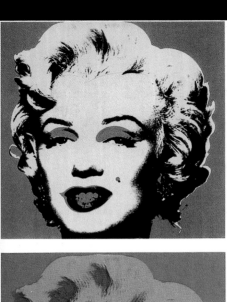
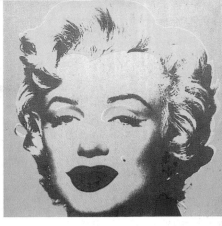
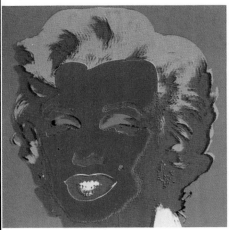
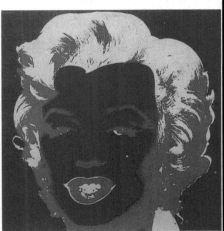
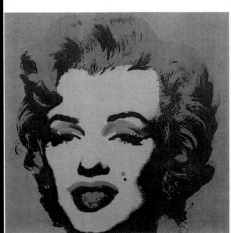
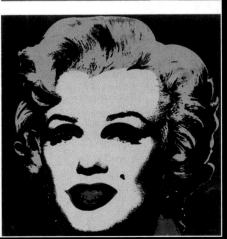

London
1909-1992
Francis Bacon

"There is no tension in a painting if there is no struggle with the object"

Despite the fact that he was born in Dublin and died in Madrid, Bacon is the foremost English painter of the twentieth century. His bitter, disquieting work, with its heavily autobiographic component, has become an international reference point for the second half of the twentieth century, representing a decisive moment in the evolution of the "new figuration"—an alternative to *Informel* and Abstract Art, parallel to the sculpture of Henry Moore.

Bacon's career began late, during the war years, since the artist himself destroyed almost everything he had produced prior to that time. In his shocking triptych *Three Studies for Figures at the Base of a Crucifixion* (1944, Tate Gallery, London), Bacon reveals his plan of action with great determination. In focusing almost exclusively on portraits and the human figure, he took up the motifs and models of "classical" painting and re-invented them in the light of the individual and collective tragedies and horrors of the twentieth century. His sources vary widely, extending well beyond the traditional ones. On the one hand, Bacon created his own profound, carefully chosen artistic background. He studied and reworked Grünewald, Titian, Velázquez, Van Gogh, Picasso, the Expressionist masters, and even torsos and fragments from classical antiquity, giving his own very personal interpretation of the history of art. On the other hand, he drew on completely eccentric figurative sources, including the "expressionist" and surreal cinema of Eisenstein, von Stroheim, and Buñuel, the photographic experiments of Muybridge, x-rays, anatomical reports, and medical texts concerning odontological and maxillofacial pathologies and mutilations. Over it all hangs his unresolved problem with the body, sexuality, and the nude. The result is an anguished, painful vision of contemporary man, lacerated and de-boned, defenseless against the devastating decay that envelops, distorts, and disfigures him. Bacon's subjects (including his model and partner George Dyer) have become the very symbol of the anxiety of modern man, victim of a society that wears him down, tears him apart, and then discards him. This feeling is often exacerbated by the claustrophobic settings of many of his paintings, with their mirrors, curving walls, and disfigured faces peering out from panels, while the main figure seems to be displayed within a kind of circus ring. Bacon's work can also be interpreted as a form of Romanticism taken to the extreme, in the light of the artist's dramatic personal involvement and uneasy, disturbing contemplation of pain, death and the absolute.

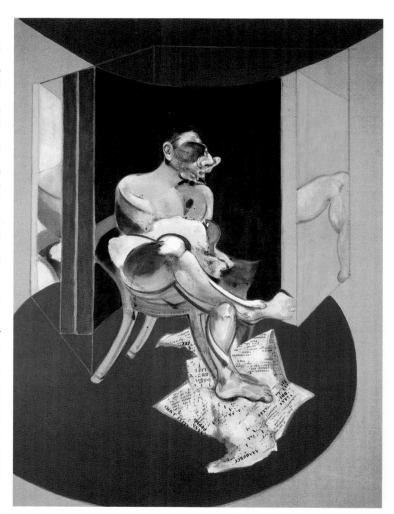

Francis Bacon
*Study for a Portrait
of George Dyer,* 1971
Private Collection

Bacon's model and partner is a focal point of the painter's production. Here he is seen seated between two mirrors that close him in, partially reflecting his image. The use of the mirror is a technical device from Renaissance painting that allows the artist to show the figure from different angles. For Bacon, however, the mirror is a chance to display the even more splintered and decomposed "other face". The setting is deliberately bare, neutral, and minimal. A circle of light, like a theater spotlight, illuminates and isolates the figure.

Francis Bacon
May-June Triptych,
(central panel), 1974
Private Collection

Bacon used the triptych
format frequently, taking

advantage of the three-part
sequence to develop the
dramatic intrigue of the image.
The central figure is an
allusion to the *Belvedere Torso*.

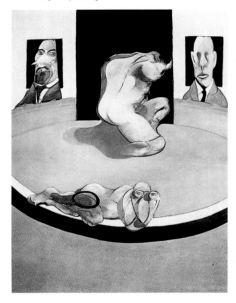

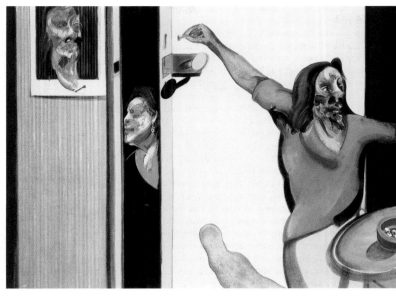

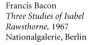

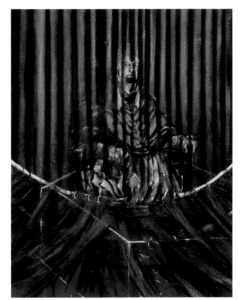

Francis Bacon
*Study after Velázquez's Portrait
of Pope Innocent X*, 1950
Tony Shafrazi Gallery,
New York

Beginning in 1933, when
Bacon first reinterpreted
Grünewald's *Crucifixion*,
the artist reworked the great
masterpieces of the past.
His series of eight canvases
based on Velázquez's painting
shows the gradual distortion
of the original model.
The chair has become a cage
imprisoning the figure,
whose hands spasmodically
grip its arms, his face
contorted into a mask of
agony and his mouth wide
open in a scream worthy
of Munch.

Francis Bacon
*Three Studies of Isabel
Rawsthorne*, 1967
Nationalgalerie, Berlin

Aside from the virtuoso
painting itself, Bacon here
expresses a fine interplay
of doubts and allusions to
the ever-relevant theme of
"to be or not to be", reality
and image.

Velázquez through the Centuries

*Few artists have enjoyed as much posthu-
mous "success" as Velázquez. Many nine-
teenth- and twentieth-century painters (from
Goya and Manet to Bacon and Picasso) have
explicitly cited his work. At times, the original
paintings have been analyzed with almost
fanatic attention, as in the case of the many
variations of* Las Meninas *produced by
Picasso. Bacon, however, is an exception. His derivations of the
portrait of Pope Innocent X were executed exclusively from a pho-
tograph. The painter never wanted to see the original, which hangs
in the Galleria Doria Pamphilij in Rome.*

Germany
1970-2000
The Return of Expressionism

Tension and Provocation in the Midst of Historic Traditions, the Berlin Wall and the Power of Images

Beginning in the 1960s, the controversial figure of Joseph Beuys (1921-1986) exerted a great influence on German art. An artist who cannot be easily classified, Beuys undermined the very foundations of the whole system of the arts, appearing in countless celebrated happenings and going back to ground zero to establish a new point of departure. Through Beuys' explorations, Germany reacquired a precise artistic identity, one that was painfully affected by presence of the Berlin Wall, which did not only separate East and West Germany physically, but also culturally, even in the field of painting. This division continued until its symbolic fall in 1989. After the terrible trauma of the war, German painting resumed the movement that had been broken off by Hitler, and returned to the "degenerate" art of Expressionism, in an updated and even more dramatic version. Within the international context, German painting re-launched the communicative power of color, with an aggressiveness and determination whose roots reach back beyond the avant-garde movements of the early twentieth century to the truly German tradition of charging the image with great emotional power.

Georg Baselitz
Head of Tears, 1986
Private Collection

Baselitz was born in Saxony in 1938, in a town whose name he adopted (in fact, his true name is Hans Georg Kern). From the beginning, he expressed a Neo-Expressionist tendency, defying scandal with violent manifestos and works branded as pornographic, for which he was charged for obscenity. In 1969, Baselitz entered a more controlled phase and painted his first upside-down canvas, which became the rule for all his subsequent work. In this way, the painter sought to accentuate the illusory nature of the image and the value of the painting as a colored surface, with no distinction between figurative and abstract.

Dieter Krieg
Untitled, 1984
Museum für moderne Kunst, Frankfurt

Krieg is one of the leading exponents of the *Neue Wilden* (New Wild Ones) group, which formed in Berlin in 1977. Unlike its other members who were more interested in individual representations, Krieg fits into the tradition of Abstract Expressionism.

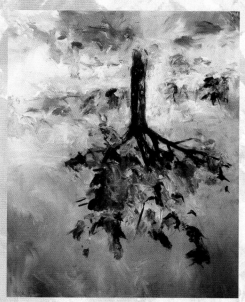

Georg Baselitz
Apple Tree, 1971-73
Jung Collection, Aachen

"The truth is the painting,
but it certainly is not <u>in</u> the
painting". With these words,
Baselitz stressed the ambiguity
of his upside-down
canvases—real and concrete
objects in and of themselves,
not merely with regard
to what they represent.
There are, nonetheless,
moments of great poetry.
Even in this paradoxical
situation where branches
grow down, the tones and
freshness of nature are
magically evoked with
skillful touches of color.

Anselm Kiefer
Interior, 1981
Stedelijk Museum, Amsterdam

Kiefer studied under Beuys
in Düsseldorf. He uses both
conventional techniques and
collages of different materials
to consciously explore the
traditions, mythic figures,
and history of Germany,
invariably filtered through
Expressionism. Here, the
empty, imposing interior
looms threateningly over
the viewer.

London

Born in 1922 and in 1937

Lucian Freud and David Hockney

Figurative Developments in England

Twentieth-century English painting featured many outstanding personalities. It was, in fact, a rich, independent field of research that split off from the dynamics of the continental avant-garde movements to produce highly original works. One needs only to think of Ben Nicholson's abstract experiments and of Graham Sutherland's transposition of plant growth into painting in the period of World War II. Then, from the 1950s on, thanks to the influence of Bacon, English painting maintained a strong interest in the figure. In recent years, two major artists have been working in this field. Lucian Freud, grandson of the father of psychoanalysis, was born in Berlin, but emigrated to England at the age of thirteen to escape from the Nazi racial laws. His work is characterized by a lonely, lucid, incisive, and meticulous form of Expressionism. David Hockney, on the other hand, moved on from Abstract Art in 1961 to establish an intense dialogue with American art, and with Pop Art.

Lucian Freud
Two Plants, 1977-80
Tate Gallery, London

Freud's favorite subject is the human figure, but his not infrequent "genre" paintings (cityscapes, still lifes) are evidence of an impressive mastery of the pictorial media. His meticulous precision produces disturbing effects.

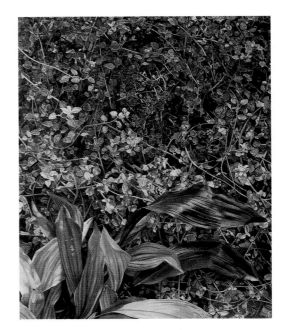

Lucian Freud
Back View of Nude (Leigh), 1991-92
Metropolitan Museum of Art,
New York

Freud's pitiless, unconventional nudes are still shocking. Some of his exhibits have even been banned to minors.

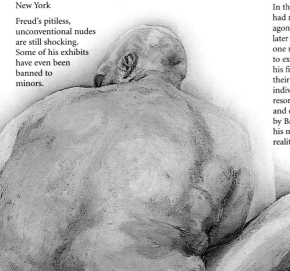

Lucian Freud
Hotel Room, 1954
Beaverbrook Art Gallery,
Fredericton (New Brunswick, Canada)

In the 1950s, Freud's style had not yet reached the agonizing intensity of his later work. Nonetheless, one notes his tendency to explore the soul of his figures and to capture their naked, painful individuality. Without resorting to the deformity and distortion employed by Bacon, Freud still shares his merciless vision of reality and sexuality.

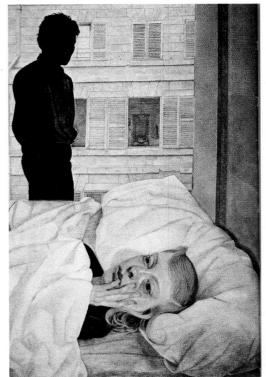

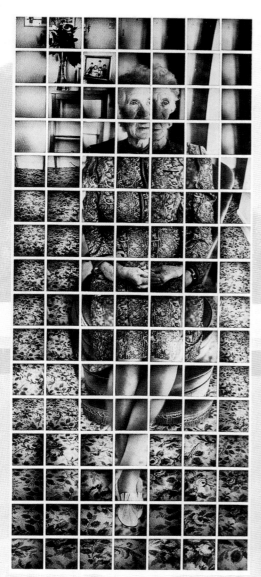

David Hockney
*My Mother, Bradford, Yorkshire,
4th May 1982*, 1982
Collection of the Artist

As with many other
contemporary American
and European painters,
photography has played a
pivotal role in Hockney's
work, thanks to the capacity
to decompose, modify, and
explore the subject. Even the
title of the painting indicates
a precise place and date, typical
of photographs arranged in
order in an album.

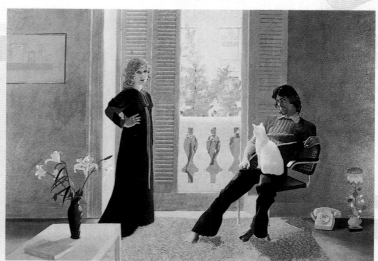

David Hockney
Mr. and Mrs. Clark and Percy,
1970-71
Tate Gallery, London

Hockney's trip to California in
1964 marked a crucial turning
point in his career and artistic
style. It was then that he began
painting with acrylics, which
give a particular "plasticized"
patina to some of his works.
He was also so struck by
the many swimming pools at
the large Californian homes
that they became one of his
favorite subjects (a version
from 1971, from a private
collection, appears in the
background on this page).
This portrait of Ossie Clark
and Celia Birtwell, celebrities
in the fashion world, is a
typical example of Hockney's
incisive depiction of reality.
Its impact recalls Hyper
Realism in the United States,
where the extreme precision
itself makes the work
appear artificial.

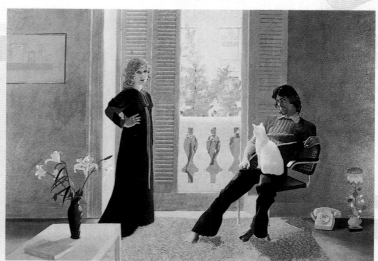

Germany, Italy
1970-2000
A Return to the Figurative

The *Transavanguardia*, Experimentation with Photography, the Interplay of Past and Present Images

The Venice Biennale and Kassel Documenta, the two major European contemporary art shows, have evidenced the polarization of international trends in painting in the last few decades, including the split between figurative and abstract, traditional materials and new means of expression. At the 1980 Biennale, art critic Achille Bonito Oliva singled out a group of Italian figurative painters (Chia, Clemente, Cucchi, Paladino, and De Maria) who all tended to use more or less traditional painting techniques, and named their movement *Transavanguardia*. They are one of the most recognizable manifestations of the renewed interest in figurative painting, which appeared (reinterpreted from a contemporary perspective) after the "crises" of the 1960s and 1970s, and also developed in other countries, including Great Britain and Germany. The main "historic" reference is still Surrealism, which has proven an inexhaustible source of symbols, figures, and themes.

Hermann Albert
Man with a Mirror, 1982
Private Collection

The recent figurative currents often use traditional objects and references. The mirror is a magic instrument *par excellence*, representing the borderline between image and reality.

Mimmo Paladino (1948)
The King, 1980
Private Collection

Paladino began his artistic career in photography but turned to abstract painting in the 1970s. His "conversion" to the figurative occurred in 1976 and became official at the 1980 Venice Biennale, when he was identified as a member of the *Transavanguardia* group. From then on, he has focused on the human figure, sometimes in large-format paintings.

The Ambiguous Pleasure of the Citation

Citationism must also be included in the neo-fig-urative movements. This is a trend based on the revival of intentionally "high-culture" painting of impeccable formal precision, filled with allu-sions to classical art. This current represents an explicit, and in part polemical, response to the supposed "death of art" foretold by critics and the public after Informel. *It may also be considered the academic artists' ironic revenge on the annoying comment, "I could have done this myself!" so often made by spectators on seeing contemporary artworks. Carlo Maria Mariani is one of the most rep-resentative exponents of this trend. His work is influenced by Escher's graphic puzzles, American Precisionism of the 1930s, the dreamlike, figurative lyricism of Balthus, Magritte, and Dalí, de Chirico's Metaphysical Painting, continuing back to Neoclassicism and beyond. Surprisingly, these many allusions to earlier art, rather than conveying a sense of traditional serenity, produce a disturbing effect, by creating a feeling of timelessness and making it almost impossible to under-stand the painting's true meaning. Is it a dream? A nightmare? Or simply a demonstration of the painter's skill? The title of this painting from 1983* (The Hand that Obeys the Intellect) *recalls a crucial line from a famous poem by Michelangelo, where he writes that the "hand" of the artist is nothing but an instrument of the mind. Mariani's painting portrays two identical figures "painting" each other, thus making it impossible to distinguish between the "subject" and the "object" in art.*

Gerhard Richter
Erna Descending the Stairs,
1966
Museum Ludwig, Cologne

Richter (1932), a leading figure in the art world of recent decades, was born and trained in Dresden, and taught at the Düsseldorf academy from 1971 to 1994. He is a versatile artist who has pursued an unusually rich creative career, full of surprising variations in style. In 1964, he described himself as the German exponent of Pop Art. He has compiled a personal archive with thousands of photographs of countless different subjects from numerous sources. Working from impressions and memories, he has created what he calls *Fotobilder* (photopaintings), a "European" and somewhat *intimiste* response to Warhol's silk-screen works depicting the icons and images of contemporary society.

New York
1958-1990 1960-1988
Keith Haring and Jean-Michel Basquiat

Urban Graffiti: From Provocation to the Museum

Sharing the tragic destiny of the *peintres maudits* (Haring died of AIDS at 34 and Basquiat of an overdose at only 28), these two acclaimed graffiti artists transformed a gesture that had been an assault on the urban landscape into a new genre of art. Haring had the most classical training of the two. After attending the School of Visual Arts in New York, he became an extraordinary creator of characters, such as the famous "radiant child", who swarmed through his generally, playful cartoon-like work. His creativity (also cleverly employed in advertising graphics) expressed itself in a great variety of materials, in a race to rival television in the non-stop merry-go-round of images. The work of Basquiat, son of a Haitian father and Puerto Rican mother, is a far less whimsical expression of the hardship of the urban multi-ethnic ghettos of New York. He is also known by his "tag" SAMO, the name he used to sign graffiti pieces he spray-painted in the subway stations of New York. "Discovered" by Andy Warhol, Basquiat recuperated primitive images, painted in an instinctive, aggressive style, which hid a growing sense of desperation.

Keith Haring
Untitled, 1981
Property of the Artist,
New York

Haring belongs to the new generation of Pop Art, reinterpreted and renovated from a novel perspective. Today, he is one of the most well-known artists, whose work continues to be increasingly in demand on the art market. It is important to remember, however, that his early works were intended as an indictment, in defiance of museum and gallery exhibits. Nonetheless, his large figures painted on New York billboards continue to be widely acclaimed, despite their being short-lived. Once again, as has happened repeatedly throughout the history of art, a "rebel" style has been assimilated and absorbed into the "system".

Keith Haring
Self-Portrait, 7 November 1985
Private Collection, Milan

Haring was an artist with an unusually keen self-awareness. He portrayed himself as an inexhaustible creator of images, with their unmistakable clear-cut outlines, lack of depth, and dynamism typical of comic strips. Suffering from AIDS, Haring devoted the last few years of his life and career to raising young peoples' consciousness of the dangers of infection.

364

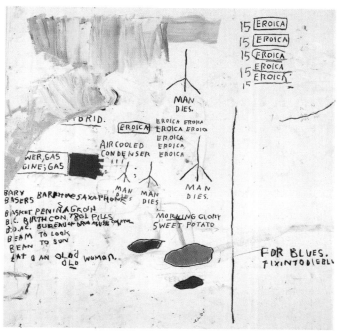

Jean-Michel Basquiat
Tabac, 1984
Bruno Bischofberger Gallery
Collection, Zurich

Basquiat was far less
influenced by advertising
imagery than Haring.
Yet, he was well aware of
the visual "totems" that weigh
so heavily on the urban
landscape, and which are
so overworked they have
become worn-out and
stripped of meaning,
like this striking death mask.

Jean-Michel Basquiat
Eroica I, 1988
Private Collection

This truly dramatic work,
painted the same year
Basquiat died of a drug
overdose, resembles a kind
of confused, anguished

spiritual testament.
The artist superimposes
writing and painting,
pitted against each other.
The dramatic interplay
of contrasts traverses the
overlaid images, the parody
of a song (on the far right),

and simple wordplay,
similar to the text of a rap
song, finally becoming
concrete in the anguished
conflict between the words
"Eroica" and "man dies".

Jean-Michel Basquiat
Self-Portrait, 1982
Private Collection

In this large-format painting,
executed in a combination of
spray paint and oils, Basquiat
portrayed himself as a tribal
warrior brandishing a
weapon. The distortion of
the figure's enlarged eyes,
teeth, hands, and feet, recalls
ethnic art. The background,
however, reveals the artist's
familiarity with the masters
of twentieth-century
American art, like Pollock,
Rauschenberg, and Twombly.

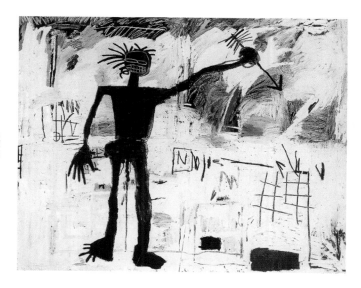

Meridians

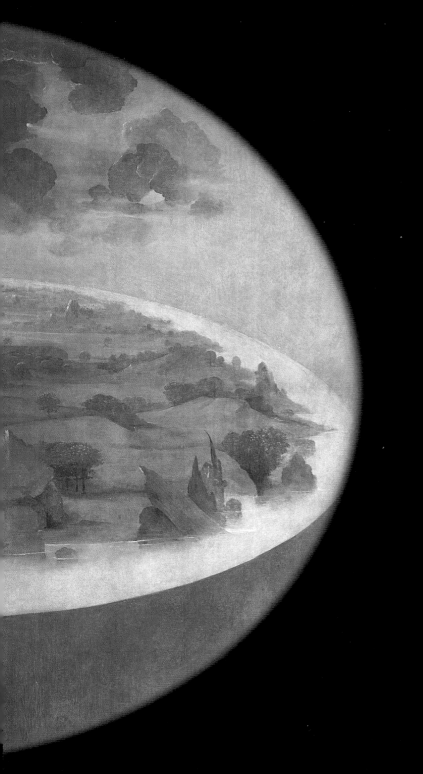

Parallels

Historic Tables: from 1410 to 1475

Limbourg Brothers
Astrological Man, illuminated page
from the *Très Riches Heures du
Duc de Berry*, 1410-16
Musée Condé, Chantilly

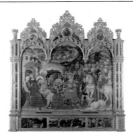

Gentile da Fabriano
Adoration of the Magi, 1423
Galleria degli Uffizi, Florence

Masaccio
*Expulsion from the Garden
of Eden*, 1424-25
Brancacci Chapel, Santa Maria
del Carmine, Florence

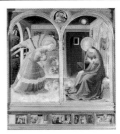

Fra Angelico
Annunciation, c. 1430
Sanctuary of Santa Maria
delle Grazie,
San Giovanni Valdarno

Konrad Witz
The Miraculous Draught of Fishes,
panel of the St. Peter Altar for the
Geneva Cathedral, 1444
Musée d'Art et d'Histoire, Geneva

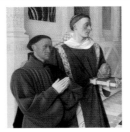

Jean Fouquet
Étienne Chevalier with St. Stephen,
c. 1450
Staatliche Museen
Gemäldegalerie, Berlin

Enguerrand Quarton
Avignon Pietà, c. 1453
Louvre, Paris

Nuño Gonçalves
Polyptych of St. Vincent,
c. 1460
Museu Nacional de Arte
Antiga, Lisbon

Bartolomé Bermejo
St. Dominic of Silos, 1477
Prado, Madrid

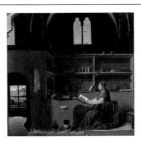

Antonello da Messina
St. Jerome in his Study, c. 1475
National Gallery, London

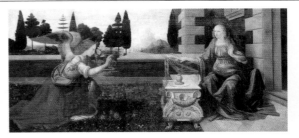

Leonardo da Vinci
Annunciation, c. 1474
Galleria degli Uffizi, Florence

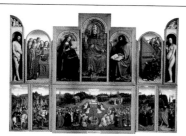

Hubert and Jan van Eyck
Polyptych of the *Adoration of the Lamb*, 1426-32
Cathedral of St. Bavon, Ghent

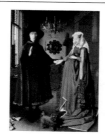

Jan van Eyck
Portrait of Giovanni Arnolfini and his Wife (The Arnolfini Portrait), 1434
National Gallery, London

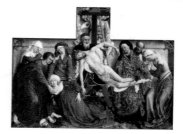

Rogier van der Weyden
Deposition, 1430-35
Prado, Madrid

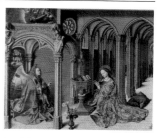

Barthélemy d'Eyck
Annunciation, 1443-45
Sainte-Marie-Madeleine, Aix-en-Provence

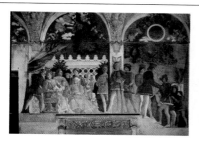

Andrea Mantegna
The Court of Ludovico Gonzaga, 1465-74
Palazzo Ducale, Mantua

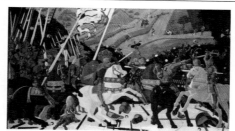

Paolo Uccello
Battle of San Romano, 1465
National Gallery, London

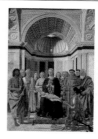

Piero della Francesca
Montefeltro Altarpiece (Brera Madonna), 1472-74
Pinacoteca di Brera, Milan

Martin Schongauer
Virgin in the Rose Garden, 1473
Church of St. Martin, Colmar

Pedro Berruguete
Federico da Montefeltro with his Son Guidobaldo, 1474-77
Palazzo Ducale, Urbino

Nicolas Froment
Mary Appearing to Moses, detail of the central panel of the *Triptych of the Burning Bush*, 1475-76
Cathedral of Saint-Sauveur, Aix-en-Provence

Historic Tables: from 1475 to 1515

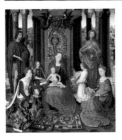

Hans Memling
*The Mystic Marriage of St. Catherine
of Alexandria*, central panel of the
San Giovanni Polyptych, 1474-79
Memlingmuseum, Bruges

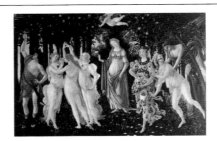

Sandro Botticelli
Primavera, 1477-82
Galleria degli Uffizi, Florence

Michael Pacher
Vision of Saint Sigisbert
outer panel of the *Altar
of the Four Latin Fathers*, c. 1482
Alte Pinakothek, Munich

Andrea Mantegna
The Dead Christ, c. 1500
Pinacoteca di Brera, Milan

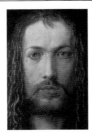

Albrecht Dürer
*Self-Portrait at 28
(Self-Portrait in Furcoat)*, 1500
Alte Pinakothek, Munich

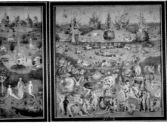

Hieronymus Bosch
The Garden of Earthly Delights, 1503-04
Prado, Madrid

Albrecht Altdorfer
Rest on the Flight into Egypt,
1510
Gemäldegalerie, Berlin

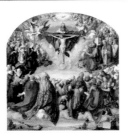

Albrecht Dürer
Adoration of the Trinity, 1511
Kunsthistorisches
Museum, Vienna

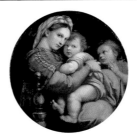

Raphael
The Madonna of the Chair,
1513
Galleria Palatina (Palazzo
Pitti), Florence

Quentin Metsys
Banker and his Wife, 1514
Louvre, Paris

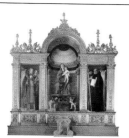

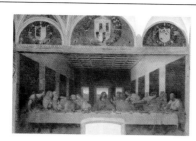

Giovanni Bellini
Frari Triptych (Madonna and Child with Saints), 1488
Sacristy, Church of Santa Maria Gloriosa dei Frari, Venice

Leonardo da Vinci
The Last Supper, 1494-97
Refectory, Convent of Santa Maria delle Grazie, Milan

Vittore Carpaccio
Stories from the Life of St. Ursula, 1495
Gallerie dell'Accademia, Venice

Michelangelo
Holy Family (Doni Tondo), c. 1504
Galleria degli Uffizi, Florence

Giorgione
The Three Philosophers, c. 1505
Kunsthistorisches Museum, Vienna

Lorenzo Lotto
Portrait of a Young Man, 1505
Kunsthistorisches Museum, Vienna

Leonardo da Vinci
Mona Lisa (La Gioconda), 1502/06-13
Louvre, Paris

Titian
Sacred and Profane Love, 1514
Galleria Borghese, Rome

Giovanni Bellini
Nude Woman in front of the Mirror, 1515
Kunsthistorisches Museum, Vienna

Mathis Grünewald
Crucifixion, central panel of the *Isenheim Altarpiece*, 1515
Musée Unterlinden, Colmar

Historic Tables: from 1515 to 1548

Titian
Assumption, 1516-18
Santa Maria Gloriosa
dei Frari, Venice

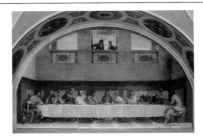

Andrea del Sarto
Last Supper, 1519
Convent of San Salvi, Florence

Rosso Fiorentino
Deposition, 1521
Pinacoteca, Volterra

Parmigianino
*Self-portrait in a Convex
Mirror*, c. 1524
Kunsthistoriches Museum,
Vienna

Mabuse,
Danaë, 1527
National Gallery, London

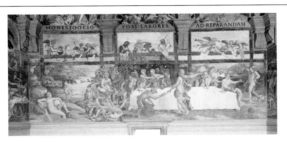

Giulio Romano
The Country Banquet, 1526-28
Sala di Amore e Psiche, Palazzo Te, Mantua

Jan van Scorel
Mary Magdalen, c. 1528
Rijksmuseum, Amsterdam

Hans Holbein the Younger
Portrait of Henry VIII,
1539-40
Galleria Nazionale d'Arte
Antica, Rome

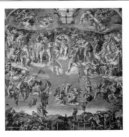

Michelangelo
Last Judgment, 1537-41
Sistine Chapel (rear wall),
Vatican City

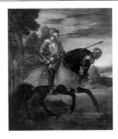

Titian
*Charles V at the Battle
of Mühlberg*, 1548
Prado, Madrid

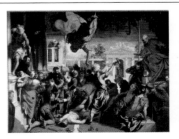

Jacopo Tintoretto
St. Mark Rescuing a Slave, 1548
Galleria dell'Accademia, Venice

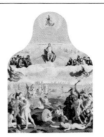

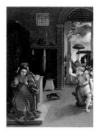

Jacopo Pontormo
Deposition, c. 1525
Church of Santa Felicita,
Florence

Albrecht Dürer
Four Apostles, 1526
Alte Pinakothek, Munich

Lucas van Leyden
Triptych of the Last Judgment,
central panel, 1526
Stedelijk Museum, Leyden

Lorenzo Lotto
The Annunciation, 1527
Pinacoteca, Recanati

Albrecht Altdorfer
*The Battle of Alexander
(The Battle of Issus)*, 1529
Alte Pinakothek, Munich

Lucas Cranach the Elder
*Judith with the Head
of Holofernes*, c. 1530
Kunsthistorisches Museum,
Vienna

Domenico Beccafumi
Birth of the Virgin, 1530
Pinacoteca Nazionale,
Siena

Correggio
Jupiter and Io,
c. 1531
Kunsthistorisches
Museum, Vienna

Marteen van Heemskerck
St. Luke Painting the Virgin, 1532
Frans Hals Museum, Haarlem

Historic Tables: from 1548 to 1610

Veronese
*Juno Presenting Gifts
to Venice*, 1553-54
Palazzo Ducale, Venice

Pieter Bruegel the Elder
Triumph of Death, c. 1562
Prado, Madrid

Pieter Bruegel the Elder
Return of the Herd, 1565
Kunsthistorisches Museum,
Vienna

François Clouet
Lady in her Bath, c. 1570
National Gallery of Art,
Washington, D.C.

Jacopo Tintoretto
Adoration of the Shepherds,
1577-78
Sala Superiore, Scuola
di San Rocco, Venice

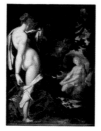

Bartholomeus Spranger
*Hermaphroditus and
Salmacis*, detail, c. 1582
Kunsthistorisches Museum,
Vienna

El Greco
Burial of the Count Orgaz,
1586-88
San Tomé, Toledo

Hans van Aachen
Ritratto di Rodolfo II, 1591
Vienna, Kunsthistorisches
Museum

Caravaggio
Madonna of Loreto, 1605
Church of Sant'Agostino,
Rome

Jan Bruegel
Bouquet in a Clay Vase, c. 1607
Kunsthistorisches Museum,
Vienna

Adam Elsheimer
Flight into Egypt, 1609
Alte Pinakothek, Munich

Pieter Paul Rubens
*Autoritratto con Isabella
Brandt*, 1609-10
Monaco, Alte Pinakothek

Veronese
*Mars and Venus United
by Love*, c. 1570
Metropolitan Museum of Art,
New York

Antoine Caron
Augustus and the Sibyl, c. 1571
Louvre, Paris

Titian
Pietà, 1570-76
Galleria dell'Accademia, Venice

El Greco
El Espolio, 1577-79
Sacristy, Toledo
Cathedral

Caravaggio
Basket of Fruit, 1596
Pinacoteca Ambrosiana, Milan

Annibale Carracci
Homage to Diana,
detail of the frescoes
in the Galleria Farnese,
1597-1602
Palazzo Farnese, Rome

Caravaggio
The Calling of Saint Matthew,
1599-1600
Church of San Luigi dei Francesi,
Rome

Juan Sanchez Cotan
Still Life with Fruit and Vegetables, 1602-03
José Luis Varez Fisa Collection, Madrid

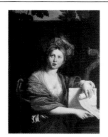

Domenichino
The Sibyl of Cuma, c. 1610
Pinacoteca Capitolina, Rome

Historic Tables: from 1610 to 1650

Peter Paul Rubens
*The Rape of the Daughters
of Leucippus*, c. 1618
Alte Pinakothek, Munich

Bernardo Strozzi
The Cook, 1620
Galleria di Palazzo Rosso,
Genoa

Sir Anthony van Dyck
*Marchesa Elena Grimaldi,
Wife of Marchese Nicola
Cattaneo*, 1622
National Gallery of Art,
Washington, D.C.

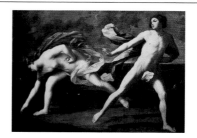

Guido Reni
Atalanta and Hippomenes,
1622-25
Museo di Capodimonte, Naples

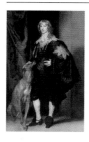

Sir Anthony van Dyck
*James Stuart, Duke of Lennox
and Richmond*, c. 1634
Metropolitan Museum of Art,
New York

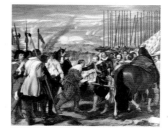

Diego Velázquez
Surrender of Breda, 1633-35
Prado, Madrid

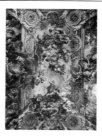

Pietro da Cortona
Allegory of Divine Providence,
1633-39
Palazzo Barberini, Rome

Francisco de Zurbarán
St. Margaret, 1635-40
National Gallery,
London

Sébastien Stoskopff
Still Life with Glasses in a Basket, 1644
Musée des Beaux-Arts, Strasbourg

Rembrandt van Rijn
*A Woman Bathing in
a Stream*, 1654
National Gallery, London

Nicolas Poussin
Landscape with Orpheus and Eurydice, 1648
Louvre, Paris

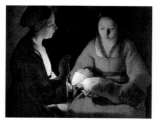

Georges de La Tour
The Newborn, c. 1648
Musée des Beaux-Arts, Rennes

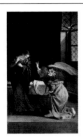

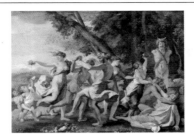

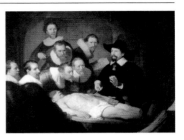

Orazio Gentileschi
The Annunciation, 1623
Galleria Sabauda, Turin

Frans Hals
The Laughing Cavalier, 1624
Wallace Collection, London

Nicolas Poussin
A Bacchanalian Revel Before a Herm of Pan,
1631-33
National Gallery, London

Rembrandt van Rijn
The Anatomy Lesson of Dr. Nicolaes Tulp, 1632
Mauritshuis, The Hague

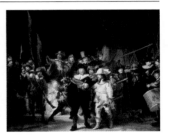

Georges de La Tour
The Penitent Magdalen,
1638-43
Metropolitan Museum
of Art, New York

Jusepe de Ribera
Jacob's Dream, 1639
Prado, Madrid

Philippe de Champaigne
Triple Portrait of Cardinal Richelieu, 1642
National Gallery, London

Rembrandt van Rijn
The Night Watch, 1642
Rijksmuseum, Amsterdam

Historic Tables: from 1650 to 1730

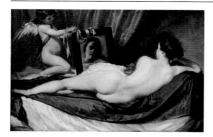

Diego Velázquez
Venus and Cupid (The Rokeby Venus), 1650
National Gallery, London

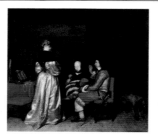

Gerard Ter Borch
*Gallant Conversation
(The Paternal Admonition)*, c. 1650
Rijksmuseum, Amsterdam

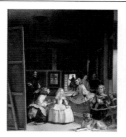

Diego Velázquez
*Las Meninas
(The Maids of Honor)*, 1656
Prado, Madrid

Juan Valdés Leal
Way to Calvary, 1657-60
Prado, Madrid

Bartolomé Estebán Murillo
Two Women at a Window,
c. 1670
National Gallery of Art,
Washington, D.C.

Evaristo Baschenis
Still Life with Musical Instruments, c.1670
Private Collection

Claude Lorrain
Seascape, 1674
Alte Pinakothek, Munich

Luca Giordano
*Perseus Turning Phineas
and his Followers to Stone*, 1680
National Gallery, London

Sebastiano Ricci
Bathsheba Bathing, 1720
Museum of Fine Arts, Budapest

Jean Watteau
Gersaint's Shop Sign, 1720
Castle of Charlottenburg, Berlin

Canaletto
Stonemason's Yard, c. 1727
National Gallery, London

Pieter de Hooch
The Mother, c. 1660
Rijksmuseum, Amsterdam

Johannes Vermeer
View of Delft, c. 1660-61
Mauritshuis, The Hague

Jan Steen
Beware of Luxury
("In weelde siet toe"), c. 1665
Kunsthistorisches Museum, Vienna

Johannes Vermeer
Allegory of Painting, c. 1670
Kusthistorisches Museum,
Vienna

Meindert Hobbema
The Road to Middelharnis, 1689
National Gallery, London

Hyacinthe Rigaud
Louis XIV, 1701
Louvre, Paris

Caspar van Wittel
St Peter's in Rome, c. 1711
Richard Green Collection,
London

Jean-Antoine Watteau
Gilles, 1717-19
Louvre, Paris

Paul Troger
Christ Comforted by an Angel,
c. 1730
Museo Diocesano, Bressanone

Historic Tables: from 1730 to 1780

William Hogarth
In a Gaming House, scene from
The Rake's Progress, 1733
Sir John Soane's Museum, London

Jean-Baptiste-Siméon Chardin
The Cook, 1738
Alte Pinakothek, Munich

François Boucher
Morning Coffee, 1739
Louvre, Paris

William Hogarth
The Shrimp Girl, c. 1740
National Gallery, London

Bernardo Bellotto
*View of the New Market
in Dresden*, 1751
Gemäldegalerie, Dresden

Franz Anton Maulbertsch
The Education of Mary,
c. 1755
Kunsthalle, Karlsruhe

Giambattista Tiepolo
Woman with Parrot, 1761
Ashmolean Museum,
Oxford

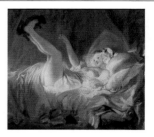

Honoré Fragonard
La Gimblette (The Ring-Biscuit),
c. 1765-1772
Fondation Cailleux, Paris

Francisco Goya y Lucientes
The Parasol, 1777
Prado, Madrid

John Singleton Copley
Brook Watson and the Shark, 1778
National Gallery of Art, Washington, D.C.

Francesco Guardi
Gondola on the Lagoon, c. 1770
Museo Poldi Pezzoli, Milan

Jean-Étienne Liotard
The Chocolate Girl, 1744-45
Gemäldegalerie, Dresden

Anton Raphael Mengs
Self-Portrait, 1744
Gemäldegalerie, Dresden

Vittore Ghislandi called
Fra Galgario
*Portrait of a Knight of the
Constantinian Order (Gentleman
in a Tricorn Hat)*, c. 1745
Museo Poldi Pezzoli, Milan

Giambattista Tiepolo
Rinaldo in Armida's Garden, c. 1745
Art Institute of Chicago

Jean-Étienne Liotard
François Tronchin, 1757
Musée d'Art et d'Histoire,
Geneva

Benjamin West
Penn's Treaty with the Indians, 1771-72
Pennsylvania Academy of Fine Arts,
Philadelphia

Sir Joshua Reynolds
*Portrait of Miss Bowles
with her Dog*, 1775
Wallace Collection, London

Honoré Fragonard
The Reader, c. 1776
National Gallery of Art,
Washington, D.C.

Historic Tables: from 1780 to 1840

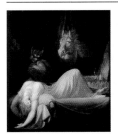

Henry Fuseli
The Nightmare, 1790-91
Goethe Museum, Frankfurt

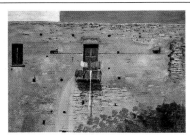

Thomas Jones
A Wall in Naples, 1782
National Gallery, London

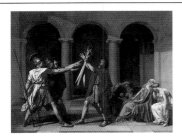

Jacques-Louis David
The Oath of the Horatii, 1784-85
Louvre, Paris

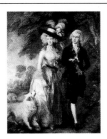

Thomas Gainsborough
The Morning Walk, 1785
National Gallery, London

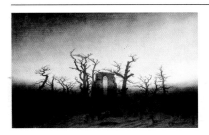

Caspar David Friedrich
Abbey in an Oak Forest, 1809
Castle of Charlottenburg, Berlin

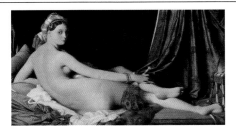

Jean-Auguste-Dominique Ingres
Great Odalisque, 1814
Louvre, Paris

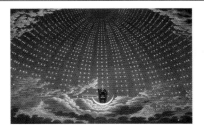

Friedrich Schinkel
The Queen of the Night, 1815
Hochschulbibliothek, Berlin

Joseph Mallord William Turner
Fiery Sunset, 1825-27
Tate Gallery, London

Eugène Delacroix
Liberty Leading the People, 1830
Louvre, Paris

Johann Erdmann Hummel
Polishing the Granite Bowl, c. 1830
Nationalgalerie, Berlin

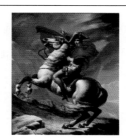

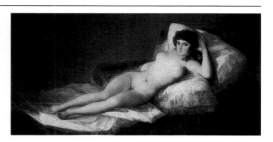

Giandomenico Tiepolo
The Swing of Pulcinella,
1791-93
Ca' Rezzonico, Venice

William Blake
The Omnipotent, 1794
British Museum, London

Jacques-Louis David
*Napoleon Crossing the Saint
Bernard*, 1800
Musée National du Château
de Malmaison, Paris

Francisco Goya y Lucientes
Maja Nude, c. 1803
Prado, Madrid

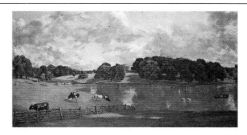

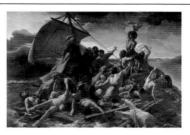

John Constable
Wivenhoe Park, Essex, 1816
National Gallery of Art, Washington, D.C.

Théodore Géricault
Raft of the Medusa, 1818-19
Louvre, Paris

Francisco Goya
*Saturn Devouring
One of His Sons*,
1820-23
Prado, Madrid

Eugène Delacroix
Women of Algiers, 1834
Louvre, Paris

Carl Spitzweg
The Poor Poet, 1837
Neue Pinakothek, Munich

Historic Tables: from 1840 to 1880

Christoffer Vilhelm
Eckersberg
*Woman Standing in Front
of a Mirror*, 1841
Hirschsprung Collection,
Copenhagen

Jean-Auguste-Dominique
Ingres
The Contesse d'Haussonville,
1845
Frick Collection, New York

Jean François Millet
Gleaners, 1848
Louvre, Paris

Adolf von Menzel
*Flute Concert of Frederick the Great
at Sanssouci*, 1852
Nationalgalerie, Berlin

Francesco Hayez
The Kiss, 1859
Pinacoteca di Brera, Milan

Edouard Manet
Déjeuner sur l'herbe, 1863
Musée d'Orsay, Paris

Claude Monet
Terrace at Sainte-Adresse, 1866
Metropolitan Museum of Art,
New York

Dante Gabriel Rossetti
Monna Vanna, 1866
Tate Gallery, London

Adolf von Menzel
The Foundry, 1875
Nationalgalerie, Berlin

Claude Monet
*Woman with a Parasol -
Madame Monet and Her Son*, 1875
National Gallery of Art,
Washington, D.C.

Edgar Degas
The Absinthe Drinker,
1875-76
Musée d'Orsay, Paris

Gustave Moreau
The Apparition, 1876
Musée Gustave Moreau,
Paris

Ford Madox Brown
The Last of England, 1855
Museum and Art Gallery,
Birmingham

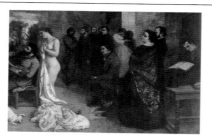

Gustave Courbet
Painter's Studio, 1854-55
Musée d'Orsay, Paris

John Everett Millais
The Blind Girl, 1854-56
Museum and Art
Gallery, Birmingham

Silvestro Lega
Il pergolato (The Trellis), 1868
Pinacoteca di Brera, Milan

Claude Monet
Impression: Sunrise, 1873
Musée Marmottan, Paris

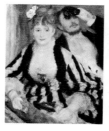

Pierre-Auguste Renoir
La loge (The Theater Box),
1874
Courtauld Institute of Art,
London

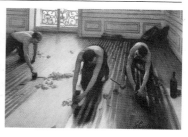

Gustave Caillebotte
The Floor Scrapers, 1875
Musée d'Orsay, Paris

Historic Tables: from 1880 to 1900

Arnold Böcklin
The Isle of the Dead, 1880
Kunstmuseum, Basel

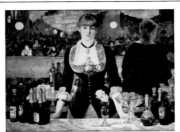

Édouard Manet
Bar at the Folies-Bergère, 1881
Courtauld Institute of Art, London

John Singer Sargent
Children of E.D. Boit, 1882
National Gallery of Art,
Washington, D.C.

Mary Cassatt
*Children Playing on the
Beach*, 1884
National Gallery of Art,
Washington, D.C.

Giovanni Segantini
*Ave Maria al trasbordo
(Mary Crossing the Lake)*, 1886
Private Collection, San Gallo

Paul Gauguin
*Vision After the Sermon, Jacob Wrestling
with the Angel*, 1888
National Gallery of Scotland, Edinburgh

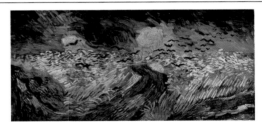

Vincent van Gogh
Wheat Field with Crows, 1890
Van Gogh Museum, Amsterdam

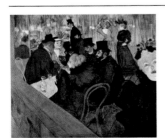

Henri de Toulouse-Lautrec
At the Moulin Rouge, 1892-95
Art Institute of Chicago

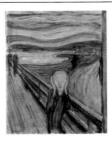

Edvard Munch
The Scream, 1893
National Gallery, Oslo

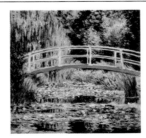

Claude Monet
White Water Lilies, 1899
Pushkin Museum of Fine
Arts, Moscow

Paul Cézanne
Les Grandes Baigneuses (Bathers),
c. 1900-06
National Gallery, London

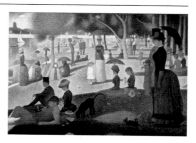

Pierre-Auguste Renoir
The Umbrellas, c. 1885
National Gallery,
London

Paul Signac
The Modistes, 1885
E.G. Bührle
Collection, Zurich

Paul Cèzanne
Mont Sainte-Victoire, c. 1887
Courtauld Institute, London

Georges Seurat
*Sunday Afternoon on the Island
of La Grande Jatte*, 1884-1886
Art Institute of Chicago

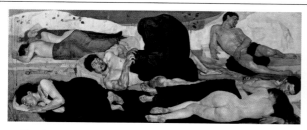
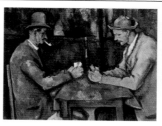
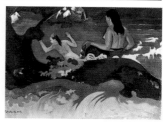

Ferdinand Hodler
Die Nacht (The Night), 1890
Kunstmuseum, Bern

Paul Cézanne
The Card Players, 1890-92
Louvre, Paris

Paul Gauguin
Fatata te Miti (By the Sea), 1892
National Gallery of Art, Washington, D.C.

387

Historic Tables: from 1900 to 1915

Edvard Munch
Four Girls on a Bridge, 1905
Wallraf-Richartz Museum,
Cologne

Pablo Picasso
Les Demoiselles d'Avignon, 1907
Museum of Modern Art,
New York

Emil Nolde
Flower Garden, 1908
Erbengemeinschaft, Krefeld

Gustav Klimt
The Kiss, 1908
Österreichische Galerie, Vienna

Piet Mondrian
The Silver Tree, 1911
Gemeentemuseum, The Hague

Pablo Picasso
Nature morte à la chaise cannée, 1912
Musée Picasso, Paris

August Macke
Large Zoological Garden, 1912
Museum am Ostwall, Dortmund

Amedeo Modigliani
Large Nude, 1913-14
Museum of Modern Art, New York

Giorgio de Chirico
Le Chant d'Amour, 1914
Museum of Modern Art,
New York

Paul Klee
Saint Germain near Tunis, 1914
Centre Pompidou, Paris

Georges Braque
Houses at l'Estaque, 1908
Kunstmuseum, Bern

Wassily Kandinsky
The Railroad at Murnau, 1909
Lenbachhaus, Munich

Umberto Boccioni
The City Rises, 1910-1911
Museum of Modern Art, New York

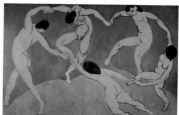

Henri Matisse
La Danse (Dance), 1910
Hermitage, Saint Petersburg

Franz Marc
The Dream, 1912
Thyssen-Bornemisza Collection,
Madrid

Ernst Ludwig Kirchner
Berlin Street Scene, 1913
Brücke-Museum, Berlin

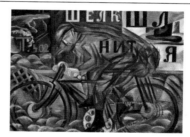

Natalia Goncharova
The Cyclist, 1913
Russian Museum, Saint Petersburg

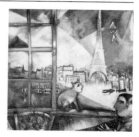

Marc Chagall
Paris through the Window, 1913
Peggy Guggenheim Collection,
Venice

Wassily Kandinsky
Painting with Red Spot, 1914
Centre Pompidou, Paris

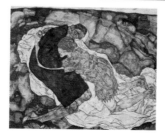

Egon Schiele
Death and the Maiden, 1915
Österreichische Galerie, Vienna

Kasimir Malevich
*Suprematism-Abstract
Composition*, 1915
Museum of Figurative Arts,
Yekaterinenburg

Historic Tables: from 1915 to 1936

Marcel Duchamp
*The Bride Stripped Bare by her
Bachelors, Even*, 1915-23
Philadelphia Museum of Art

Marc Chagall
The Promenade, 1917-18
Russian Museum,
Saint Petersburg

Amedeo Modigliani
Gypsy Woman with Baby,
1918
National Gallery of Art,
Washington, D.C.

Georg Grosz
Gray Day, 1921
Staatliche Museen, Berlin

Joan Miró
Harlequin's Carnival, 1924-25
Albright-Knox Art Gallery, Buffalo

George Bellows
Dempsey and Firpo, 1924
Whitney Museum of American Art,
New York

Wassily Kandinsky
Several Circles, 1926
Solomon R. Guggenheim
Museum, New York

Lyonel Feininger
Street at Night, 1929
Gemäldegalerie Neue Meister, Dresden

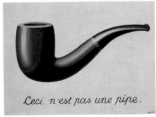

René Magritte
The Treachery of Images, 1929
Los Angeles County Museum of Art

Edward Hopper
The Lighthouse at Two Lights, 1929
Metropolitan Museum of Art, New York

Christian Schad
Operation, 1929
Lenbachhaus, Munich

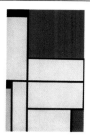

Piet Mondrian
Painting I, 1921
Private Collection, Basel

Pablo Picasso
The Lovers, 1922
National Gallery of Art,
Washington, D.C.

Fernand Léger
Still Life with Fruit Bowl, 1923
Musée d'Art Moderne,
Villeneuve-d'Ascq

Henri Matisse
*Decorative Figure
on an Ornamental
Background*, 1925-26
Musée National d'Art
Moderne, Paris

Otto Dix
Metropolis, 1927-28
Galerie der Stadt, Stuttgart

Charles Demuth
I Saw the Figure 5 in Gold, 1928
Metropolitan Museum of Art,
New York

Paul Klee
*Separation in the
Evening*, 1929
Felix Klee Collection,
Bern

Grant Wood
American Gothic, 1930
Art Institute of Chicago

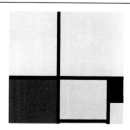

Piet Mondrian
Composition I, 1931
Thyssen-Bornemisza Collection,
Madrid

Georgia O'Keeffe
Summer Days, 1936
Whitney Museum
of American Art, New York

Historic Tables: from 1937 to 1960

Balthus
The Mountain, 1937
Metropolitan Museum of Art, New York

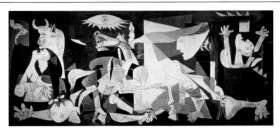

Pablo Picasso
Guernica, 1937
Centro de Arte Reina Sofía, Madrid

Paul Delvaux
Pygmalion, 1939
Musées Royaux des Beaux-Arts,
Brussels

Piet Mondrian
Victory Boogie-Woogie, 1942-44
Private Collection

Salvador Dalí
*One Second before Awakening
from a Dream Caused by the Flight
of a Bee around a Pomegranate*,
Thyssen-Bornemisza Collection,
Madrid

David Alfaro Siqueiros
Self-Portrait (El Coronelazo), 1945
Museo Nacional de Arte, Mexico City

Jackson Pollock
Enchanted Forest,
1947
Peggy Guggenheim
Collection, Venice

Jackson Pollock
Blue Posts, 1952
Heller Collection, New York

René Magritte
Golconde, 1953
Menil Collection, Houston

Lucian Freud
Hotel Room, 1954
Beaverbrook Art Gallery,
Fredericton
(New Brunswick, Canada)

Renato Guttuso
Crucifixion, 1940-41
Galleria Nazionale d'Arte
Moderna, Rome

Joan Miró
*The Beautiful Bird Reveals the
Unknown to a Couple of Lovers*,
1941
Museum of Modern Art,
New York

Edward Hopper
Nighthawks, 1942
Art Institute of Chicago

Fernand Léger
The Builders, 1950
Musée Fernand Léger, Biot

Francis Bacon
*Study after Velázquez's Portrait
of Pope Innocent X*, 1950
Tony Shafrazi Gallery,
New York

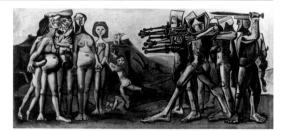

Pablo Picasso
Massacre in Korea, 1951
Musée Picasso, Paris

Josef Albers
Homage to the Square, 1958
Sidney Janis Gallery, New York

Jasper Johns
Three Flags, 1958
Barton Tremaine Collection, Connecticut

Yves Klein
Blue Sponge Relief, 1958
Ludwig Museum, Cologne

Historic Tables: from 1960

Mark Rothko
No. 19, 1960
Private Collection

Piero Manzoni
Artist's Shit no. 025, c. 1961
Private Collection

Andy Warhol
Twenty-five Colored Marilyns,
1962
Modern Art Museum,
Fort Worth, Texas

Lucio Fontana
Spatial Concept. Expectations, 1962
Private Collection

Francis Bacon
*Study for a Portrait of George
Dyer*, 1971
Private Collection

David Hockney
*Portrait of an Artist
(Pool with Two Figures)*, 1971
Private Collection

Georg Baselitz
Apple Tree, 1971-73
Jung Collection, Aachen

Mimmo Paladino
The King, 1980
Private Collection

Keith Haring
Self-Portrait, 7 November 1985
Private Collection, Milan

Jean-Michel Basquiat
Eroica I, 1988
Private Collection

Lucian Freud
Back View of Nude (Leigh),
1991-92
Metropolitan Museum of Art,
New York

Robert Rauschenberg
Spot, 1963
Staatsgalerie, Stuttgart

Roy Lichtenstein
We Rose up Slowly, 1964
Museum für moderne Kunst, Frankfurt

Alberto Burri
Red Plastic, 1964
Palazzo Albizzini Foundation,
Città di Castello (Perugia)

Gerhard Richter
*Erna Descending the
Stairs*, 1966
Ludwig Museum,
Cologne

Anselm Kiefer
Interior, 1981
Stedelijk Museum, Amsterdam

Hermann Albert
Man with a Mirror, 1982
Private Collection

Carlo Maria Mariani
*The Hand that Obeys
the Intellect*, 1983
Private Collection,
United States

Dieter Krieg
Untitled, 1984
Museum für moderne Kunst,
Frankfurt

Geographic Tables: Venice and Northern Italy

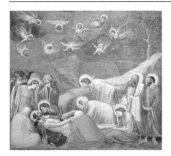

Giotto
Lamentation, 1304
Scrovegni Chapel, Padua

Cosmè Tura
Spring (The Muse Erato),
c. 1460
National Gallery, London

Andrea Mantegna
*Oculus on the ceiling of the
Camera degli Sposi*, 1465-74
Palazzo Ducale, Mantua

Leonardo da Vinci
Virgin of the Rocks,
1483-86
Louvre, Paris

Lorenzo Lotto
Stories of St. Barbara, 1524
Suardi Chapel, Trescore Balneario (Bergamo)

Titian
Urbino Venus, 1538
Galleria degli Uffizi, Florence

Tintoretto
Finding of the Body of St. Mark,
1562-66
Pinacoteca di Brera, Milan

Pietro Longhi
Painter in his Studio, c. 1740
Ca' Rezzonico, Venice

Giambattista Tiepolo
Neptune Offering Gifts to Venice, 1748-50
Palazzo Ducale, Venice

Francesco Hayez
The Kiss, 1859
Pinacoteca di Brera, Milan

Giovanni Bellini
Virgin and Child between St. Catherine and St. Mary Magdalen, c. 1500
Gallerie dell'Accademia, Venice

Giorgione
Tempest, c. 1506
Gallerie dell'Accademia, Venice

Titian
Assumption, 1516-18
Church of Santa Maria
Gloriosa dei Frari, Venice

Correggio
Madonna of St. Jerome, 1523
Galleria Nazionale, Parma

Veronese
Feast in the House of Levi, 1573
Gallerie dell'Accademia, Venice

Guercino
The Return of the Prodigal Son, 1619
Kunsthistorisches Museum, Vienna

Canaletto
Grand Canal, 1730-35
Wallraf-Richartz Museum, Cologne

Giuseppe Pellizza da Volpedo
Il Quarto Stato (The Fourth State), 1898-1901
Galleria d'Arte Moderna, Milan

Umberto Boccioni
Simultaneous Visions, 1911
Von der Heydt Museum, Wuppertal

Giorgio Morandi
Still Life with Mannequin, 1918
Hermitage, Saint Petersburg

Geographic Tables: Florence

Cimabue,
Crucifix, c. 1260-70
Church of San Domenico, Arezzo

Tuscan masters including Coppo
di Marcovaldo and Cimabue, *Last
Judgment and Stories from the Old and New
Testaments*, second half of 13th century,
Baptistery of San Giovanni, Florence

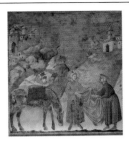

Giotto
*St. Francis Giving his Mantel
to a Poor Man*, 1306-10
Basilica of San Francesco,
Upper Church, Assisi

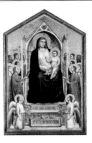

Giotto
Ognissanti Madonna,
1306-10
Galleria degli Uffizi,
Florence

Masolino and Masaccio
Madonna and Child with St. Anne,
c. 1424
Galleria degli Uffizi, Florence

Paolo Uccello
Battle of San Romano, 1465
National Gallery, London

Piero della Francesca
*Portrait of Federico
da Montefeltro, panel
of the Urbino diptych*
(reverse side), 1465-70
Galleria degli Uffizi, Florence

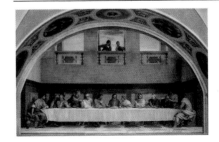

Andrea del Sarto
Last Supper, 1519
Convent of San Salvi, Florence

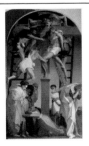

Rosso Fiorentino
Deposition, 1521
Pinacoteca, Volterra

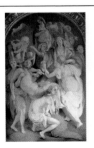

Jacopo Pontormo
Deposition, c. 1525
Church of Santa Felicita,
Florence

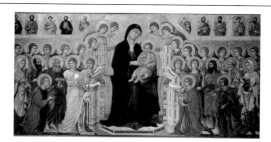

Duccio di Buoninsegna
Maestà, 1308-11
Museo dell'Opera del Duomo, Siena

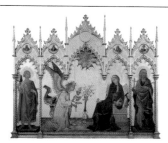

Simone Martini
Annunciation, 1333
Galleria degli Uffizi, Florence

Gentile da Fabriano
Polyptych of Valle Romita,
1400-1410
Pinacoteca di Brera, Milan

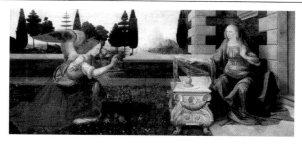

Leonardo da Vinci
Annunciation, c. 1474
Galleria degli Uffizi, Florence

Sandro Botticelli
Birth of Venus, 1484-86
Galleria degli Uffizi, Florence

Orazio Gentileschi
Annunciation, 1623
Galleria Sabauda, Turin

Silvestro Lega
Il pergolato (The Trellis), 1868
Pinacoteca di Brera, Milan

Giovanni Fattori
In vedetta (On Patrol), 1872
Private Collection, Rome

Amedeo Modigliani
Self-Portrait, 1919
Museo de Arte
Contemporanea
de Universidade,
São Paulo

Geographic Tables: Rome and Southern Italy

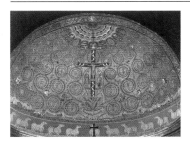

Triumph of the Cross,
Mosaic decoration of the semi-dome
of the apse, 1128
Basilica of San Clemente, Rome

Creation of the Stars, c. 1176
Cathedral, Monreale

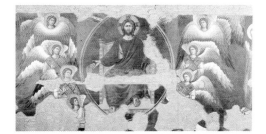

Pietro Cavallini
Last Judgment, c. 1293
Church of Santa Cecilia in Trastevere, Rome

Caravaggio
St. Matthew and the Angel,
1602
Church of San Luigi
dei Francesi, Rome

Domenichino
The Sibyl of Cumae, c. 1610
Pinacoteca Capitolina, Rome

Guido Reni
Atalanta and Hippomenes, 1622-25
Museo di Capodimonte, Naples

Jusepe de Ribera
Jacob's Dream, 1639
Prado, Madrid

Renato Guttuso
Crucifixion, 1940-41
Galleria Nazionale d'Arte
Moderna, Rome

Mimmo Paladino
The King, 1980
Private Collection

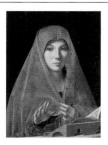

Antonello da Messina
Annunciation, c. 1477
Galleria Nazionale, Palermo

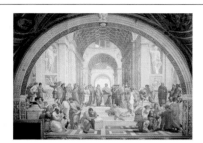

Raphael
School of Athens, 1510
Stanza della Segnatura,
Vatican Museums, Rome

Michelangelo
Last Judgment, 1537-41
Sistine Chapel (rear wall),
Vatican City

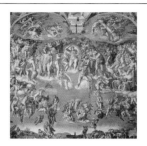

Caravaggio
Basket of Fruit, 1596
Pinacoteca Ambrosiana, Milan

Pietro da Cortona
Allegory of Divine Providence,
1633-39
Palazzo Barberini, Rome

Bernardo Cavallino
St. Cecilia in Ecstasy, 1645
Museo di Capodimonte, Naples

Luca Giordano
*Perseus Turning Phineas and his Followers
to Stone*, 1680
National Gallery, London

Giorgio de Chirico
The Disquieting Muses,
1918
Private Collection,
Milan

Geographic Tables: Paris

Jean Fouquet
Madonna and Child,
panel of the *Melun Diptych*,
c. 1450
Musée Royaux des Beaux-Arts,
Antwerp

Philippe de Champaigne
Triple Portrait of Cardinal Richelieu, 1642
National Gallery, London

Jean-Antoine Watteau
Gilles, 1717-19
Louvre, Paris

Jean-Baptiste-Siméon Chardin
The Return from Market, 1739
Louvre, Paris

Eugène Delacroix
Liberty Leading the People, 1830
Louvre, Paris

Jean-Auguste-Dominique
Ingres
Madame Moitessier, 1856
National Gallery, London

Édouard Manet
Olympia, 1863
Musée d'Orsay, Paris

Claude Monet
Déjeuner sur l'herbe, 1865
Pushkin Museum of Fine Arts, Moscow

Henri de Toulouse-Lautrec
*Yvette Guilbert Saluant
Le Public*, 1894
Musée Toulouse-Lautrec,
Albi

Pablo Picasso
Les Demoiselles d'Avignon, 1907
Museum of Modern Art, New York

Henri Matisse
The Red Room, 1908-09
Hermitage, Saint Petersburg

Marc Chagall
Paris through the Window, 1913
Peggy Guggenheim Collection, Venice

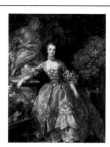

François Boucher
*Portrait of Marquise
de Pompadour*, 1759
Wallace Collection, London

Honoré Fragonard
The Reader, c. 1776
National Gallery of Art,
Washington, D.C.

Jacques-Louis David
*Portrait of Monsieur Lavoisier
and His Wife*, 1788
Metropolitan Museum of Art,
New York

Théodore Géricault
The Insane Woman (Envy),
1820-24
Musée des Beaux-Arts,
Lyons

Edgar Degas
*Dancer at the Photographer's
Studio*, 1875
Pushkin Museum of Fine
Arts, Moscow

Pierre-Auguste Renoir
A Girl with a Watering Can,
1876
National Gallery of Art,
Washington, D.C.

Georges Seurat
Une Baignade, Asnières, 1884
National Gallery, London

Marcel Duchamp
*The Bride Stripped Bare by her
Bachelors, Even*, 1915-23
Philadelphia Museum of Art

Geographic Tables: France

Matteo Giovannetti
The Prophets Ezekiel
and Jeremiah, 1352
Audience Chamber,
Palais des Papes, Avignon

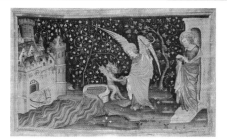

Hennequin de Bruges
The Harvest of the Damned,
from the tapestry series
of the Apocalypse, 1374-81
Castle of Angers

Melchior Broederlam
The Presentation in the Temple
and Flight into Egypt, 1392-99
side panels of the Champmol
Altarpiece,
Musée des Beaux-Arts, Dijon

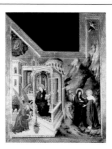

Melchior Broederlam
The Annunciation
and Visitation, 1392-99
side panels of the Champmol
Altarpiece,
Musée des Beaux-Arts, Dijon

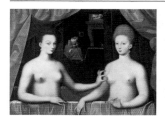

Anonymous French artist
Two Ladies in Their Bath, c. 1594
Louvre, Paris

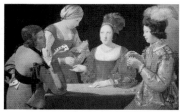

Georges de La Tour
The Cheat with the Ace of Clubs, c. 1632
Kimbell Art Museum, Fort Worth

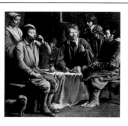

Le Nain Brothers
The Peasant Meal, 1642
Louvre, Paris

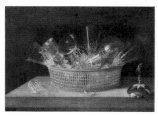

Sébastien Stoskopff
Still Life with Glasses in a Basket, 1644
Musée des Beaux-Arts, Strasbourg

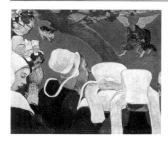

Paul Gauguin
Vision After the Sermon,
Jacob Wrestling with the Angel, 1888
National Gallery of Scotland,
Edinburgh

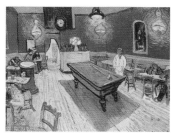

Vincent van Gogh
The Night Café, 1888
Yale University Art Gallery,
New Haven

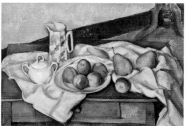

Paul Cézanne
Peaches and Pears, 1888-90
Pushkin Museum of Fine
Arts, Moscow

Fernand Léger
The Builders, 1950
Musée Fernand Léger,
Biot

Jean Malouel
Pietà, 1400-10
Louvre, Paris

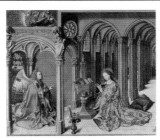

Barthélemy d'Eyck
Annunciation, 1443-45
Church of Sainte-Marie-Madeleine,
Aix-en-Provence

Enguerrand Quarton
Coronation of the Virgin, 1453-54
Musée de l'Hospice,
Villeneuve-les-Avignons

Nicolas Froment
Mary Appearing to Moses, detail
of the central panel of the *Triptych
of the Burning Bush*, 1475-76
Cathedral of Saint-Sauveur,
Aix-en-Provence

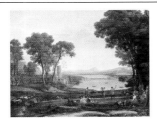

Claude Lorrain
*Landscape with the Marriage
of Isaac and Rebekah*, 1648
National Gallery, London

Nicolas Poussin
Self-Portrait, 1650
Louvre, Paris

Pierre Subleyras
The Painter in his Studio,
after 1740
Gemäldegalerie der Akademie
der bildenden Künste, Vienna

Gustave Courbet
The Trout, 1871
Kunsthaus, Zurich

405

Geographic Tables: Spain

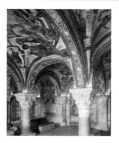

View of the Panteón de los Reyes,
c. 1063-1100
San Isidoro, León

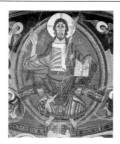

Christ in Majesty, fresco
detached from the central apse
of San Clemente (Taüll), c. 1120
Museu Nacional d'Art
de Catalunya, Barcelona

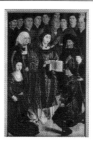

Nuño Gonçalves
Polyptych of St. Vincent,
c. 1460
Museu Nacional de Arte
Antiga, Lisbon

Pedro Berruguete
Federico da Montefeltro
with his Son
Guidobaldo, 1474-77
Palazzo Ducale, Urbino

Luis Eugenio Meléndez
Still Life with Box of Sweets,
Bread Ring, and Other Objects
1770 Prado, Madrid

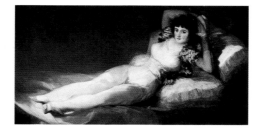

Francisco Goya y Lucientes
Maja Clothed, c. 1803
Prado, Madrid

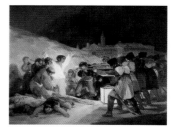

Francisco Goya y Lucientes
May 3, 1808,
1814
Prado, Madrid

Salvador Dalí
One Second before Awakening
from a Dream Caused by the Flight
of a Bee around a Pomegranate
Thyssen-Bornemisza Collection,
Madrid

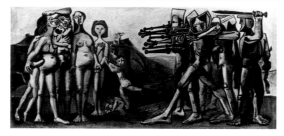

Pablo Picasso
Massacre in Korea, 1951
Musée Picasso, Paris

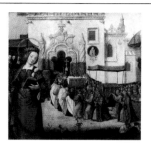

The Arrival of the Relics of St. Auta
at the Church of Madre de Deus
in Lisbon, c. 1522
Museu Nacional de Arte Antiga,
Lisbon

El Greco
Portrait of Cardinal
don Fernando Niño, c. 1596
Metropolitan Museum of Art,
New York

Francisco de Zurbarán
St. Casilda, 1630-35
Thyssen-Bornemisza
Collection, Madrid

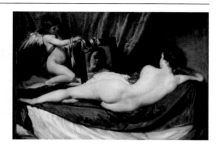

Diego Velázquez
The Toilet of Venus
(The Rokeby Venus), 1650
National Gallery, London

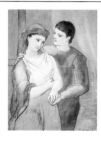

Pablo Picasso
The Lovers, 1922
National Gallery of Art,
Washington, D.C.

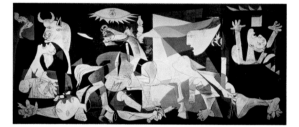

Pablo Picasso
Guernica, 1937
Centro de Arte Reina Sofia, Madrid

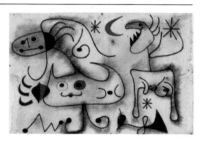

Joan Miró,
Personage and Bird before the Moon, 1944
Perls Galleries, New York

Geographic Tables: Germany

Master Theodoric,
Saint Ambrose, 1357-67
Národní Galerie, Prague

Master of the Garden of Paradise
The Garden of Paradise, c. 1410
Städelsches Kunstinstitut,
Frankfurt

Stephan Lochner
Last Judgment, c. 1435
Wallraf-Richartz Museum,
Cologne

Albrecht Dürer
*Self-Portrait at 28
(Self-Portrait in Furcoat)*,
1500
Alte Pinakothek, Munich

Adam Elsheimer
Flight into Egypt, 1609
Alte Pinakothek, Munich

Jean-Étienne Liotard
The Chocolate Girl,
1744-45
Gemäldegalerie, Dresden

Franz Anton Maulbertsch
The Education of Mary,
c. 1755
Kunsthalle, Karlsruhe

Caspar David Friedrich
Sunset (Brothers), 1830-35
Hermitage, Saint Petersburg

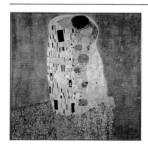

Gustav Klimt
The Kiss, c. 1908
Österreichische Galerie, Vienna

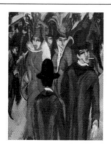

Ernst Ludwig Kirchner
Berlin Street Scene, 1913
Brücke-Museum, Berlin

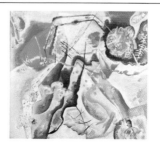

Wassily Kandinsky
Painting with Red Spot, 1914
Centre Pompidou, Paris

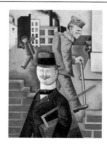

Georg Grosz
Gray Day, 1921
Staatliche Museen, Berlin

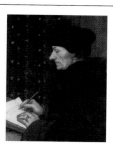

Hans Holbein the Younger
*Portrait of Erasmus
of Rotterdam*, 1523
Louvre, Paris

Albrecht Altdorfer
*The Battle of Alexander
(The Battle of Issus)*, 1529
Alte Pinakothek, Munich

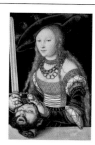

Lucas Cranach the Elder
*Judith with the Head
of Holofernes*, c. 1530
Kunsthistorisches Museum,
Vienna

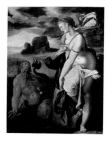

Bartholomeus Spranger
Glaucus and Scylla, c. 1582
Kunsthistorisches Museum,
Vienna

Adolf von Menzel
The Foundry, 1875
Nationalgalerie, Berlin

Edvard Munch
The Scream, 1893
National Gallery, Oslo

Emil Nolde
Flower Garden, 1908
Erbengemeinschaft, Krefeld

Paul Klee
Separation in the Evening, 1929
Felix Klee Collection, Bern

Geographic Tables: Belgium

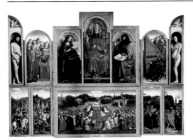

Hubert and Jan van Eyck
*Polyptych of the Adoration
of the Lamb*, 1425-32
Cathedral of St. Bavon, Ghent

Jan van Eyck
Portrait of a Man, 1433
National Gallery, London

Rogier van der Weyden
Nativity, 1450-55
Central panel of the *Bladelin Triptych*,
Gemäldegalerie, Berlin

Hans Memling
Saint Michael Weighing Souls,
central panel of the *Last
Judgment Triptych*, 1466-1473
Muzeum Narodowe, Gdansk

Jan Bruegel
Bouquet in a Clay Vase, c. 1607
Kunsthistorisches Museum,
Vienna

Peter Paul Rubens
Descent from the Cross,
central panel, 1612
Cathedral, Antwerp

Peter Paul Rubens
*The Rape of the Daughters
of Leucippus*, c. 1618
Alte Pinakothek, Munich

Jacob Jordaens
Jordaens' Family in a Garden, 1621-22
Prado, Madrid

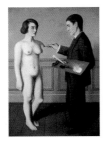

René Magritte
Attempting the Impossible, 1928
Courtesy Galerie Isy Brachot,
Brussels

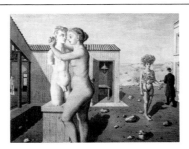

Paul Delvaux
Pygmalion, 1939
Musées Royaux des Beaux-Arts,
Brussels

Hans Memling
St. Ursula Shrine, before 1489
Memlingmuseum, Bruges

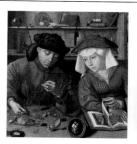

Quentin Metsys
Banker and his Wife, 1514
Louvre, Paris

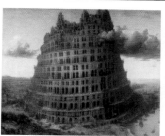

Pieter Bruegel the Elder
The "Little" Tower of Babel, c. 1563
Museum Boymans-van Beuningen,
Rotterdam

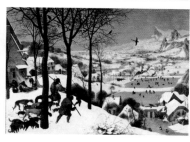

Pieter Bruegel the Elder
Hunters in the Snow, 1565
Kunsthistorisches Museum, Vienna

Sir Anthony van Dyck
Marchesa Balbi, 1622-23
National Gallery of Art,
Washington, D.C.

Sir Anthony van Dyck
The Lomellini Family, 1625
National Gallery of Scotland,
Edinburgh

Fernand Khnopff
Art (or The Sphinx or The Caresses), 1896
Musées Royeaux des Beaux-Arts, Brussels

411

Geographic Tables: Holland

Hieronymus Bosch
Cure for Madness, 1475-80
Prado, Madrid

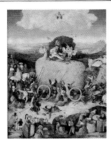

Hieronymus Bosch
Hay Wain, central panel
of the triptych, 1500-02
Prado, Madrid

Lucas van Leyden
Triptych of the Last Judgment,
central panel, 1526
Stedelijk Museum, Leyden

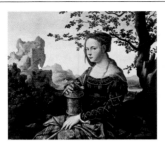

Jan van Scorel
Mary Magdalen, c. 1528
Rijksmuseum, Amsterdam

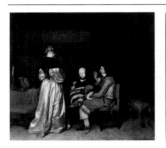

Gerard Ter Borch
Gallant Conversation
(The Paternal Admonition), c. 1650
Rijksmuseum, Amsterdam

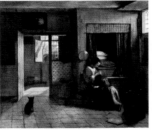

Pieter de Hooch
The Mother, c. 1660
Rijksmuseum, Amsterdam

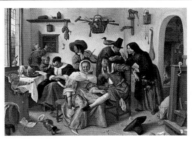

Jan Steen
Beware of Luxury, c. 1665
Kunsthistorisches Museum, Vienna

Rembrandt
The Jewish Bride, detail, 1666
Rijksmuseum, Amsterdam

Maarten van Heemskerck
*Self-portrait in Rome
with the Colosseum*, 1553
Fitzwilliam Museum, Cambridge

Frans Hals
The Laughing Cavalier, 1624
Wallace Collection, London

Rembrandt
Self-Portrait with Collar,
1629
Mauritshuis, The Hague

Rembrandt
The Night Watch, 1642
Rijksmuseum, Amsterdam

Johannes Vermeer
The Lacemaker, c. 1670
Louvre, Paris

Meindert Hobbema
The Road to Middelharnis, 1689
National Gallery, London

Vincent van Gogh
Prisoners' Round, 1890
Pushkin Museum of Fine
Arts, Moscow

Piet Mondrian
*Pier and Ocean
(Composition no. 10)*, 1915
Kröller-Müller Rijksmuseum, Otterlo

Geographic Tables: England

Hans Holbein the Younger
The French Ambassadors, 1533
National Gallery, London

Sir Anthony van Dyck
James Stuart, Duke of Richmond and Lennox,
c. 1634
Metropolitan Museum of Art, New York

William Hogarth
The Young Heir Taking Possession, first scene from
The Rake's Progress, 1733-1735
Sir John Soane's Museum, London

Canaletto
The Eastern Façade of Warwick Castle,
c. 1751
Museum and Art Gallery, Birmingham

William Blake
The Omnipotent, 1794
British Museum, London

Joseph Mallord William Turner
Dido Building Carthage, 1815
National Gallery, London

John Constable
Flatford Mill, 1817
Tate Gallery, London

Francis Bacon
Study after Velázquez's Portrait of Pope Innocent X, 1950
Tony Shafrazi Gallery, New York

Lucian Freud
Hotel Room, 1954
Beaverbrook Art Gallery, Fredericton
(New Brunswick, Canada)

David Hockney
Mr. and Mrs. Clark and Percy, 1970-71
Tate Gallery, London

Joseph Wright of Derby
*An Experiment on a Bird
in the Air Pump*, 1768
National Gallery, London

Thomas Gainsborough
Painter's Daughters, 1755-56
National Gallery, London

Sir Joshua Reynolds
*Portrait of Miss Bowles
with her Dog*, 1775
Wallace Collection, London

Thomas Jones
A Wall in Naples, 1782
National Gallery, London

Ford Madox Brown
The Last of England, 1855
Museum and Art Gallery,
Birmingham

John Everett Millais
The Blind Girl, 1854-56
Museum and Art Gallery,
Birmingham

William Holman Hunt
The Awakening Conscience,
1853-54
Tate Gallery, London

Dante Gabriel Rossetti
Monna Vanna, 1866
Tate Gallery, London

Geographic Tables: The United States

Benjamin West
Portrait of Colonel Guy Johnson, c. 1776
National Gallery of Art, Washington, D.C.

John Singleton Copley
Brook Watson and the Shark, 1778
National Gallery of Art, Washington, D.C.

Gilbert Stuart
Portrait of a Gentleman Skating, 1782
National Gallery of Art, Washington, D.C.

Thomas Cole
View from Mount Holyoke, Northampton, Massachusetts, After a Thunderstorm (The Oxbow), 1846
Metropolitan Museum of Art, New York

Mary Cassatt
Children Playing on the Beach, 1884
National Gallery of Art, Washington, D.C.

Charles Demuth
I Saw the Figure 5 in Gold, 1928
Metropolitan Museum of Art, New York

Grant Wood
American Gothic, 1930
Art Institute of Chicago

Charles Sheeler
Classical Landscape, 1931
Barney Ebsworth Foundation, Saint Louis

Jasper Johns
Three Flags, 1958
Barton Tremaine Collection, Connecticut

Josef Albers
Homage to the Square, 1958
Sidney Janis Gallery, New York

Mark Rothko
No. 19, 1960
Private Collection

Andy Warhol
Campbell's Soup Cans, 1962
Kikimo and John Powers Collection, Colorado

James Abbott McNeill Whistler
*Arrangement in Gray and Black
(Portrait of the Artist's Mother)*, 1871
Musée d'Orsay, Paris

Thomas Eakins
The Biglin Brothers Racing, 1872
National Gallery of Art,
Washington, D.C.

John Singer Sargent
Children of E.D. Boit, 1882
National Gallery of Art,
Washington, D.C.

Edward Hopper
Hotel Room, 1931
Thyssen-Bornemisza Collection, Madrid

Georgia O'Keeffe
Summer Days, 1936
Whitney Museum
of American Art, New York

Jackson Pollock
Blue Posts, 1952
Heller Collection, New York

Robert Rauschenberg
Spot, 1963
Staatsgalerie, Stuttgart

Keith Haring
Untitled, 1981
Property of the Artist, New York

c. 1390–1441 Jan van Eyck

1395–1455 Fra Angelico

c. 1399–1464 Rogier van der Weyden

c. 1400–1451 Stephan Lochner

1401–1428 Masaccio

c. 1415–1466 Enguerrand Quarton

1416–1492 Piero della Francesca

c. 1420–1481 Jean Fouquet

c. 1430–1498 Michael Pacher

c. 1430–1479 Antonello da Messina

c. 1430–1515 Giovanni Bellini

c. 1435.–1494 Hans Memling

c. 1440.–1495 Bartolomé Bermejo

1445–1510 Sandro Botticelli

c. 1450–1516 Hieronymus Bosch

1452–1519 Leonardo da Vinci

1453–1491 Martin Schongauer

1466–1530 Quentin Metsys

1471–1528 Albrecht Dürer

1472–1553 Lucas Cranach the Elder

1475–1564 Michelangelo

c. 1477–1510 Giorgione

c. 1480–1528 Mathis Grünewald

c. 1480–1556 Lorenzo Lotto

1483–1520 Raphael

c. 1489.–1534 Correggio

c. 1490–1576 Titian

c. 1494–1557 Pontormo

1495–1540 Rosso Fiorentino

1497–1543 Hans Holbein the Younger

c. 1515–1572 François Clouet

c. 1525–1569 Pieter Bruegel the Elder

1519–1594 Tintoretto

1528–1588 Veronese

1541–1614 El Greco

1560–1609 Annibale Carracci

1571 1675 1779

1571–1610 Caravaggio

1575–1642 Guido Reni

1577–1640 Peter Paul Rubens

c. 1580–1666 Frans Hals

1594–1665 Nicolas Poussin

1593–1652 Georges de La Tour

1599–1641 Sir Anthony van Dyck

1599–1660 Diego Velázquez

1600–1682 Claude Lorrain

1617–1682 Bartolomé Esteban Murillo

1632–1675 Johannes Vermeer

1634–1705 Luca Giordano

1684–1721 Antoine Watteau

1696–1770 Giambattista Tiepolo

1697–1768 Canaletto

1697–1764 William Hogarth

1699–1779 Jean-Baptiste-Siméon Chardin

1703–1770 François Boucher

1723–1792 Sir Joshua Reynolds

1727–1788 Thomas Gainsborough

1738–1820 Benjamin West

1741–1825 Henry Fuseli

1746–1828 Francisco Goya

1748–1825 Jacques-Louis David

1774–1840 Caspar David Friedrich

1775–1851 William Turner

1776–1837 John Constable

1791–1824 Théodore Géricault

1798–1863 Eugéne Delacroix

1815–1905 Adolf von Menzel

1819–1877 Gustave Courbet

1821–1893 Ford Madox Brown

1827–1901 Arnold Böcklin

1828–1882 Dante Gabriel Rossetti

1832–1883 Édouard Manet

1834–1903 James Whistler

1834–1917 Edgar Degas

1840–1926 Claude Monet

1841–1919 Pierre-Auguste Renoir

1845–1926 Mary Cassat

1848–1903 Paul Gauguin

1853–1890 Vincent van Gogh

1859–1891 Georges Seurat

1862–1918 Gustav Klimt

1863–1944 Edvard Munch

1866–1944 Wassily Kandinsky

1867–1956 Emil Nolde

1872–1944 Piet Mondrian

1879–1940 Paul Klee

1880–1938 Ernst Ludwig Kirchner

1881–1973 Pablo Picasso

1882–1916 Umberto Boccioni

1882–1967 Edward Hopper

1884–1920 Amedeo Modigliani

1888	1946	2003

1888–1970　Giorgio de Chirico

1890–1918　Egon Schiele

1891–1969　Otto Dix

1893–1959　Georg Grosz

1893–1981　Joan Miró

1898–1967　René Magritte

1904–1989　Salvador Dalí

1908–2001　Balthus

1909–1992　Francis Bacon

1912–1956　Jackson Pollock

1915–1995　Alberto Burri

1923–1997　Roy Lichtenstein

1928–1987　Andy Warhol

1932–　Gerhard Richter

1937–　David Hockney

1938–　Georg Baselitz

1958–1990　Keith Haring

1960–1988　Jean Michel Basquiat

Index of Painters

Photographic Sources

Archivio Alinari, Florence
Archivio Electa, Milan
Archivio Lessing/Contrasto, Milan
Archivio Scala, Antella (Florence)
Civici Musei e Gallerie
d'Arte of Verona
Diego Motto, Milan
Fondazione Palazzo Albizzini,
Città di Castello (PG)
Musei Civici of Venice
Palazzo Te, Mantua
Sergio Anelli/Electa, Milan

By kind permission of the Ministry of Culture, Rome,
also the photographic archives of the following departments:
Soprintendenza per i Beni Ambientali, Architettonici,
Artistici e Storici of Arezzo;
Soprintendenza ai Beni Culturali, Rome;
Soprintendenza Speciale alla Galleria d'Arte Moderna
e Contemporanea, Rome
Soprintendenza per il Patrimonio Storico, Artistico
e Demoetnoantropologico of Mantua;
Soprintendenza per il Patrimonio Storico, Artistico
e Demoetnoantropologico of Milan;
Soprintendenza per i Beni Architettonici
e per il paesaggio, Milan;
Soprintendenza per il Patrimonio Storico, Artistico
e Demoetnoantropologico of Venice

Thanks also go to the photographic archives
of museums and public and private bodies that have
supplied material

Holders of rights to any unidentified photographic
material are invited to bring the matter to the attention
of the publishers.